SURVEYING CENTRAL BRITISH COLUMBIA

A Photojournal of Frank Swannell, 1920–28

SURVEYING CENTRAL BRITISH COLUMBIA

A Photojournal of Frank Swannell, 1920–28

Jay Sherwood

ROYAL **BC** MUSEUM

VICTORIA, CANADA

© 2007 by Jay Sherwood

Published by the Royal British Columbia Museum
675 Belleville Street
Victoria, British Columbia
V8W 9W2 Canada
www.royalbcmuseum.bc.ca

Printed in Canada

Library and Archives Canada Cataloguing in Publication Data
Sherwood, Jay, 1947-
 Surveying central British Columbia.

 Includes bibliographical references: p.
 ISBN 978-0-7726-5742-8

 1. Swannell, F. C. (Frank Cyril). 2. Surveying - British Columbia – History – 20th century. 3.
British Columbia – History – 1918-1945. 4. British Columbia – History – 1918-1945 – Pictorial
works. 5. Surveyors - British Columbia - Biography. I. Royal BC Museum. II. Swannell, F. C.
(Frank Cyril). III. Title.

FC3845.C46S53 2007 971.1'03 C2007-960174-X

Contents

This book is dedicated with love to my family.

It is also dedicated to the people that Frank Swannell worked with and met in the 1920s. I hope that *Surveying Central British Columbia* has helped bring alive the spirit of these people.

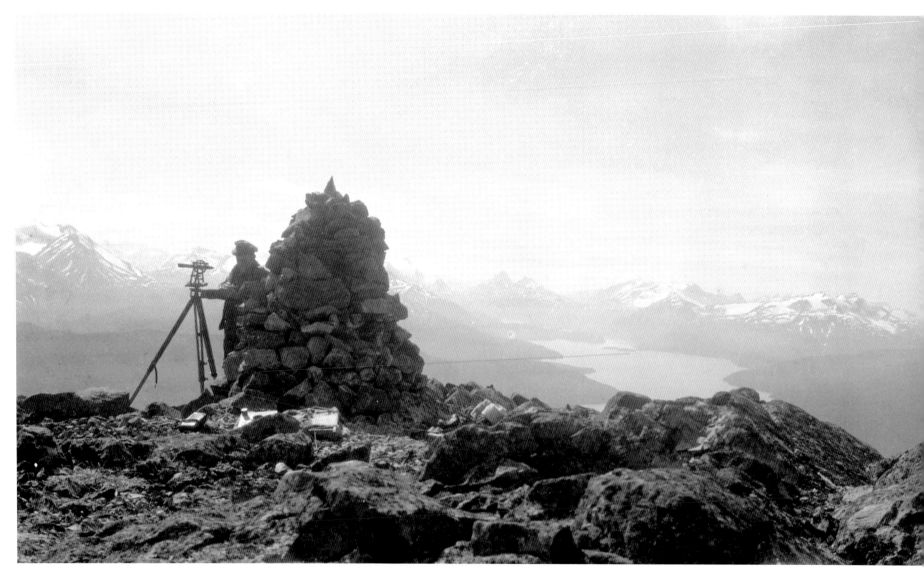

■ Swannell surveying at Rhine Crag cairn. This triangulation station above Tahtsa Lake, which Swannell surveyed in 1921, was one of the main locations for his survey of central British Columbia. (See page 6 for an explanation of triangulation surveying.) BC Archives I-58729

INTRODUCTION

Surveying Central British Columbia follows Frank Swannell's career from 1920 to 1928 after his return from service in World War I and the Russian Civil War. During these years Swannell worked for the British Columbia government, surveying and mapping the central part of the province along the east side of the Coast Mountains between the present-day Highway 16 on the north, and Highway 20 on the south. The numerous lakes and waterways of the headwaters of the Nechako, Morice and Dean rivers were encompassed in Swannell's surveys.

This photojournal is independent of *Surveying Northern British Columbia*, which chronicled Swannell's surveying and photographs in the northern part of the province during the years prior to World War I. Some of the people and places that appeared in the first book are also present in *Surveying Central British Columbia*.

This book continues the two main themes of the previous photojournal: a celebration of the life of one of British Columbia's most famous pioneer surveyors, and a recognition of the significance of Swannell's photographs for the history of this province. Swannell and the men on his survey crew usually departed from Victoria in May and did not return until October, when the onset of snow in the mountains precluded further surveying. In the years before World War I it took Swannell more than a week to reach the Nechako Valley. The further development of train and automobile transportation, which had started in the central part of the province just before World War I, enabled Swannell's surveyors to reach their starting location at Burns Lake, Houston or the Chilcotin in just a few days. The store at Ootsa Lake provided a place for Swannell to purchase supplies and send and receive mail. On the main lakes of the upper Nechako waterways Swannell would occasionally meet other people, but in the mountains, the men would sometimes work for weeks without encountering anyone. Summer weather in the Coast Mountain region was often cool and rainy, and flies and mosquitoes also made life difficult at times. Frequent windstorms made travel perilous on the big lakes.

Since the main purpose of Swannell's surveying was to map the region, it was necessary to climb to the top of many mountains each summer. This was challenging and occasionally dangerous work. After spending hours carrying surveying equipment to a peak, Swannell and his assistants would sometimes find that clouds and rain had lowered onto the mountain, preventing them from making their measurements, and they would have to return on the next favourable day. Even if the weather remained good it was usually cold and windy on the peaks, making it difficult to obtain accurate readings. In spite of the adverse working conditions, Swannell's surveys and maps were so accurate that they were not supplanted until the development of improved surveying techniques and equipment after World War II.

Swannell's photographs of central British Columbia during the 1920s are not as well known as the pictures he took between 1908 and 1914. However, his photographic eye and attention to detail are once again visible in the pictures that he took after World War I, and many of them have historical importance. Swannell's photographs help recognize and remember some of the First Nations people and settlers of the area and their way of life. The men who worked on Swannell's surveying crews and scenes from their daily life are also portrayed. Swannell's photographs in the 1920s include communities that were developing in the area; the Grand Trunk Railroad; automobiles and the early roads of the central part of the province; travel on the waterways; and transportation in the remote areas of the region. Many of the more than 1,500 pictures that he took during these years are vistas from mountain peaks. Swannell used these photographs to assist him in filling in the details for his maps. Today these mountain photographs document changes that have occurred in the landscape of the Coast Mountain region in the 80 years since Swannell was there. Swannell's numerous photographs of the lakes of the upper Nechako watershed are an invaluable record of the geography of this area before it was altered by the Kenney Dam in the 1950s.

Swannell's photographs of central British Columbia in the 1920s do not have the diversity of his pre-war pictures, and what is missing reflects the numerous changes that had occurred between the frontier British Columbia of the early 20th century and life after the Great War. There are only a few pictures of Hudson's Bay Company posts. Although some still remained, many had closed during the war, and the Hudson's Bay Company had lost significant economic influence. There are no photographs of stern-wheelers or stagecoaches. After the completion of the Grand Trunk Railroad the stern-wheelers soon disappeared from the Skeena, Nechako and upper Fraser rivers. Automobiles had superseded horses for long-distance travel in the region. Swannell also did not take any photographs of the Yukon Telegraph Trail. The telephone had replaced the telegraph as the main means of long-distance communication, and though the Yukon Telegraph Trail still existed, it was no longer a main transportation route. Almost all of Swannell's photographs of the First Nations people were taken at their reserves, and it was evident that the development of these reserves and the establishment of residential schools dramatically altered their lives. Swannell seldom met any First Nations people when he was surveying in the Coast Mountains, and his journals note many overgrown trails that did not appear to be used any more.

Surveying Central British Columbia also illustrates Swannell's interest in and contribution to the history of the province. He noted and photographed evidence that he found from R.C. Palmer's 1862 wagon road survey and the 1864 Chilcotin War. In the 1870s the CPR, while searching for a terminus for their railroad, explored several routes through the Coast Mountains in the central part of the province. Swannell discovered and recorded evidence of the CPR surveys. From 1926 to 1928, when he was surveying in the Chilcotin and the Coast Mountains near Bella Coola, Swannell followed Alexander Mackenzie's route through the area. Using Mackenzie's journal he noted and photographed many of the same landmarks that Mackenzie described. Swannell also made a map of Mackenzie's route through the region. In his retirement years, Swannell wrote three magazine articles for *The Beaver*, chronicling the historical discoveries he made during his surveys in the 1920s.

Swannell's work in central British Columbia demonstrates that he was probably our province's best mapmaker of the 20th century, and the last of British Columbia's great cartographers. During the fall and winter of each year, Swannell and his office staff would calculate all of their field measurements. Swannell would use these calculations to produce large, detailed maps known both for the information they provided and for their beautiful handiwork. The Surveyor-General sometimes complained that Swannell had too much information and detail in his work, much to Swannell's chagrin.

Swannell's photographs and journals between 1920 and 1928 provide an opportunity to view a mountain region of the province that was little known to non-native people at the time, and to learn about the history of the area and some of its inhabitants in the years after World War I. *Surveying Central British Columbia* is a photojournal of Frank Swannell's record of the great mapping and triangulation survey of central British Columbia between 1920 and 1928.

A note on terminology and the photographs that appear in the book.

In the early 20th century surveyors used feet and miles for their measurements. A foot is 30 cm, and a mile is 1.6 km.

Swannell uses the word Indian to describe the First Nations people. This was the name that was commonly used at the time. He also uses Siwash, another word that was used for the First Nations people. Siwash was sometimes used as a derogatory term depending on the person who used it and the tone in which it was used. Throughout his journals Swannell wrote respectfully of the First Nations people he met, and by all accounts he had a good relationship with them, so the term Siwash was used simply as a variation for Indian.

The sources of the photographs, maps and documents in this book are noted in their captions. Most are from the Swannell collection at the BC Archives in Victoria; a few can be found only at Library and Archives Canada in Ottawa. Swannell took all the photographs, except for the ones he appears in (taken by unidentified members of the surveying crew) and those made recently (photographers credited). During his surveying of central BC, Swannell shot many sets of panoramic photos to assist his mapping and because of his personal interest in the scenery of the region. He had many panoramas in his yearly photo albums, including the ones in this book.

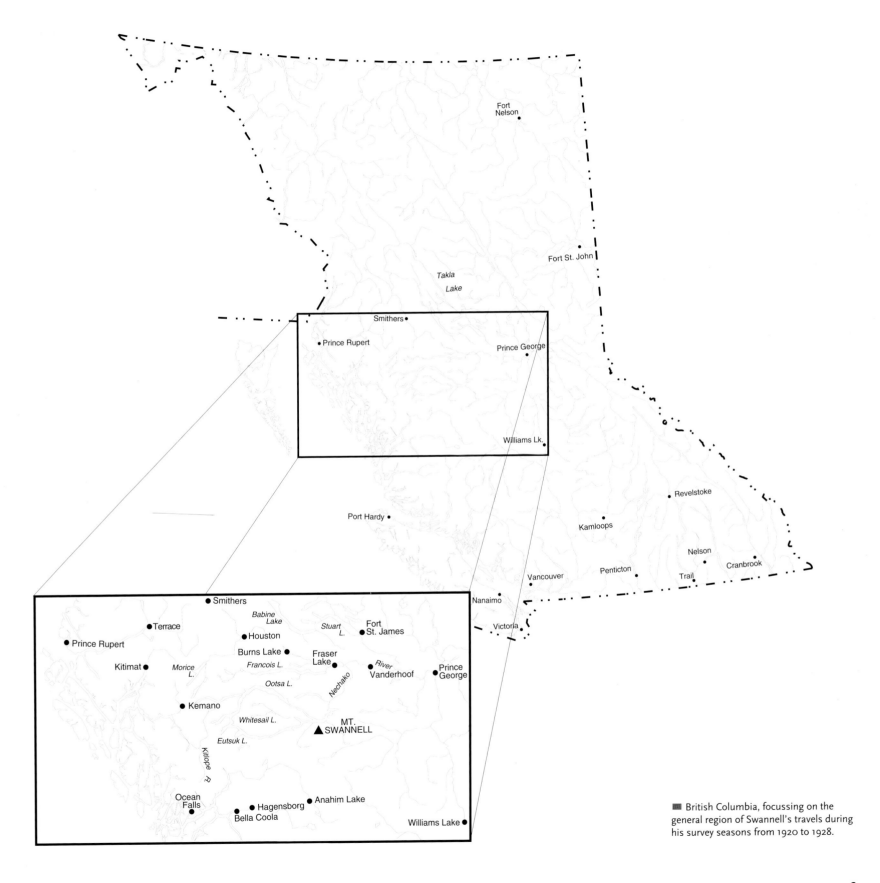

Fort
Nelson

Fort St. John

*Takla
Lake*

Smithers •

• Prince Rupert

Prince George
•

Williams Lk.•

Revelstoke

Port Hardy •

Kamloops
•

Nelson
• Cranbrook
•

Penticton
•

Vancouver
•

Trail
•

Nanaimo
•

Victoria
•

Smithers •

*Babine
Lake*

*Stuart
L.*

Fort
● St. James

Terrace ●

● Houston

Prince Rupert ●

Burns Lake ●

Fraser
Lake
●

River
● Vanderhoof

Prince
● George

Kitimat ●

*Morice
L.*

Francois L.

Ootsa L.

Nechako

● Kemano

Whitesail L.

▲ MT.
SWANNELL

Eutsuk L.

Kitlope R.

Ocean
Falls
●

● Hagensborg

● Anahim Lake

Bella Coola
●

Williams Lake ●

British Columbia, focussing on the
general region of Swannell's travels during
his survey seasons from 1920 to 1928.

SURVEYING AND WORLD WAR I

The years before World War I had been the golden age of surveying in British Columbia. It was a time of prosperity in the province, and survey crews worked for the provincial government on a wide range of projects throughout BC. Between 1909 and 1913 the government spent an average of over four per cent of its budget on surveying, the highest level at any time in British Columbia's history. From 1910 to 1914 an annual average of 29 surveyors received their professional designation, compared to fewer than 10 per year during the next 90 years. In his 1914 annual report G.H. Dawson, the Surveyor-General, reported: "Survey parties in charge of sixty-six British Columbia land surveyors, especially selected for the work assigned to them, have been engaged during the year."

The beginning of World War I in August 1914 suddenly and dramatically changed surveying in British Columbia. The Surveyor-General observed: "The outbreak of war with Germany early in August had the effect of stopping in great part the private surveying throughout the Province. From returns received up to this date, it is evident that had the war not taken place the total area of land and timber surveyed would have exceeded that done in any previous year." Government survey crews that worked in remote regions remained in the field. Frank Swannell and his crew were on the upper Finlay River and did not learn about the war until October. However, many of the crews that were surveying in accessible areas stopped their field season early, either because the government brought them back, or the men left to join the war effort. In December 1914 Dawson wrote: "The efficiency of the Branch has reached its maximum for the present, as the majority of the surveyors, articled pupils, and survey hands usually employed on Government survey parties are volunteering for active service in His Majesty's forces."

In the Surveyor-General's report for 1915, G.H. Dawson described the gloomy conditions that would affect surveying in British Columbia throughout World War I.

The conditions under which the work of this Branch has been carried on during the past year have been abnormal. For several years past the annual appropriation for surveys has been so large as to permit of extensive surveying operations being carried out.... This year, on the contrary, owing to conditions arising from the war, the vote for surveys has been reduced very materially, immigration to the Province has practically ceased, and the financial conditions prevailing have rendered it impossible, in the majority of cases, for the owners of rights to timbered and other lands to proceed with the survey of same. Consequently the area surveyed during the year is a fraction only of what has been done in recent years. The area surveyed by this Branch during the year 1914 was 1,012,000 acres; this year it was 127,000 acres.

Dawson also wrote: "With the exception of the survey of the Alberta-British Columbia Boundary and the topographic survey of the Okanagan Valley, no survey work has been undertaken by the Branch for which there was not an immediate and pressing necessity." He noted: "The practice of former years of sending out surveyors for the entire season in charge of large survey parties was this year abandoned. No parties were sent out in the early spring, and to a limited number of surveyors two or three months' work only was allotted during the summer months, while the strength of the parties was very

J.E. Umbach, Surveyor-General from 1916 to 1930.
Surveyor-General's Office photograph

Triangulation is a type of surveying where control points (survey monuments) are set, usually on a mountain, high point of land, or in an open location in a valley that has a good view of the surrounding area. A short base line (also known as a subtense line) is established and the distance is measured along this line. From the two ends of the line, angles are read to the control points that can be seen at each location. If two angles and a distance are known it is possible to calculate the remaining angle and distances through trigonometry. New control points can then be set further away and measured from the control points that have already been established. To provide additional accuracy, new short base lines are occasionally set up, measured and tied into the established control points.

A traverse is a basic survey using distances and angles. The distance between two survey stations is accurately measured (in Swannell's surveys with a steel tape). Using a theodolite (transit) the surveyor sets up his instrument on a survey station and measures the difference in the angle between the direction of the previous survey station and the next station on the traverse. During his survey of central British Columbia Swannell used triangulation for most of his work. Traverses were usually done for short distances along rivers or between lakes or in locations where no triangulation station was visible. The beginning and end of a traverse was at a base line or triangulation station.

materially reduced, and, as already stated, the surveyors were assigned to districts where there was absolute necessity for surveying to be done." Dawson commented on a change that benefitted government surveyors going to the central and northern part of the province: "Surveyors working in this section can now reach their work by the Grand Trunk and Canadian Northern Pacific Railways, thus avoiding the long and expensive journey over the Cariboo Wagon road from Ashcroft, and the expense to the Department of large pack trains to keep the parties in supplies during the season."

In 1916, G.H. Dawson, the Surveyor-General who had presided over the department during its golden years, resigned, and was replaced by J.E. Umbach, Chief Draughtsman in the department. Umbach's report at the end of 1916 noted that conditions had not improved. "In so far as the administration of the Survey Branch is concerned, the end of 1916 marks the close of the second year under conditions brought about by the war and other causes necessitating retrenchment in survey expenditures.... The appropriation for the past year was approximately the same as for the previous year, and the policy followed in carrying out the work was practically along the same lines.... As in the previous year, the parties sent out were small, averaging about six men, and were employed for only a comparatively short season, varying from a few weeks to less than five months, and averaging about three months." The amount of land surveyed was almost the same as 1915. Umbach commented on the BC surveyors who were serving in the war. "As far as has been ascertained, 110 British Columbia land surveyors have enlisted with his Majesty's Forces for foreign service. Twelve of these have made the supreme sacrifice. The qualifications of a land surveyor are such as to peculiarly fit him for a soldier, and this statement is verified by the fact that several surveyors at the front have already received high military honours."

Umbach's 1917 report described a situation that was even worse than the previous two years. "The outstanding feature of the policy of this Branch for the year has been strict economy and the confinement of expenditures to only what was considered the most necessary work in the field.... Owing to the comparatively small appropriation available and the increased cost of labour and supplies, it was necessary to confine operations to a very short season. On account of the uncertainty of the market in ordinary supplies the ration allowance was discontinued this year and surveyors were allowed the actual cost of their supplies." Only 54,000 acres of Crown land were surveyed, less than half of the 128,000 acres in 1916. At the end of his report the Surveyor-General was hopeful

for 1918. "Although statistics show that the aggregate of both field and office work is slightly less than for the year 1916, which was also a 'small year', the indications are that the bottom of the curve has been reached and passed, and that a considerable increase in the work falling to this Branch may be looked for during the coming year." Umbach concluded his report by noting that five more surveyors had enlisted in 1917 and four had been killed in service.

Umbach's hopes for improvement in surveying in British Columbia during 1918 turned out to be misplaced. "The appropriation for Crown land surveys for the current year was $70,000, being lower than that for any year since 1907. In consequence it has been necessary to further curtail field operations and to confine the work to only the most necessary surveys." To compound the disheartening situation, J.E. Laverock (BCLS #11) and one of his assistants, J. Griffiths, drowned when their boat capsized during a storm in Dean Channel while they were returning from Ocean Falls to their survey camp. Despite his gloomy report for 1918 the Surveyor-General was hopeful for 1919. "In my report for the year ending December 31st 1917, I ventured to predict that the work of the Branch would show a considerable increase during 1918. While the statistics would appear to show that this prediction has not eventuated to any appreciable extent as far as the routine work of the office is concerned, the special work of various natures dealt with during the year would indicate considerable expansion, which will be reflected in the next annual report of this Branch."

At the end of his report Umbach recognized the contribution of the BC land surveyors in World War I. "The recent successful conclusion of the great world war prompts me to here pay a tribute to the part played by British Columbia land surveyors in the great military struggle. According to available information, 122 surveyors enlisted for overseas service during the war. Of these, twenty-three have laid down their lives, two have been prisoners in Germany for about three years, and many others will return with wound stripes. The rapid promotion of many of these men, in some instances from the ranks, is evidence that the contribution of the profession of land surveying from British Columbia to the nation's cause was one of quality as well as quantity." *Roll of Honour,* a booklet produced by the Corporation of British Columbia Land Surveyors, stated that of the approximately 250 members actively working during World War I, 129 enlisted, including, "as far as is known, every able-bodied man of military age."

The end of World War I brought improvements to surveying in British Columbia. The appropriation for

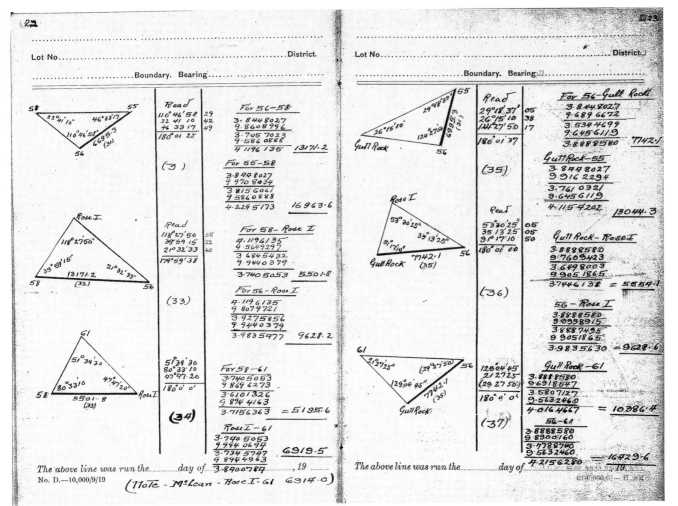

These two pages are triangulations from Swannell's 1920 field book. The "Read" column includes Swannell's readings for the three angles of the triangle. All of them measure very close to 180 degrees. The first triangle on the page includes stations 58, 55 and 56. Swannell had already calculated the distance between stations 55 and 56. With the angles that he read he was able to calculate the distances between stations 56 and 58, and 55 and 58. For the next triangle (Rose Island, station 58 and station 56), Swannell used his calculated distance for station 56-58, 13171.2 feet, and his angle readings to calculate the distance between Rose Island and stations 58 and 56. The remainder of the triangulations follow the same pattern, adding Gull Rock and station 61 to the triangulation network. Surveyor-General's office

Crown surveys increased from $70,000 to $110,000 in 1919. Although this was a sizable increase from the previous year, the money available for surveying was still far below the pre-World War I level. In his 1919 annual report the Surveyor-General wrote that one of the main objectives was to employ surveyors who had returned from the war. "This year was the first to be affected by post-war conditions, and it has been the aim of the Branch to so conduct its business as to assist as much as possible in reconstruction and the rehabilitation of the returned men, and at the same time to maintain a proper standard of efficiency." Returned soldiers comprised almost all the surveyors employed by the government, and two thirds of the total number of men on the survey crews. Umbach noted: "It is gratifying to know that, with very few exceptions, surveyors report that the work of these returned men has been very highly satisfactory." He also commented: "If it was true that a surveyor was readily transformed into an efficient soldier, it is likewise true, from the experience of the past year, that the soldier found no great difficulty in reverting to his civilian profession of surveyor."

One of the immediate objectives of the British Columbia government was to survey the grants of land that were given to returning soldiers. According to Umbach "a special attempt has been made to survey all lands in the districts covered which were held by men who served in the overseas army." In addition, "under the provisions of the 'Soldiers Homestead Act' large areas of lands have reverted to the Crown, which are now open for settlement. In many cases, however, the surveys are not suitable for the disposition of these lands as pre-emptions." The Surveyor-General noted: "Some work of this nature was carried out during the past season, particularly in the Hazelton and Fort George districts."

In 1920 British Columbia's allocation for surveying was $231,000, more than double the previous year. The provincial government spent almost two per cent of its

budget on surveying, more than for any year between World War I and World War II. However, there would not be a return to the golden age of surveying that existed in the years before the war. Instead of a wide variety of surveys throughout the province, work was targeted for specific projects. Umbach also developed a new system of organization for the survey crews that he described in his 1920 government report:

Owing to the high cost of equipment, supplies, labour and transportation, it was recognized that survey costs for the year would be greater than any previous year. In order to keep these costs at a minimum it was decided in the spring to depart somewhat from the methods of organization followed in previous years by arranging stronger parties for a longer season, thus reducing as much as possible the relative overhead charges. In some instances a qualified land surveyor was appointed as assistant in order to permit the surveyor in charge to cruise ahead of the party, laying out the work to best advantage, and finding the original corners of previously surveyed lands, thus preventing any delay in the actual line-work.

The government employed 53 BC land surveyors, 16 of them as assistants. Forty of the men were World War I veterans.

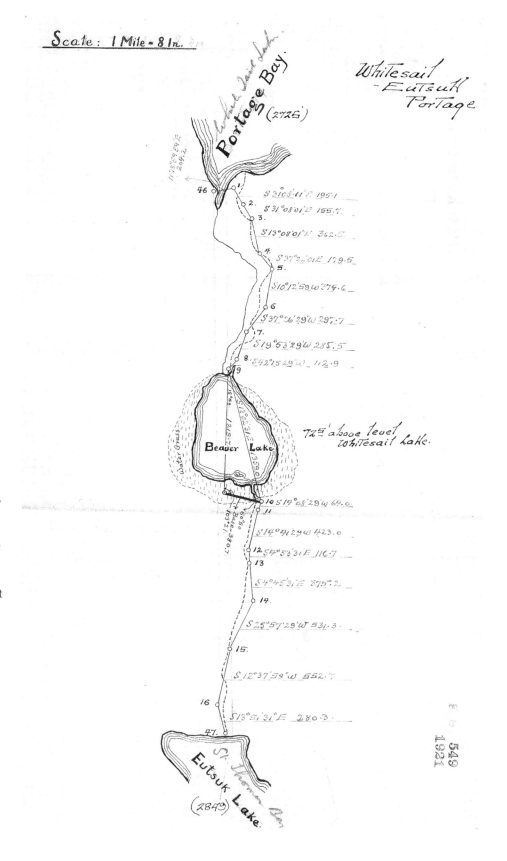

Much of the increase in surveying work in 1920 went to triangulation surveys. Thomas Kains, the Surveyor-General of British Columbia from 1891 to 1898, had advocated triangulation surveys as the most effective method of establishing accurate co-ordinated surveys in British Columbia, particularly because of the rugged, mountainous terrain found throughout most of the province. Kains's ideas were slow to be adopted in British Columbia. However, the success of Frank Swannell's exploratory surveys in northern BC from 1912 to 1914, and G.B. Milligan's in the northeast part of the province in 1913 and 1914, showed that Kains's ideas were correct, and some work started on triangulation surveys along the British Columbia coast in 1917 and 1918.

Umbach wrote that triangulation surveys were "the most accurate method of establishing control, but in the Interior, where triangulation stations are necessarily on the tops of the mountains, it is usually difficult and expensive to make connection between the triangulation survey and the land surveys which are in the valleys. On the British Columbia coast-line, however, presenting innumerable channels and inlets, triangulation stations can be established on the shore-line and an accurate and inexpensive means of control effected."

During the latter part of World War I the demand for forestry licences had increased significantly, and a large portion of the limited surveying funds in 1917 and 1918 were used for that purpose. In 1917 Umbach wrote that, "Owing to increased activity in the timber and pulp industries, this Branch is being called upon to clear constantly increasing numbers of applications for timber-sales and hand-logger licenses." He also observed: "The Admiralty charts in the past have been used to a large extent. As the number of alienations increase, however, it is found that the charts are not sufficiently reliable for our purposes. It has been found necessary, therefore, to have traverse connections made between various unconnected, isolated lots or groups of surveys, and a large portion of the surveys made on the Coast during the past season was confined to work of this nature."

At the same time, Umbach realized the necessity for a more accurate and permanent triangulation network survey along the British Columbia coast. "Arrangements are being made whereby it is hoped to have these coast-line traverses connected with the stations of the Geodetic Survey of Canada which is being projected along the Coast between the southern boundary of Alaska to the 49th parallel. In this way it will be possible to prepare maps of greater geographical accuracy than would otherwise be obtainable."

In his 1918 report the Surveyor-General noted: "The work of triangulating and traversing portions of the coast-line has also been continued." Umbach commented: "The fact that the end of a large inlet was found this year to be about twelve miles out of place on the [Admiralty] chart is quoted as an example of the necessity for this work." Umbach's report for the next year showed the expansion of triangulation surveying along the coast. "The work of triangulating the Coast inlets was continued this year and about 450 miles of coast-line was covered, including the tying-in of all existing surveys along the shores so covered. A connection was made to the astronomic station at Bella Coola, thus introducing an important factor in the control of the mapping of this work."

During 1920 the provincial government made a major effort to establish an effective network of triangulation stations along the British Columbia coast. The Surveyor-General reported: "Two parties were employed for the season on the continuation of the triangulation of the Coast channels and inlets. One other party was employed part of the season on this class of work. In all 667 miles of coast-line were so surveyed. This net of triangulation now extends from Smith Inlet, near the north end of Vancouver Island, to the north end of Grenville Channel, or within 15 miles of the mouth of the Skeena River, and including all the main inlets. All existing surveys en route have been tied in to the triangulation."

By the end of 1920 a triangulation network had been established along a large portion of the province's coastline. In the same year the Surveyor-General gave a similar triangulation survey and mapping project along the east side of the Coast Mountains in central British Columbia to a surveyor who had just returned from war and was experienced with this type of work. That surveyor was Frank Swannell. Surveying and mapping central British Columbia would become Swannell's extensive and famous project for the next nine years.

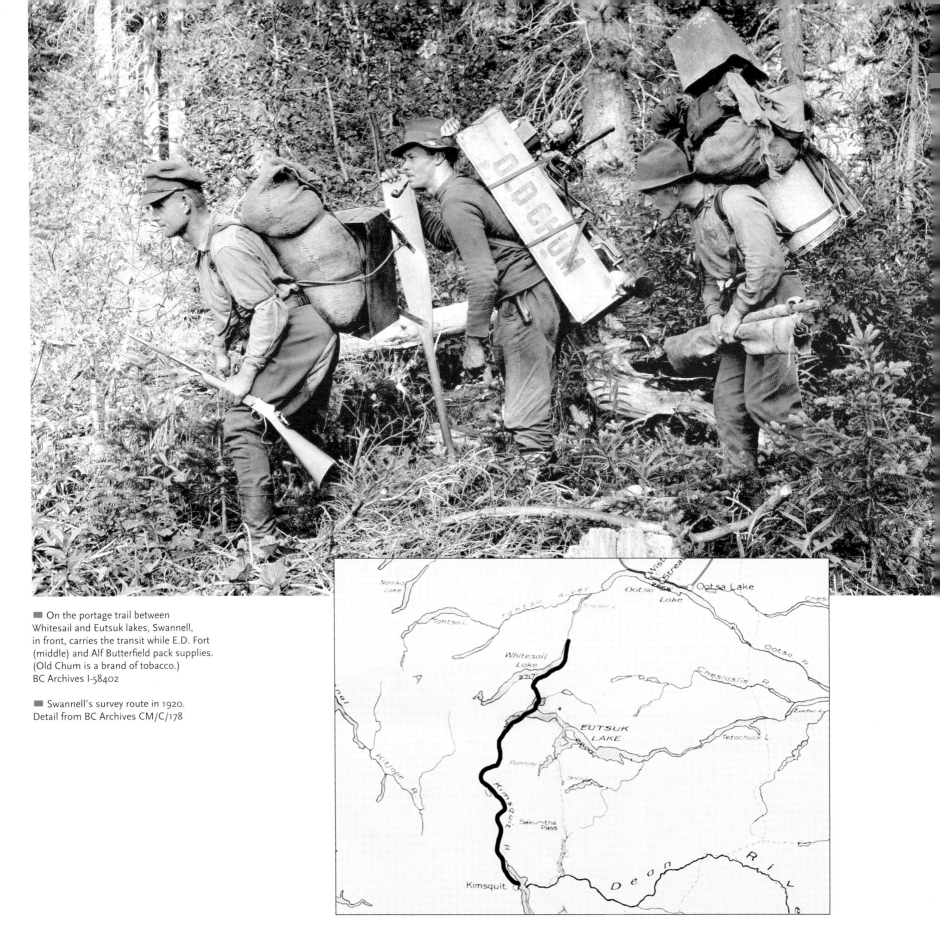

■ On the portage trail between Whitesail and Eutsuk lakes, Swannell, in front, carries the transit while E.D. Fort (middle) and Alf Butterfield pack supplies. (Old Chum is a brand of tobacco.)
BC Archives I-58402

■ Swannell's survey route in 1920. Detail from BC Archives CM/C/178

1920

Thursday 10th [June] – Wrote Surveyor-General enclosing general expense accounts.... Big boat gets away 9:30. Alf Butterfield & I leave in Barker's boat 1:45 – gets very cold and strong breeze. Alf covers grub with pack cover and sits on top. Water slopping inboard when we are quartering on seeks lowest level, hence much discomfort for Alf. 5 pm petrol plays out – land on low spot. Put to sea again but stopped by signalling from south shore – Put in and find the others camped there. Had been held up by wind. Camp 1

It was Frank Swannell's first night in a surveying camp in BC since October 1914, when he was returning from his exploratory survey of the Finlay River. Many events had occurred in the intervening five and a half years.

Panorama of Chikamin Mountain. Swannell's surveyors are in the middle, en route to the top of the mountain. Chikamin, the Chinook word for iron and other metals, was the local name for this mountain. Swannell used this name on his map, based on information provided by Chief Louis from Cheslatta Lake. BC Archives I-58516–19

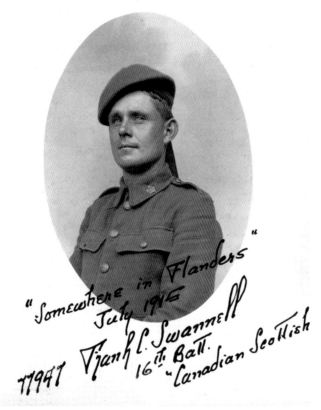

"Somewhere in Flanders."
BC Archives I-68453

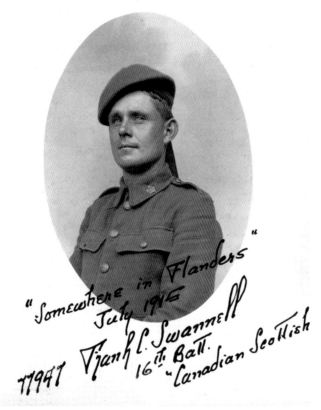

"Somewhere in Flanders July 1916

77947 Frank C Swannell
16th Batt.
"Canadian Scottish"

When Swannell arrived in Victoria in November 1914, at the end of his surveying season he wanted to enlist in World War I. He was 34 years old, married and had three children, and although there was no necessity or pressure for him to enlist, Swannell had a sense of patriotic duty. He hoped to establish a surveying corps, for there were many BC land surveyors who wanted to enlist, and Swannell believed that their surveying expertise would be useful for mapping the battlefields on the Western Front. On November 10, the day after he returned, Swannell went to "see Surveyor-General, but no discussion except regarding enlistment in the army. Spent the day seeing local surveyors regarding the formation of a surveyors corps." Two days later a "deputation of the two Milligans, Bishop, Whyte, Schjelderup, Butterfield, Noakes and myself interview the Surveyor-General as to the formation of a Surveyor's Corp – It is agreed that representations be made to the Imperial authorities through McBride [the premier of British Columbia]." Unfortunately the proposal was not accepted.

By the end of November, Swannell passed his medical examination and enlisted in Company B of the 88th Victoria Fusiliers (the Fusiliers became part of the 16th Batallion of the Canadian Scottish Regiment). In February 1915 he was shipped to England for training, and on April 26 he arrived in France. Two days later he fought in the 2nd Battle of Ypres. Swannell's diary describes conditions during the battle: "Friday – April 30. Lay in trenches all day – terrific artillery duel – French battery directly behind us being searched for by the Boches – At one time the Germans centered on our trench – Lieut. Morton crawled in with me & later Metcalfe – terribly cramped – For 20 minutes the shrapnel had our exact range – a shrapnel bullet struck two inches from my knee.... Terrible night, continuous artillery fire & cramped in corner of trench. Moved at 3 am & occupied shelter trenches along road near canal bridge. Was enfiladed by rifle fire during night & badly scared." The next day Swannell wrote that they were "under fire almost continuously.... Firing right over our heads so close that the rush of air lifts our caps.... Desultory artillery fire all night – a 'un éclat d'obus' tears a jagged hole through my great coat." Swannell spent May 2 in "the trenches all day. Shell ricochets & drives 6 inches into tree against which the Lieut. & May were standing – does not explode."

In May, Swannell was at the Battle of Festubert. On May 18 he was "struck on top of head with spent shrapnel bullet – half stunned ... at 10:30 start for front line – arrive 2:30 – very bad going thru muddy trenches & shell-cut roads.... Dig in by dawn only 500 yds from Germans & 200' behind old Ger. trench captured by British but untenable – blown to pieces by shells & full of dead bodies & debris. Get a lively time with flares & shrapnel while digging & several hit. Feel crack on head more now – half comatose. Raining nearly all day & night – plastered with mud." The next day a "timing ring of shell & fragment tear thru my sheet, plaster me with mud." On May 20 Swannell described being "under heavy shell fire most of day – we being within 300 yds of German advance trenches & directly behind Ger. Comm. Trench down which German snipers creep. Shell fire very bad 6-8 pm – never thought to see it through.... Most of us never saw a German – they did not wait for us.... At 6 am 21st [May] get back to 3rd line & stop there all day – 84 casualties out of 126 in our company – the machine gun fire was like sleet.... We were a woeful sight – what was left of us – mud from head to foot – stained with lyddite, clothes torn with shrapnel, barb wire. Germans shelling the road so we hit for the British trenches – worst sight of all in the half-light – blown to pieces sandbags & odds & ends of humanity – stumbling along, catching one's feet in the dead men's accoutrements."

On the evening of May 21 a charge was ordered. "Crossing Germ. Communc. Trench German machine

guns train on us & mow us down – I rush 50 yds then fall flat besides Hammond shot thru leg – Poor Milburn (Plat. Sergeant) leading killed almost instantaneously. I tripped on Milburn's equipment & fell on my face. Bullets clipped the high grass in which I lay." A week later in the battle "three shells drive right into our parapet – I nearly get it from a fragment glancing from my shovel & grazing my thumb. Dive into safety in the covered dugout – Flewin, Tucker, Major Gibson & I live in this cave – most foul smelling with decayed vegetation – shell crater, water filled behind with dead mans boots & hand projecting – lots of dead lying around unburied." In a letter to his cousin Swannell described a gas attack that he witnessed. "The Germans gassed the trench in front of us at dusk – we could see the poor chaps staggering back gasping – then the French artillery opened fire to drive back the German infantry attack.... Over a long mile the yellow gas cloud lay just above the white puffs and splash of fire as the French shrapnel burst. The attack withered away."

During June Swannell fought in the battle of Givenchy where there was heavy artillery fire. In the summer of 1915 Swannell volunteered for the Royal Engineers so that he could obtain extra pay, which was needed at home, and use his surveying experience. At the battle of Messines in July Swannell began surveying the trenches, a very dangerous job, for German snipers were

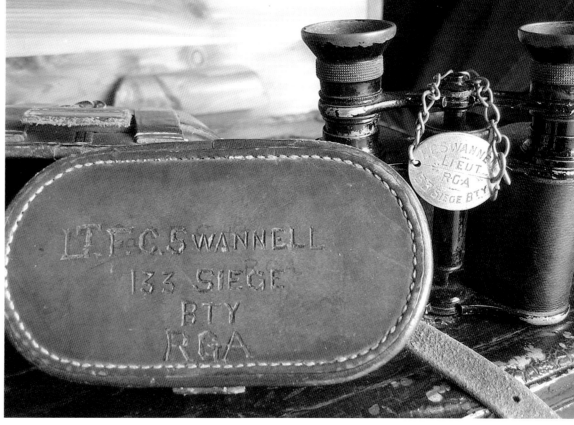

shooting at anything that appeared above the trenches. "Baxter runs the tape out along the traverse. Then we clear it as well as we can without exposing more than our arms – then I pop up and read the bearing – Baxter holding a chain-pin or bayonet as a foresight...."

■ *Above*: Swannell's binoculars and identification tag when he was with the Imperial Army. Jay Sherwood (with permission of Swannell family)

■ Swannell's tin-lined stationery box that he used in Russia in 1919. "N.R.E.F." stands for the Northern Russia Expeditionary Force. Jay Sherwood (with permission of Swannell family)

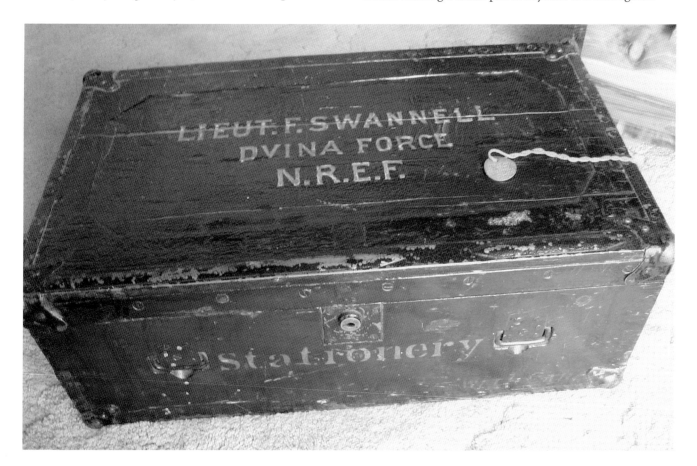

The General puts me out with a transit, it'll only last a few hours – and I want an abnormally long diagonal eyepiece or I'll last 'quick' too." In late August Swannell had a harrowing experience. "Borrow 100' tape from Divisional Engineers and survey Front Line Trench 138. Down by 'Lone Tree' we just finish when a 'whizz bang' [small field gun shell] lands exactly where we had been – cuts a branch clean off the tree." By the end of August Swannell had become proficient at surveying in the trenches. "Now expert at bobbing up & reading prismatic like greased lightning. Under cover I get dial of approximate bearing – then Baxter holds bayonet above parapet ahead & I bob up & clamp exact bearing. Baxter takes some awful risks dashing across with the chain."

Swannell's mapping ability was recognized, and in September he was promoted to sergeant and moved into the 1st Canadian Division Headquarters, a much safer place. In November Swannell was sent to England on appointment to commission in the Imperial Forces, where he worked on making maps and doing some instructing.

Swannell enjoyed the work and being in England. However, by early summer 1916 the effects of the concussion at Festubert and shellshock at Givenchy, aggravated by mental strain and overwork, began to affect Swannell. "June 20 – ... feel thoroughly discouraged as I don't seem to pick up things quickly.... June 21 – Take long lonely walk after dinner. Pretty homesick.... July 2 – spend day quietly – consult Dr. Morris about my condition." On July 21 Swannell was given 10 weeks sick leave and 3 months of unfit General Service.

On September 5 he was sent back to Canada on leave. As the ship approached the Newfoundland coast 10 days later he noted in his diary that he was thinking of Jack Mitchell, the BC Forest Branch representative on his 1912 crew. Mitchell, a Rhodes scholar from Newfoundland, also served in World War I and had written Swannell in France in 1915. Later Swannell would learn that Mitchell died that day in the battle of High Wood, part of the fighting at the Somme.

From Montreal he travelled by train to Winnipeg where he switched to the Grand Trunk Pacific. In 1914, before the line was completed, Swannell had travelled on this railroad from Prince Rupert to the Bulkley Valley en route to Fort St. James. In the Nechako Valley, where Swannell had surveyed in 1908 and 1909, he stopped at Vanderhoof, the new town that had been established along the railroad line. George Ogston, a friend and former Hudson's Bay Company employee at Fort St. James, met Swannell there and they visited. Swannell's wife, Ada, was waiting for him when he arrived in

Prince Rupert. In his diary he noted the "Prince Rupert weather – pouring rain." From Prince Rupert Swannell and his wife travelled by boat to Vancouver, and then took another boat to Victoria. There they were met by Swannell's children, George Copley, his close friend and survey assistant from 1909 to 1914, and George's wife, Mabel.

Six months of rest and time with his family appeared to help Swannell, and in March 1917 he returned overseas. He travelled on the SS *Prince Rupert* to Prince Rupert. The ship stopped at Ocean Falls. "Huge pulp plant costing $2,000,000 under construction. Several thousand men on the payroll." On March 21 Swannell reached the port city on BC's north coast. "Arrive at Prince Rupert & lo! a miracle – fine weather." He boarded the Grand Trunk Pacific, arriving at Fort Fraser the next day, where he was greeted by William MacAllan, the Indian Agent and a friend that Swannell had met many times during his surveying in northern BC. "MacAllan down to meet me at Fort Fraser. 2 feet of snow here. Go with Sam Ellis up to the old fort. Townsite absolutely deserted." The Hudson's Bay Company store at Fort Fraser closed in 1915, and the bustling railroad community that Swannell visited in 1914 was, like many villages in northern BC, in an economic depression. Swannell spent three days at Fort Fraser visiting friends that he knew from the pre-war years when he surveyed in the area. At Fort George he met Pat Sharkey, the cook on his survey crew from 1908 to 1912. When the train stopped at Mount Robson Swannell enjoyed the scenery. "Wonderful view of Mt. Robson – clear cut and sunbathed – To see this and then think of those Flanders trenches" he wrote wistfully.

The trip across the Atlantic to England proved dangerous. Off the coast of Ireland a "periscope popped up under our stern – 30 yards away. – Too close for our gun to depress onto her.... U-Boat evidently miscalculated – so close that the explosion of a torpedo would have been fatal for herself – jolly lucky for us." When they arrived at Liverpool the "transport ahead of us has her bows stove in by a mine off the mouth of the Mersey – docks in a sinking condition."

Once he was back to work in London the effects of shell shock soon returned. In his entry for April 29 Swannell wrote: "My head still has me half crazy mad. That shrapnel bullet was a good investment for the Boche." Swannell spent the remainder of 1917 making maps and doing a topographic survey at Salisbury Plains. On one occasion Swannell visited Oxford. He was invited to join some of the faculty for supper and was called on to say grace. Usually this was given in Greek or Latin but

since Swannell knew neither language he recited the Lord's Prayer in Chinook Jargon.

In March 1918 Swannell commented on the war weariness that had set in after almost four years of conflict. "I notice a decided change in the attitudes of most soldiers whether regulars or camouflaged civilians towards the war. The old eager keen Hun strafer is disappearing and giving place to a sober-minded fed-up individual who merely does his job through force of habit." The same month shell shock returned and later that spring Swannell once again went on leave, this time in England. His entry for May 16, 1918 described his birthday. "My birthday – the 38th – last night slept 6 hours – shrewdly suspect the sleeping draught was more potent than usual. Home letter of April 19th arrives

wonderfully in time with photos of the children for a birthday gift, taken by Mrs. Morley – those of baby most excellent – as Agnes has scribbled on the back 'some kiddie'. Can't keep my eyes off them – It is hard, bitter hard not to be home to Victoria."

When World War I ended Swannell had the opportunity to return home. Instead, he joined the Allied Expeditionary Force that was fighting in the Russian Civil War against the Communists. It is uncertain why he remained in the army. Probably the British wanted his mapping expertise, and he felt a duty to oblige their request. In April 1919 Swannell left England for Archangel in northern Russia. There he was in charge of the mapping section of the Dvina Force. On July 7 the Russian soldiers that the British were working with

■ Swannell took several photographs of life in northern Russia during April and May, 1919. BC Archives I-68452

mutinied and began firing at the Allied troops. Swannell was shot and severely wounded in the left shoulder and would have died if he had not been rescued by his assistant. Months of recovery in hospitals followed, first in Russia, and then in England. In early 1920 Swannell was discharged from the Army and returned to Victoria in March.

After his wound in Russia, Swannell's left shoulder was permanently weakened, and his left hand lost much of its mobility. In addition to his physical injuries there were the emotional consequences of the war. Swannell knew most of the 24 BC land surveyors who died in World War I. Among those killed was Captain J. Herrick McGregor, one of the owners of the first surveying company where Swannell worked. G.B. Milligan, like Swannell, did exploratory surveys in northern BC in 1913

and 1914, and the two travelled back to Victoria together at the end of the 1914 field season. Milligan was killed in the war. Pete MacDonald, who worked on Swannell's survey crew from 1910 to 1912, and who met Swannell in France in 1915, was killed. Jack Mitchell, another member of his 1912 crew, died in 1916. Several of Swannell's friends from Victoria were also killed in the war.

Things did not go smoothly for Swannell when he returned to Canada. He had only a few weeks with his family before he had to get ready for the 1920 field season. Swannell's son, Lorne, still remembers, with sadness, that his father, who had been away for most of the past five years, was only home for a short time before leaving again for several months. At the Surveyor-General's office Swannell found that J.E. Umbach was much more formal and official than G.H. Dawson.

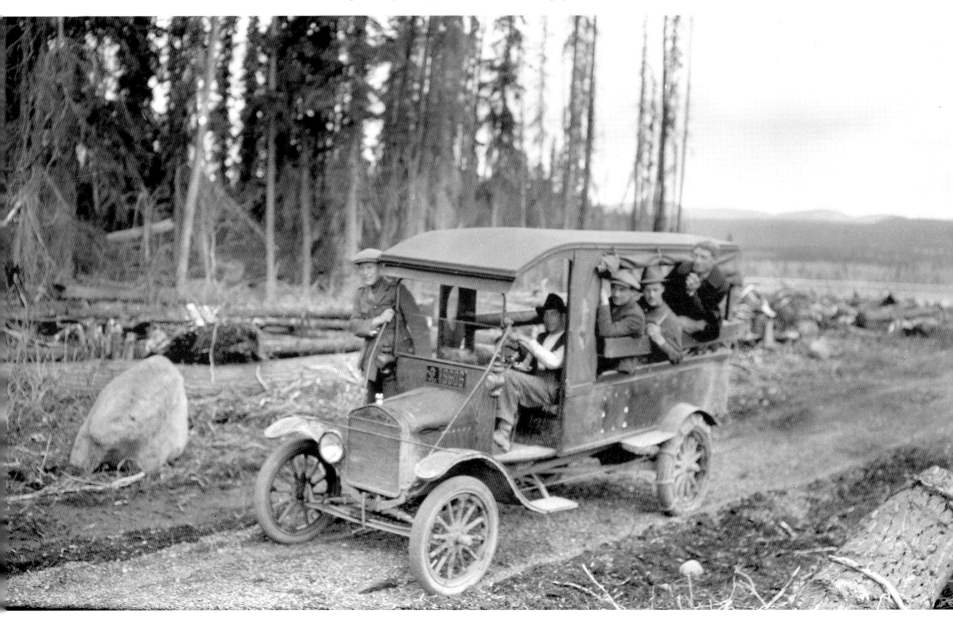

◾ Automobile transportation in the central interior became more commonplace after World War I. This road between Burns and Francois lakes was one of many constructed in rural areas. BC Archives I-33702

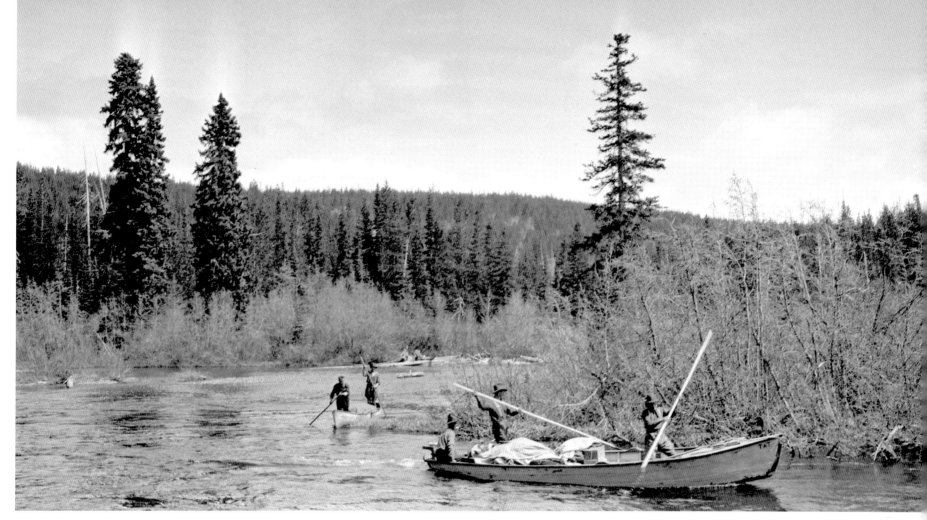

Whitesail River. Although outboard motors made travel on the waterways of central BC easier, most early engines were not very powerful. The men still had to pole or line their boats in places on the river where the current was swift. BC Archives I-58495

Instead of the freedom and latitude that Dawson gave Swannell in his instructions for the exploratory surveys and the friendly tone of his letter, Umbach's directives in his May 13 letter were very specific. After detailed instructions regarding the organization of his surveying crew and the wages and expenses that would be paid, Umbach gave Swannell his surveying assignment.

Your work will consist of making a surveyed connection between the head of Dean Channel and the Head of Gardner Canal with a tie to the surveys in the vicinity of Eutsuk Lake. This may be done either by a triangulation throughout or by a combination of triangulation and traverses as may be found most convenient on the ground. At the same time, you are to make a topographical reconnaissance survey of as much adjoining territory as may be possible to cover during the season, and extending easterly to connect with the topographical map prepared by Mr. R.P. Bishop BCLS in connection with the survey of the 53rd parallel.

A triangulation was made in 1919 of Dean Channel by J.T. Underhill BCLS and you will be expected to connect with Mr. Underhill's most northerly station on this work which is situated on the shore of Kimsquit Indian Reserve and has been tied by traverse to the NW Corner of the Reserve.

Mr. Underhill has this year been instructed to triangulate Gardner Canal and his instructions are to make a definite connection to the SW Corner of the Indian Reserve at the head of the canal. You will arrange to tie your work to this same corner. You will be expected to prepare a complete and detailed report on the country covered by you for this Department in connection with similar work. You will be particular to comply with all the Regulations set out in the above instructions and will not fail to furnish the Department with full and complete monthly reports of the progress you are making. You will arrange to supply yourself with full information with regard to existing surveys and reports on the country in which you will be working and should there be anything in these instructions which is not quite clear to you, you will, before leaving for the field, communicate with this Department.

At a meeting on May 13 Umbach had also wanted to select Swannell's route to reach his survey work.

However, Swannell knew the area and conditions and realized that Umbach had made a poor choice. "Umbach anxious to persuade me to go in from Kimsquit up old trail blaze up Salmon River – Gets Morris in to back him. Object strenuously to back-packing over the top of the Coast Range with river swollen & passes choked with snow. Get my way via Ootsa Lake."

On June 2 Swannell left Victoria on the SS *Prince George* with two members of his crew, A.J. "Alf" Butterfield, and Ed Lee, from Saltspring Island. They spent the next day at Vancouver before the boat left in the evening for Prince Rupert. "The King's birthday & English Bay thronged with bathers.... Ed evidently will be a good man at rustling – has acquired 2 doz bottles of beer." En route to Prince Rupert the boat stopped for four hours at Ocean Falls. The chief timekeeper at the pulp mill, a man that Swannell knew at Fort George, gave them a tour through the mill. In Prince Rupert Swannell picked up Viktor Kastberg, their cook and packer. Kastberg had been one of the two Forest Service representatives on Swannell's exploratory survey in the Omineca in 1913.

Swannell spent Sunday, June 6, at Burns Lake. He went to see Wilhelm Schjelderup (BCLS #82) who had articled with Swannell and worked on his survey crews from 1909 to 1911. Schjelderup was both a friend and a partner in some real estate properties. "Confer with Schjelderup about our various properties – Up at his bungalow a few minutes, but don't see Mrs. S. by reason of the recent advent of a daughter. Bill not exactly bubbling over with hospitality either."

While he was at Burns Lake Swannell met Charles Musclow. A trapper who lived in the remote area beyond Ootsa Lake, Musclow was a strong, experienced outdoorsman who would be part of Swannell's survey crew for the next three seasons. "Arrange with Musclow for Chestnut freight canoe & Peterboro for $1.00 per day – petrol payable by me – boat due to arrive Friday – He to get it thru to Ootsa & if required to take one ton provisions in at rate to be settled later."

On June 7 Swannell's crew left Burns Lake. "Pull out by special stage – a ramshackle 'Tin Lizzie' 10:30 am – 2 miles from Francois Lake too many mudholes – leave

car & push on on foot to so-called Francois Lake Hotel – Sent team back for outfit – heavy rain & get soaked. Kastberg & I cross lake by govt ferry – 2 miles across & walk through 8 miles to Pat Mulville's store – away at supper at Bostrom's ranch, so a dirty youth camped in a dilapidated tent alongside the store informs us – turns up finally.... While getting a supper of crackers & cheese & sardines pick out a cooking outfit & superintend the packing up of the grub. Dead tired, but as the hospitality of a blanket under the counter is not tendered we push on another mile to Newman's ranch – cabin empty but warm, so take possession."

The following day Swannell and his crew walked 15 miles to Ootsa Lake. There Swannell met E.D. Fort (BCLS #209), his assistant for the season. While at Ootsa Lake, Swannell hired C.D. "Shorty" Haven, a trapper, prospector and experienced outdoorsman. Haven, who was originally from the United States, had a farm at Uncha Lake and won first prize for his timothy seed at the Chicago International Exposition. Ed Lee, who also kept a diary, described Haven as "60, short, muscular, 5 ft tall, active as a boy and game for all, a hunter and prospector." Swannell's crew spent June 9 with the Bennett's, a family who had established a store and operated the post office at Ootsa Lake. While he was there Swannell arranged for another boat for surveying on the lakes and waited for the equipment to arrive by wagon. The crew slept on the living room floor that night.

As he was writing his journal in the first camp of the 1920 field season, Swannell probably remembered that 10 years previously he had travelled on Ootsa Lake past this site. In the fall of 1910 he, Tom Greer, and Anton Olson had canoed the Great Circle route of the lakes of the upper Nechako watershed while Swannell was surveying lots on the upper Nechako River.

During the next two days Swannell and his crew travelled along Ootsa Lake, up the Sinclair River, through Sinclair Lake, and up the Whitesail River to Whitesail Lake where their surveying would begin. On June 11 Swannell intended "to turn out at 4 am – but rain sets in solid and continues until 11 am – early lunch and starts rain again but clears toward evening.... On spit on Sinclair Lake strike a solitary trapper – a Swede 'Sandy Sunday' (Sunde) by name – has canvas canoe & cache on Whitesail Lake – which he can't connect as the river is too much for him to get up alone – arrange to give him a man & he to take up 400 lbs for us – Our Evinrude runs us easily 2 miles up Whitesail River." This was the same location where Swannell had camped in 1910. Swannell was beginning to realize that the outboard motor made travel on the waterways easier, both for the distance the boat could cover on the lakes, and its ability to get up the rivers easier than poling and lining a canoe. Travelling up the Whitesail River during spring run-off proved dangerous for Swannell and his men. "Kastberg and the Swede Sunde in the latter's canoe with 500 lbs. – Alf & I in the poling boat which leaks damnably – Try poling Alf forward but decide he will serve God best with a paddle. Very poor poles – heavy green brittle pine. Get along fine for three miles until my pole & shoulder give out together in a swift chute round a sweeper – thick willow into the water, but Alf lines up a hundred yds – My shoulder hopeless & no axe to cut a new pole – so drag the boat up by wading until Sunde seeing our fix comes down with a new pole." Meanwhile the "Tat", their boat with a motor, made it smoothly up the river. "The Evinrude does such marvellous work."

Further up the Whitesail River "very nearly drown Alf – He volunteers to carry a line across the riffle – gets to point & can't move as crotch deep in icy swift water with the drag of rope behind.... He tries to pull up on it – is swept off his feet, whirled round & round & smashed under the log jam – for it seems minutes can see his face seemingly a foot under – Drop the line & let the canoe go smash against the jam.... Kastberg runs out on the swaying logs & hauls Alf's head & shoulders out – miraculously he regains consciousness almost immediately."

Frank Swannell (left) and R.P. Bishop at Hallett Lake in November 1911, while surveying in the upper Nechako region. BC Archives I-68451

When they reached Whitesail Lake the men set up a camp near the outlet of the lake where they would stay for the next 10 days. Sunday, June 13 was a day of rest for the men after their adventures on the Whitesail River. The following day two men patched the cedar canoe while the rest of the crew started the triangulation of Whitesail Lake.

There were two main objectives for Swannell's surveying in 1920: a triangulation and topographic survey of the headwaters of the Nechako River, particularly in the Eutsuk Lake area; and a connection between R.P. Bishop's (BCLS #73) survey of the 53rd parallel in central British Columbia and J.T. Underhill's (BCLS #146) survey of Dean Channel along the coast. The British Columbia government was interested in the economic possibilities of the headwaters of the Nechako River, particularly its hydro-electric potential. E.P. Colley (PLS #67), a provincial land surveyor who died when the *Titanic* sank in 1912, had surveyed some lots for agriculture on Ootsa, Eutsuk and a few other lakes in the area, but no detailed survey of the region had been completed. Before World War I the provincial government had surveyed several latitude and longitude lines in the central part of the province, including the latitude lines from 52° to 55° and 124° longitude. The Dominion Observatory had established an accurate monument on all but the 55th parallel. In 1913 Bishop surveyed 93 miles along 53°N latitude, and then made a triangulation tie into Eutsuk Lake. Underhill's surveys were part of the triangulation being established along the coast. Swannell's survey would start connecting the coast network with the surveys of the interior. Since both had accurate control points established by the federal

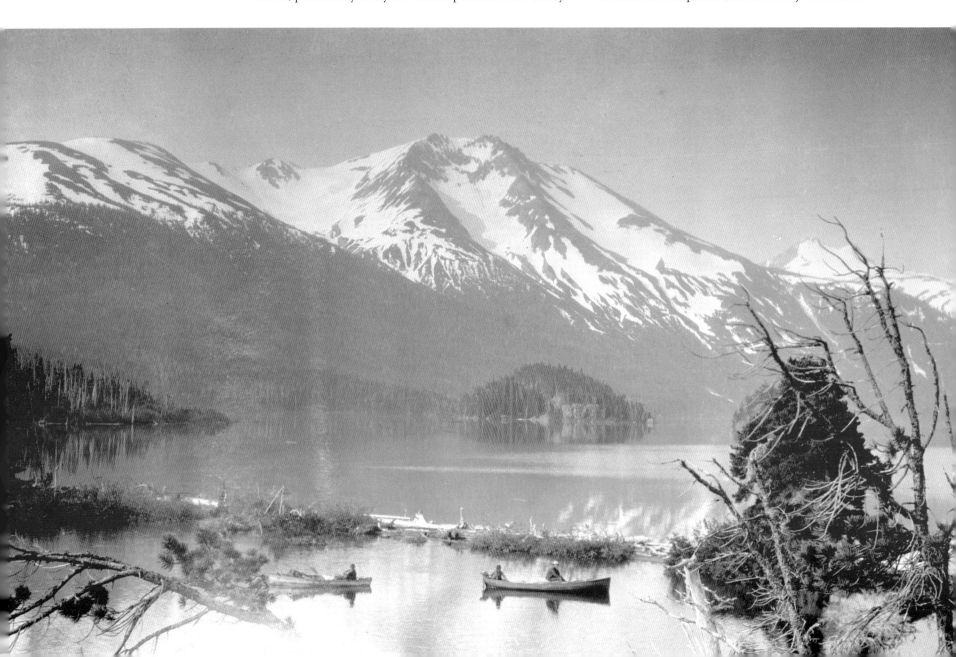

■ The crew travels on Whitesail Lake during one of its rare times of calm. Mount Arete looms in the background.
BC Archives I-58566

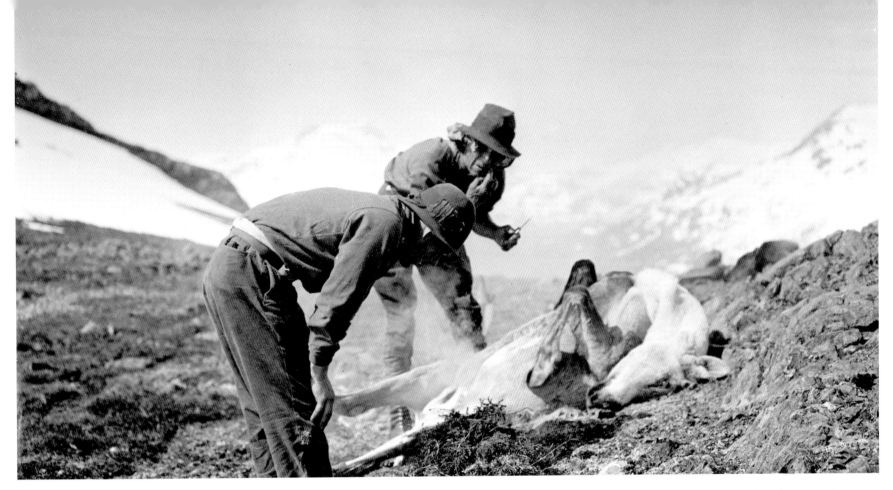

government Swannell's connection would provide a link that would extend across central British Columbia and strengthen the province's triangulation network. At the same time Swannell's triangulation network on the east side of the Coast Mountains would parallel the surveying that was being done along the coast.

The only potential difficulty for Swannell beginning his survey on Whitesail Lake was if he failed to find Bishop's survey posts when he reached Eutsuk Lake. However, he had confidence in R.P. Bishop's work, for Bishop had surveyed for Swannell in 1908 and 1911. The two men were close friends and both had a keen interest in the history of the area they were surveying. Throughout the early 1920s Swannell and Bishop worked in the same region on surveys that connected several times.

Since Whitesail was a large lake on one of the headwaters of the Nechako, Swannell decided to do a triangulation of this lake before proceeding across the divide to Eutsuk Lake. The first thing Swannell needed was to set and measure a base line that could be used for the triangulation surveys. "Alf & Fort start cutting out a base – best we can get only 900 ft. – Heavy chopping through a clump of dry dead spruce to get a sight line through to ΔBear Green [a triangulation station]. Bear Green we name the green patch at the outlet where so many bears are reported to have been killed – Evidently site of an ancient Indian village as old cache pits are

still to be seen & one place might have been a keekillie house." The next day the crew finished the base, "staking it out every thirty feet."

On June 16 Swannell sent a couple of men to erect a triangulation station on a high rocky hill while Alf and Ed set stations along the west shore of Whitesail Lake. Swannell took observations on the sun to calculate his latitude. Now he was ready to begin surveying Whitesail Lake.

The following day three men went to do a traverse survey down the Whitesail River and connect it to Swannell's triangulation. Swannell and Alf Butterfield began reading the angles from the base line to some of the stations that had been set. However, "terrific wind sets in making accurate reading impossible.... Learn on return to camp that Kastberg has been entertaining ladies to afternoon tea – Harrison's two young sisters – whose names Beatrice & Lucretia they want me to immortalize on mountain peaks." The next day Swannell's party split into three groups, two of them setting signals along the lake, while Swannell continued reading survey angles for the triangulation.

On Saturday, June 19, Swannell experienced one of the storms that frequented Whitesail Lake. "Drizzling at 5:30 am – at breakfast the Eutsuk Mts. to the south vanish in clouds – the lake still & leaden, the white trig signals standing out sharp against the shore – Then the

■ Viktor Kastberg dresses a caribou killed on Core Mountain. Swannell recorded in his diary that the men had to contend with "a blizzard of blackflies attracted by the blood."
BC Archives I-58542

rain drives on us turning to snow by 9 am – Work out of the question so den up (and incidentally freeze) in my mosquito tent – Rain & snow stop at noon but a high west wind sets in and piles the lake against our beach."

The weather was bright and sunny the next day so the men resumed work. One of Swannell's survey stations was at Cache Island, "so named as I find a deep square hole in the centre with the rotten remains of a lining of hewed boards – very old Indian cache." On June 21 Swannell and Kastberg climbed Cariboo Hill. This triangulation station provided Swannell with his first survey angles above Whitesail Lake and an observation of the area. "Splendid view – six small lakes visible – Make a panoramic sketch and rake in a lot of useful shots – Very windy but keep from freezing by a big fire – and this is the end of June!"

Throughout the remainder of June, Swannell continued the triangulation of Whitesail Lake. There were many days of cold, rainy weather, and windstorms on the lake almost every afternoon. In his government report Swannell wrote that, "The lake is subject to violent winds,

almost invariably from the mountain passes to the west. The Indians have named it Whitesail (i.e. Whitecap) Lake on this account." The men would usually awake around 4 am and get an early start if the day seemed suitable, for they had to utilize the opportunities for good work conditions. Swannell described a day at Camp 4. "Wind comes up at 11am – whitecaps still running – but canoe rides beautifully – read No. 7 – crawl around under the lee of the rocky points to No. 9 – Blowing hard now – Find Δ9 – 11 not intervisible – raining now so pull into cove & camp – dog tired, shoulder aching damnably – head bad – After supper cruise headland & start slashing line – Fiendish country – brush balsam & spruce & foul with fallen timber bluffs."

Camp 5 was located at Storm Point. "Wind gets up at noon – quit reading angles in disgust as distortion & mirage very bad – Resolve to make Cummings Creek – Round two rocky points well, but the boat not an inch gunwale to spare – plunges down as if she never would come up – At third point find danger too great – shoot into a narrow crevice & nearly smash up the canoe before

Shorty Haven, Ed Lee and Viktor Kastberg stand in the snow outside the cabin on Chikamin Mountain where they stayed overnight.
BC Archives I-57106

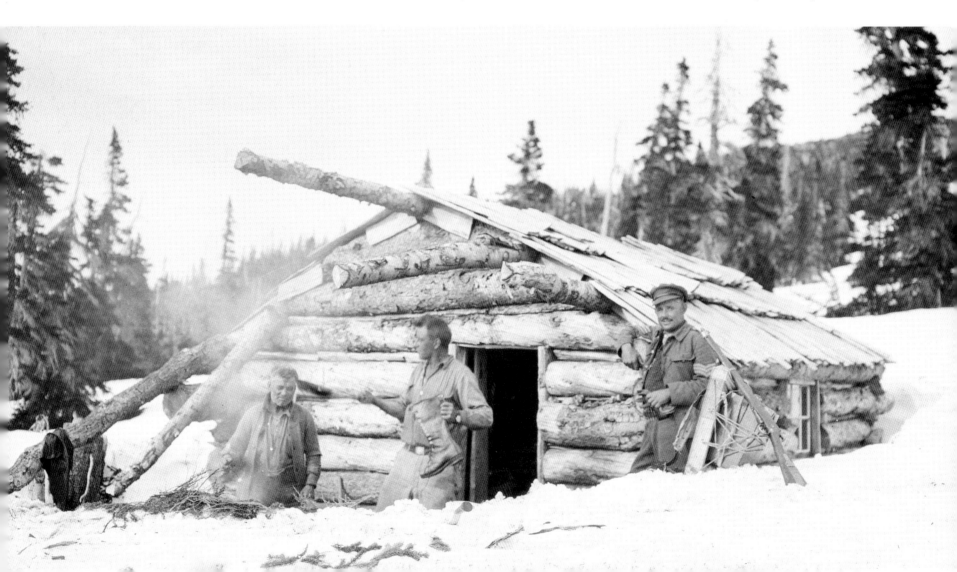

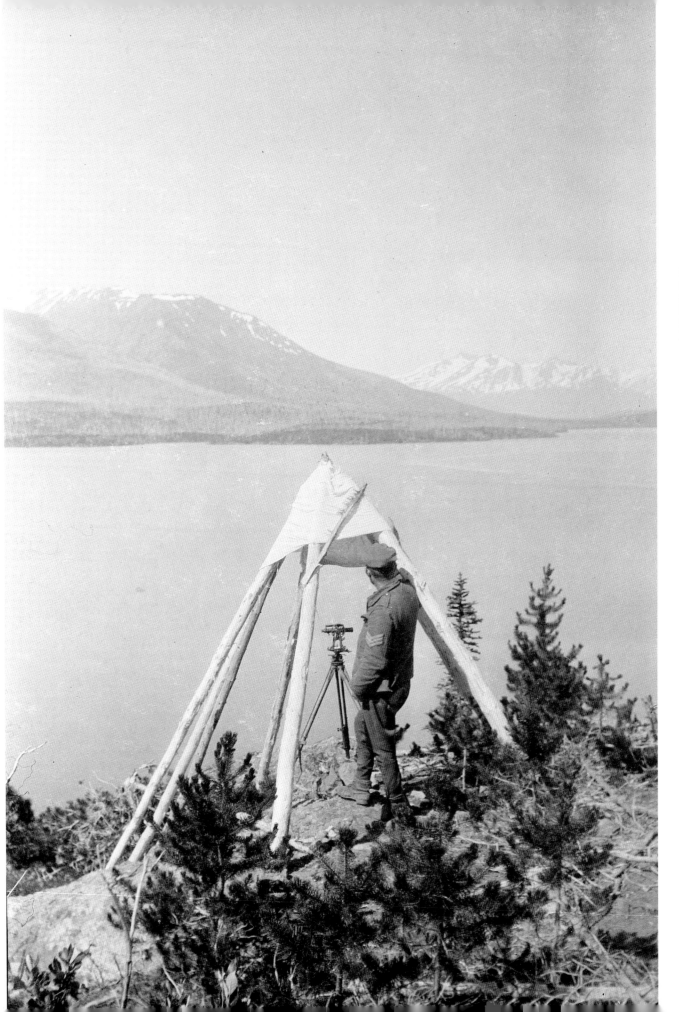

Swannell at Eutsuk Bluff, where he established his first official triangulation station for his survey of central BC. From here he surveyed directly to the station that Bishop had set on Eutsuk Lake below him. BC Archives I-57140

we can get the load out – Evening rain sets in, with wind and a very heavy sea running – Worst point on the lake this Camp 5."

Conditions at Camp 6 at Lagoon Spit were not much better. "Get up at 4 o'clock to steal a march on the lake – Down to Δ21-21A to complete but could not read stations to the eastward on account of the rising sun – Wind springs up at 7 & only get past the shelterless shore in time. Try to read Δ23 with indifferent success owing to the waves causing bad distortion – Scramble around through the willow on the bar between lake & lagoon to a large creek – in flood – 50' wide – current runs far out into the lake causing a seething boil of waves in which our canoe could not live for a moment – High wind & heavy sea only dies down late at night – Awakened by a beaver close by flopping around – Bright moonlight & eerie phosphorescence on rotten logs near by. Black flies annoying today & mosquitoes on the job." In his diary Lee also described the "terrible storms which catch the lake, great caution having to be displayed for safety."

While surveying on Whitesail Lake the crew lived off the land as much as possible. Many days the men caught fish. Sometimes caribou were shot on the hills above the lake. Ed Fort shot a big goat on Little Whitesail Lake. "He 'eats' most wondrous tough," wrote Swannell. "The tough old goat comes up as 'humbugger steak' through the medium of a buffalo knife and balsam stump – whereof splinters are incorporated in the result."

By early July Swannell's crew reached Little Whitesail Lake. On July 6 Swannell, Kastberg and Butterfield climbed Core Mt, Swannell's first mountain station for his 1920 triangulations. The men left at 7 am, and by 9:20 reached the summit of the top ridge, where they spotted and killed two caribou. "Set cairns & read both peaks of this mountain – wonderful view in every direction – Caribou in view sunning themselves on the snow in the heat of the day." Swannell finished his surveying by 7 pm and the men packed the caribou meat down the mountain. "Strike it very bad in the timber – bluffs & thickets and lower still devil's club – a chaotic jumble of huge boulders & fallen timber – Flies fierce – land along swamp 1/4 mile above lake. Get to camp 9:30 all in."

Three days later Swannell and some of his crew climbed Chikamin Mountain. In his report to the Surveyor-General, Swannell described the mountain as "a perfect cone which is an excellent landmark from every direction, and which I therefore utilized as the main triangulation point for the entire survey." At 4 pm "Shorty, Alf, Ed & I start to climb Chicamon Mt. up the Silvertip Trail so called – Very steep – hot & mosquitos dense as smoke – at 3500 old camp – snow 5 foot deep in timber here – trail peters out – spend a futile hour dashing around trying to cross cut it – start up in the general direction of the cabin spread out formation – I finally locate it nearly buried in snow at 7 o'clock – dirty, filthy – been overrun by bushy-tails – floor dirt in pools with melting snow – clean up as best we may, build a huge fire against the snow in the doorway and a smudge inside to fumigate – finally habitable when new brush has been cut for the bunk."

The next morning the men left at 7 am, reaching the summit two hours later. "Tier after tier of cloud sweeps up & between us & the craggy comb ridge half mile away – the black cliffs above the fleecy mists a wonderful sight. – Makes reading impossible, so send Alf & Ed to plant a cairn on Arete Mt. Get reading done in the afternoon – grand view of glaciers across Eutsuk. Shorty & I set up a huge cairn & leave summit 4:30." The men "reached Whitesail Lake at dusk – succeed by firing distress signals to get the motorboat from camp – Home 10 pm – damn rough descent."

On July 12 Swannell's crew reached Cummings Bay where they laid out a check base along the beach. This smaller base line down Whitesail Lake would be used by Swannell to check some of the measurements that he had taken, and to make his triangulation network more accurate. While he was there a Dominion Geological Survey crew arrived, headed by S.C. McLean. Swannell

recorded that the two men had a "long palaver about the work & McLean finally promises to make a micrometer traverse of Eutsuk Lake."

By July 21 Swannell had finished his triangulation of Whitesail Lake and the crew began the portage to Eutsuk Lake. After completing the portage, Swannell ran a traverse to connect the Whitesail and Eutsuk lake surveys (see field map on page 8). On July 23 Swannell made "a long move of 25 miles today – quite calm until afternoon – set 4 signals, 2 on Big Bear Island – At 6 pm arrive at sand beach around the big rock headlands where Olson, Tom Greer & I camped ten years before.... Hunt up Bishop's cairn – find it three foot under water – actually ran our boat aground on his fallen flag pole. Visibility bad & can't pick up his mountain stations." Swannell seldom expressed his personal emotions in his journal but this camp on Eutsuk Lake must have brought back some vivid memories. "Climb up with Fort to the bluff where I sketched the country from 10 years

Survey party and Geological Survey crew at Eutsuk Lake. Swannell is kneeling in front and Fort is sitting on the bow of the centre canoe. BC Archives I-33623

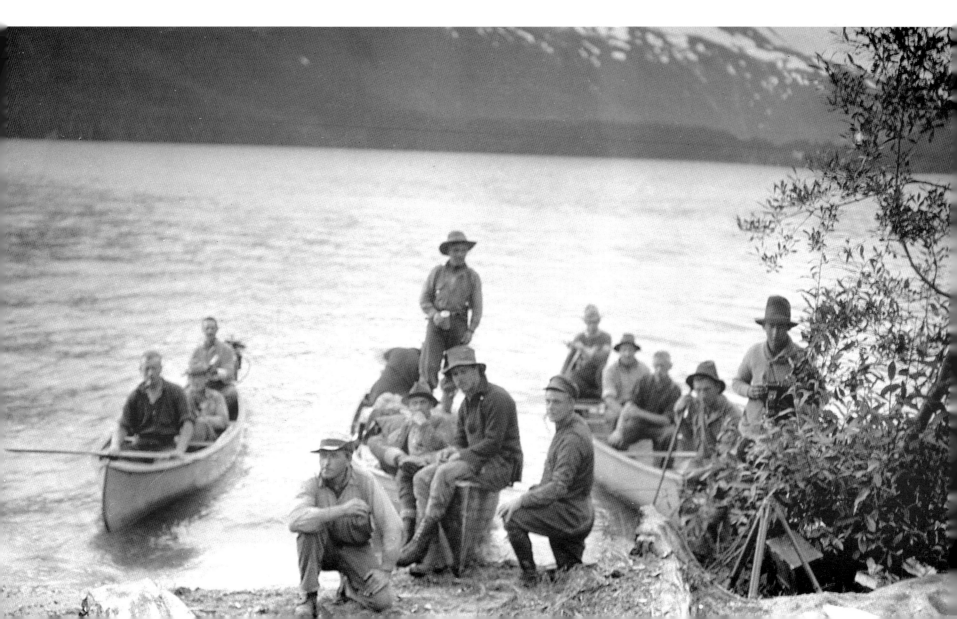

ago – actually found the flat rock on which I had rested my camera – looking as if placed there yesterday – the old B.T. illegible as the gum had not run over it. Much water has run over weirs since I cut that bearing tree."

Swannell spent a few days at this camp resurveying from Bishop's station back to the previous mountain that Bishop had used when he came from the 93-mile meridian on the 53rd parallel. He established a new survey station on the bluff above the lake. This station connected Swannell's triangulation survey with Bishop's work and a few of Colley's lot surveys on Eutsuk Lake. In Swannell's annual report he noted that, "The Dominion Geological Survey having a party on this lake, they undertook to make a plane table micrometer traverse of the shore-line and minor topography, leaving me free to extend the main triangulation. This arrangement will result in a topographic map more detailed and accurate than either party could have unaided." Since Colley's lot

surveys and Bishop's 1913 survey covered the eastern part of Eutsuk Lake, Swannell did not have to spend as much time at this lake as he did at Whitesail.

Swannell's crew returned to the portage from Whitesail Lake on July 29. The Geological Survey crew arrived the following afternoon. "We are taking today as our Sunday for the sheer joy of seeing others pack over the portage – the heavy freights staggered in – the cook, my old friend Max Gebhardt, from Manson Creek, has a most worried look – move isn't handled well – cooking outfit & tents get left until the last – I relent & take one load over for them – the college boys very green & can't put up a pack – but several show rare judgement in avoiding weight…. McLean a comical sight packing with a tumpline made of signal material – his shirt open & his chest smeared with blood – squashed mosquitos & blackflies."

Throughout the first half of August Swannell's crew surveyed from triangulation stations on the mountains

The peaks of Mount Haven (left) and Mount Musclow dominate the far shore of Eutsuk Lake. Swannell travelled into the bay between the mountains en route to the Kimsquit. BC Archives I-33447

around Eutsuk Lake while McLean's crew worked along the lake below. Swannell tied his triangulation into the base line and some of the stations that McLean set on Eutsuk Lake.

Occasionally the two crews would meet. In his journal for August 8 Swannell wrote:

Beautiful clear sunny day. Dominion Geological Survey party arrive in afternoon. Sing-song of united crews in evening – Conferring with Brock and McLean, but leave them for the campfire and the gaiety – being requested by Brock to lead the singing away from frivolity & ragtime. Get some of the old-time favourites started – Regret to say I induce Alf to drone out the old Nechaco crews song "The Telegraph Trail" – must say I'd forgotten its unprintable character. Now be it known there are 70 odd stanzas narrating tribulations and adventure – mostly a la Boccaccio of a certain <u>horse-packer</u> – It halts at every trading post & telegraph cabin between Quesnel on the Fraser & Dawson City.... Commences this doggerel trail-song of the North:

Oh I went up in the summer time
And I came down south when the snow
was a-flying
With a lol-de-dol-de-day
Oh a packer's life is full of hell
As I'm the boy can surely tell
With a etc. –

Lee's diary also recorded this occasion. "Day of rest, a Dominion survey, Geographical, joins our camp, 9 of them in all, they have music. We have a concert by the campfire. As Shorty says, 'This is the first music the lake has heard and there is assembled here the largest party of white men ever been together on the lake'."

On August 9 Swannell's crew climbed Mount Musclow, the highest peak in the Eutsuk Lake area. "Fairly clear but clouds start driving up from the west before breakfast is over – but decide to tackle the mountain on the only feasible place i.e. the north shoulder.... At 4500 steepens & timber gets scraggy – finally after a desperate pull get out onto the shoulder – From here a gradual slope up to the main peaks – slide

■ Cosgrove Lake and Smaby Pass were named after two loggers who explored this area for Pacific Mills, the company operating the pulp mill at Ocean Falls. In front is the canoe the men portaged up from Eutsuk Lake. Behind the canoe is a trapper's cabin. BC Archives I-33714

rock, snow & green pasture – Edge along for 1 1/2 miles with a huge glacier 1200' below to the west – across the main peak rises in sheer crags 2000 feet – clouds rising up rapidly – Chicamon & Arete Peaks gone already – Push on nevertheless – by noon reach comb crest – Partly in clouds now." Unfortunately, for Swannell, the clouds didn't lift in the afternoon.

The following day Swannell's men began cutting trail, packing supplies and surveying from Eutsuk Lake across the Coast Mountains to the Kimsquit River. They moved into Musclow (Little Eutsuk) Lake following "an old time portage used by long dead Siwashes who got their salmon from the Kimsquit." At the end of this lake the men cut a mile of trail to Cosgrove Lake, then portaged their supplies and a canoe. The next day, while the rest of the men moved camp to Cosgrove Lake, Swannell and Alf remained at Little Eutsuk "to get our cairn on Mt. Musclow 'fixed' as soon as the rain clouds lift a bit – no luck in the morning – cruise over to Surel Lake to determine difference of elevation – get an awful showing up by mosquitos – Dash down the lake & succeed in getting the cairn clear of clouds for a couple of minutes from two shore stations – Wind comes up on leaving Camp 1 & we have the worst sea yet to quarter into – Engine runs out of petrol & I have an awful time holding the boat's head into the wind with the oars while Alf refills."

Lee's entry for August 13 mentioned that George Seel "came to our camp and is going to assist us in getting on with our trail as far as the fish houses ... built many years ago by the Indians and used for drying salmon which they caught at the coast and brought up the range for their own use. Their old trails we find showing where hundreds of Indians inhabited the country. Old camps and bones may be seen at intervals." In his government report Swannell wrote that the Native trail beyond Cosgrove Lake had not been used for many years and the trail could hardly be traced. This necessitated cutting 12 miles of new trail, "following the old blazes wherever traceable." While they were making their way through the Coast Mountains Swannell made triangulations from the summit of some of the nearby peaks. On August 14 he was on the top of Mount Cosgrove. "Mosquitos have followed us up in a cloud – nag at us all our time on top – Grand view from here – Pondosy Lake away to the east – three heretofore unknown mountain lakes between – green glacier water. To the west the Pass – our pass – a gap where the Kimsquit must be – But peak after peak until lost in the blue haze of distance – several over 10,000'. Map roughly on 4 mile to inch scale – read four rounds of angles – Finish 5:45 pm – Meanwhile Shorty has made a corral around me with loose rock so that erecting a cairn only takes half an hour."

Four days later came "The Disastrous Experiment of Climbing Without Sizing Up a Route" while climbing Mount Seel. "Circle around behind the huge mass of Seel Mt. for three miles over rockslide & glacier – round a shoulder & to our dismay instead of Seel Valley & Smaby Pass below – mountain peaks we never saw before – a

■ Shorty Haven at a cairn on Mount Cosgrove. Swannell wrote about the "grand view from here," where he could see the route through the Coast Mountains into the Kimsquit River valley. While Swannell surveyed, Shorty built the cairn around him. BC Archives I-58569

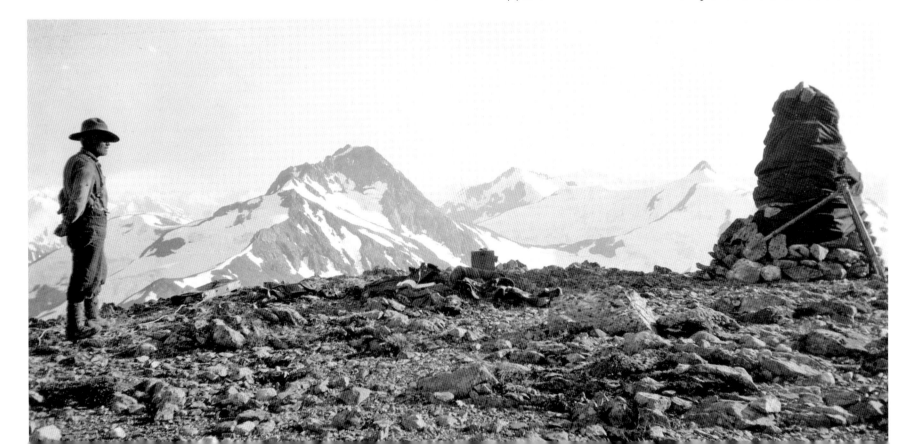

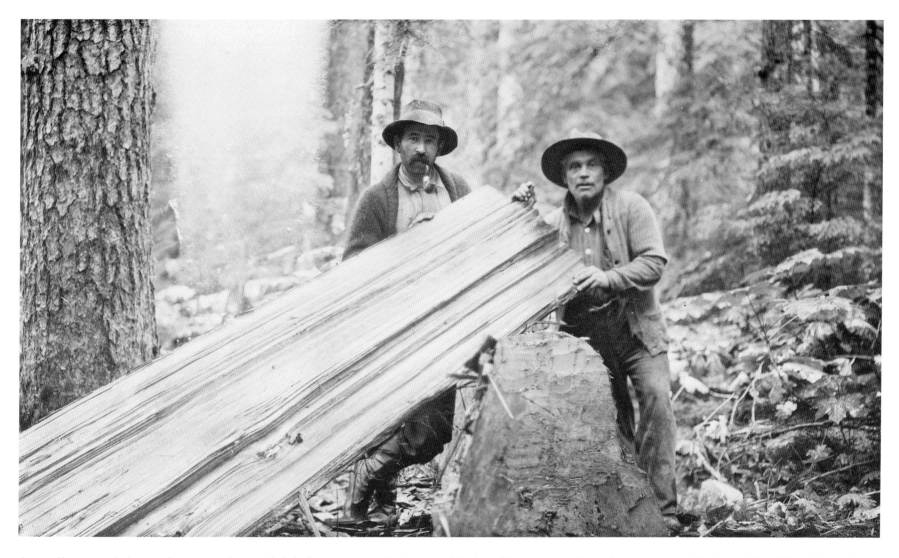

deep valley 2000' below us & a tremendous rockslide & glacier between us and the ridge-end where Fort had set the cairn. 2:30 – I at least am very tired – but nothing for it – we have to worm our way down to the glacier foot 1000' below & then up a steep interminable snow slope with occasional crevasses. At 5 o'clock drag to the shoulder & at last sight familiar country – Get to a bare hummock of rock & hastily read a round of angles – while Shorty builds a cairn." It got dark before they got back to camp so at "8:30 camp against a big log with plenty of firewood (although our matches are damp & we only get a light with the third to last) – Mosquitos fierce until 10 pm when it gets to be too cold for 'em – Shorty insists on my wrapping myself in the canvas – he curls up against the fire – Get some fitful sleep but a long long night. At dawn strike out & find we crossed the trail in the dark last night – Reach camp 6 am – coffee & rum & to bed for half a day."

By August 26 Swannell's crew was above the Kimsquit Valley. "5 am a drizzling rain starts – Regular Coast weather – clouds & rainsqualls driving up the Kimsquit obscuring the peaks.... – set Shorty & Alf erecting a big signal on a bluff near camp – will tie it to our signal further up the pass & I hope get a forward point in the lush meadows 2500' below us in the Kimsquit Valley – The remnant of our signal canvas being exhausted – (largely evident as patches on the knees of the outfits overalls) – have to use tracing-linen for a flag – rather expensive material, but the background being green must have white to show against it." Swannell noted that, "cook-fly nearly drowned out although Kastberg manages to bake 14 bannocks." In the afternoon the "trail crew return sodden & soaked 2 pm – Dole out the last of our Hudson Bay rum – a spoonful per man in a cup of hot coffee. Has a great effect on the

George Seel and Shorty Haven with split cedar planks that they used to construct a lean-to. Before World War I, George Seel came from Germany to the Ootsa Lake area, where he became a trapper and prospector. In 1927 he married Else Lubcke, a German writer from Berlin who responded to his ad for a bride. After World War II, Else corresponded with Ezra Pound, the famous American poet, for several years. George and Else lived at Ootsa Lake until George's death in 1950. BC Archives I-57117

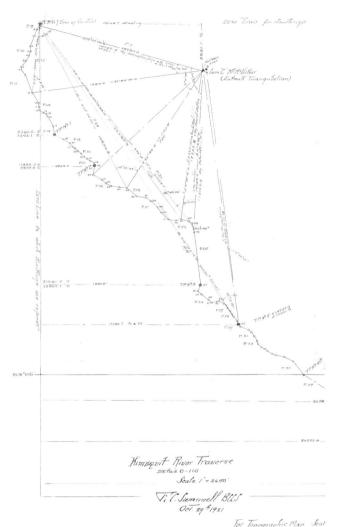

After describing his surveying during the summer he wrote about their present situation.

We now have 3 miles steep drop of 2000 ft. which will land me at the top of Block 1849 Kimsquit Valley. I have my mountain stations level with the camp, but the last week has been almost continuous rain with no work beyond trail cutting & packing possible. A deep valley cuts through to the Kitlope but owing to clouds of mist I cannot tell how far Kitlope Lake is away. Should the rainy weather continue I shall have to abandon the triangulation & traverse both ways which will prove slow work.

■ A portion of Swannell's field book map of the traverse down the Kimsquit River valley. The first station of the traverse, "T.P. 0", was connected by triangulation to Cairn "C" on Mount McVickar, one of the stations in the Eutsuk triangulation. The numbers are Swannell's traverse stations as he surveyed down the Kimsquit valley. Whenever Swannell could see the cairn on Mount McVickar, such as at stations 9 and 30, he would make a tie. Swannell also made connections to his first station, "T.P. 0", at places like stations 35 and 44. Swannell was well-known for his "extra shots" that made his surveying so accurate. Surveyor-General's office

■ Far right: Constructing a tree bridge across the Kimsquit River. In his diary Swannell wrote: "Cut down the big spruce we bivouacked under – rig up spring boards – takes the four of us one hour – 5 foot on the stump – makes an excellent bridge." Swannell took four photographs of his crew building this bridge.
BC Archives I-58590

morale – the glow of brotherly love & intense politeness & consideration for others lasts the day through." At the end of his journal entry for the day Swannell observed, "Allowing for a six mile error in latitude on the old Govt. map I've hit the top of the Kimsquit Valley surveys."

Before going down into the Kimsquit Valley, Swannell wrote a letter to the Surveyor-General and sent it with a man that he had temporarily hired who was returning to Ootsa Lake.

'Camp Altitude 3700' Headwaters Kimsquit River – August 29, 1920. I have to report that the summer was late in melting this year – there being six feet in the timber at altitude 4500 as late as the beginning of July and snow in the portage between Whitesail & Eutsuk Lakes on our arrival on the ground. Mountain work being quite out of the question I filled in the interval by making a triangulation of Whitesail & adjacent small lakes together with taking topography.

The weather improved at the end of August so Swannell spent a few days at the headwaters doing some surveying and a triangulation from the top of a nearby mountain. One afternoon, after surveying on a mountain, Swannell and Kastberg decided to "go goat hunting on a forlorn hope (our bacon is nearly finished)." The men eventually located and shot a goat. "Our pack-frames the other side of the mountain – nasty work packing a quarter [of the goat] each before we reach them – slide them a few hundred feet on the snow. Reach camp 7 pm, tired, jackets smeared with blood, but triumphant." Meanwhile Lee and a few men began transporting the equipment down into the Kimsquit valley. "We carry on with the descent and it is fair, layed out by marvelous work of the Indians," Lee wrote.

On September 4 Swannell wrote that, "Shorty & I cruise downstream for the Siwash fish-house that has become a legend at Ootsa Lake." Near Seel Creek they found "dismantled trappers lean-to of huge cedar slabs – some piled up as if for moving down the river." Further down the valley they found an old camp. "Pencilled on blaze: 'Aug. 30/18 – A.C. Garde, F. Cook, C.V. Harrison – From Whitesail & Ootsa Lake en route to Ocean Falls.' These men left Eutsuk with 3 days grub – took 9 days to make Kimsquit – so nearly starving they ate rotting salmon. Rumour has it Harrison & Cook had been sent their fares & orders to report as conscripts – Hoped to escape by making for Kimsquit but were neatly nabbed there & drafted to Siberia."

During September Swannell's crew ran a 30-mile traverse line down the Kimsquit. Swannell began the traverse at a place in the Kimsquit valley where he could take a reading to one of his triangulation stations on the mountains above. As they worked their way down the Kimsquit Swannell and his men encountered thick undergrowth in the forest that made travel difficult. The men sometimes found blazes and evidence of old camps, and on a couple of occasions they passed an old cabin, but they could not locate a trail that provided an easy route down the valley. There was "no drink as the Kimsquit is too foul with rotten salmon – the last of a big August run." After two days Swannell decided "to abandon the dash for Kitlope as likely to result in our using up all our grub in September – likely getting a tie through to neither Kitlope nor Kimsquit – Will make sure of the latter by cutting a chained traverse line down." One of the primary goals of Swannell's 1920 survey work was to connect Bishop's survey station on Eutsuk Lake with the coast network, and it was important for him to establish at least one accurate link.

■ Inside the saw filer's shack at the Kimsquit logging camp, with Byles, the camp manager (left), and "Happy", the filer, who was working on a cross-cut saw. BC Archives I-57112

As they surveyed down the Kimsquit valley, Swannell observed that there were "bear signs everywhere – grizzly, black & cub – like a farmyard – River stinking of rotten salmon." He often noticed evidence of "rotten salmon dragged inland by the bears whose tracks are everywhere crisscrossed in the mud – on the bar half eaten fish – the claw marks on the logs where bruin sat waiting for a fish to swim within reach of a swoop of his paw." Lee noted that the "terrible odor made the work sickly. Tracks of wild animals everywhere numerous." He also observed "numerous bear trails, huge fish half eaten on the trail. I take precautions having a gun. Tracks measure 12 to 14 inches in length. Also wolves of large size."

Crossing the large streams and river was a challenge. Sometimes the men found a tree that had fallen across the waterway, but at other places they had to take the time to cut one down. Further down the Kimsquit, Swannell found evidence that a forestry crew had been cruising in the area within the past week. On September 13 Swannell and Shorty Haven started "for Kimsquit 'light' (i.e. one blanket & one canvas sheet for the two of us)." About four miles down the river they found the forestry crew at a trapper's cabin, and they traded some provisions. "At noon Shorty & I push on – At Mile 18 (above Kimsquit) sight a most wonderful edifice worthy of Heath Robinson – a trappers cabin with a huge slab chimney resembling Troitsa church belfry after the 18 pdr [pounder] shell landed – a vast cask ingeniously made by slabbing off a round of 4' log & nailing the slabs together – full of poisonous rotten salmon poisoning the air – trap bait –

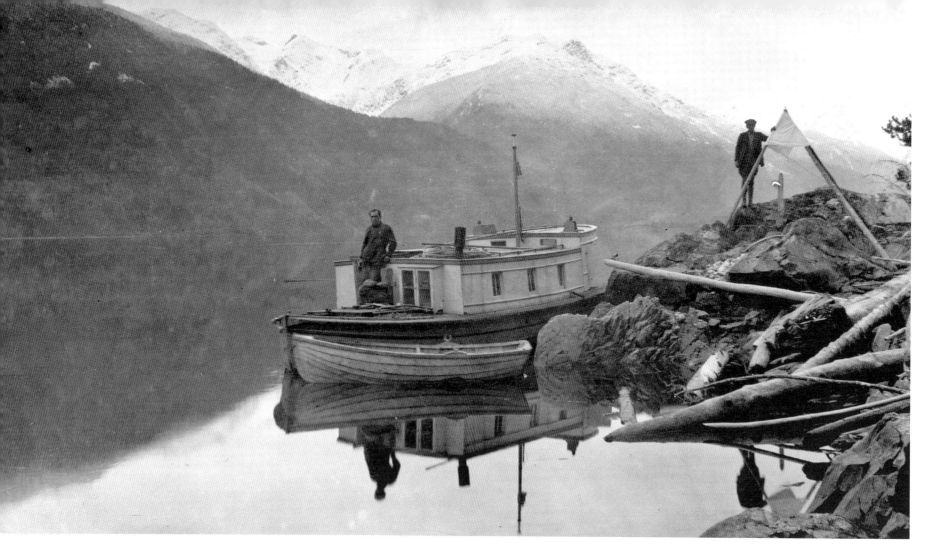

The launch *Cruiser* at rest in the calm waters of Dean Channel. The boat was owned by Pacific Mills, the company operating the Ocean Falls pulp mill. BC Archives I-58595

Two miles down the trail meet Adam the Trapper in miner's gum boots & variegated rags, packing in grub with a tump line – long beard – face of the sickly white of a fishes belly – with a nervous laugh & uneasy manner – Evidently a man who has been too much alone."

The heading for Swannell's diary entry for September 14 proclaimed: "The Hike for Kimsquit – and Kimsquit at last!"

Under way 7 am after a sumptuous breakfast of bannock & coffee.... – trail good in places – strike railway location line – River one long boulder strewn rapid – rotten salmon everywhere...& live ones struggling ever upstream in water not half covering them. The smell absolutely sickening – Large king salmon 30 lb. in weight now predominant. – The trail seems interminable.... – Finally strike the logging railway grade just in time to see the trucks loaded with men steam home for their dinner – Loggers being luxurious nowadays won't take lunch pails into the woods with them – Reach the cookhouse as the men are halfway through hogging their meal – Get the flunkey's eye – and maybe we don't eat – first.

The logging camp at Kimsquit and the railway line constructed up the valley for a few miles had started in 1917. It was part of the operations for the Pacific Mills pulp and paper plant at Ocean Falls.

After buying some supplies at the logging camp, Swannell and Shorty headed back to join the rest of the crew and continue the traverse down the Kimsquit. At one place they found an "old grave where trail runs along beaver stream – boulders piled on top of several layers of poles, so the wolves cannot dig up the body." As their traverse approached the logging camp, Swannell's survey crew had some of their meals there. Lee noted that "we are now reviving from the hard trip and we notice the excellent food of the logging camp ... is renewing our run down constitution." In his diary he described the food for a few pages.

During October the survey crew completed their work by running a triangulation survey on Dean Channel from the Kimsquit River to Underhill's station at the mouth of the Dean River. On October 18, Swannell and his men boarded the *Bess B,* which took them to Ocean Falls. There, the men who were returning to Victoria got

A portion of Range 4, Coast District. Swannell drew this map of central BC after his 1920 surveying. The only topographic features on Swannell's map are the thread of his surveys that connect Bishop's station at Eutsuk Lake with Underhill's station on Dean Channel. BC Archives CM/W/14104

During the 1920 field season R.P. Bishop extended the previous survey of the 55th parallel west to the Middle River. In his government report Bishop wrote that he tied his survey into several of the stations that Swannell had set during his exploratory surveys of 1912 and 1913. He noted Swannell's triangulation survey of Inzana Lake and recommended that similar surveys be done for many of the unmapped lakes of the area.

on the Grand Trunk Pacific steamer SS *Prince George* that took them to Vancouver, where they boarded another ship to Victoria.

Swannell had completed his first season of mapping central British Columbia, making the initial link that connected the surveys of the interior and the coast in this part of the province. In his annual government report the Surveyor-General wrote that, "Mr. Swannell established a tie by triangulation between the western extremity of the 53rd parallel and the triangulation of Dean Channel at Kimsquit, carrying on at the same time a reconnaissance survey of the areas traversed. His report and map when completed will convey a considerable amount of new information regarding this district previously only slightly explored."

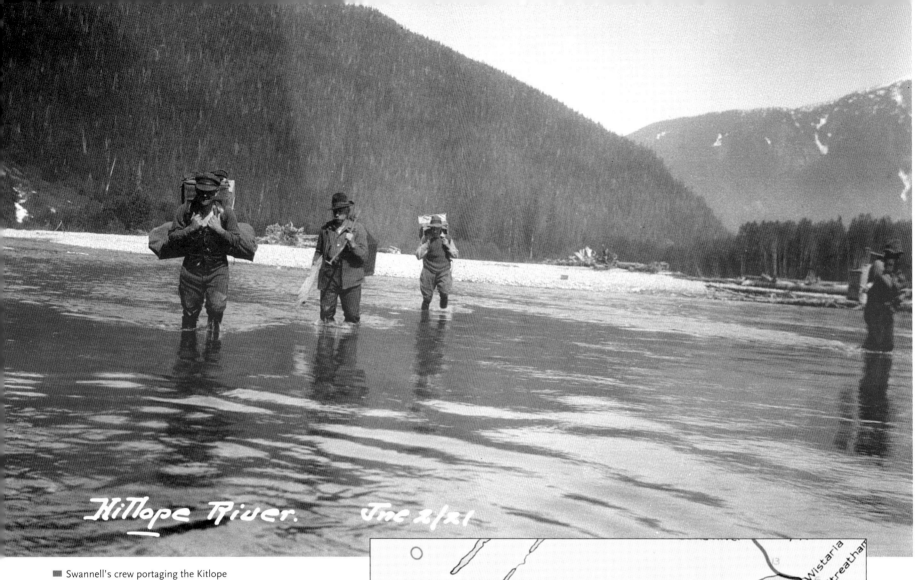

Kitlope River. *Jne 2/21*

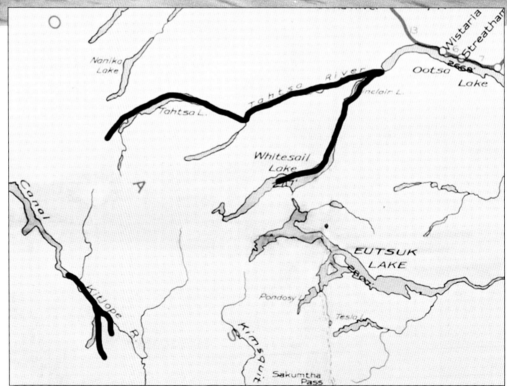

▨ Swannell's crew portaging the Kitlope River. The avalanche slope on the left is still visible today. Since 1921, an island has developed behind where the men are walking, constricting the river. The depth of the Kitlope prevents a portage at this location today. BC Archives I-58417

▨ Swannell's survey route in 1921. Detail from BC Archives CM/C/178

34

1921

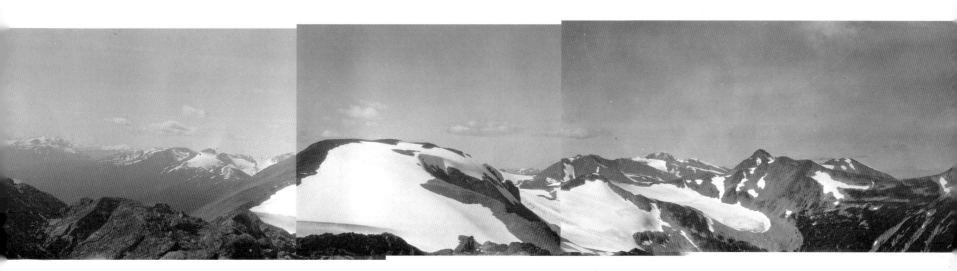

Through the winter of 1920-21, Swannell worked on calculating the data from the 1920 field work, and produced his first map covering the upper Nechako River watershed and adjacent Coast Mountains. In early May 1921 Umbach sent Swannell a letter with instructions for his 1921 field surveying. "The details of the work to be done by you are as follows. All ties to be made between the triangulation of Gardner Canal and your work of last year. This tie will be effected by means of a traverse or triangulation as may be found more convenient with as much topographical information as can be readily obtained. You are to make a topographical survey of Pondesy Lake, south of Eutsuk Lake in order that same may be used to fill out the general map of the district. On completion of the above mentioned work you will extend topographical and triangulation surveys north of Whitesail Lake as far as the season will permit."

This year Swannell would begin his surveying along the BC coast. Since he only had time to tie his survey to Underhill's triangulation at Kimsquit in 1920, Swannell's first objective in 1921 was to connect Underhill's work in the Gardner Canal to the traverse he made down the Kimsquit Valley in the previous season. This would provide a second connection to Swannell's link between

the triangulation network along the coast, and the surveys that had been done in the interior. Initially, Umbach considered flying Swannell's crew and supplies into the area with Major McLaren from the Dominion Air Board. This would have been a new method of transporting surveyors to remote work sites. However, the idea did not materialize, and it was not until the 1930s that Swannell began using airplanes as part of his transportation to surveying locations.

Swannell's surveying assistant during 1921, 1922, 1923 and 1925 was A.C. Pollard (BCLS #238), who was articling under Swannell to be a surveyor. Pollard married Swannell's daughter, Minnie, in 1924. Viktor Kastberg and Charles Musclow returned to the crew and were joined by Musclow's younger brother, Harry, Douglas Lowe, and Max Gebhardt. Swannell had met Gebhardt, a gold miner, in Manson Creek in 1913 during his exploration survey of the Omineca region. Gebhardt, who now lived at Francois Lake, had worked for McLean's Geological Survey crew in 1920.

On May 18 Swannell and his Victoria crew members departed on the SS *Tees*, a cargo ship that operated on the BC coast for many years. At Campbell River the ship had to wait for six hours for the tide at Seymour Narrows

■ Tahtsa Lake sits at the far left of Swannell's panorama taken from Rhine Crag
BC Archives I-58710, I-58711, I-58713

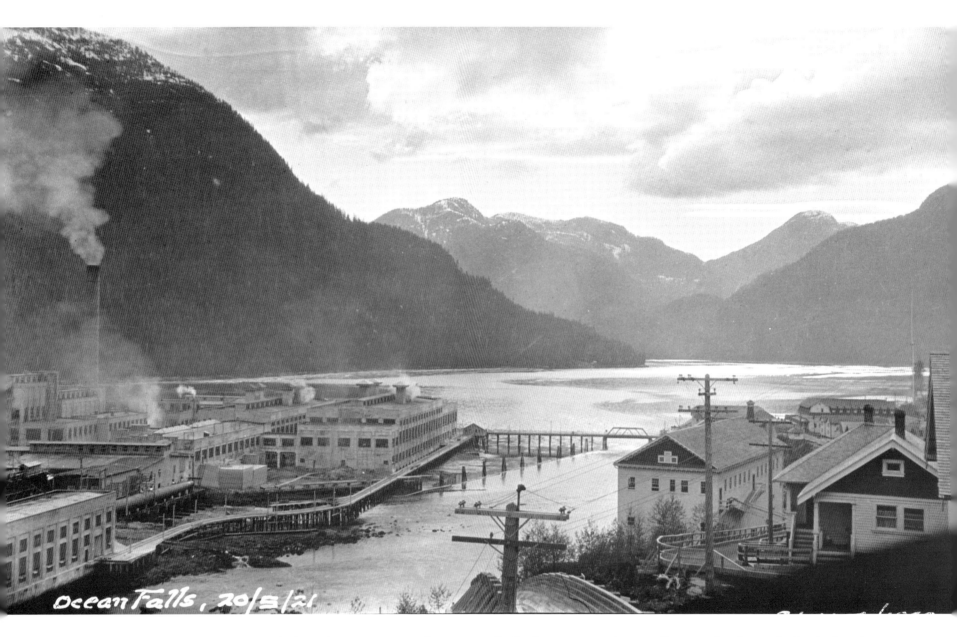

Ocean Falls, 20/5/21

to slacken. The SS *Tees* stopped at Ocean Falls for three hours before continuing up the coast to the pulp mill at Swanson Bay where they arrived at 3:30 am. There they transferred to a boat owned by Axel Spongberg who operated a logging camp on Gardner Canal. Swannell and his crew spent Sunday, May 22 at the camp making preparations for their survey work at the head of Gardner Canal. The following day it was "pouring without intermission – Run up to head of canal by Spongberg & camp in deep bay head of the long rocky spur at the river mouth. This inlet hemmed in by very steep and rugged mountains everywhere – No level country except at Kemano Mouth & the tideflats at the head."

Swannell spent a few days at the head of Gardner Canal locating Underhill's surveying stations in the area. He also set his own station near their camp. "Lowe and Pollard climb mountain behind camp and set signal in fifteen feet of snow at altitude 3000." Then the crew moved camp a few miles up the Kitlope River in preparation for a traverse of the river between Gardner Canal and Kitlope Lake. At the First Nations village of Misk'usa, Swannell found a station that Underhill had set in 1920, along with a note: "For God's sake tie in to this Δ station. I have made a two days search for SW Cor. of Indian Reserve but cannot find same. Best of luck. J.T. Underhill." The Reserve at Misk'usa had been

surveyed by A.L. Poudrier in 1891, and although Underhill found evidence of Poudrier's work, he could not locate any of the original survey posts.

It took Swannell and his crew about a week to survey a traverse from Gardner Canal through Underhill's station at Misk'usa and up the Kitlope River to the lake. During that time the river rose due to spring run-off. "River now pretty swift and our keeled boat doesn't handle well. Reach lake 4 pm – strong whirlpool at outlet caused by river from the East driving straight against a rockwall." Swannell's crew established a camp on the lake about two miles from the outlet.

Swannell's diary entry for June 2 noted, "Kastberg and men out all day erecting signals. Beautiful sunny day." This was one of the few days of clear weather that the crew had while they were at Kitlope Lake. It was still clear the following morning so Swannell decided to try to establish a triangulation station on the mountain behind their camp. "Climb Peak 13 from directly behind camp – Good route – reach snow at noon after 5 hrs climbing.... Alt. 3000. Blane, Pollard & I push on over interminable snow slopes – Glare very bad & snow too soft – Curious effect – the next ridge of snow seems miles off although only 200' perhaps.... The Kimsquit Mts. in plain sight until we nearly reach the summit (5500) – but rapidly disappear in a rain haze. Summit very flat & snow probably 15' deep – No use erecting signal – nothing to read. Very annoying after lugging 40 lbs of transit around on my back from 7 am to 3 pm...Interminable climb down & get in trouble among bluffs. Reach camp 8 pm all played out – Rum punch restores the morale. Net result of day – two ptarmigan."

Swannell set out a base line at the junction of the upper Kitlope River and the lake outlet, and began his

■ The first pulp mill established on BC's north coast was at Swanson Bay. Swannell also photographed the town in 1909, shortly after the mill opened. BC Archives I-33734

Swanson Bay *May 20/21*

triangulation of Kitlope Lake. Most days there was rain. On June 7 Swannell noted that it was "raining off & on all afternoon. Lake rose six inches last night – Storm of last night must have flooded all the feeders." Swannell also observed the presence of seals in the lake.

After completing the triangulation of Kitlope Lake, Swannell moved camp to the Tezwa River, which drains into Kitlope Lake. From here, he ran a traverse up the river for about four miles. On June 16 Swannell and his crew made another attempt to survey from the mountains above the Kitlope valley. "Climb Deception Mt. with grub, blankets & instruments. At 4000 alt strike last place we can camp & get wood – Small depression we fill with yellow cedar being the only place for the four of us to lie – Above here snow slopes and crags. Weather dull but fine." In his diary entry for the following day Swannell recorded

that they spent a "miserable night – cramped with cold. At 7:30 start up a terrible deep snow slope – Cornice one side and drops over crags on the river side – Reach summit (5300) at noon – Here flattens out into a huge snow field – Drop at SE. High peaks to east never clear from clouds and fail to positively tie last year's work. – Low pass through to Kimsquit Lake – Everywhere nothing but exceedingly precipitous sided mountains with snow caps or immense glaciers above – nearly all absolutely inaccessible. At 5:30 pm give up waiting for clouds to raise – some nasty snow slopes with unknown cliffs below – Get several long glissades & Lowe makes one unpremeditated one. Reach camp in 2 1/2 hrs." Although Swannell was unable to make a direct connection to any of his 1920 surveying stations, he was able to take readings on some of the same mountains that he saw in the previous year.

▓ Swannell's two photographs provide a unique record of Swanson Bay from both water and land in 1921. The ruins of this once-thriving community can still be seen from the waters of the Inside Passage. BC Archives I-33735

Swanson Bay

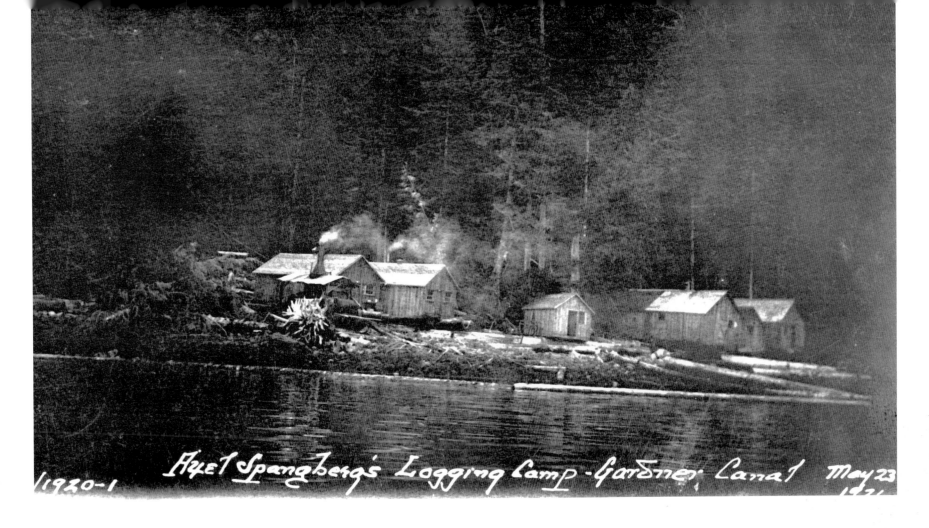

1920-1 Axel Spongberg's Logging Camp - Gardner Canal May 23

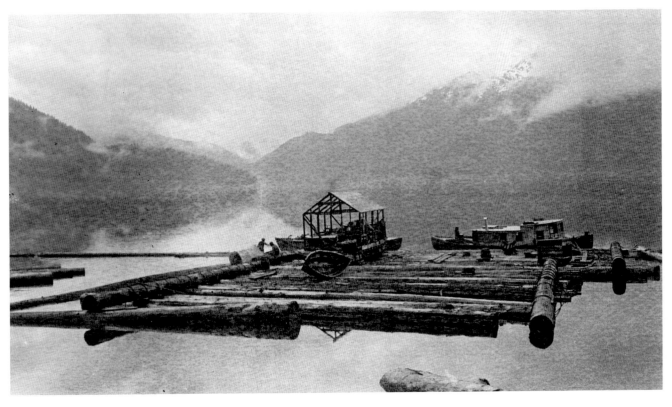

■ *Above:* Axel Spongberg's logging camp in Gardner Canal. Spongberg was a logging contractor for the Swanson Bay pulp mill. BC Archives I-33737

■ Some of the logging operations at Spongberg's camp. BC Archives I-33738

G'psgolox Pole

The nine-metre-high G'psgolox mortuary totem pole was carved in 1872 on commission by Chief G'psgolox of the eagle clan of the Haisla people. The Haisla were one of the few First Nations groups along the coast who did not have a large number of people die during the smallpox epidemic of 1862, and the pole was a thank you to the spirits for saving the people of the Kitlope valley. The pole represents the worlds of water, earth and air. The top image represents the good Tsooda spirit whose hat revolves around his head. In Haisla legend the Tsooda spirit brought G'psgolox's children back to life after they died. The middle figure is the grizzly bear Asolget, while the bottom figure is the mythical grizzly bear that lives underwater. The empty space in the middle signifies loss.

The G'psgolox totem pole stood in the village of Misk'usa along the Kitlope River near the foot of Gardner Canal. It was placed in a location facing directly down the river into Gardner Canal, making it not only a cultural symbol but also a geographic marker.

In the 1920s several countries in Europe collected totem poles for their museums, but at the end of that decade Sweden did not have a totem pole. By 1929 the Haisla used Misk'usa only seasonally, and the Swedish consul in Prince Rupert and the Indian Agent considered the village abandoned. They had the totem pole cut down and taken to Stockholm for the Folken Museum Etnografiske.

In the 1990s the Haisla began negotiations to repatriate the G'psgolox totem pole. They carved two replicas of the pole. One was sent to the museum in Stockholm. In 2006 Sweden returned the original totem pole to the Haisla. It is now at Kitimat, and is the first totem pole repatriated from Europe to a First Nations community. The second replica has been erected in Misk'usa, where a bear has made scratches on the pole and bitten off one of its hands.

Swannell's three photographs of the G'psgolox totem pole are the best photographic record of this famous pole. There is only one other known picture.

Indian Camp - Mouth Kitlope River

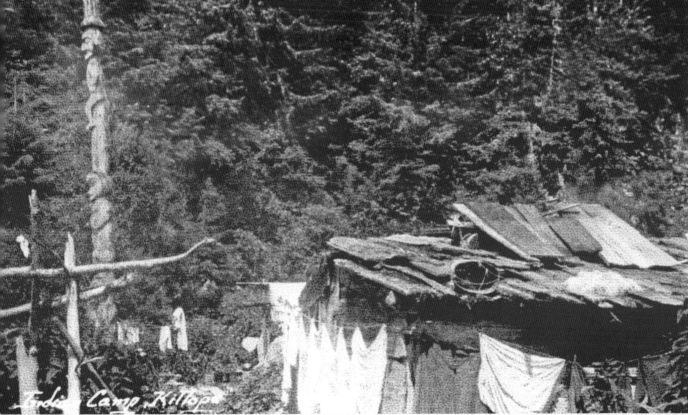

Indian Camp Kitlope

■ *Facing page*: Swannell's photograph shows enough detail of the G'psgolox mortuary pole to compare it with the pole today (see page 172). The skyline in the picture can be used to find where the pole was located in Misk'usa. BC Archives I-33181

■ *Left*: The pole and some of the village buildings. Today, this place is overgrown with vegetation, indicating that the cleared area at Misk'usa was more extensive in 1921. BC Archives I-58650

■ *Below, left*: The village at the mouth of the Kitlope River, with the mortuary pole in the centre. The gravel apron around Misk'usa is indicated in Swannell's map of the Kitlope. At high tide, boats could come in almost to the village. Today, the river has cut the channel down further, the gravel apron is gone, and it is no longer possible to bring a boat into Misk'usa as shown in the picture. BC Archives I-58649

After resting at camp for two days Swannell resumed his survey of the Tezwa River. "Traverse until 3:30 amid almost continuous showers – then it pours – Wait an hour under a big root hoping it will let up – Drenched before we arrive at camp – Pours all the rest of the afternoon and night. The river rises 6 inches per hour – Get scared for our boat and haul it high & dry. Current becomes very strong and water muddy." The rainy weather continued the following day. "Weather makes a fainthearted attempt at clearing up – Try to traverse and get a mile done very miserably. At 3:30 sets in to pour & return to camp – Almost continuous downpour until midnight – Racket of a big slide during the night." On June 22 Swannell's crew had their "first fine sunny day since the 2nd June. Traverse in morning and move camp in afternoon to old lake camp. – Camp pitched early & bask in unwanted sun & spread blankets and clothing out – as everything going mouldy."

The following day Swannell once again climbed the mountain behind their camp on the lake. "Weather clear

but 83 Mt. cuts out peaks to the East. Measure base and read all likely peaks from 3 pts, tying to lake triangulation & Gardner Inlet points." Although Swannell was able to connect his survey of Kitlope Lake with Underhill's survey on Gardner Canal he was still unable to make a direct connection with his 1920 work on the Kimsquit.

The next morning, while it was still clear, Swannell set a few more triangulation stations on Kitlope Lake to tie into his station on the mountain. Then he spent a few days completing the traverse on the Tezwa River. In his journal for June 25 he noted that it was "raining heavily all morning. In afternoon partially clears up. Go up river – badly swollen having risen 3 feet overnight & swept several of our stations away – read one from boat with water 1 foot below levelling head of transit. Showers continue, but work until 8 pm & get down to where river runs in from the west – Large grey timber wolf on bar 150 yds away motionless for some time & then leisurely lopes away." The next day Swannell completed the traverse of the river. "Rain commences in the afternoon

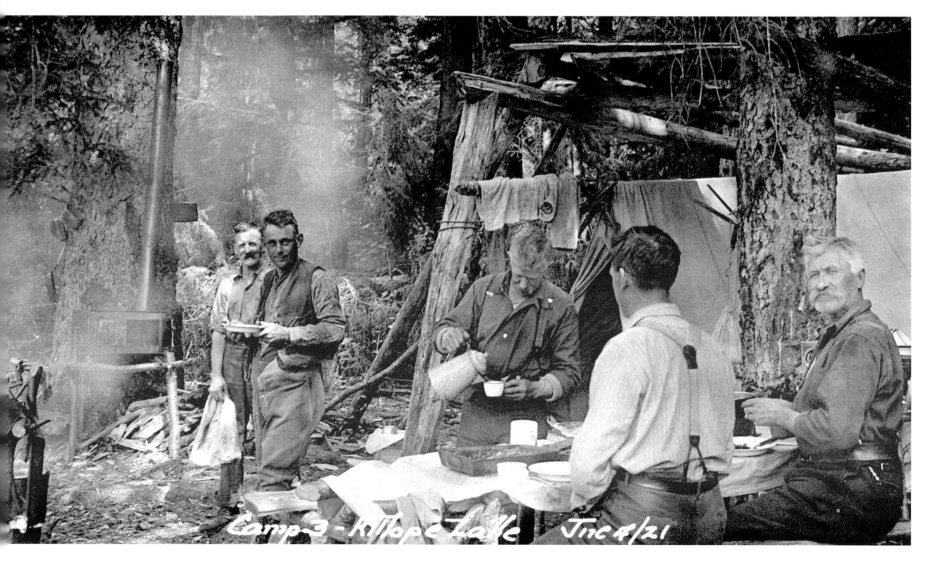

■ The main camp for Swannell's crew at Kitlope Lake. The men built stools and a table to eat at, a bench for their stove and a platform to cache food and supplies.
BC Archives I-33630

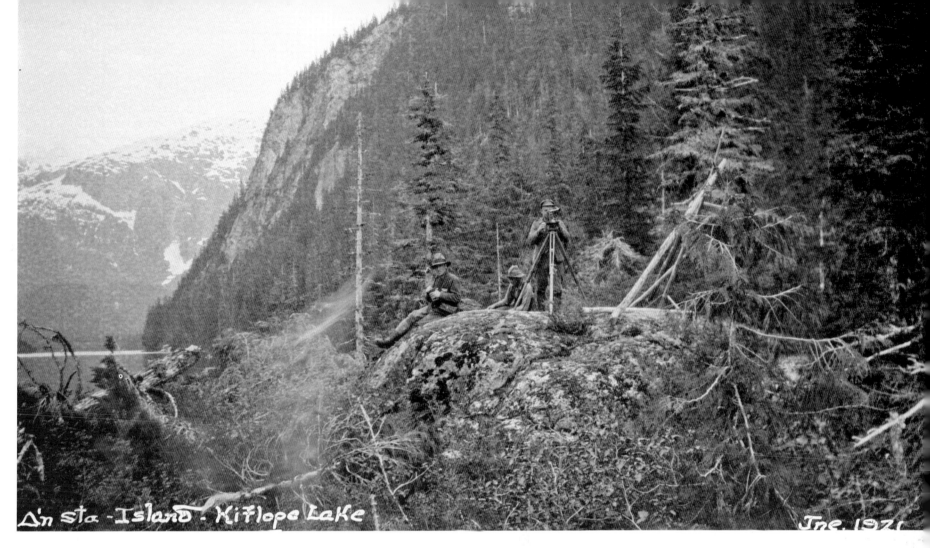

A'n sta -Island - Kitlope Lake Jne. 1921

and pours most of night alternating with wind squalls –
the most execrable climate I have ever struck. Butter plays
out & flour and fruit very low."

Swannell waited a few days at Kitlope Lake, hoping
for another opportunity to get up on the mountains, but
since the weather didn't clear and food was running low
he decided to leave. In his government report to Umbach,
Swannell described his surveying in the Kitlope. "Six
weeks at the commencement of the season were spent
endeavouring to get a tie across from Gardner Inlet to
the headwaters of the Kimsquit River, in order to obtain
a check on the triangulation between the 53rd parallel as
run and the Coast triangulation. Owing to the exceedingly
inclement weather and the abnormal depth of snow
in the mountains intervening, a direct tie by a rigid
triangulation was impossible in the time at my disposal.
I, however, mapped the Lower Kitlope River and lake and
carried a traverse and triangulation 30 miles inland from
tide-water, from which point I succeeded in tying into
some of my previously fixed points on the eastern fringe
of the Coast Mountains."

On June 28 Swannell's crew went down the river
and started up Gardner Canal. "Go up Inlet to where

the Siwashes are hand-logging – Arrange for John Paul
to run launch for us at daylight & bring it back from
Butedale – By evening the Indians have changed their
minds & we pull out on our own after considerable
trouble with the engine – Run all night – Pass Spongberg's
camp in the dark, reaching Crab River at daylight." They
returned to Spongberg's camp the next day where their
"boat swamped over night, having caught gunwale under
log. All morning drying out engine – Magneto sparking
too feebly, so we use cells instead." Swannell's crew left
in the afternoon of June 30 in the rain. The next day
there was "rain squalls & choppy sea. Camp at old Indian
village site 6 pm (Lowe Inlet)." On July 2 the men arrived
at Prince Rupert in the late afternoon.

After a day in Prince Rupert, Swannell and his crew
took the train to Burns Lake where they got outfitted at
Aslin's store and arranged for the goods to be shipped
to Ootsa Lake. On July 6 Swannell arrived at Bennett's
at Ootsa Lake. In his diary for July 7, Swannell wrote,
"Kastberg in a black mood & I flare up at him – whereat
he goes off in a sulk and later says he'll quit. Altho not
entitled to it in view of his previous good service allow
him pay & expenses to Victoria. Hire Evinrude starts.

■ This island in Kitlope Lake was a
traditional place for the Haisla people
to gather huckleberries. Although
huckleberries are still plentiful, the
island has more trees and is much more
overgrown than it was in 1921, probably
because it is not used as much. The
big rock, which is still visible, made an
excellent triangulation station with a
good view of the lake. BC Archives I-58646

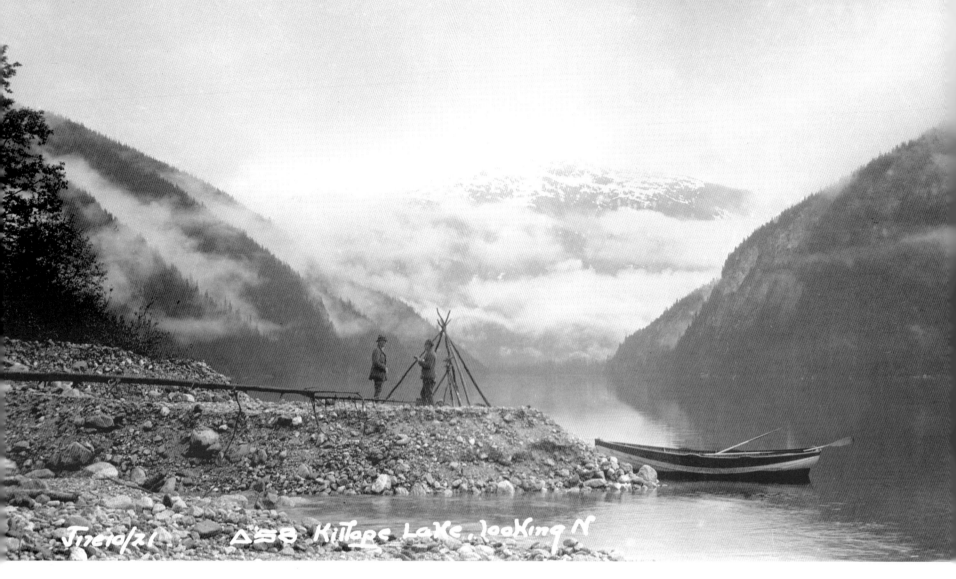

Jne10/21 △'58 Kitlope Lake, looking N

Looking north over Kitlope Lake. (See page 172 for a comparison photograph taken in 2005.) BC Archives I-58673

(Settlement with Kastberg for wages and debt of $200 Swannell owes him)." The reason for the disagreement with Kastberg is unknown. Although Kastberg never worked for Swannell again the two men did remain life-long friends. At Ootsa Lake Charles Musclow and his brother Harry joined the crew.

Swannell spent a few days at Bennett's, working on his survey from the Kitlope, and setting and reading some triangulation stations on Ootsa Lake. On July 11 Swannell and his crew left Bennett's and travelled to the western end of Ootsa Lake, where they turned up the Tahtsa River, heading for Tahtsa Lake. Over 50 miles long, the Tahtsa is a major drainage in the upper Nechako basin and ends at the base of the Coast Mountains. Swannell reported that of all the lakes in the area "Tahtsa Lake itself most deeply penetrates into the [Coast] range, its western end being only 22 miles from Kemano Bay, Gardner Inlet."

On July 12, while Charles Musclow and his brother Harry took some goods upstream, Swannell and the other crew members laid out a base line near the river. Swannell and Douglas Lowe then climbed Mosquito Peak north of the Tahtsa River where they set a triangulation station that could be tied into when the crew reached Tahtsa Lake. From Mosquito Peak, Swannell connected with some of his surveying stations on Whitesail Lake as well as stations on Ootsa Lake. The following day the survey crew continued up the river, setting another base line and taking solar observations for latitude. That night the men camped at Musclow's cabin above the Blue River trail. On July 14 Swannell's men encountered "bad water all day and only make 4 miles – one place chop through a driftpile & at another portage across one – main channel very ugly – only 10' gap in driftpile – Flies very annoying – finally camp in desperation on a jutting point of real solid country. The river a maze of swift crooked channels & beaver sloughs – main channel unnavigable. Pole & line in addition to the engine, the water is so swift." Another day of difficult travel on the river, including setting fire to a driftpile, brought Swannell's crew to Tahtsa Lake on July 16.

The next day Pollard and Lowe set a series of signals along the lake while Swannell prepared for the surveying. On July 19 "Pollard & Lowe climb Rhine Mt. and set two large cairns. Max & I chop out base along lakeshore – Dense willow & flies on the rampage. Take solar for latitude." The following day Pollard and Lowe continued their work while Swannell measured the base line. During the next week Swannell made a triangulation survey of Tahtsa Lake using the stations that Pollard and Lowe had set.

On July 27 Swannell and Pollard climbed Sweeney Mountain and found evidence of some of the mining activity that was occurring in the area. "Pollard & I cruise back of camp and at noon strike a good horse trail which carries us up Sweeney Mt. Old bunk house framework & powder-house at timber-line. Charlie goes down river. Get two grouse and would have had half a dozen more if Mike (the dog) had not been along."

Two days later Swannell and his crew were ready to "move camp 13 miles to sheltered bay near the two islands. Beautiful sunny day and lake like glass. Good trolling – Catch 5 silver trout, the largest 5 lbs." Swannell spent early August triangulating the western part of Tahtsa Lake. On August 10 he and Pollard climbed Laventie Mountain south of Tahtsa Lake. "By a marvellous fluke sight Cosgrove Cairn through a gap in the mountains north of Coles Lake." This provided Swannell with an unexpected opportunity to make another tie between his surveys around Tahtsa Lake and his 1920 work.

Looking southeast over Kitlope Lake. The glacier has since retreated to the top of the mountain. (See page 173 for a comparison photograph.) BC Archives I-59973

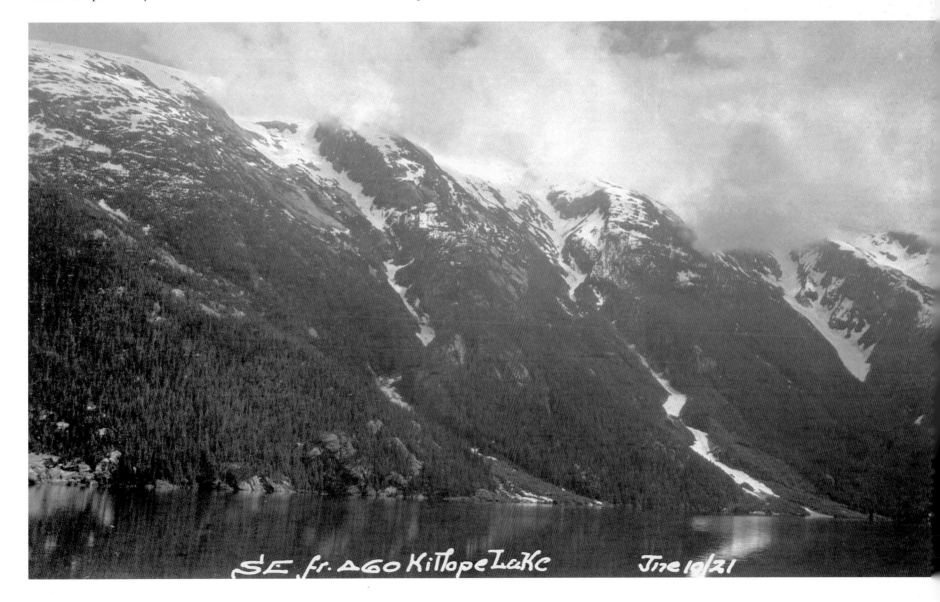

SE. fr. A60 Kitlope Lake Jne 10/21

By the middle of August Swannell had almost completed triangulating Tahtsa Lake and was ready to search for the trail that would lead from the lake to Penteuch Pass in the Coast Mountains, and down to Kemano on Gardner Canal. During the 1870s the Canadian Pacific Railway sent surveyors to all possible sites between the 49th parallel and the Skeena River, searching for a suitable location for its Pacific terminus. In 1874 Charles Horetzky travelled from Kemano up through Penteuch Pass. Two years later C.H. Gamsby made a winter trip up the Kitlope River and crossed a divide leading into the headwaters of the Nechako. (Horetzky Creek, on the west side of Penteuch Pass, and Gamsby River, one of the major tributaries of the Kitlope, recognize these two surveyors.) In July, Swannell had spent a day at the head of Tahtsa Lake and "cross-cut

valley futilely for trail to the Kemano. Note where raft timber have been cut over 40 years ago, but no sign of old camp or railway location line."

On August 15 Swannell and Charles Musclow began their search for Penteuch Pass. Initially they went up a creek that ran into the northwest corner of the lake. When this route did not lead to a pass they returned and went up another creek that entered at the middle of the head of the lake. Swannell and Musclow didn't locate a trail, but the two men eventually found a lake that was three miles long and 500 feet higher than Tahtsa. There they camped for the night. After a day of rain the men headed up the mountain and found a pass at 5000 feet and a valley that extended for five miles before dropping into a box canyon. "Clouds lower and can't see 100 yds, so forced to go back. Immense glacier to south with flattish grassy valley

Swannell, A.C. Pollard and Douglas Lowe camping on Deception Mountain while on their "dash for Kimsquit". BC Archives I-57133

Kitlope to Prince Rupert

The crew used this skiff to travel along the north coast. BC Archives I-33739

where ice has receded – Resolve to move camp to it – but near camp slip & badly twist my ankle – Get back with difficulty & in great pain. Musclow gets one ptarmigan & one blue grouse. Decide I can't travel, let alone the weather being bad." The next day Swannell and Musclow made a "very slow & painful trip over exceedingly rough country to the lake – which reach – and heartily glad too – at 1 pm. Make smoke signal & Pollard comes with boat." Swannell spent the following week in camp resting his ankle and working on his calculations and map of Tahtsa Lake while Pollard handled the surveying. The crew set a base line at the head of the lake and established some stations in the area. On August 26 "Mike tackles a porcupine & has an unhappy time while we pull the quills out of his nose with the pliers."

When Swannell's ankle had healed sufficiently he resumed his search for the Kemano trail. On August 28

"at mouth of large creek to north of head of lake find a great deal of chopping – some 35 years old & old trail blazes heading inland – Decide it is the Kemano Trail." Rainy weather during the first week in September limited the work that Swannell's crew could do. September 7 was a "fair day – All hands go over the Penteuchltenay Pass – 3 1/2 miles easy ascent from the lake – Summit a boulder strewn gut – Siffleur Lake 1 1/2 miles long above timberline. Half mile further on get a wonderful view of Kemano Bay, down the east fork of Kemano River. This is the route of the CPR Party under Horetzky in 1876." Swannell had finally found the pass through the Coast Mountains that Horetzky followed and described. This was the first of several occasions when Swannell and his crew followed routes travelled by the CPR surveyors through central British Columbia. Swannell set a triangulation station near the pass and read angles to

all the features that he could see in that area, including Kemano and Gardner Canal.

In his report to the Surveyor-General, Swannell described Penteuch Pass. "We had reason to believe Tahtsa Lake was the 'First Lake' referred to in the Canadian Pacific Railway exploration of 1874 from Kemano Bay. Search for the pass over which they ran their line was naturally made at the head of Tahtsa Lake." After describing their initial failures to locate the pass Swannell wrote that, "Later we found an old, very faint trail leading inland from a creek entering Tahtsa Lake on the north side, a mile from the lake-head. The going is easy through alpine meadows. At 1 mile from Tahtsa and at an altitude of 3,100 feet a steep ascent brought us into a basin with a tarn lying against rock slides and cliffs. An easy ascent to an altitude of 3,700 feet, followed by a short scramble up a cataract-bed,

led to a small grassy basin and a rough boulder-strewn gap. This is the summit of the pass (4,025 feet) and is 3 miles from Tahtsa Lake. Two hundred and fifty feet below, to the west, lay Siffleur Lake of the Canadian Pacific Railway report, draining due west. Half a mile beyond we looked down the deep straight valley of the Horetzky (or Penteuchltenay) Creek and could plainly see the flats of Kemano Bay, Gardner Inlet, 18 miles away." Swannell then gave Horetzky's description of the pass. Today Tahtsa Lake is the upper end of the Nechako Reservoir, while underneath Penteuch Pass passes the water tunnel that leads to the penstock for Alcan's Kemano power generator.

On September 8, Swannell's crew began heading down Tahtsa Lake. They spent a day climbing Rhine Crag and surveying from the cairns erected earlier. Although it was not a high peak, Rhine Crag was a

■ The little outboard motor doesn't have enough power for this swift section of the Tahtsa River. Swannell (right) and two of his crew pull while the man standing in the canoe pushes with a pole. They tow another canoe behind them.
BC Archives I-58738

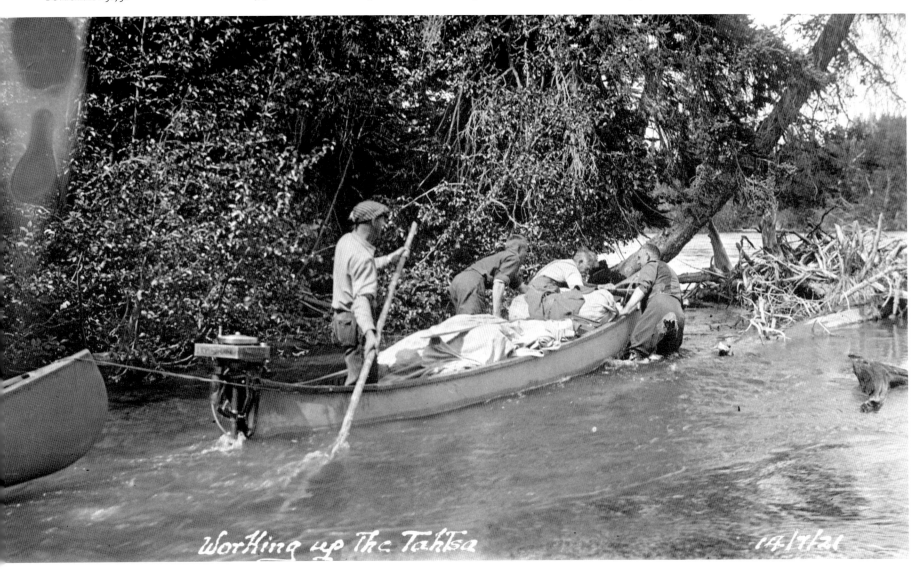

Working up the Tahtsa 14/7/21

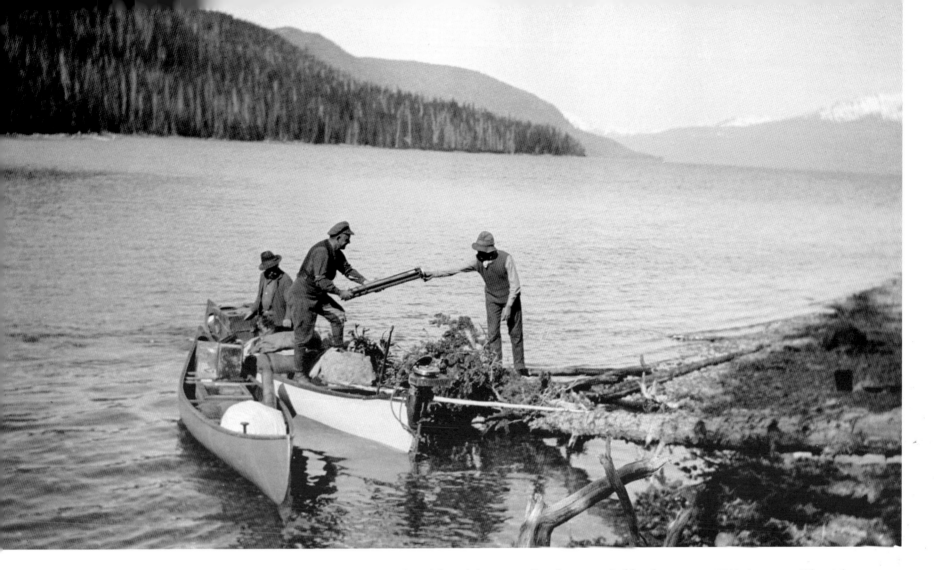

Moving camp at Tahtsa Lake.
BC Archives I-33750

distinctive mountain with a prominent location, and it would become one of the main peaks in Swannell's triangulation network. Going down the Tahtsa River the crew again stayed overnight at Musclow's cabin. On September 11 "Charlie Musclow & I leave 7:30 am and reach Bennett's late in the afternoon. Glorious run down river & lake although nippy with frost in the early morning. Pollard, Lowe & Harry Musclow climb Huckleberry Mt. today."

The following day they left Bennett's at 5 pm and arrived at the trail to Stoney Mountain where the rest of the survey crew was camped. On September 13 Swannell and his crew climbed "Stoney Mt. (Wells) up old Indian hunting trail – formerly used for getting caribou meat down. Top flattish for miles. Returning just make camp by dark." Stoney Mountain would become one of the major peaks in Swannell's survey of central British Columbia.

The next day the men moved up to Whitesail Lake where Swannell had spent a sizable portion of the 1920 field season. "Five miles up lake catch a grizzly swimming across – Head him back & spend half an hour trying to get photos – to get sun behind us have to go to

windward & with heavy swell and strong wind hard to run close without drifting him. Bear frantic with fright – Turns on the canoe several times with a roar. Try to head him into a sunlit bay unsuccessfully – will not change his course. Max ready with an axe to chop his paws if he tries to board. Landing, he disappears up the hill in a series of huge leaps. Camp at Δ23 and get excellent observations on Polaris. Wonderful moonlit night."

On September 15 Pollard and Charlie Musclow climbed Mount Chikamin, one of Swannell's main 1920 triangulation stations. Pollard added all the stations from the 1921 survey that he could observe, making a stronger connection between the 1920 and 1921 surveys. During the next week they finished the 1921 field season by surveying at several stations in the area. On September 25 Swannell and his Victoria crew members left on the Grand Trunk ship SS *Prince George,* arriving in Victoria on the morning of September 28.

Swannell had completed his second season of surveying central British Columbia. Although he had not firmly tied Underhill's survey of the Kitlope with the Kimsquit he had made another connection between the

■ Charles Musclow in the bow of the canoe and his brother, Harry, in the stern. Charles Musclow was born in a small farming community in Ontario in 1892. His father had emigrated from Germany when he was young. Besides working on the family farm, Charles was also a boxer. He became a sparring partner for Jack Johnson, the world heavyweight champion, and spent some time with him in the United States. In the winter of 1910 Charles and his older brother, Bill, went out to Ootsa Lake for adventure and spent the winter trapping in the area.

When World War I started Charles tried to enlist but was rejected because his father was German. Then, in 1917, Musclow received a draft notice. Stung by his previous rejection, he left Ontario and rode the rails across the country to northern BC. He went back into the remote country south of Ootsa Lake and remained there for the duration of the war and a few years after. He spent the winter trapping, the spring selling his furs at Ootsa Lake, and the summer and fall roaming throughout the vast wilderness of northern BC.

In 1921 Charles' younger brother, Harry, came out from Ontario for a year.

After three summers working for Swannell, Musclow went to the Northwest Territories in 1923 to work on a geological survey crew. He then went back to Ontario and became one of the original members of the Red Lake gold rush in the northwestern part of the province.

When he married in 1928, Musclow brought his bride to BC for a six-week honeymoon in the Ootsa Lake area and they climbed Mount Musclow. Charles Musclow has the rare distinction of having geographical features named for him in two provinces and one territory.
BC Archives I-57131

coast and interior surveys. The survey of the Tahtsa River and Thatsa Lake had added a large area to the triangulation network that he was developing, and from Pentcuch Pass he was able to make a survey connection to Gardner Canal at Kemano Bay. Swannell's surveys from Stoney Mountain and Rhine Crag added two important peaks that would be used frequently during his surveying of central British Columbia. The Surveyor-General wrote about the importance of the triangulation surveys being done in the province. "Triangulation surveys constitute the most accurate and economical means of establishing control where conditions make this class of work possible.... A feature of this work is that each year we find geographic features greatly at variance with, or entirely omitted on, the charts of the Coast. This year a survey was made of an inlet or lagoon running north and south through Hunter Island, measuring 12 miles in length, which has not been shown on any Admiralty Chart, although this island is immediately adjacent to the main steamer-channel between Vancouver and Prince Rupert."

Umbach also reported: "One party was engaged in establishing a tie between the head of Gardner Canal and the triangulation net established last year in the vicinity of Eutsuk Lake and the westerly end of the surveyed portion of the 53rd parallel of latitude.... Mr. Swannell was employed on a reconnaissance and triangulation survey in the valley of the Kitlope and Kemano Rivers, at the head of Gardner Canal, and extending to the lake district to the east of the Coast Range. Another tie was established by him between the Coast triangulation of Gardner Canal and interior surveys. An interesting feature of this work was that Kitlope Lake was found to be almost 20 miles away from the position in which it has been shown heretofore on maps of the province."

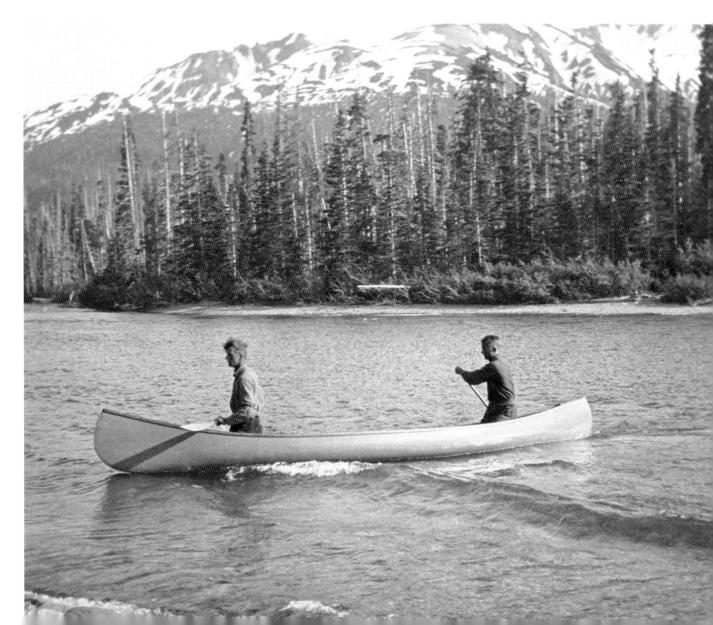

■ Kemano Glacier from the west end of Tahtsa Lake, showing the extent of this well-known glacier in 1921.
BC Archives I-58782

■ *Below*: Looking east from Penteuch Pass. The tarn that Swannell describes sits in the foreground while Tahtsa Lake lies behind.
BC Archives I-58605

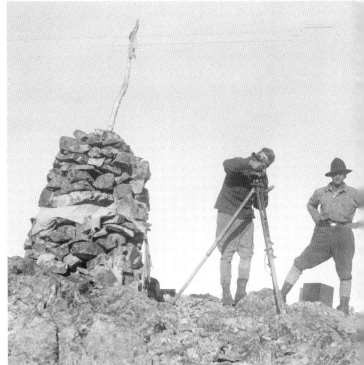

 Tahtsa Lake.
BC Archives I-57990

■ *Right*: A.C. Pollard and Harry Musclow on Huckleberry Mountain.
BC Archives I-57128

■ *Below*: The village of Burns Lake developed alongside the Grand Trunk Railway after the railway's completion in 1914.
BC Archives I-33754

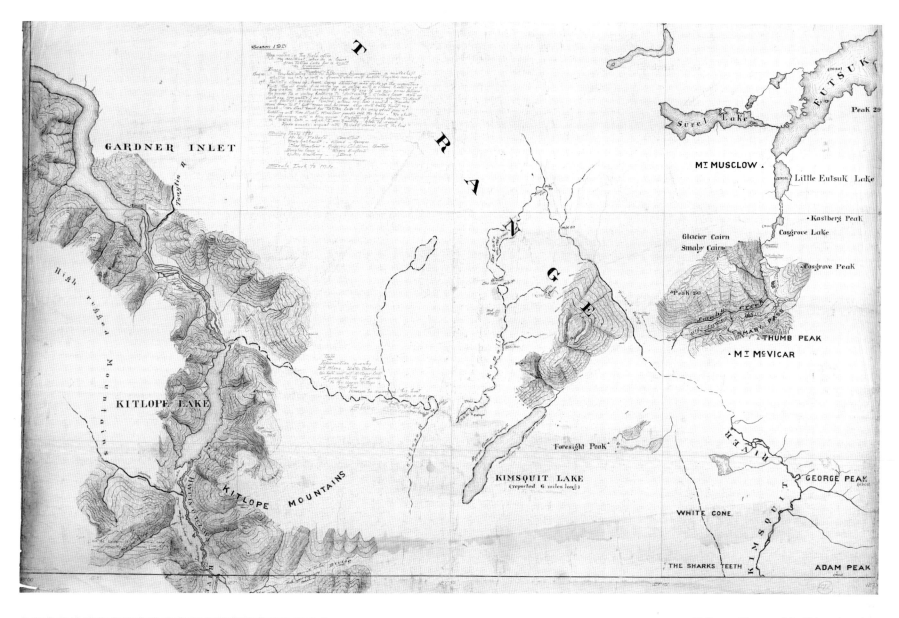

In 1921 R.P. Bishop did a triangulation of the area around the 55th parallel that he surveyed the previous year. Swannell later connected his triangulation network to some of the stations that Bishop established.

Swannell's map of the Kitlope, based on the surveying he did there. He made a similar map of the Tahtsa drainage.
BC Archives CM/C/14233

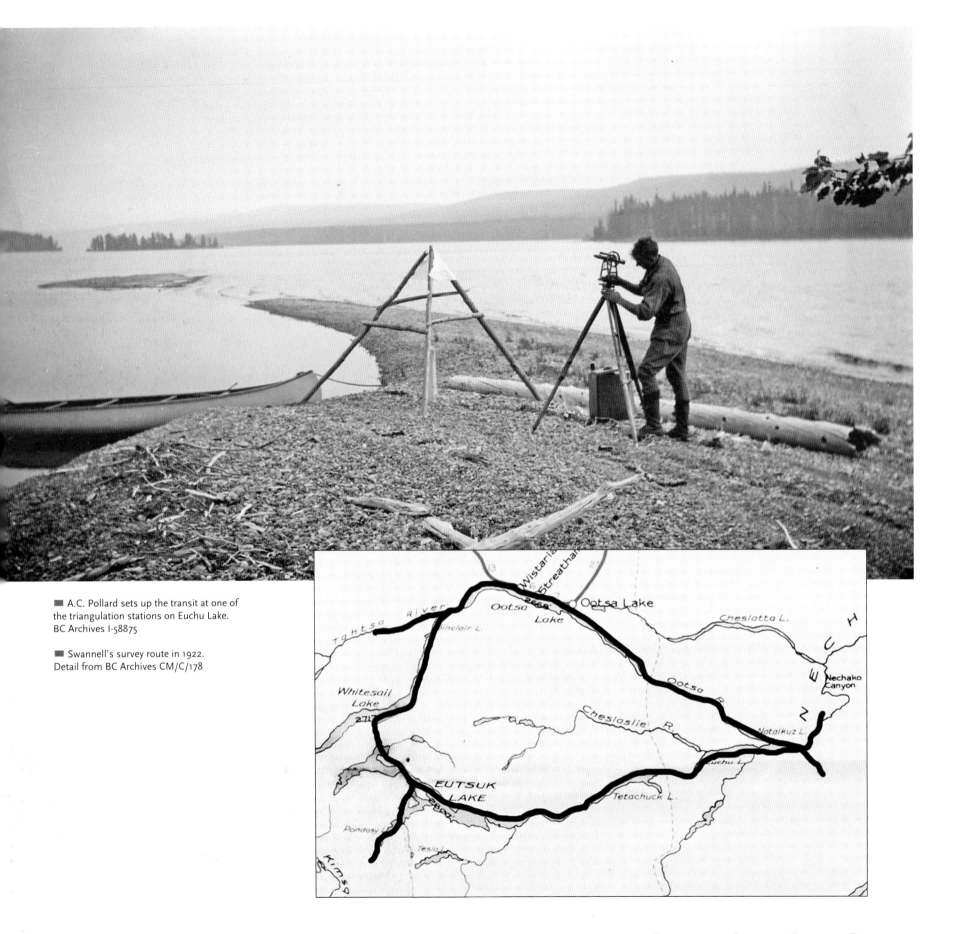

■ A.C. Pollard sets up the transit at one of the triangulation stations on Euchu Lake. BC Archives I-58875

■ Swannell's survey route in 1922. Detail from BC Archives CM/C/178

1922

During the winter of 1921-22, Swannell worked on his calculations for the 1921 field season and made two maps: one based on his surveys in the Kitlope and the other for the Tahtsa drainage. In early March Swannell received notification that he would be receiving a military pension award for partial disability because of the permanent weakness in his left arm from the wound in Russia. On May 5 Swannell met Umbach for "lunch at the Hudson's Bay – straightened out accounts for 1921.... Agreed to practically all I ask for coming season but says $7000 limit of appropriation." Although it was the third season that he was working for the Surveyor-General, Umbach's May 10 letter was still formal. "I have to give you the following detailed instructions for the continuation of the triangulation and topographic reconnaissance survey in Coast District Ranges 4 & 5. You are to complete the areas not yet covered by you West of Eutsuk Lake and Troitsa Lake. You are to establish a connection to Mr. McLean's base line on Ootsa and carry a triangulation and reconnaissance via Natalkuz and Euchu to Tetachuck Lake. On the completion of this work you will make a connection by resection to Bishop's triangulation station 'Fulton' and if possible to 'Taltapin'." Umbach also provided several other specific details regarding the organization of his survey crew. His letter ended by saying, "In replying please quote File 038/60."

A.C. Pollard, surveying assistant, and Max Gebhardt returned to Swannell's crew and were joined by Bob Stranack. On May 28 Swannell and his wife, Ada, along with Stranack and Pollard, left Victoria on the steamship SS *Prince George*. The ship first sailed to Seattle. During the seven-hour layover Frank and Ada took the electric train to Tacoma. The SS *Prince George* then travelled overnight to Vancouver. Frank and Ada spent a day visiting friends before Swannell and his crew resumed sailing on the SS *Prince George*, bound for Prince Rupert. For their trip up the Inside Passage they had a "splendid day – sunny even at Ocean Falls." In Prince Rupert Swannell visited Pat Sharkey, who had been a cook on Swannell's crews from 1908 to 1912. He also met D.B. Morkill (BCLS #57) who was en route to Houston to survey mineral claims in the

■ Lindquist Pass panorama.
BC Archives I-58654–56

■ *Below*: Burns Lake.
BC Archives I-33743

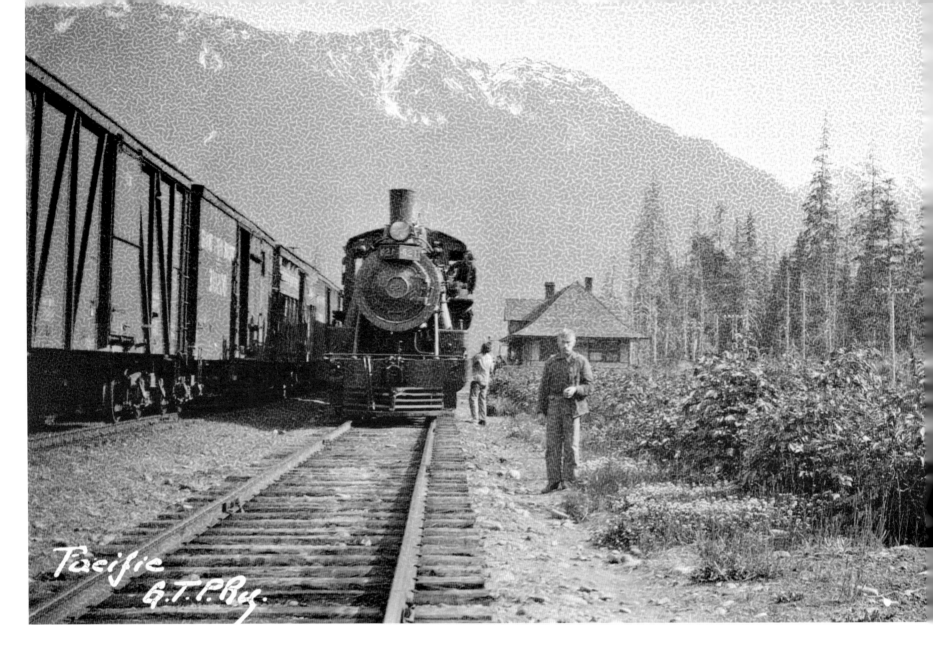

Pacific
G.T.P.Ry.

area. Swannell, Stranack and Pollard arrived at Burns Lake on June 1.

While "Bob & Pollard go with Cecil Bennett & the wagon" to Ootsa Lake, Swannell had lunch at Schjelderups. Later in the day he picked up Max Gebhardt and they bought a "Peterboro canoe from McLean for $100 – more than it is worth but cheaper than wasting a couple days at Ootsa Lake hunting a boat." Swannell and Gebhardt reached the south bank of Francois Lake where they stopped overnight at Keefes. In his diary entry for that evening Swannell noted that there were many fires in the area. In fact, forest fires would be the principal difficulty Swannell encountered in his surveying this year. On June 2 Swannell and Gebhardt "push on with canoe lashed on a motor truck & reach Bennett's 1 pm. Road execrable but better than last year. Waggon arrives 6 pm."

Swannell's crew spent a few days at Bennett's preparing for their surveying. One day Swannell and Pollard took some of their equipment down to Henson's place at the foot of Ootsa Lake where the trail from Ootsa to Cheslatta Lake started. Before World War I this place had been "Louis's Dumping Ground" where Chief Louis of the Cheslatta First Nations unloaded goods and supplies. Swannell had started his Great Circle trip here in 1910. After World War I the small settlement of Marilla developed around this area.

The men set some triangulation stations along the northeast shore of Ootsa Lake. However, Swannell encountered a problem when he went to tie his triangulation with McLean's work. In his government report Swannell wrote that, "the Geological Survey, under S.C. McLean, having in 1920 measured a base at Ootsa

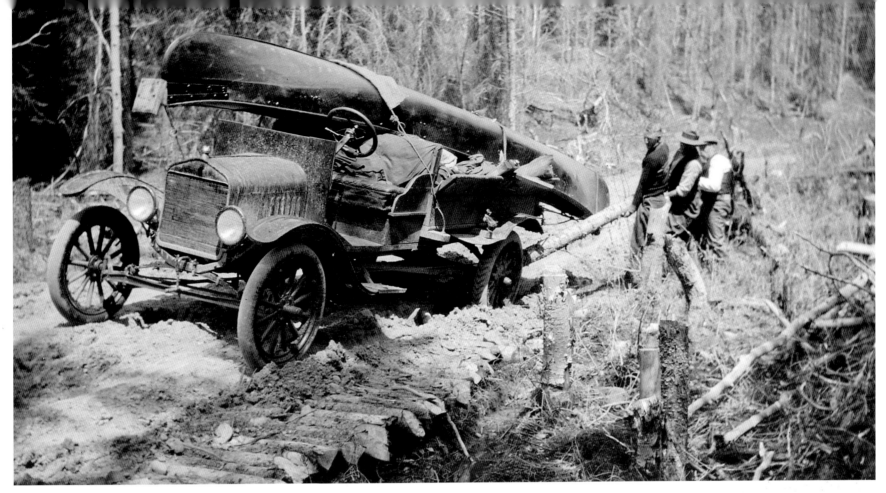

■ Stuck in a mud hole on Ootsa Road.
BC Archives I-58791

Lake Post-office, I was further instructed to carry my own triangulation down to this as a check. Most unfortunately, however, the road-gang, in altering the location of the Ootsa-Francois Road, had destroyed the monument at one end of Mr. McLean's base, thus ruining a careful bit of work. Had a few angles not been read from this point the previous season, no check at all could have been obtained."

On June 6 Swannell's crew set up Camp 1 at Henson's. "Charlie Musclow joins us in evening, coming down with young VanDecar, old Mitchell & Schreiber – Says he will stay with us for his board rather than loaf around Bennett's. Chas Musclow's time starts." Swannell needed one more crew member and was probably glad to have Musclow back for another season. The next day, while Pollard and Stranack set up some triangulation stations and made preparations "Charlie & I run load down and cache it 4 miles down Natalkuz – Tow the hunting party down Intatah Lake – Pass 'Kentucky Bill' (Ingram) & Vantine on Ootsa River – Say they have been starving for 4 days. Big fire along Euchu."

Swannell was now ready to begin his surveying for the 1922 season. This year he was working on the Great Circle, the lakes and rivers of the upper Nechako. The Great Circle began at Natalkuz Lake at the head of the Nechako River, several miles above present day Kenney Dam. From the northwest arm of Natalkuz Lake, one drainage led up a series of rivers through Intatah, Ootsa and Sinclair lakes to Whitesail Lake at the head. Up the southwest arm of Natalkuz another drainage passed through Euchu, Tetachuck and Eutsuk lakes. The portage between Eutsuk and Whitesail lakes was just over one mile long. Swannell had travelled on these lakes in 1910. In 1920 he made a triangulation survey of Whitesail Lake and completed Eutsuk Lake. Before World War I, E.P. Colley had surveyed lots for agriculture around Ootsa, Tetachuck and part of Eutsuk lakes. Vilhelm Schjelderup had also surveyed some lots on the upper Nechako waterways. Swannell's 1922 surveys would complete the mapping of the major lakes in the headwaters of the Nechako. They would also connect the surveys that had been made along these lakes to the triangulation network that he was developing.

Swannell's crew spent a few days surveying at the east end of Ootsa Lake before moving camp to Henson's lot on Intata Lake, which Swannell noted "takes in almost the whole of the only good piece of land adjacent to the lake." Swannell spent almost three weeks at this 10-mile-long lake, surveying the lake itself and several triangulation stations in the area. On June 10 he noted "Kentucky Bill's camp fire on Ootsa River now well away in the timber." Swannell's government report commented that, "there is a fairly heavy stand of spruce

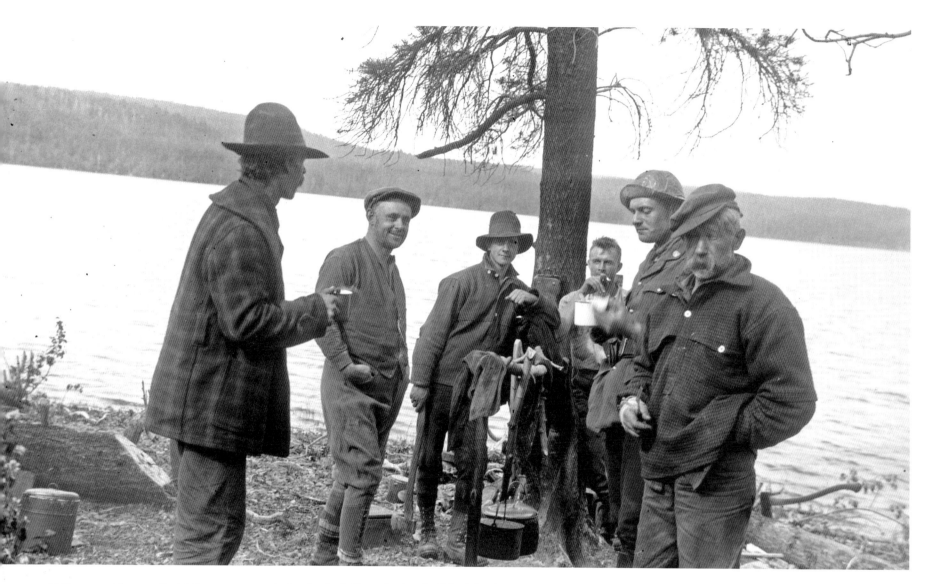

Henson and the mountie visit the camp on the upper Nechako River. From left to right: the RCMP officer, Frank Swannell, Bob Stranack, Charles Musclow, Bill Henson and Max Gebhardt. BC Archives I-58863

and pine in the hills at the head of the lake, but much of this was ruined this year by a fire started through criminal carelessness on Ootsa River." On June 16 Swannell wrote in his diary that, "Henson & a Mountie from Telkwa pass – looking for a Chelaslie Siwash." The next day "Henson returns without the Indian."

Swannell and some of his crew went to Bennett's store at Ootsa Lake on June 20. He noted that the smoke from forest fires was thick. Returning the following day, Swannell met "Kentucky Bill & Bill Elder on their way to build a cabin at the head of Natalkuz. Warn the former about his carelessness with fire on the Ootsa River." Swannell and Charlie Musclow climbed Mount Swannell on June 23. "See over 40 lakes – fires in every direction – lucky enough to strike horse trail to a long-time camp occupied last year – & meat trail up the mountain." On June 28 "Kentucky Bill &

partner pull out for Ootsa Lake – slash they have been burning creeps & fanned by afternoon wind is running well by night – cleans out Bill's tent & burns his grub, clothes & rifle. All hands two hours in evening fighting fires. Reading Intatah triangulation all day. Very smoky, surveying nearly impossible." The next day Swannell's crew started "Natalkuz triangulation – spend more time fighting fire. See bear on open hill under signal."

The men moved their camp to the head of the Nechako River at the outlet of Natalkuz Lake on July 1. "Camp at cabin of the Negro McHenry – open land here – probably village site. Strong wind in evening – very smoky heretofore." Swannell's crew spent the first half of July at this camp. He divided his men into two groups so that he and Pollard could use two transits and survey at several different locations. Since they were at the beginning of the

Great Circle, Pollard and Bob Stranack set up a base line near their camp and surveyed around Natalkuz Lake while Swannell and Musclow did triangulation surveys and took another trip back to Bennett's at Ootsa Lake. Swannell spent a half-day there working on surveying calculations and making an initial map of his work. Schjelderup had surveyed several lots around the outlet of Natalkuz Lake and these were tied into Swannell's survey. Smoke from the forest fires continued to make surveying difficult, particularly at the triangulation stations on the hills. "Heavy wind & forest fires burst into dense smoke again, the sun showing through as an orange coloured disc," Swannell wrote on July 3.

During the afternoon of Saturday, July 15, Swannell's crew travelled down the Nechako River to the head of its "Grand Canyon". On Sunday "all hands hike down trail the length of the canon to Murray Lake. Lower three miles of canon fiendish water & one waterfall or cataract rather – take many photos. Indian keekillie holes high above cataract on bench." Swannell had visited the "Grand Canyon of the Nechako" when he surveyed in the area in 1910 and he took several pictures of the river

at that time. When the men returned from the Nechako River, Swannell spent a day going to Tatelkuz Lake in an attempt to connect the land surveyed around there with his triangulation. "Erect signal on bluff just above where the river pirates into a glacial lake 1/2 mile long – too smoky to distinguish land features."

Swannell's crew began working up the southern portion of the Great Circle on July 19. "Moved camp to Euchu Lake at Peninsula – all recently burnt over – Max & Bob clearing for base line – survey part of Euchu River." Swannell's crew spent about two weeks around Euchu Lake. On Sunday, July 23 they "worked all day on Euchu triangulation. Visibility for once good but brush fires all starting up, again, especially in the hills west of Cheslaslie Lake." They took their "Sunday" the following day. As the men surveyed this drainage, the forest fires and smoke worsened. "Fine but very smoky & had to abandon reading signals by early afternoon. Fires everywhere from Alkatcho to Ootsa," Swannell wrote on July 26.

The next day "four of us took cache ahead to near foot of Tetachuck Falls – While lining rapids below the stern fouled on a rock. The canoe sheered & partly filled

The crew, along with their dog, Mike, packed and ready to move camp. Swannell's photographs of the lakes of the upper Nechako River provide an invaluable record of what this area looked like before the Kenney Dam was constructed in 1952. BC Archives I-58846

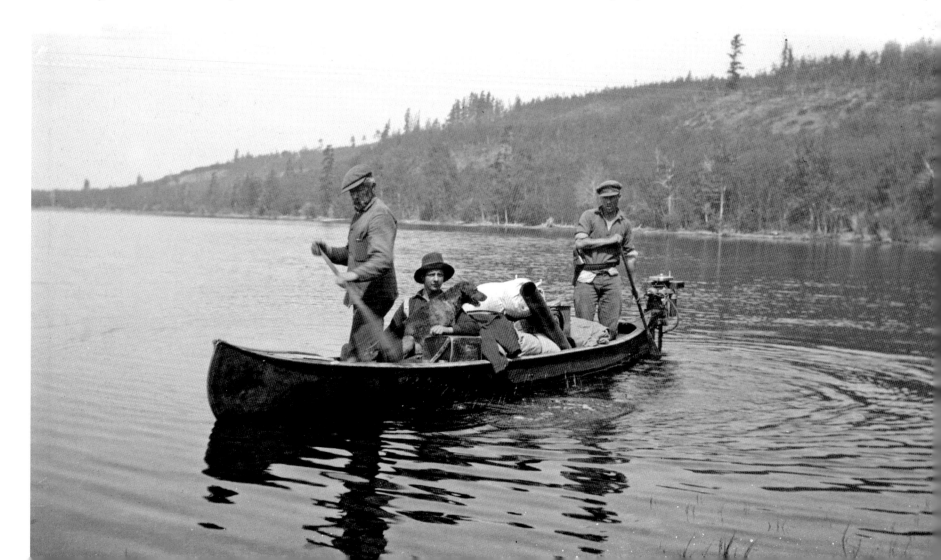

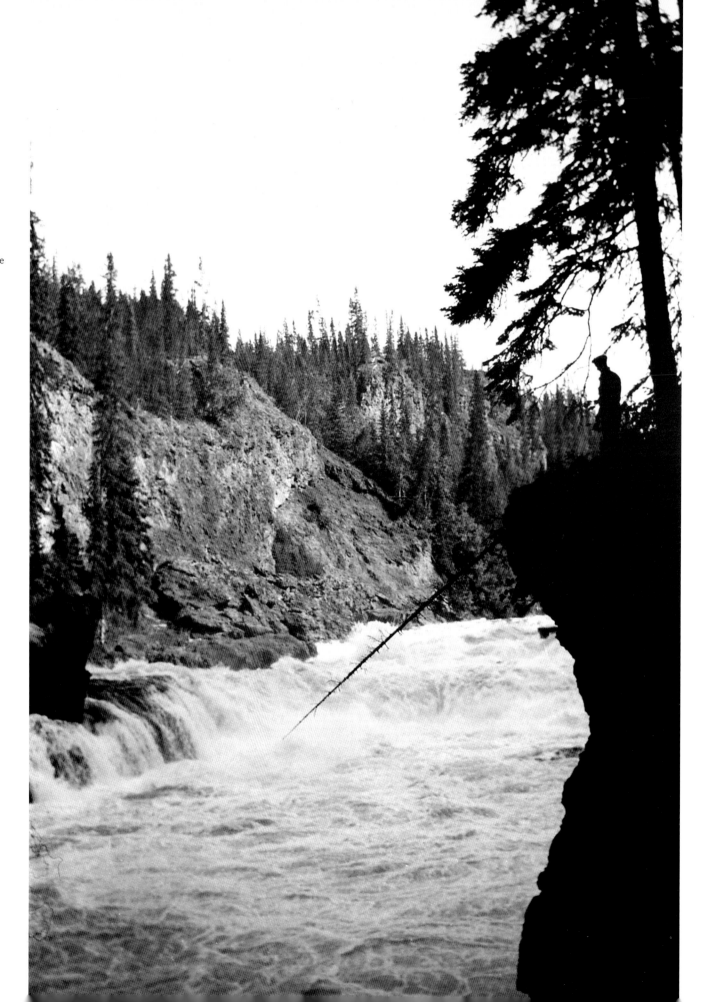

One of Swannell's crew has a bird's-eye view of the Nechako River canyon falls. Swannell took several pictures of the "Grand Canyon of the Nechako" in 1922 and 1923. BC Archives I-58806

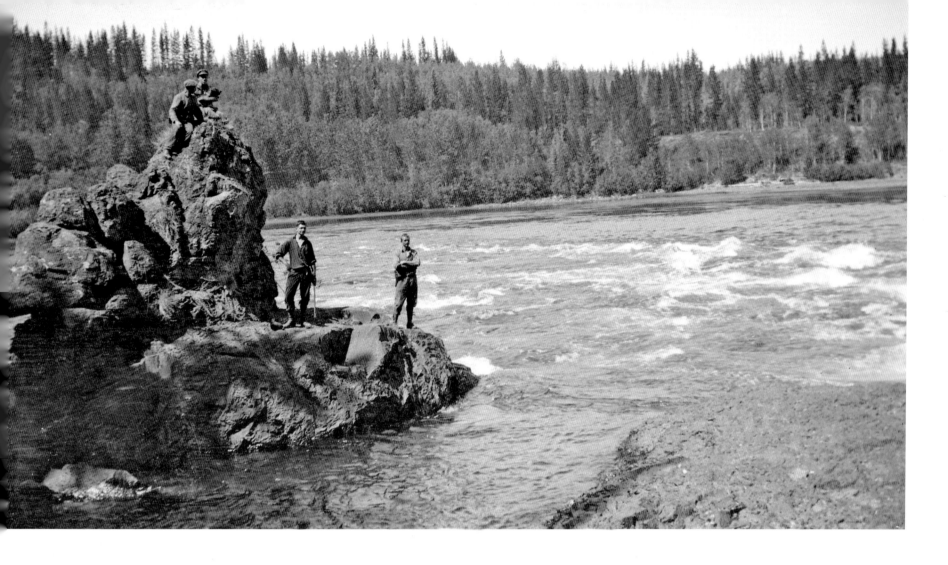

TRIANGULATION DIAGRAM
showing connection between
CHELASLIE and EUCHU LAKES
R IV - Coast District
Scale - 1inch = 1mile.
F.C. Swannell B.C.L.S
March 1st 1923

Above: At the foot of the Nechako River canyon. Charles Musclow (right) and Bob Stranack stand on the lower rocks.
BC Archives I-58811

Swannell's diagram showing his triangulation of Euchu Lake, as well as parts of Chelaslie and Natalkuz lakes. The triangulations of these lakes were connected to triangulation stations like Mount Swannell and Burnt Hill, lots like L338, and base lines like NB and SB at the east ends of Euchu and Chelaslie lakes. Swannell surveyed most stations to several others, enabling him to make accurate calculations for each location.
Surveyor-General's office

■ Pollard cutting Bob Stranack's hair. In the wilderness, crew members relied on each other for friendship, entertainment and haircuts. Bob Stranack was born in 1903 in India, where his father worked for a bank. His family sent him to England in 1913 for education. He immigrated to Canada in 1920 to work on the farm of a family friend in Nova Scotia. Two years later, Stranack moved to Victoria. After surveying for Swannell, he spent a few years travelling to Australia, Fiji and several other countries before returning to Canada. BC Archives I-58844

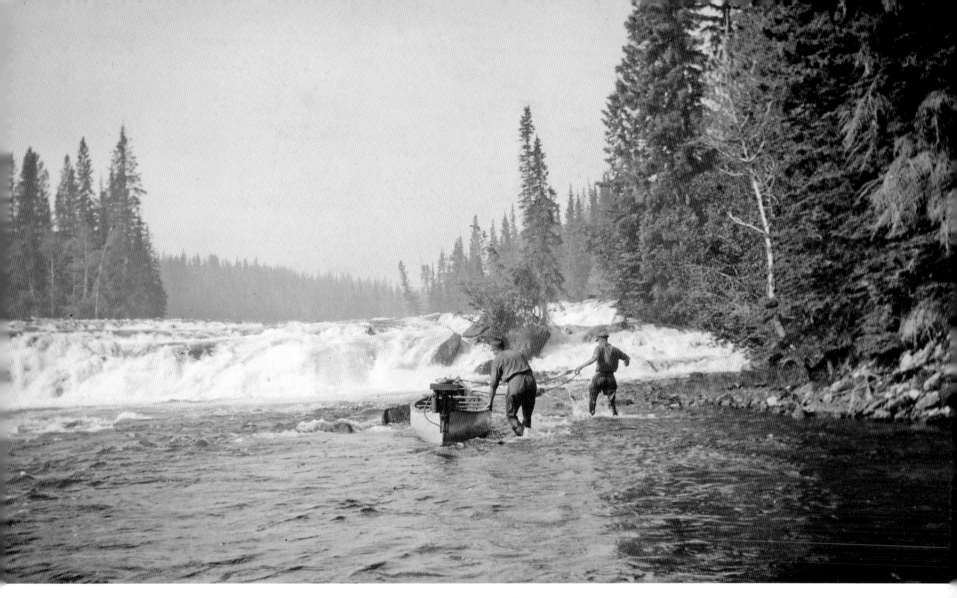

■ Canoes at Tetachuck Falls. Swannell also photographed these falls in 1910. BC Archives I-58880

before we could get Max & Pollard to let go – went down broadside on a canoe unmanageable being so full of water. Manhauled her through next attempt. Got 550 lbs. across Portage Trail to foot of Tetachuck Lake." On July 29 the crew started a "traverse of the Bella Coola Trail to connect surveyed land with triangulation. Country burnt over & still burning along trail. Day very oppressive – hot." Even though the next day was Sunday they completed "trail traverse – very hot day & all in working in burnt country without water." On July 31 they "made today Sunday.... Find foundations of three Siwash cabins & one with hewn sills near large keekillie holes along trail near head of lake – later was housing an assay outfit – many crucible & part of a rock crusher nearby."

On August 2 Swannell's crew completed their survey of Euchu, read one station at Chelaslie Lake, which drained into Euchu, and moved camp to the head of Tetachuck River. Two days later they finished a traverse survey between Euchu Lake and Tetachuck Crossing and tied their survey into the large block of land that had been surveyed along Tetachuck Lake before World War I. "Smoke & mist so dense all morning that shore not visible 100 yds away." Then the crew began moving their supplies up to Eutsuk Lake. He observed the "remains of old house built of hewn timbers near head of Tetachuck Lake – I noticed this 12 years ago." On Eutsuk Lake Swannell met Shorty Grell. By August 8 Swannell's crew reached St. Thomas Bay at the portage to Whitesail Lake. "Pollard & I went to Atna Bay but too smoky to do anything. Fire opposite Big Bear Island started from campfire of VanDecar, Schreiber party undoubtedly – Grell reported seeing smoke from his cabin 14th July."

From Eutsuk Lake, Swannell's crew headed up the Surel River where they built "skid road for canoe 1/4 mile to above falls & cut out portage trail to Surel Lake." Surel River and Surel Lake were on the north side of Mount Musclow. This drainage was immediately north of Smaby Creek and only a few miles from where Swannell had been in 1920 when he went over the Coast Range and down the Kimsquit valley. Swannell wanted to

return to this area at a different location where he could see both the Kimsquit and Kitlope valleys and make a definite connection between his 1920 and 1921 coastal surveys and his triangulation network in central British Columbia. On August 9 the survey crew "portaged outfit and moved camp to head of Surel Lake, Charlie & I taking canoe up Surel River from top of the falls."

The next day Swannell and Pollard climbed Ptarmigan Peak while Charlie went to set a cairn on the next mountain north above Lindquist Lake. "Rain in afternoon prevents reading station so Pollard & I start at 3 pm for the Kitlope. At 5:30 reach point 2000' directly over Ear Lake.... Ear Lake draining by a short stream into the Kitlope & the latter continuing northward in a wide floodbed. Rustle wood & sleep out as best we may near timber line. Mosquitos bad until dusk. Luckily a clear starlit night." The next morning "at 6 am strike back over mountain behind but stopped by crevasses in big glacier

■ Trapper Shorty Grell at Eutsuk Lake. In 1906, Shorty Grell, (at that time Shorty Dunn) was Bill Miner's accomplice in the famous BC train robbery near Kamloops. Shorty was arrested and received a life sentence in 1907. Paroled in 1915, he reverted back to his original birth name. In 1921 he hired on with two men to drive a herd of cattle from the Cariboo to the Burns Lake area. From there he went to the Ootsa Lake area where he became a trapper. He also worked at Henson's store at Marilla for parts of several winters. Respected and well-liked by the local residents, Shorty lived peacefully in this area until he drowned in an accident in 1927. His cabin at Eutsuk Lake still remains. BC Archives I-58840

■ *Far right*: Charles Musclow at the top of the portage around the falls on the Surel River. BC Archives I-58867

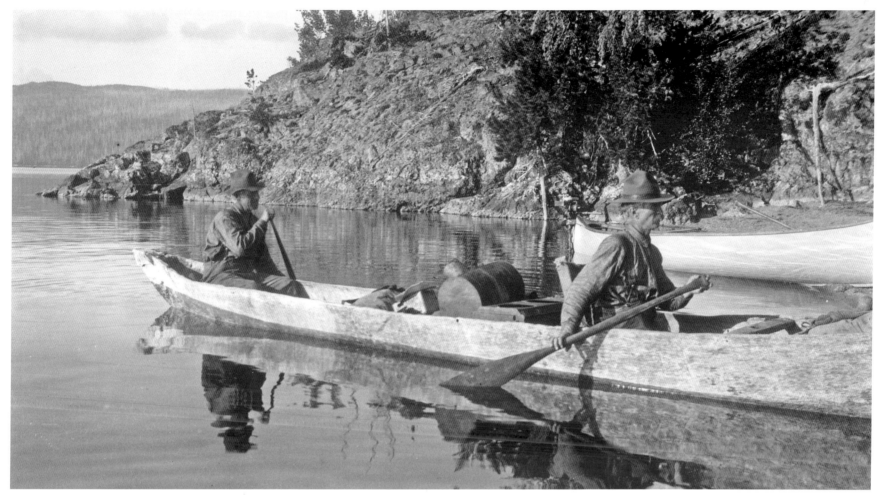

other side – Have to go all the way back & scramble round – weak & dizzy from want of food & sleep – nothing to eat since lunch yesterday. At 11 am relief expedition spots us by the spray of snow we make glissading onto a glacier – All right after some grub & all wrong after some rum." After a short rest Swannell and Pollard climbed Ptarmigan Mountain again since the weather was clear. On August 14, after a Sunday of relaxation, Bob Stranack stayed in camp as cook while Pollard and Max went to do some triangulations around Lindquist Lake, and Swannell and Charlie climbed Peak 3. "Visibility fine – get Rhine Crag, Stoney – Mt. Fulton ... Peak 3 is 7000 feet."

Swannell had now made his connection with both of his coastal surveys. In his government report, Swannell calculated that Ear Lake was 40 miles from Gardner Inlet and 38 miles from Dean Channel. He noted that Horetzky had visited Ear Lake and Tochquonyalla (Lindquist) Lake in Lindquist Pass during his CPR surveys. In addition, Swannell was able to make a link with two of his major triangulation stations from Peak 3. An additional bonus

was sighting Mount Fulton, almost 100 miles away. This was one of Bishop's main peaks in his triangulation network around the 55th parallel. Swannell had made his first connection with this network to the north, achieving one of his objectives for the summer.

The following day Swannell & Musclow followed a trap line route that led from Surel Lake towards Kimsquit to the summit of the Coast Range. He was able to observe the route that he had taken in 1920. At the summit "see large black bear & jump a big grizzly & cub at 75 yds – very shaggy & brown – stare at each other a minute. Then the bears scramble up the mountain, peering down at us from a bluff." On August 16 Swannell's crew finished triangulating Surel Lake and returned to Eutsuk Lake. The week spent around the summit of the Coast Range had been very successful for Swannell. He had now completed the connection between the coast network, his interior triangulation network, and Bishop's survey of the 53rd parallel. He had mapped this area of the Coast Mountains and tied it into some of the main peaks of his surveying.

■ Price and Crawford in canoe. These two prospectors, who Swannell met on Eutsuk Lake, were the men who saved Cliff Harrison (see page 18). BC Archives I-58839

Before leaving Eutsuk, Swannell and Pollard spent a day at Pondosy Lake. "Succeed in observing Smaby Glacier & Cosgrove Peaks, although very smoky." Swannell had added another lake to his map and made another tie with his 1920 surveys. On August 18 the men moved across the portage to Whitesail Lake. "Lake lives up to its reputation. Fine but windy." The next day Swannell's crew travelled down Whitesail Lake. Pollard tried to read from one of the 1920 triangulation stations on the lake but it was too smoky. "Find haymakers at Tahtsa Forks burnt out & Ellison among the ruins." On August 22 Swannell's crew arrived at Bennett's for dinner. There Swannell received a telegram from Umbach that had been sent the previous day instructing him to make a "traverse to Tatelkuz Surveys. Additional three hundred appropriated."

At Ootsa Lake Swannell hired Jimmy Morgan, a 14-year-old boy whose family had a farm in the area. Morgan was with the crew for the remainder of the season. On August 23 Musclow and Morgan left for Nadina Mountain to set a triangulation station on this high, prominent mountain to the northwest.

After spending a day around Ootsa Lake resetting some of McLean's signals, Swannell's crew headed up the Tahtsa River. Swannell hoped to survey from one of his 1921 stations again and add some of the triangulation stations that he had set this year. On Saturday, August 26 Swannell climbed "River Crag & remain there 6 hours without being able to read a single angle – smoke from fires north of Tahtsa and towards Nadina." The next day Pollard and Stranack spent "all day on mountain top without getting a single sight."

Swannell returned to Bennett's and prepared to go down to Tatelkuz Lake to make the traverse that the Surveyor-General had requested. Along the way the men spent two days doing a traverse of the Ootsa River and tying it into nearby surveys. "Two coyotes barking near camp last night trying to entice Mike [the dog] away." While Swannell, Max and Charlie took the canoe down to the foot of Natalkuz Lake, Pollard and Jimmy brought horses from the Bennett's. They crossed the Nechako River at the ford of the Nechako at the end of the Kluskus trail and began a traverse and triangulation down the trail to Tatelkuz Lake. It took the men about a week to complete this survey. Tatelkuz Lake was the most easterly location of Swannell's surveying in central British Columbia.

Before returning, Swannell went back up Mount Swannell on September 17. "Windy but not too cold. Reach summit at 12:30 – Fires still burning fiercely along Bella Coola trail & surging up like a bad storm from beyond. Visibility nevertheless good in certain directions

at intervals – Got Stoney Cairn, Peak 3, Nadina, Chikamin & Mt. Fulton – latter a 100 mile shot." At 5950 feet Mount Swannell is not a high mountain but it is in a location with good visibility to many of the peaks of central British Columbia, and it became the main peak in the southeast part of Swannell's triangulation network. From the mountain Swannell had tied into a major station from both 1920 and 1921, a prominent peak in the Coast Range, and the new station on Nadina. He had also made a second connection with Bishop's triangulation station on Mount Fulton.

Swannell's crew moved back to their previous camp on the Nechako River. He read surveying angles at two stations along the river while Pollard read a station from the top of a nearby bluff. Then the crew returned to Bennett's on September 23. The next day was Sunday and Swannell worked on his accounts all day. "Go to Presbyterian Service in evening, but am the 'congregation' all by myself – Hard lines on the parson, McCrimmon. The Bennett's & McLean the Road Super arrive 8 pm – the

latter half drunk." Monday, September 24 was Swannell's last entry for the 1922 field season.

Despite the forest fires and smoke, 1922 had been a successful field season for Swannell. He had expanded his triangulation network considerably and made several important connections. He had sighted Mount Fulton twice but both readings were from almost 100 miles away. In his report to Umbach, Swannell wrote, "I regret to state it was impossible to complete ... a rigid triangulation to Mount Fulton. The main stations, 30 to 40 miles apart, should have been read early in the summer, but for three months smoke from forest fires made it absolutely impossible to see distant points. Although seriously hampered by smoke, I ran a chain of minor triangles down Ootsa, Intata, Natalkuz, Chelaslie, and Euchu Lakes, tying in several isolated surveys, connecting up with the large block of surveyed land along Tetachuck Lake and the surveys at Tatelkuz Lake. Topography was taken along this belt and a reconnaissance of a very rugged mountain area at the headwaters of the Kitlope River made."

◼ A.C. Pollard surveying the aftermath of the forest fire at Pondosy Lake. BC Archives I-58856

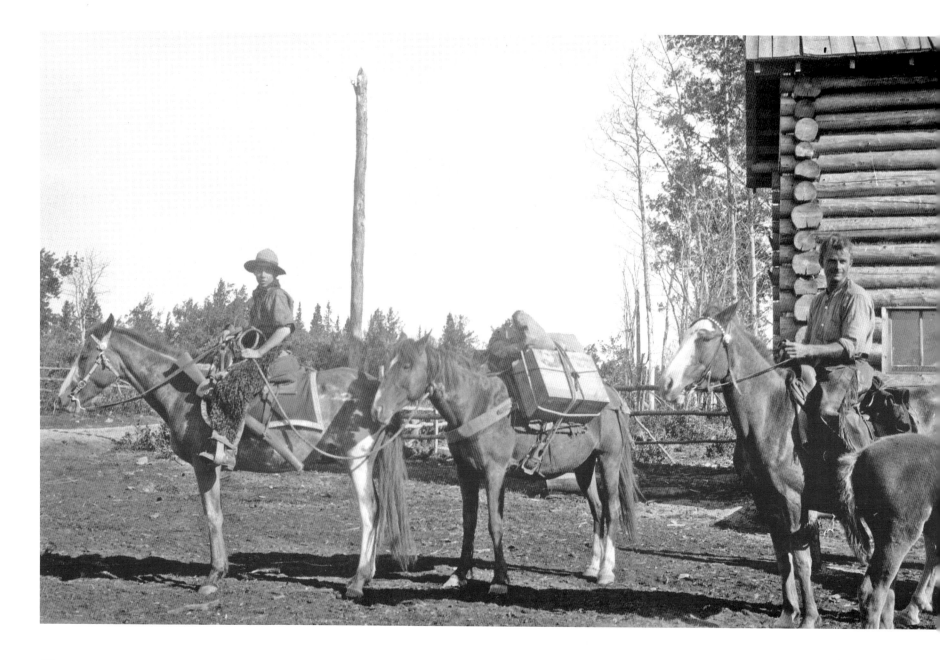

Jimmy Morgan (left) and Charles Musclow ready to start the pack train for Nadina. When Morgan was a year old, his family travelled by horse over a hundred miles of trails from Bella Coola to Ootsa Lake where they had acquired land for a farm. In later years, he worked as a forest ranger in the Telegraph Creek region and with Tommy Walker. Morgan appears in the books, *Spatsizi* by Tommy Walker, *Notes from the Century Before* by Edward Hoagland, and *In the Land of the Red Goat* by Bob Henderson.
BC Archives I-58847

More importantly, Swannell had enough survey stations and calculations to know that the survey network that he was developing was accurate. He was now able to calculate distances between some of the major survey stations through two different triangulations, and have the distances agree very precisely. In his government report Swannell provided some examples to the Surveyor-General, including two large triangulation networks, Whitesail-Eutsuk and Ootsa, which could be used to measure the distance between Rhine Crag and Stoney Mountain.

The 1920-21 work fixed three points commanding the plateau east of the Coast Range; these points marked by large cairns are: Rhine Crag (altitude 6,312 feet), at the east end of Tahtsa Lake; Mount Wells, south of the west end of Ootsa Lake; and Mount Swannell, in the Fawnie Range south of Natalkus Lake. By erecting cairns on Nadina and Uncha Mountains we bridged the gap to Mount Fulton. Three main bases and three check-bases were used. The Eutsuk triangulation extended by a base measured by the Geological Survey gave a value of 63,000.3 feet for the distance

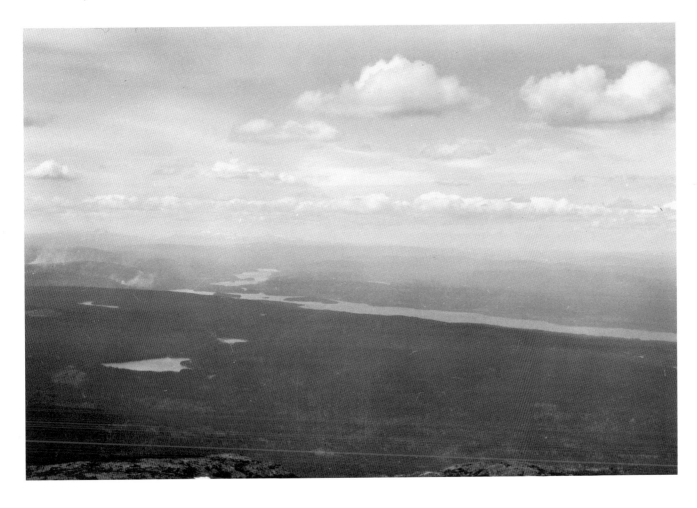

Looking over Chelaslie Lake from Swannell Mountain. (See page 168 for a comparison photograph taken in 2005.) BC Archives I-58824

Arete Peak · Δ23 Whitesail Lake. Expanding my Whitesail base westward, I obtained a value 63,000.0; the mean of the two results was taken and expanded to the large triangle Chikamin Peak–Rhine Crag-Mount Wells (Stoney Mountain), whose shortest side is 24 miles. Working down to the Tahtsa Lake triangulation, we got a value of 36,590 feet for the distance between Rhine Crag and Huckleberry Mountain. The Tahtsa Lake base gave 36,591 as the value of this distance. These agreements are satisfactory, especially as owing to the mountainous country the bases were far too short. The distance Rhine Crag-Mount Wells, as obtained by the Whitesail-Eutsuk triangulation

is 179,611 feet. The Ootsa Lake triangulation, based on the Geological Survey base at Ootsa Lake Post-office gives 179,615 feet. This is an error of 4 feet in 34 miles.

Swannell's ability to achieve such a high degree of accuracy in triangles that extended several miles was remarkable considering the rugged terrain in which he worked and the basic surveying equipment he was using. Through careful surveying, ties to as many locations as possible at each station, and the hard work of his crew members Swannell was able to minimize the amount of error in his triangulation surveys.

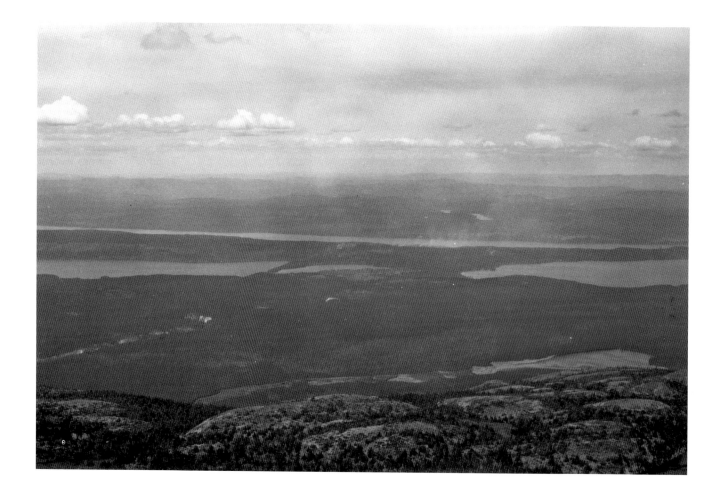

Looking over Natalkuz Lake from Swannell Mountain. (See page 168 for a comparison photograph taken in 2005.) BC Archives I-58825

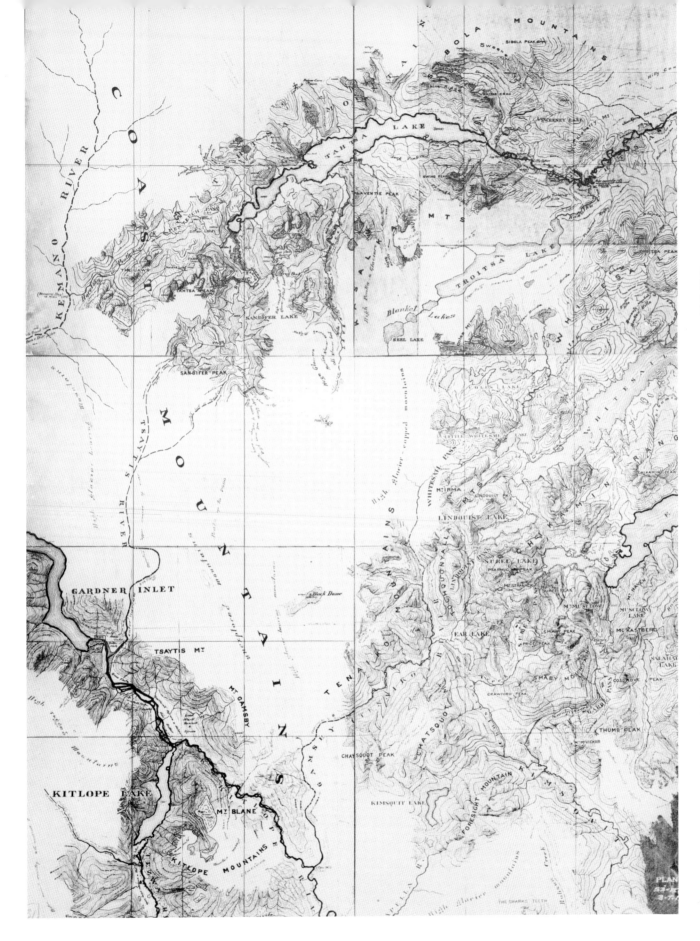

In 1922, R.P.Bishop began surveying in the Chilcotin, doing a triangulation of Chilko Lake and the nearby area. He investigated the feasibility of enabling "the great storage capacity of that lake to be used for the generation of water-power." Bishop concluded that, "owing to the length of tunnel necessary to make use of this head of water, any scheme to develop it may lie outside the realm of practical politics for the present, but it will in all probability be used eventually." He went on to observe that, "The industrial development of this Coast will depend more and more on water-power, especially as recent authoritative reports on the subject show that electrical smelting of iron ores is economically possible on this Coast, provided that a sufficiently large supply of cheap power can be obtained. It seems within the bounds of possibility that, whereas England attained industrial supremacy on the Atlantic by reason of her deposits of coal and iron, this country may rise to a similar position on the Pacific by reason of her supply of 'l'houille blanche'."

Tremblay Lake Joe was a well-known First Nations man who lived at Trembleur Lake at the mouth of the Middle River. Swannell had met him on the Stuart River waterway several times during his surveys before World War I. In 1909 Tremblay Lake Joe guided Swannell's canoe through the Grand Rapids on the Tachie River, and in 1911 Swannell took a series of photographs of him and his family at Trembleur Lake. BC Archives I-33195

1923

Having triangulated the lakes of the Great Circle route, Swannell was next expected to complete a survey of the area inside the boundary formed by these waters. The Surveyor-General also wanted Swannell to make a survey of Troitsa Lake and the adjacent area during 1923. This would complete the mapping of the land between Tahtsa and Whitesail Lakes, directly west of the Great Circle route. Umbach's third directive was to "tie in triangulation stations Nadina and Uncha to stations Fulton and Taltapin," which Swannell had been unable to complete in 1922 because of the prolonged smoke from forest fires. In addition, Umbach wanted Swannell to go to northern BC to make a few small surveys that would complete the triangulation network around Bishop's survey of the 55th parallel. This provided Swannell an opportunity to return to the area where he had surveyed before World War I. Most important, it enabled him to again meet some of the people he knew, and to take some outstanding photographs.

A.C. Pollard was Swannell's assistant for the third year. Jimmy Morgan also returned. C.A. Goodrich was the cook, Harry McLean the canoeman, and Michael Fenton the packer. Jack Michel from the Cheslatta Reserve and Bill Henson from Ootsa Lake were on the crew for part of the summer. Swannell and Goodrich left Victoria on June 6 and travelled to Vancouver where they boarded the SS *Prince Rupert*. D.B. Morkill and some of his survey crew were also on the ship. Swannell spent a day in Prince Rupert where he visited Pat Sharkey and went to a watchmaker to get his chronometer (the timepiece that he used to help determine longitude) repaired. Then he travelled by train to Burns Lake where he spent part of Sunday with Schjelderup and picked up Harry McLean before heading to Francois Lake. On Monday, June 11 Swannell went down Francois Lake "looking for a good mountain to cut in Taltapin from. All hills down lake timbered & flat on summits." The next day they headed to Ootsa Lake, "arriving at Bennett's noon. Meet Chief Louis & klootch at the landing." Swannell had met Chief Louis of the Cheslatta in 1910 and in 1911 when he surveyed reserves at Cheslatta Lake.

Swannell spent a couple days at Ootsa Lake getting his supplies and equipment organized before leaving for Eutsuk Lake. On the Whitesail River they saw a "bear out on bar near Big Eddy … swims river – try to lasso him. Reach Whitesail-Eutsuk Portage 3pm & meet Mikkelson, Grell & Vantine, who help us across." After sleeping at Shorty Grell's cabin that night, Swannell's crew spent three days at Eutsuk Lake. One day they surveyed a First Nations trail that ran north from Eutsuk Lake at Sand Cabin. Another day Swannell and Harry McLean climbed Eutsuk Mt., the highest peak on the south side of the land inside the Great Circle. "Build large cairn & take topo." Then they returned to Ootsa Lake. Swannell wrote that it was "gruelling work 3 men carrying large canoe across at the portage."

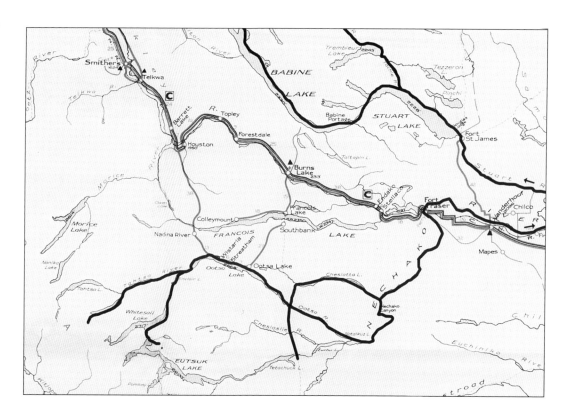

Swannell's survey route in 1923. The arrows show the route to Takla and Babine lakes. Detail from BC Archives CM/C/178

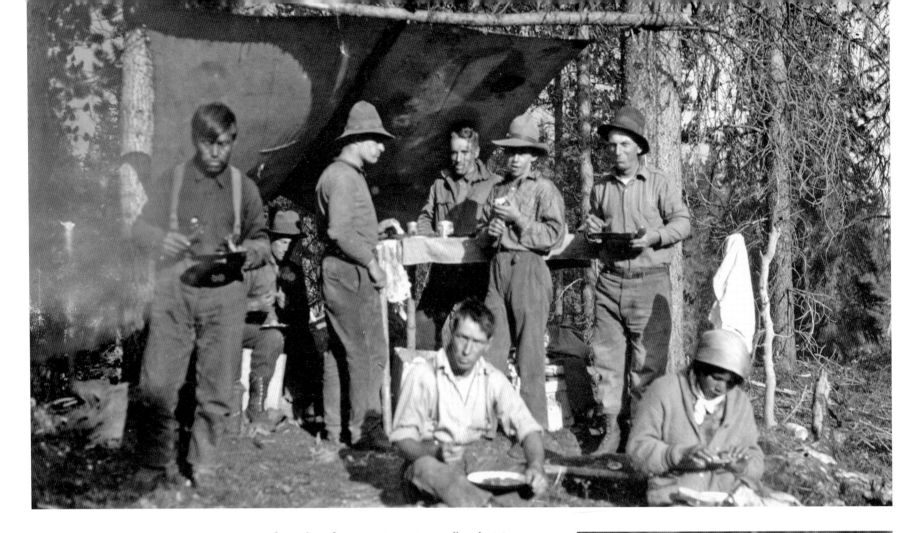

Pollard's crew camping beside the Chelaslie River. Bill Henson and Jack Michel's wife are sitting on the ground. Standing, from left to right, are Jack Michel, Mike Fenton, A.C. Pollard, Jimmy Morgan and C.A. Goodrich. Harry McLean is seated behind them. BC Archives I-33633

Right: Jack Michel's wife and her baby at a campsite on the St Thomas trail. BC Archives I-68542

After a day of preparations, Swannell and McLean headed east down Ootsa Lake in the late afternoon of June 21. "Leave with heavy canoe load – reaching foot of lake in three hours & camping. Find one Capper – reputed U.S. Officer there with one horse – evidently delate cheechako [truly inexperienced]." After they set a survey station above One Eye Lake the pack train arrived. "Packtrain 5 horses reaches Ootsa Crossing 9pm – Swim horses across after considerable difficulty – nearly 1/4 mile swim." Pollard arrived at Ootsa Lake on June 24 where Swannell and McLean picked him up at Bennett's. When they returned to camp at the foot of Ootsa Lake late that evening they found "One Eye's crowd camped here, who potlatch us a leg of moose – in very high condition." While Swannell read triangulation stations from the tops of the hill, Pollard traversed the First Nations trail that ran from Ootsa Lake to the Chelaslie River and Cheslaslie Lake. "Take Capper & horse across Chelaslie R." The next day, from their camp at the head of Chelaslie Lake, Swannell left at "6 am & run cache to TetaChuck & cross Capper."

Swannell left Pollard with part of the crew to survey the Cheslaslie drainage while he and MacLean surveyed the Nechako River down to the Grand Canon and climbed Cut-Off Bluff. One day "Harry misses big buck.

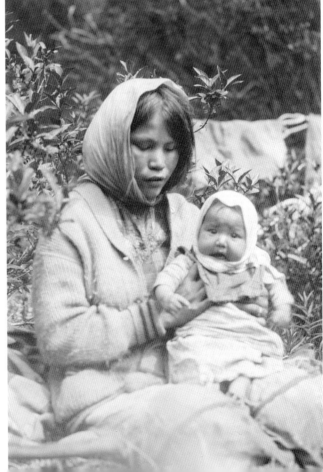

Bannock, beans & rice for supper." By July 5 Swannell and McLean had finished their traverse on the Nechako River. "Reach TetaChuck crossing 5 pm & find that feckless youth Capper marooned here having lost his horse." They celebrated July 6 as Dominion Day, reached Ootsa Lake on the following day, and on Sunday, July 8 arrived "at Bennett's for breakfast." Most of the next week was spent along Whitesail Lake surveying the western end of the land inside the Great Circle. In his entry for July 14 Swannell estimated his "seasons totals to date – by canoe 752 miles, car 220 miles, backpack 11 miles, packtrain 46 miles."

Swannell then went back to check on Pollard's surveying. On July 18 he left "Ootsa Crossing 7 am with Siwash Michel & 2 pack horses & 1 saddle horse. Reach Pollard's camp on Chelaslie River 4 pm. By packtrain 18 miles. Canoe 2 miles. Hrs. travel 9. Michel's squaw

a young girl – had been an orphan and brought up 'anyhow' – Michel says – Dat girl just be all same coyote – no blankets – no nothing – first time I catchem – He all light now. Me I school'm." After spending a day with Pollard, Swannell was ready to take McLean and go to northern BC to do the surveys Umbach wanted there.

Swannell returned to Bennett's where he spent July 21, before going down the lake to Knox's place in the evening. The next day he left "Ootsa Lake with Knox's wagon 6 am reaching Cheslatta 3:30 pm 13 miles very rough road. Run length of Cheslatta lake, stopping at I.R. 3 to see Chief Louis." The next day "by 3:00 get canoe down Cheslatta Creek smashing 3 holes in her in the rapids. Portage 150 yds down into the Nechako, snubbing with rope down the steep descent. Camp at Cheslatta Falls." On July 24 Swannell and McLean started down the Nechako River. "Break camp 7 am, reaching Fort Fraser

■ The survey team's freight wagon loaded with a canoe. Knox (right) is taking McLean along with Swannell and their equipment on the trail between Ootsa and Cheslatta lakes. Swannell first travelled on this trail in 1910 at the beginning of his Great Circle trip.
BC Archives I-58420

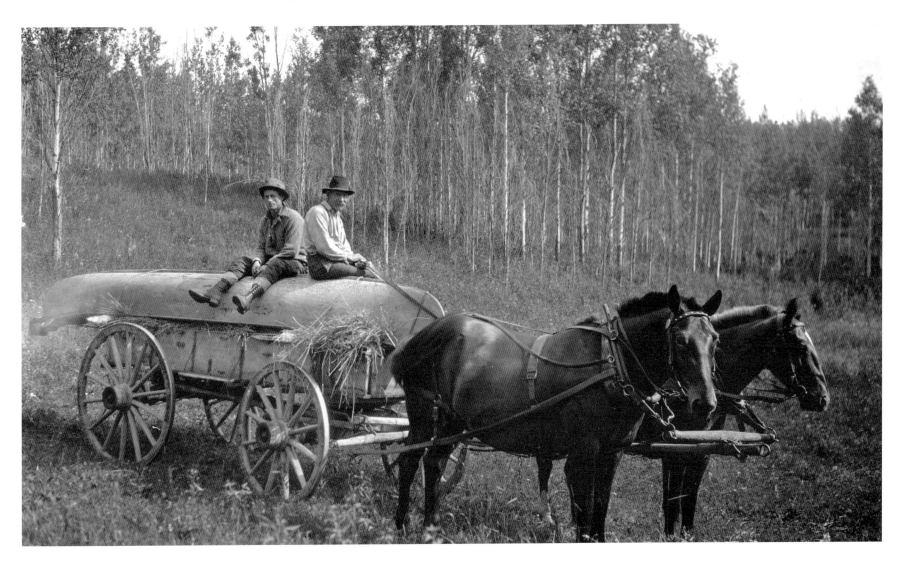

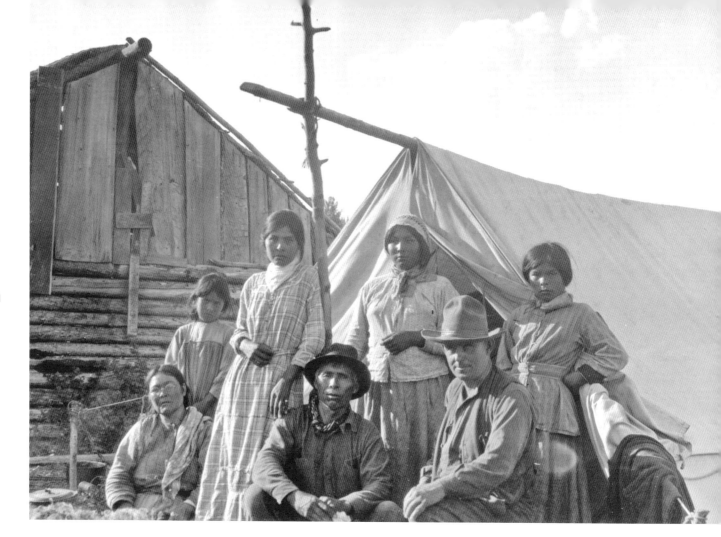

■ Chief Louis and family. Well-known in the region, Chief Louis was leader of the Cheslatta people for many years. Swannell photographed him and his family in 1910 and 1911 while surveying some of the Cheslatta reserves. BC Archives G-03731

■ *Below*: Portaging down a cataract on the Cheslatta River. BC Archives H-02586

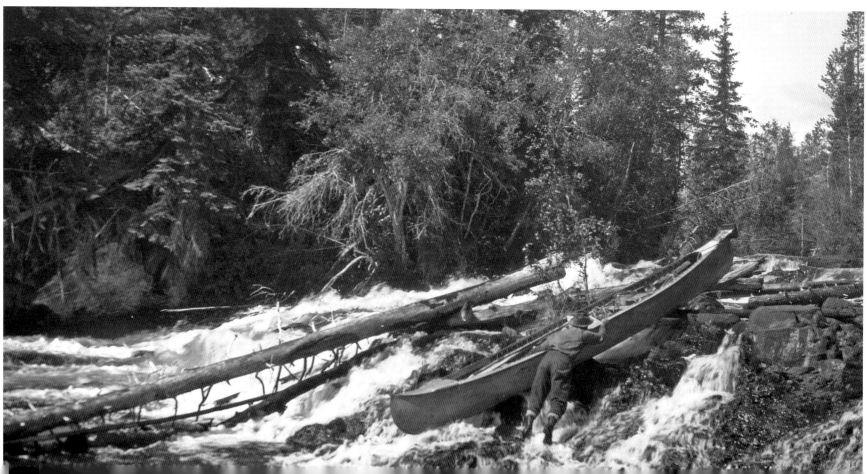

1:30 pm. At canyon 24 miles up eddy and whirlpools very bad – ship much water. At next canyon narrowly missed point of rock island. When MacAllan, Indian Agent, recognizes me he dashes wildly up hill yelling 'get ice Sheldon'. Much presence of mind for on reaching the cabin we discern beer bottles bobbing in a bucket of iced water." Swannell had first met William MacAllan during his 1908 surveys when MacAllan was operator at the Yukon Telegraph Trail cabin at Bobtail Lake. After he became the Indian Agent, MacAllan accompanied Swannell on his survey of the reserves at Bear Lake in 1911.

The next day in the early morning they arrived at Vanderhoof, where Swannell visited friends, including Mrs. Alf O'Meara, the wife of one of his former crew members. Continuing down the Nechako River, they stopped at Hulatt, one of the communities along the railroad, to repair their outboard motor engine. Twelve miles up the Stuart River Swannell and McLean found a "scow across a boulder in midstream with road foreman Christian, Ericksen & Jim Tong aboard. Get them ashore and take one man with us." The next afternoon their engine broke down and they had to spend a day and a half paddling and poling to Fort St. James.

■ *Left*: Dorothy O'Meara, wife of Alf O'Meara, one of Swannell's former crew members, at her family home near Vanderhoof. BC Archives I-57143

■ *Below*: Milne's Landing was a community on the Nechako River when Swannell first came through in 1908. By 1923 most of the people had moved to Vanderhoof, a village that developed nearby along the railroad. BC Archives I-33974

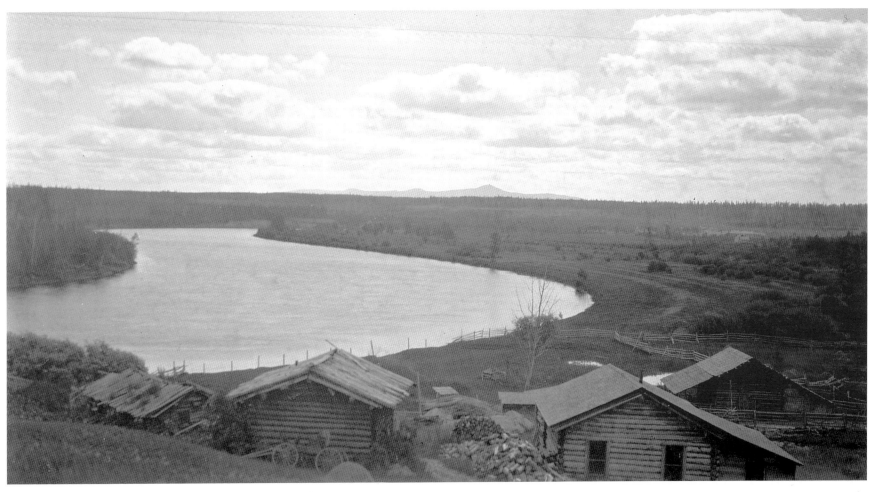

Settlers clearing on the Stuart River, near the farming community of Chilco. BC Archives I-58915

Below: Sam Cocker's ranch, north of Vanderhoof, across the Nechako River. Cocker (left) was a well-known pioneer settler in the area. Harry McLean stands beside him. BC Archives I-57117

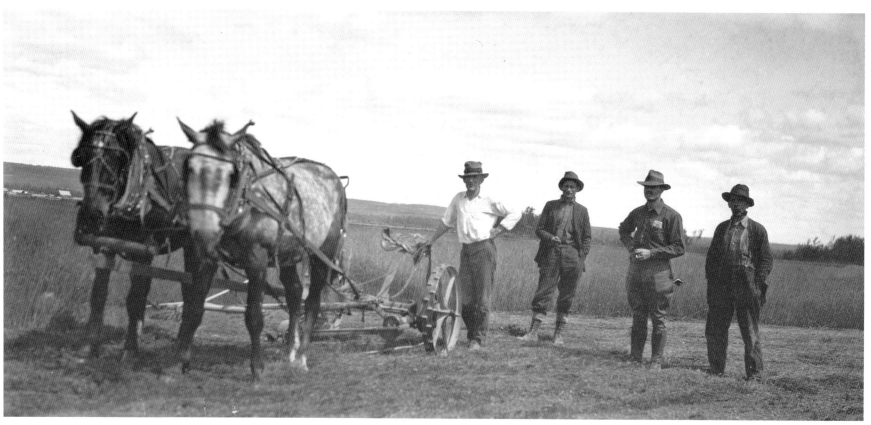

Swannell was stormbound at Fort St. James on July 29 and 30. Twelve years earlier he had spent the same days of the summer at Fort St. James in similar conditions. A.C. Murray, the factor at the Hudson's Bay Company store in 1911, was still in charge of the post. However, the Bay was no longer the primary source of commerce, for a new community was developing on the shores of Stuart Lake and other businesses were being established. In 1911 Swannell and his survey crew had organized a sports day at the Fort while they were stormbound, but no event like that occurred while he was there in 1923. At Fort St. James, Swannell visited Lawrence Dickinson, one of his pre-World War I crew members, who had established a business in the community.

On July 30 Swannell got "supplies at HBCo, borrow old Murrays engine & ship ours out. Leave 7 pm & travel 6 miles, camping under limestone cliff at dark. Very bad sea." Swannell was at the base of Mount Pope, the mountain where he began his exploratory survey of northern BC in 1912. He also surveyed from this peak at the beginning of his 1913 field season.

On July 31 Swannell and McLean journeyed up Stuart Lake and the waterways to the crossing of the 55th parallel on the Middle River. He estimated that they travelled 55 miles. The outboard engine made it possible to cover much more distance than the pre-war years when

◼ *Left*: Fort St James, 1923. The fence around the Hudson's Bay Company post had been taken down since Swannell's last visit in 1914. The fourth building from the left is the Men's House where Swannell stayed when he visited Fort St James between 1909 and 1914. Stuart Lake is to the left of the picture. Library and Archives Canada E008222006

◼ *Left*: Bear cub swimming in Middle River. BC Archives I-58890

◼ *Below*: Dave Hoy (centre), his wife and Harry McLean, near Pinchi. Swannell first met Hoy in the Nechako River valley in 1909. By 1923 Dave had married and moved to Fort St James where he operated a freighting business for many years. He had some scows that travelled between Fort St James and the head of Takla Lake. BC Archives I-57157

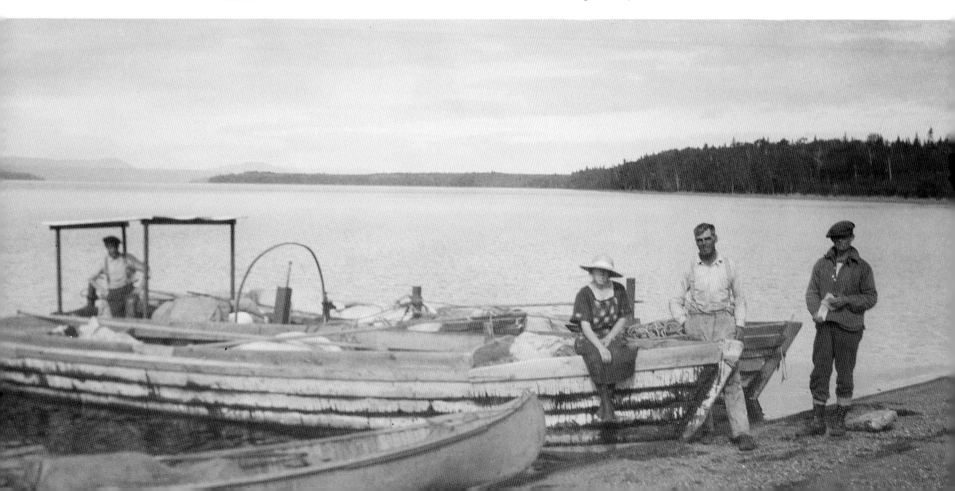

Plughat Tom's Potlatch

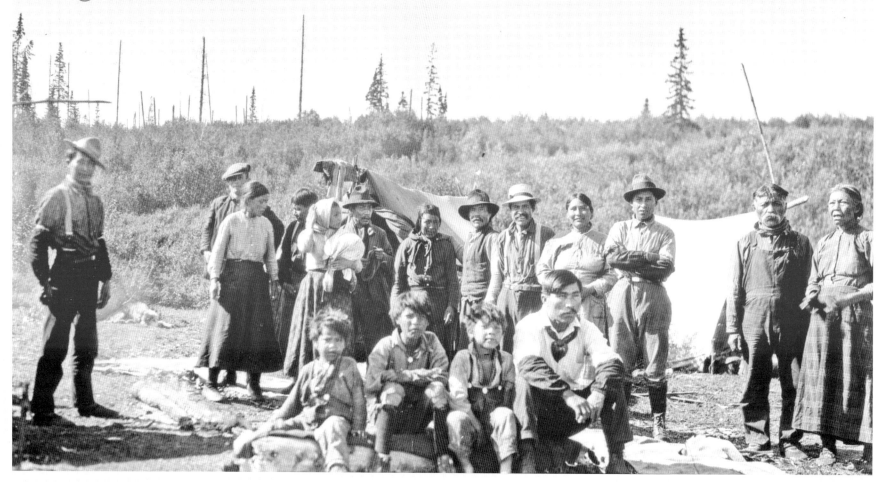

■ *Above*: Some of the people who gathered for Plughat Tom's potlatch at Takla Lake. Plughat Tom and his wife are on the far right. Before World War I, Plughat Tom transported Father Coccola on his summer ministries from Fort St James to Bear Lake. Swannell rented the "priest's canoe" from Plughat Tom for a month in 1913 while he was surveying along Takla Lake. BC Archives G-06642

■ *Facing page, above*: Plughat Tom and others preparing for the potlatch. BC Archives G-03745

■ *Facing page, below*: The woman standing has berries for the potlatch. BC Archives I-33202

Swannell was stormbound at Fort St. James on July 29 and 30. Twelve years earlier he had spent the same days of the summer at Fort St. James in similar conditions. A.C. Murray, the factor at the Hudson's Bay Company store in 1911, was still in charge of the post. However, the Bay was no longer the primary source of commerce, for a new community was developing on the shores of Stuart Lake and other businesses were being established. In 1911 Swannell and his survey crew had organized a sports day at the Fort while they were stormbound, but no event like that occurred while he was there in 1923. At Fort St. James, Swannell visited Lawrence Dickinson, one of his pre-World War I crew members, who had established a business in the community.

On July 30 Swannell got "supplies at HBCo, borrow old Murrays engine & ship ours out. Leave 7 pm & travel 6 miles, camping under limestone cliff at dark. Very bad sea." Swannell was at the base of Mount Pope, the mountain where he began his exploratory survey of northern BC in 1912. He also surveyed from this peak at the beginning of his 1913 field season.

On July 31 Swannell and McLean journeyed up Stuart Lake and the waterways to the crossing of the 55th parallel on the Middle River. He estimated that they travelled 55 miles. The outboard engine made it possible to cover much more distance than the pre-war years when

■ *Left*: Fort St James, 1923. The fence around the Hudson's Bay Company post had been taken down since Swannell's last visit in 1914. The fourth building from the left is the Men's House where Swannell stayed when he visited Fort St James between 1909 and 1914. Stuart Lake is to the left of the picture. Library and Archives Canada E008222006

■ *Left*: Bear cub swimming in Middle River. BC Archives I-58890

■ *Below*: Dave Hoy (centre), his wife and Harry McLean, near Pinchi. Swannell first met Hoy in the Nechako River valley in 1909. By 1923 Dave had married and moved to Fort St James where he operated a freighting business for many years. He had some scows that travelled between Fort St James and the head of Takla Lake. BC Archives I-57157

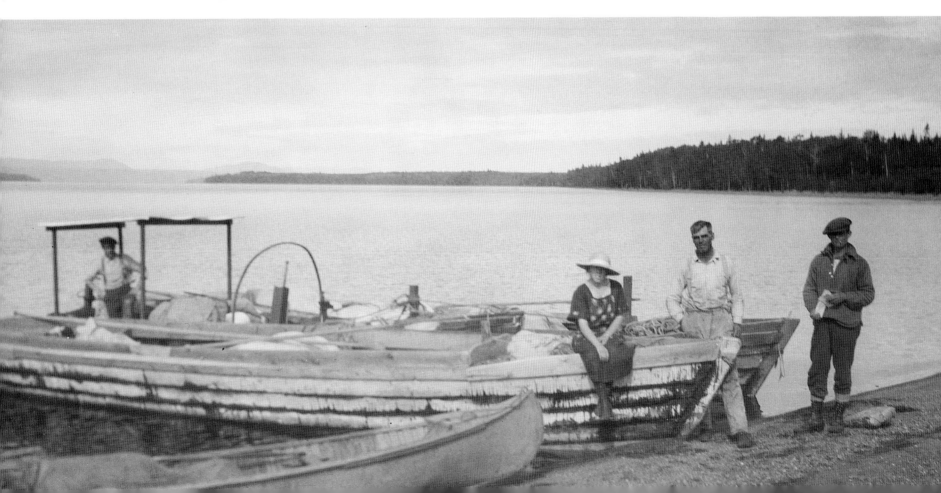

Plughat Tom's Potlatch

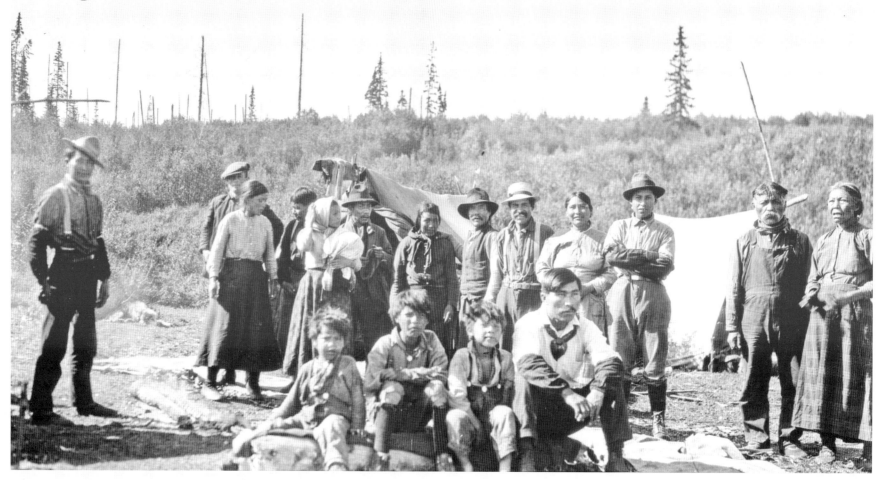

■ *Above*: Some of the people who gathered for Plughat Tom's potlatch at Takla Lake. Plughat Tom and his wife are on the far right. Before World War I, Plughat Tom transported Father Coccola on his summer ministries from Fort St James to Bear Lake. Swannell rented the "priest's canoe" from Plughat Tom for a month in 1913 while he was surveying along Takla Lake. BC Archives G-06642

■ *Facing page, above*: Plughat Tom and others preparing for the potlatch. BC Archives G-03745

■ *Facing page, below*: The woman standing has berries for the potlatch. BC Archives I-33202

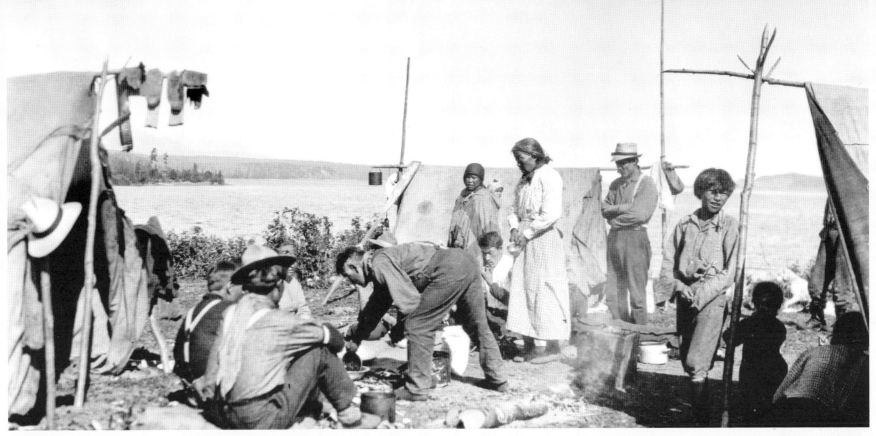

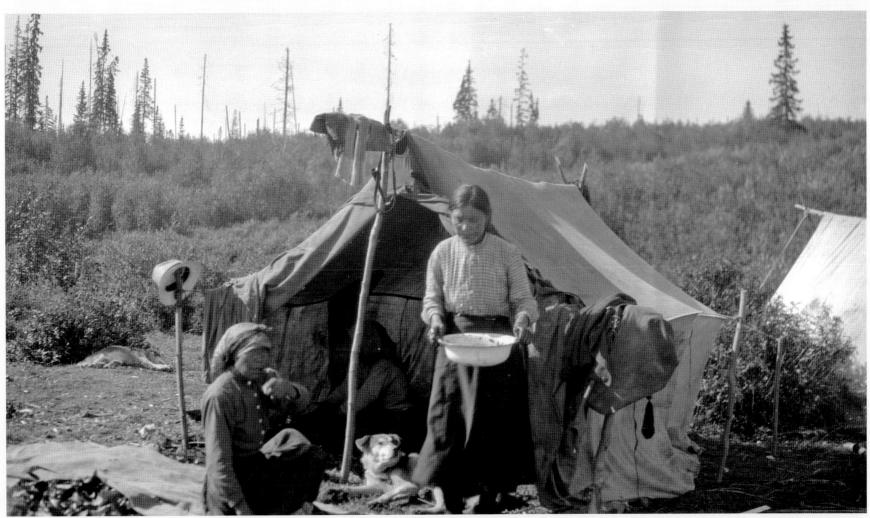

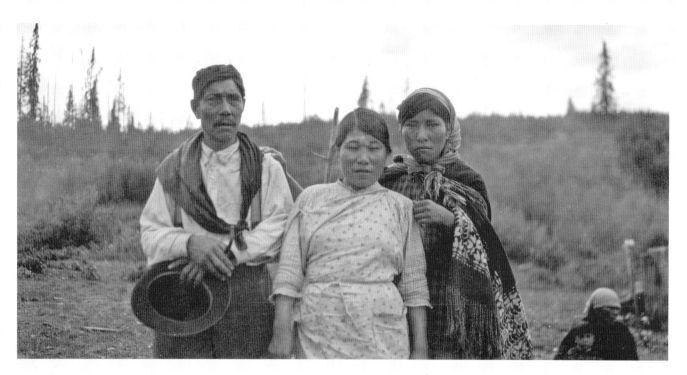

■ Daniel Teegee and family at Takla Lake. Swannell had met Teegee several times while surveying in the area before World War I. Teegee appears in the book *Driftwood Valley* by Theodora C. Stanwell-Fletcher. His daughter, Madeline (centre), married Johnny French. BC Archives I-33194

■ *Below*: On the far right is Johnny French from Bulkley House. Johnny is mentioned several times in *Driftwood Valley*. BC Archives I-68544

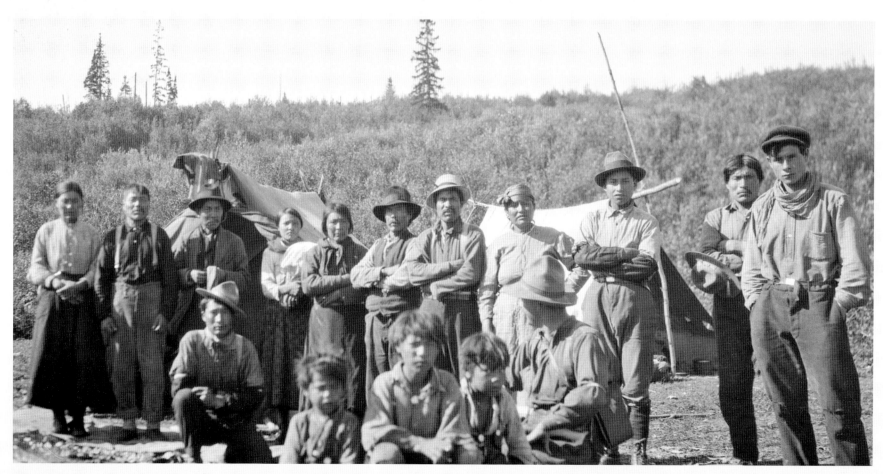

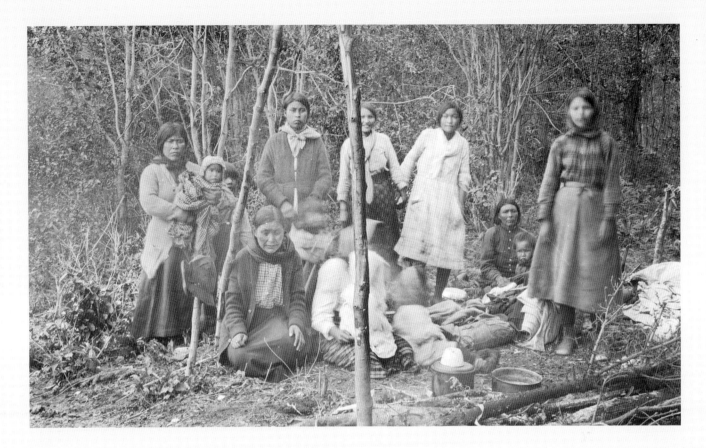

■ Women from Bear Lake. Plughat Tom was originally from Bear Lake, so many First Peoples from that area travelled to Takla Lake for the potlatch. When Swannell visited Bear Lake in 1911, he photographed a group of women then, too.
BC Archives I-68545

■ *Below*: An obviously happy Frank Swannell (fourth from the left) is surrounded by friends: Bear Lake William (who he first met in 1911) on his right, Plughat Tom on his left and Daniel Teegee in front of Plughat Tom.
BC Archives I-33201

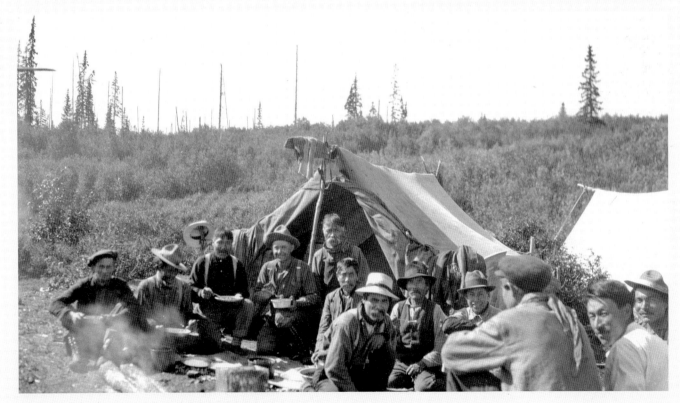

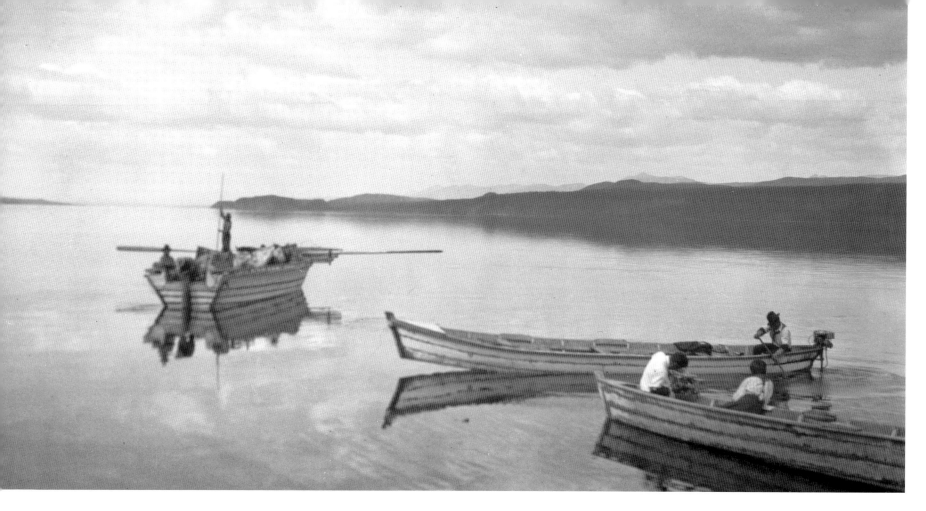

The ferry across Takla Lake between West Landing and Takla Landing. It was part of the historic route from Hazelton to the mining community of Manson Creek. The ferry transports some horses on this run. BC Archives I-33785

Swannell and his surveyors canoed up these rivers and lakes. The next morning they reached Takla Lake, stopping when they arrived at the trail to the Nation Lakes. Swannell had followed this trail during his 1912 survey of the area. "Spend afternoon re-setting old signals. Take photos of black bear and cub swimming river – old lady cuffs cub hard on reaching shore." The next day they packed "transit 5 miles back on Nation Trail and find Nation Mt. not visible from Burnt Hill. Very heavy rainstorm 2 pm lasting rest of day and gale of wind. Get to beach 5 pm drenched and perished with cold. So chilled we cannot knot a rope, hold an axe & without gasoline would have found it next to impossible to get a fire started." The following morning the weather was still bad so Swannell and McLean decided to continue up the lake to the East Landing of Takla Lake.

On August 4 Swannell and McLean participated in a special ceremony across Takla Lake. "Potlatch taken in by us at West Landing, as guests of Daniel Teegee, Plughat Tom, Bear Lake William & sundry Sikannie. Fine sunny day." Although the federal government had declared potlatches illegal, in remote areas like Takla Lake it was unlikely that anyone would prosecute the First Nations people for continuing to celebrate this important part of their culture. Plughat Tom, a prominent First Nations person from Bear Lake, was hosting the potlatch, and

many people from Bear Lake had come to Takla for this event. Swannell knew Plughat Tom, Daniel Teegee and Bear Lake William from his surveying in the area so he and McLean were invited to the potlatch.

During the next week Swannell, McLean and a couple of First Nations people he hired temporarily did some triangulation and traverse surveys around Takla Lake. Swannell tied into a few of the triangulation stations that he set in 1912, and some of the stations Bishop made during his 1920 and 1921 surveys. Smoke from forest fires made it difficult for Swannell to get all the readings that he wanted. When he finished the surveys around Takla Lake, Swannell returned to Fort St. James for a couple of days before going back up to Stuart Lake. This time, instead of heading up the waterways, he stopped at Tachie, picked up some supplies, and went to Portage, where he took the trail that connected Stuart and Babine lakes. On August 17 Swannell and McLean left at 6:30 and "got wagon at Portage and are across by 2 pm, and push on 18 miles up Babine Lake." By August 19 they reached the arm of Babine Lake that led to Morrison Lake and spent the next day packing goods and equipment to the lake. Swannell and McLean set out a base line at the hatchery on the lake and spent the rest of August triangulating Morrison Lake.

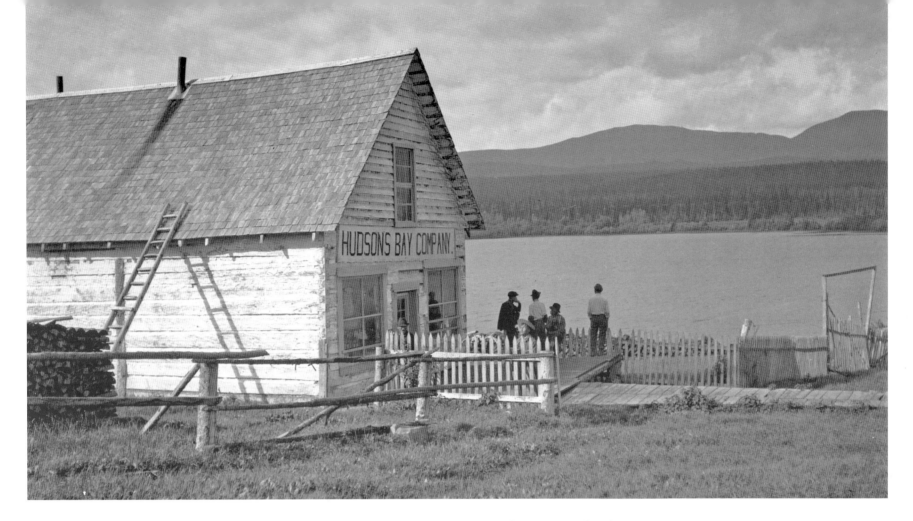

On September 1 Swannell and McLean packed back to Babine Lake and travelled down to the Hudson's Bay Company post at the lake outlet where they camped "in HBCo cabin. Evening at Fort with Walter Aiken [the HBC Factor]." Swannell had travelled with Daniel Teegee from West Landing to Fort Babine in 1913 to purchase supplies before he started his surveying in the Omineca Mountains. The next day was Sunday. "Saw Indian school-teacher Morrisey and was introduced to the Chief Daniel Leon. Get syllabic prayer book, snowshoes and flintlock trade musket. In afternoon go 8 miles down river with Walter Aiken & Hearn [the superintendent of the Morrison Lake hatchery] – in view of the impending potlatch not welcome at the salmon smokehouses. Salmon plentiful – 2 men get 540 spring salmon one afternoon. Catch one trout 1 1/2 lbs. Spend evening at Fort – Hell to pay in the cabins – Geordie on the rampage with 2 bottles of peppermint – Fights with Jansson." Since Swannell did not know the First Nations people at Fort Babine he was not invited to their potlatch. Although there is no photographic record of this ceremony, Swannell did take some pictures of the salmon fishery.

Swannell spent a couple days surveying around Fort Babine before heading down Babine Lake. On September 6 he was back at "Portage at 1 pm and arrange with Chief John to take outfit across to Yakutche in wagon. Arrive after dark at 9 pm and stop at Hatchery." During the next week Swannell did some surveys around Tachie on Stuart Lake and then travelled back to Ootsa Lake. In his report to Umbach, Swannell commented about his travels on the waterways of central and northern BC.

> While my assistant, A.C. Pollard, BCLS, was making the triangulation and traverse control for the map of the St. Thomas Lake country, I with one man, took a canoe overland from Ootsa to Cheslatta Lake, and thence to and down the Nechako, up the Stuart River, and into Stuart, Trembleur, Takla, and Babine Lakes. This was done in connection with the triangulation of part of Takla Lake to complete the survey of the 55th parallel and the triangulation of Morrison Lake. I mention this trip to point out the wonderful system of natural waterways in the Northern Interior. We travelled altogether 1,800 miles by canoe in the course of executing various scattered surveys between Whitesail Lake and Takla and Babine Lakes. The only portages were 13 miles by wagon from Ootsa to Cheslatta Lakes, 250 yards at the falls of Cheslatta River, and 9 miles by wagon between Stuart and Babine Lakes.

■ The Hudson's Bay Company trading post at Fort Babine was one of the few remaining after World War I. The company built this particular store after 1913 when Swannell had visited Fort Babine with Daniel Teegee. The abandoned post found at Fort Babine today was built later. BC Archives I-33788

Fort Babine and the Salmon Fishery

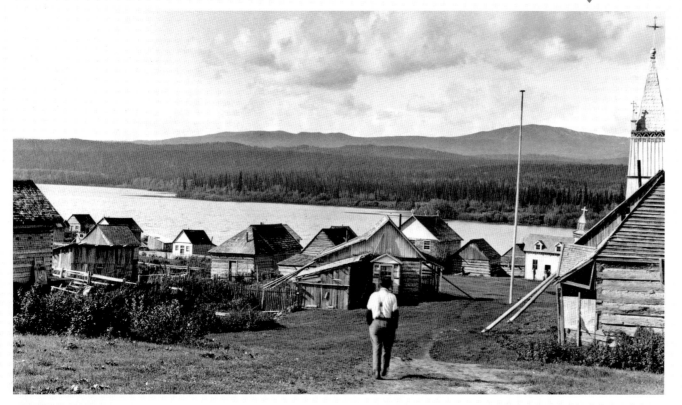

■ Fort Babine. The church is the only building still left from 1923, though it has had some alterations since then. Swannell's photographs of the village show that there were more houses at Fort Babine in 1923 than today. At that time the narrow side of most houses faced Babine Lake, while today the wide side of almost every house looks over the water. (See photograph on page 171.) BC Archives F-07900

■ *Below*: Babine Chief Daniel Leon sits on the right. This First Nations leader was a friend of Father Coccola and worked for the Hudson's Bay Company. He marked the Babine traplines for Indian Affairs and travelled to Ottawa to speak on behalf of his band. In 1957 Chief Daniel Leon formally met Queen Elizabeth II in Terrace. BC Archives I-33196

■ *Facing page, above*: Swannell's photographs of the Babine River salmon fishery provide an excellent record of the operation in 1923. They illustrate some of the techniques used by First Peoples as well as the size and quantity of salmon being caught. BC Archives F-07916

■ *Facing page, below*: Smoke houses in a First Nations village on Babine River. BC Archives I-33782

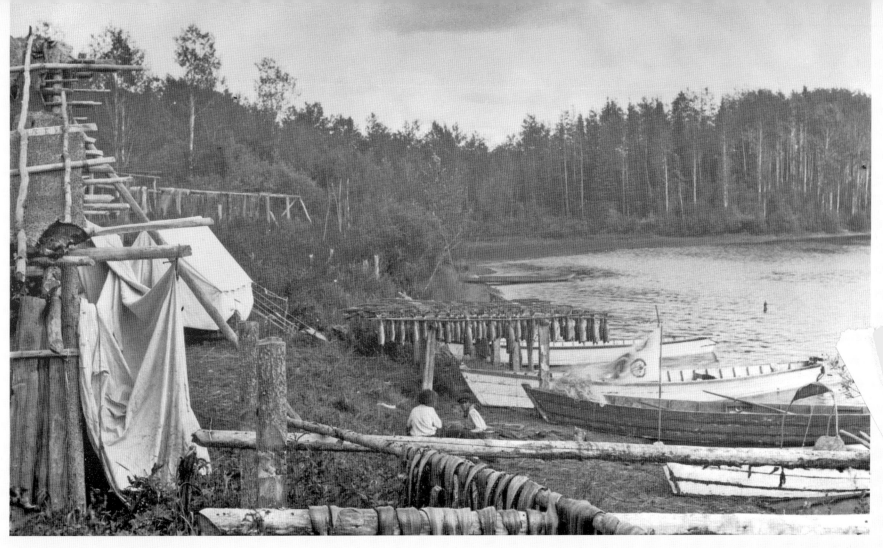
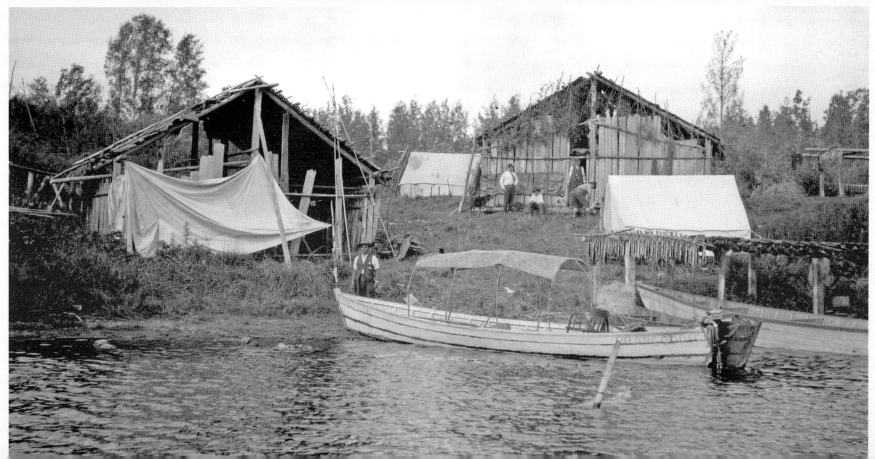

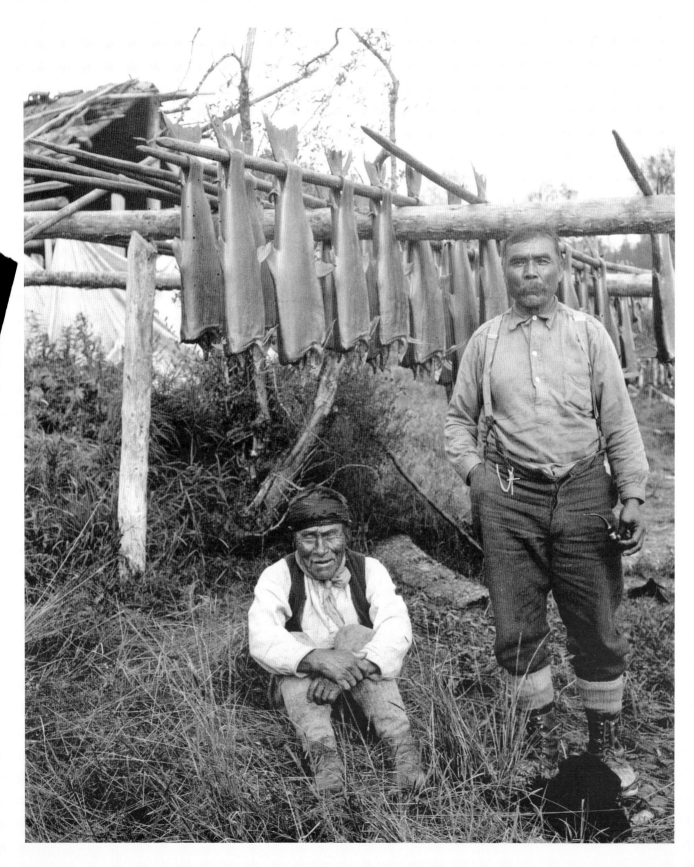

Drying spring salmon from the Babine River. Chief Old Fort Michel (right) was head of the First Nations band that lived at the original Hudson's Bay Company site on Babine Lake. He had a traditional fishing site on the river. In 1915 he made a presentation to the Indian Commissioners, emphasizing the need for a reserve along the river that was not only large enough to preserve the First Nations salmon fishery, but would also include sufficient land for firewood to smoke the fish. BC Archives I-58934

Facing page, above: Smoke houses in a First Nations village on Babine River. After the federal government banned the traditional weirs in 1910, nets became the primary method used in salmon fishing. Some of the nets being used by First Peoples at this site are draped over poles in the foreground. BC Archives I-33781

Facing page, below: First Peoples travelling on the Babine River. BC Archives I-33780

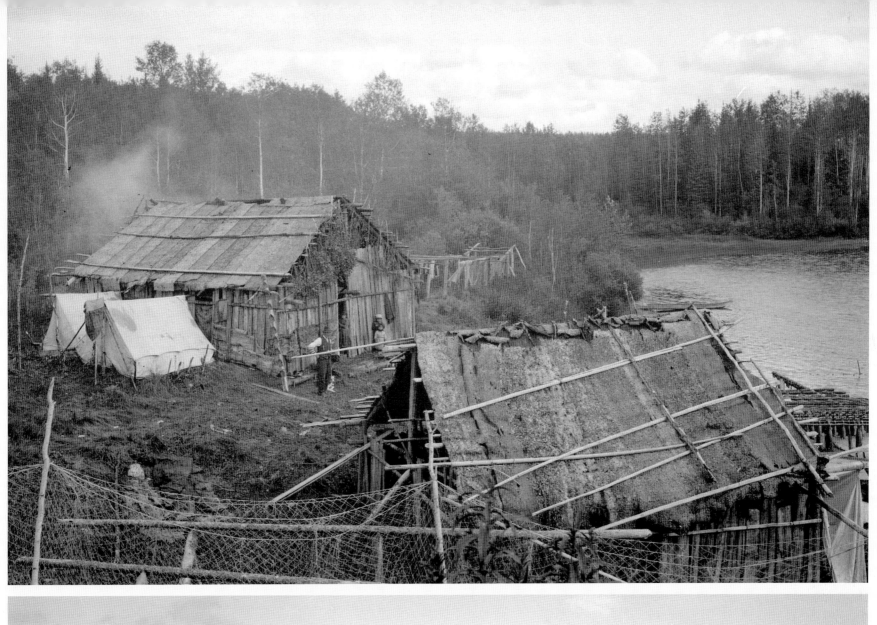

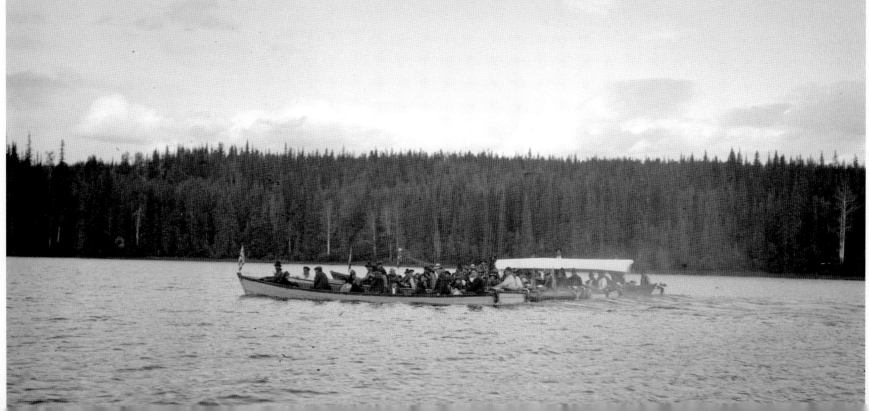

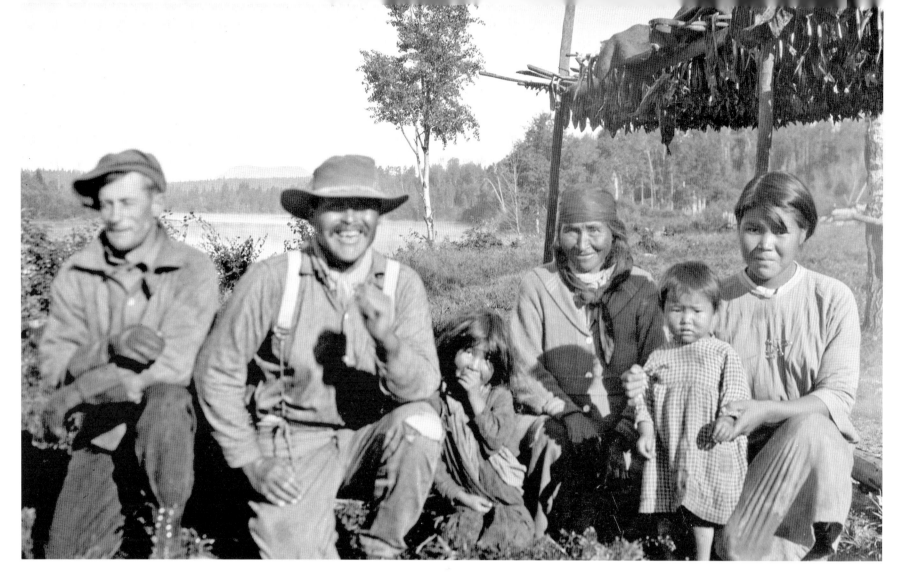

■ *Above*: A First Nations family at Kuzche with some Kokanee drying on racks. BC Archives I-68543

■ First Nations Kokanee traps on the Tachie River. BC Archives G-03737

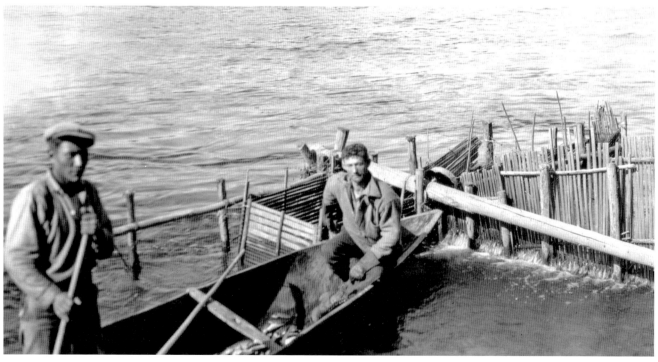

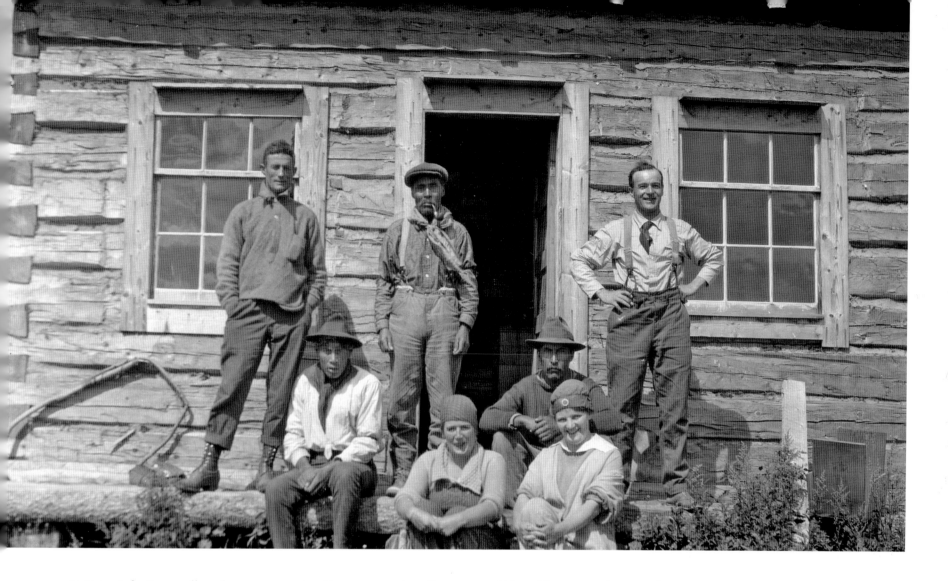

At Ootsa Lake Swannell made arrangements with the Eddings, one of the families living at the lake, to use their boat since his engine wouldn't work. By September 18 he was on the Tahtsa River "at Musclow Cabin. Run downstream to end of Troitsa Trail and pack across in 4 loads. Start to build raft but Baptiste arriving hire his canoe." The next day he travelled up Troitsa Lake to Pollard's camp. On September 20 both Swannell and Pollard worked on the triangulation of Troitsa Lake. "Cold raw miserable day – Have to light fires for warmth at stations. 2 transits, read 12 stations. 10 1/2 hrs. working, threatening snow." The next day Swannell's crew travelled to the head of Troitsa Lake. From there the men moved up to the two Blanket Lakes and surveyed them. They were close to the Coast Mountains and the weather was cold and often rainy, but Swannell's crew continued working and completed triangulating the lakes in four days. Then they moved back to Troitsa Lake and spent two days finishing the triangulation of this lake. By September 28 Swannell's crew had moved "to foot of lake and read 7 stations. Get canoe and stuff packed

2 3/4 miles across to Tahtsa River – very heavy packs. Eddings waiting with boat." The following day Swannell and Pollard climbed a hill and did one more triangulation station to complete their survey of the Troitsa Lake area. "Start down in Eddings boat 2 pm camping at 6 pm. Run 30 miles of river." They reached the Ootsa Lake Post Office in the late afternoon of the following day.

On October 1 Swannell's crew travelled to Burns Lake. There they rented a truck and headed to Houston. Pollard and Goodrich got off at Topley, heading for Fulton Mountain. Pollard was supposed to survey from Bishop's station on Fulton and tie it into as many of Swannell's stations as possible. On October 4 Swannell tried climbing Nadina Mountain, something he had planned to do the previous year but had been unable to complete because of weather. "Long pack to base & very steep climb. Summit flattens, but bad going over slides & huge blocks of rock – Visibility fiendish – smoky – never take transit out of box. Reach summit 2 pm & arrive home at Mr. LeCroix long after dark." Once again Swannell was unsuccessful in his attempt to survey from the top of Nadina, one of the prominent

▦ Ferrier's store, Tachie. Ferrier (right, standing) was a former Hudson's Bay Company employee who started a store at the First Nations village of Tachie after World War I. Tremblay Lake Joe stands in the doorways and Harry MacLean beside him. BC Archives I-33632

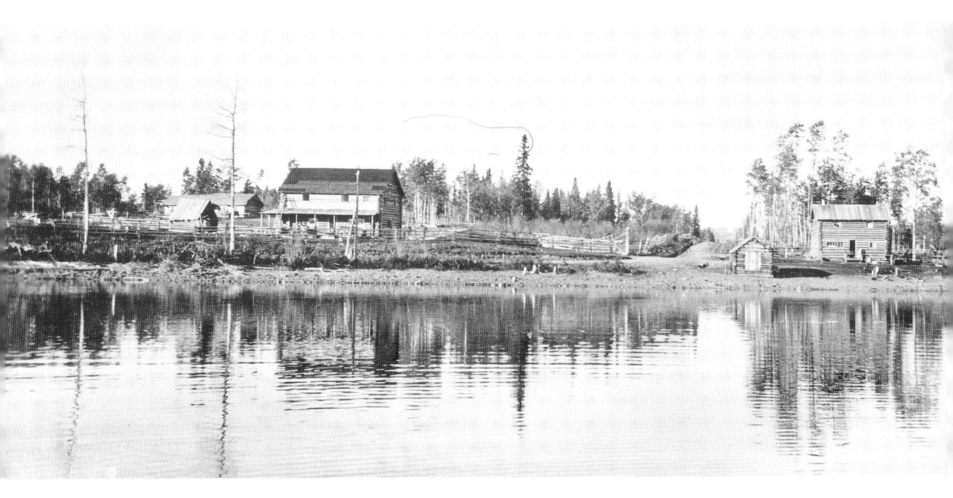

peaks of the area. Swannell and his men returned to Houston on Saturday, October 6. "Pollard and Goodrich arrive 4:30 Sunday morning – have siwashed it two nights on Fulton, Black Mts. & only got a dubious tie to Nadina."

Swannell's 1923 government report provided a "General Description of Area Within the Circle." He estimated that the area included about 1300 square miles. Swannell included a description of the Bella Coola and St. Thomas trails, and mentioned "One Eye Lake where [there] is an Indian settlement of a dozen souls, who keep a few head of horses and cattle." Swannell wrote that, "The amount of first-class farming land in the area embraced by the 'Circle' is negligible, but from the point of view of range and grazing possibilities the country offers better prospects. At present access is difficult and it is questionable whether profitable use could be made of the range lands." He noted that, "The area is a trapping preserve of the Cheslatta Indians."

After four years Swannell had completed the main part of surveying central British Columbia. He had triangulated and mapped all the lakes and waterways of the upper Nechako River; the Tahtsa drainage, the upper Nechako's largest tributary; and the land within the Great Circle. Each year he had extended his surveys up to the passes through the Coast Mountains. Swannell had made two connections between the interior and coast triangulation network. Although the ties were not as definite as he and the Surveyor-General wanted, Swannell had been able to link his network with Bishop's surveys around the 55th parallel. This was the only year between 1920 and 1928 that Swannell surveyed outside central British Columbia. His work enabled him to add his 1912 to 1914 exploratory surveys to the interior triangulation network, while the pictures that he took became an important part of his photographic record of the 1920s.

Umbach summed up the cumulative results of Swannell's work in surveying central British Columbia from 1920 to 1923. "Mr. Swannell carried on the control and reconnaissance topographic work on which he has been engaged for three previous years covering the headwaters of the Nechako River. An area of some 6,000 square miles has now been covered and a

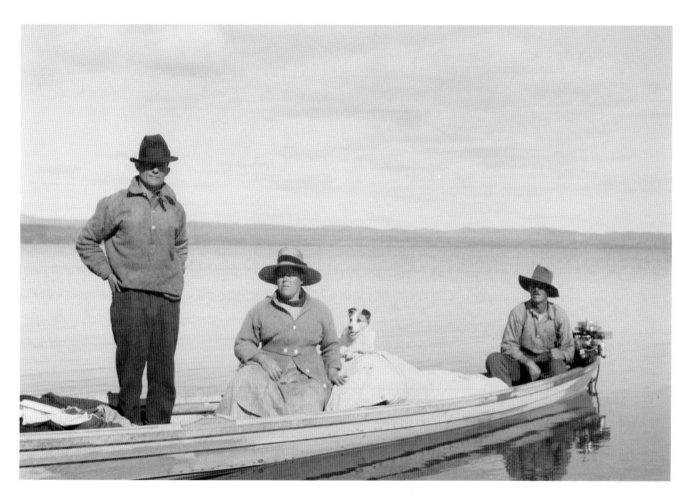

In 1923 R.P. Bishop did a survey similar to Swannell's in 1920, making a tie between the 53rd parallel and the triangulation network on the coast. In his report, he wrote:

> The main work of the season consisted in connecting the surveys based on the line of the 53rd parallel and Mr. Swannell's survey of the Eutsuk Lake neighbourhood with the Coast triangulation of North Bentinck Arm. This latter is in turn connected with the astronomical station established some years ago by the Dominion Government near the Bella Coola Telegraph office, and also with the main stations of the Geodetic Survey of Canada lying father to the west. The completion of this triangulation ties a large surveyed area in the Interior of the Province to the North American datum and so determines with sufficient accuracy for all practical purposes the geographical positions of a large number of places which were previously only approximately known.

During his survey Bishop tried to visit "Peak 9020, where I was anxious to place a cairn. The peak is the highest in the country and had been cut in by Mr. Swannell from most directions towards the north." By the time Bishop had climbed "to within about 1000 feet of the top of the mountain, we found that the ice cap which was visible from the north-west covered the whole of the summit, making it impossible for triangulation purposes." Bishop noted that he followed Alexander Mackenzie's route to the coast in several locations and "on the completion of the season's work I had an opportunity to investigate the position of Sir Alexander Mackenzie's most westerly observation station, where the great explorer painted on a rock the famous words which have been so often quoted in histories of Canada and of the Coast." Bishop also wrote: "At the time of our return a public meeting had been held on the subject of the formation of a national park in the neighbourhood and a petition intended for the Dominion Government was circulating in the valley. The idea is linked with Bella Coola's hope of a highway to connect with the Cariboo Road in the Interior.... Eventually, perhaps a ferry system might be made to connect with Vancouver Island to complete the circular trip, but this seems to be looking far into the future."

triangulation carried from the 53rd and 55th parallel of latitude. He also made a connection between previously established nets of triangulation in the vicinity of Babine and Nation Lakes." By the end of 1923 the triangulation surveys of the province first envisioned by Surveyor-General Thomas Kains in the late 19th century, and developed by Umbach's triangulation networks, covered most of the British Columbia coast and the southern part of the province. Swannell's surveys in central British Columbia, Bishop's triangulation of areas in northern BC and the Chilcotin, and the work of a few other men was beginning to produce similar results for parts of central and northern British Columbia.

■ The Eddings, pioneers living at Ootsa Lake, with Harry McLean (standing). Swannell met the Eddings several times during the 1920s. G.S. Eddings later started a mink farm that lasted a few years.
BC Archives I-57153

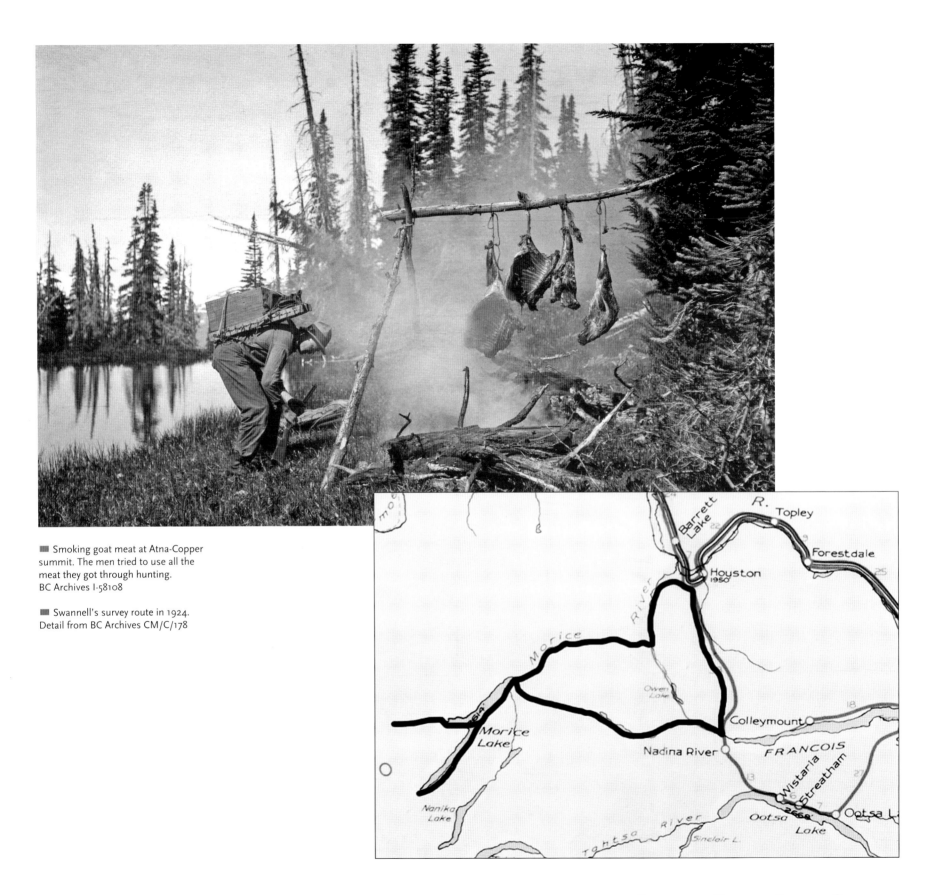

■ Smoking goat meat at Atna-Copper summit. The men tried to use all the meat they got through hunting. BC Archives I-58108

■ Swannell's survey route in 1924. Detail from BC Archives CM/C/178

1924

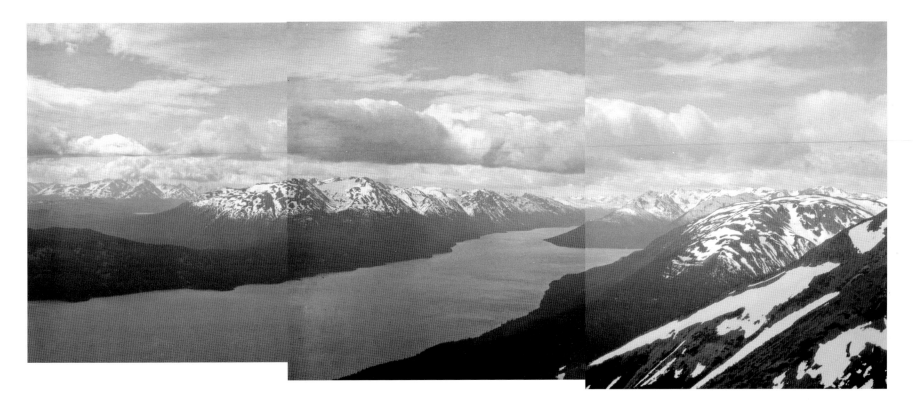

Now that Swannell had completed mapping and making a triangulation survey of the upper Nechako watershed, connected his surveys to Underhill's triangulation network on the coast; and tied into Bishop's surveys around the 55th parallel, the Surveyor-General wanted him to extend his work into the headwaters of the Morice River, one of the southern tributaries of the Skeena River watershed. In his letter of instructions to Swannell on May 21 Umbach wrote that, "Your work will consist of the extension of your main triangulation north-westerly, with the main objective of making a rigid connection with the triangulation work to be done this year by Mr. Monckton along the valley of the Kitimat River. In addition to this you will triangulate Morice Lake and any other lake in the district which will require triangulation in connection with the future topographic survey of the area, along the lines of your present surveys to the south."

P.M. (Philip Marmaduke) Monckton (BCLS #144) was a surveyor who had an office in Terrace and worked for the provincial government for many years. In 1922 he surveyed lots near the hot springs at Lakelse between Terrace and Kitimat, and in 1923 he had made some surveys to complete the coast triangulation network between Ocean Falls and Prince Rupert. In 1924 he started a triangulation network that took several years to complete and eventually extended from the coast network in the Kitimat area up into the Cassiar Mountains. Umbach wanted Swannell to connect his triangulation network with Monckton's surveys to provide another check for the accuracy of both men's work.

In early January Umbach held a meeting in Vancouver with several of the men involved in triangulation surveys, including Swannell, Bishop, and Underhill. In a letter he wrote to the Surveyor-General the same month, Swannell observed that the rule of thumb was one day of office work for one day of field work. Now that he had developed a large surveying network there were many calculations for each of the stations that he occupied, and a large amount of detail to include in the large map that he was producing each year. Five to six months of field work meant that surveying for the government was a year-round job for Swannell and his assistant. Swannell's letter noted that in the 1923 field season he and Pollard had occupied 218 triangulation stations (more than one per day), ran 160 miles of traverse surveying, and completed topographic surveying of 1450 square miles.

In early May Swannell began organizing his survey crew for the 1924 field season. Swannell did not have an assistant this year since A.C. Pollard and Swannell's daughter Minnie were getting married. Harry McLean, who had worked on Swannell's crew in 1923 and travelled with him to northern BC, returned as boatman. Mike Fenton, who had worked on Pollard's crew for a short time, was the packer. W.E. Ekins was the cook, and Ernle Money, the axeman. On May 14 Swannell sent Schjelderup a telegram. "Try locate Fenton and ascertain how many horses he's got & wire me so can decide how many yours can use. Will arrive Houston Friday 30th. Writing you, Fenton & McLean." On May 23 Swannell "received wire from McLean – Horses & boat in Houston. Will meet you there." Three days later Swannell and Money left Victoria for Vancouver where they boarded the SS *Prince Rupert* at 11 pm. After stops in Powell River, Ocean Falls and Swanson Bay the ship reached Prince Rupert at 4 pm on May 28 where it was "raining of course," Swannell noted.

The train left an hour later and arrived in Terrace that evening. Swannell stayed with Monckton for two days while the two men planned on how to connect their surveys. On May 29 it was "raining nearly all day – Look over several railway tangents suitable for bases and decide on two mountain stations." The next day Swannell went "to Lakelse with Monckton and size up the Kitimaat Valley – mountains hidden by clouds so only get bearings up general direction of valley – Leave for Houston 9:30 pm." The inability to see the mountains and select definite peaks for their surveys would affect the work of both men later that summer.

After an overnight train ride Swannell and Money arrived in Houston at 4:30 am where he found "McLean,

Fenton and packtrain waiting. Make kitchen boxes & overhaul rigging & engine – Get provisions order filled at Gould's store." On June 1 the pack train with six heavily loaded horses left at "9 am – only one horse 'Starlight' bucks." The next day Swannell and McLean "spent morning preparing load for boat & tuning engine. Left Houston 1 pm ran 6 miles down to Morice River under paddles – lost an hour portaging where main channel completely blocked by logs. Camped 4 miles up Morice River 7 pm – river muddy and very heavy current – had to paddle and line to help the engine out – very hard to choose water on account of muddiness. River badly cut up, have to cross & recross to find possible water and ship water badly in traverses – McLean & I have 1000 lbs altogether too much for flood-water." Fortunately the weather was "bright, clear and warm."

Swannell and McLean continued up the Morice River on June 3. "At low water the Morice will leave many bars and be easy lining. Brimful as now continuous poling.... Only make 4 miles all morning – many places swept back several times in spite of all I can do with a pole – No eddies around corner, 8-9 miles per hour current. At 3 pm cache 600 lbs of the load and can drive boat up the bad chutes with the pole." The next day they reached a canyon at Mile 24. "Walk up to camp at Owen Creek and bring packer Mike Fenton & Ernle Money back. Lay skids and portage boat 80 yds. River above canon much better." That night all of Swannell's crew camped together at the mouth of Owen Creek.

On June 5 Swannell "climbed Morice Mt. up to alt 4500 – left camp 6:30 am – at 9:30 rain squalls drove up from the Coast turning to wet snow. At 4500' built fire and waited until 1 pm in dense clouds. Arrived at camp 4:30 thoroughly drenched. Rain clears off 6 pm. New snow 1500' down the mountain. Mike and Harry go back for the cache, delayed 2 hrs as 'Moonlight' and 'Sparkplug' had hit back on the Owen Lake trail." Clear weather continued the following day, so Swannell went back up Mount Morice where he set a triangulation station and built a large cairn. Just under 6000 feet high, Mount Morice, like Mount Swannell, is not a high peak, but is in a favourable location with views of many mountains. Swannell noted that he was able to see Blanchet & Nanni Peaks in the Takla Lake area. Swannell had surveyed on Mount Blanchet in both 1912 and 1923 so he had another connection with Bishop's work, his surveys from the previous year, and his pre-World War I exploratory surveys. At his station on Mount Morice, Swannell read angles to several of the major peaks that he had used between 1920 and 1923, including the cairn on nearby Nadina Mountain from which he still had not surveyed.

The grizzly bear that charged Swannell at Morice Lake. Harry McLean killed it with three shots. BC Archives I-58954

■ The signal at the southwest arm of Morice Lake, on a typically windy day on the lake. BC Archives I-58976

■ *Right*: Ernle Money washing his clothes in camp at Morice Lake. This was one of the men's occasional Sunday activities. Since it took a long time to wash and dry clothes in camp, the men did not clean them often. BC Archives I-57163

After triangulating from Mount Morice, Swannell and Money went four miles up Owen Creek to tie a lot survey into the mountain. Then Swannell's crew continued up the Morice River. During the next five days that it took the men to reach Morice Lake it rained most of the time, and the water level continued to rise. In his diary entry for June 10 Swannell wrote that they "nearly smash up twice crossing where current set hard under jams. Thunderstorm 4 pm – shovel hail out of boat with paddle.... Packer about as wet and fed up as we are." The next day they passed the North Fork of the Morice "from which all the muddy water had been coming." Our branch soon becomes a torrent, 12 miles above forks in canon. Camp 5:30 at the worst place, a chute between rock portals. River falls 180 feet in the 11 or 12 miles between here and the North Fork." On the morning of June 12 Swannell's crew reached Morice Lake where they camped two miles up the lake.

Then the men "cut out trail to Long Lake, 4 miles, mostly good trail. [Long or Seymour Lake is called McBride Lake today.] Meet Moricetown Siwash David Denis & klootch, has 5 beaver. Trade sugar for 2 trout." However, the trail along the lake "practically does not exist" so Swannell's crew spent a few days cutting a new one. Monday, June 16 was their "official Sunday

– Washed clothes, mended tents and made new stock for 22 rifle and repaired max and min thermometer with spruce gum. Packer goes after horses which lit back 4 miles in night. Windy and raw, rain 5 pm until midnight. Issue rum ration."

The next day Fenton and Money took the horses beyond Long Lake to the fork of the trail to Poplar Lake while Swannell and McLean went up Morice Lake to locate the portage into Atna Lake. June 18 was "fine, cold with high west wind. McLean & I climb and set 2 cairns 4 miles apart on Seymour Mt. Grizzly in snow-filled basin on spotting us without a moment's hesitation charges. McLean stops him at 80 yds with 3 shots. First time I have seen a grizzly show fight unprovoked.... Bitterly cold wind across the snow summits. Took panorama. Reach beach 6 pm and find sea has broached and half-filled boat with sand. Waves very high." On June 19 Swannell and McLean went to Seymour Lake and traversed a base

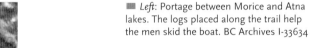
Left: Portage between Morice and Atna lakes. The logs placed along the trail help the men skid the boat. BC Archives I-33634

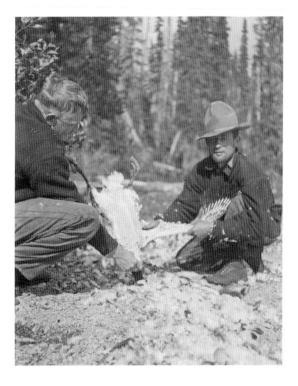
Below: Money and McLean pluck the goose that McLean shot at Atna Lake. BC Archives I-57165

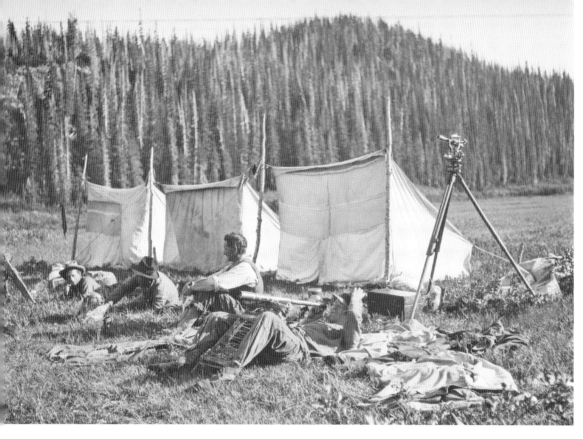

This was Swannell's survey camp at the Copper River on the west side of the Coast Mountains. BC Archives I-57167

"strong west wind springs up and we cannot get back to camp; but luckily have our blankets along. McLean sleeps under canoe & I under sail. Mosquitos bad and bushy tail rat on the ramp." The following day, Swannell and McLean finished the connection traverse from Morice Lake to Seymour Lake where they met Fenton and Money returning with the pack train. "Lake too rough to travel until 7:30 pm. McLean & I reach Camp 4 with grub 9:30 pm – ship considerable water." Swannell and Fenton climbed Redslide Mountain on July 13 where they set a cairn and read angles to the stations around the lake.

After "Survey Sunday" on Monday, July 14, Swannell's crew moved to Atna Bay and began surveying that part of Morice Lake. Heavy rain started at 3:30. "Reach camp 5:30 very wet – This finishes the rum." During the four days that they were in Atna Bay it rained most of the time. On July 17 Swannell noted that it was the "third day we have been waiting to climb Mt. Loring, which remains hid in clouds. Cut out portage trail to next lake above. Find Siwash trail leading to a cabin on a lake, probably Atna Lake." The next day "McLean & Money climb and erect large cairn on Loring Peak (7000) – Caught in thunderstorm and reach lake thoroughly drenched. Fenton & I follow old trail to large lake 35 ft. above Morice Lake. Evidently old Grease Trail, old blazes 65 years old, reblazed 10 years ago."

Swannell's crew spent the next three days getting their supplies and equipment into Atna Lake. On July 19 "McLean & Fenton make raft on next lake and fix portage around the Falls, find 1/4 mile river to 3rd lake around which no portage possible – river swift but can line up. Self and Money finish Atna Bay shore traverse." The next day they moved camp. "Leave all outfit at end of Grease Trail & cut out 1/2 mile trail. Portage to First Lake & past falls (35') into 2nd lake by 1 pm. Second lake to Atna Lake 1/4 mile river, very strong water. Attempt to line the boat, but sheer. Get 1/4 full of water and nearly upset. Cut skid road 1/4 mile across hill and haul the boat over by 6 pm. Have bivouac at Grease Trail." By July 21 the men completed the strenuous portage. "Move camp to near head Atna Lake – cut trail thru to lake along old Siwash Grease Trail. By 1 pm send boat ahead with 3 men to pitch camp. Money & I go back for final load and make cache at Atna Bay. Huge craggy mountains, all glacier and low tongue glacier near head of this lake. Try to run down young geese with the boat and McLean shoots an old one thru the head with the 30-30. Wonderful shot.... Backpack 12 loads 1 mile."

Now that they were at Atna Lake, Swannell's crew took their Sunday on Tuesday, July 22. The following day Swannell spent in camp "observing for latitude &

for future triangulation in the area. He noted the "Indian cabin at outlet owned by Big Seymour. Wind very cold, snow still deep in mountains." After spending a few days completing the traverse and taking a Sunday of no work, Swannell's crew moved to the west arm of Morice Lake on Monday, June 23. While McLean set signals down the lake, some of the men started cutting a trail up Mount Loring, and Swannell adjusted his transit and took "solar and Polaris observations for latitude and azimuth."

During the next month Swannell worked around Morice Lake. Fenton and Money set signals along the lake while Swannell and McLean did some traverses and triangulation along the shore, and climbed to the top of several mountains. On June 26 Swannell took a solar reading for latitude and commented that "Morice's [Father Morice] lat 11' [approximately 13 miles] in error. Rain and wind drive in from Coast 5 pm." Although the next day was Friday it was "Official Sunday. Cold and raw and wet." On June 28 Fenton and Money left for Houston to pick up more supplies for the trip into Atna Lake and the Coast Mountains later in the summer. By July 2 Swannell had traversed "north shore to head of lake" and the next day he "completed shore traverse this end of lake." On July 4 he started "reading signals south end of lake.... Last night grizzly prowling around camp awakens us."

Much like Whitesail Lake, there were strong winds on Morice Lake, particularly in the afternoon, and Swannell's journal often noted high winds and big waves as he and McLean worked down this side of the lake. On July 8

time" while three men went "hunting [for a] pass to the Kitimaat. Find big valley bearing magnetic north – their report very disquieting – a maze of big glaciers.... Men out 12 hrs and return very tired." The next day McLean & Fenton continued cutting a trail to the summit of the Coast Range while "Money & I pack transit and a little grub up to meat cache, rebuild the fire and climb Pat Peak and set a large cairn. Read into Morice Lake cairns and Stoney Mt. Position of Kitimaat very dubious amid a jumble of glaciers. Very hot day, all hands played out." In 1920, when Swannell was at the summit of the Coast Range looking down into the Kimsquit he gazed at a similar scene of a maze of mountains. At that time the route through the Coast Range was apparent. This time the route was not obvious and Swannell was not certain which mountains Monckton was using for his triangulation stations. The poor weather on the day he and Monckton were in the Kitimat valley was making it difficult to achieve his major objective for the summer. Swannell also did not know that poor weather was limiting the number of triangulation stations that Monckton was able to establish on the mountains in the area. Fortunately Swannell was able to connect the triangulation station on Pat Peak with both his Morice Lake survey and a major triangulation station on the upper Nechako.

Swannell's crew moved their camp near the summit on July 28. While Swannell and Money brought up food from Atna Lake, McLean and Fenton began cutting a trail into the valley below them. Swannell was hoping to find a trail or evidence of human habitation that might provide a better indication of where he was in the Coast Mountains. The next day Swannell and McLean climbed a mountain 2 1/2 miles beyond Pat Peak. From its summit "we can see that the big creek below turns abruptly into a gorge 5 miles down – the water from away down the valley running up to join it. Seems probable both form the Kitimaat as gorge enters a valley bearing in the right direction."

On a sunny July 30 the survey crew crossed the summit at 5310 feet and descended almost a thousand feet to a big meadow where they set up camp. Afterwards Swannell went for a "cruise up meadow. 4-5 sections flat mostly open meadow, much of which is dry with wild timothy. 4 miles above camp the ring of glaciers nearly reaches the valley. Most wonderful meadow I have ever seen."

The men spent the next week cutting trail and working down the valley. About two miles below their camp the valley became narrower and the river went into a box canyon that was filled with rapids and cascades. The work was slow and the crew only made about two miles a day. Along the way they did "find traces of trapping 25 years ago." By August 3 they were eleven miles down

Glaciers between the Copper and Kitimat rivers, showing the rugged terrain that Swannell had to navigate to make a connection with Monckton's survey coming up the Kitimat River.
BC Archives I-59026

the valley at a large clear creek. Swannell estimated their "totals to date – boat 417 miles, pack train 270 miles, backpack 70 miles." Two days later "Harry & I ford river and go 3 miles down to head of deep gorge into which our river and one of equal size from the north plunge, leaving main valley at a right angle. Gorge of great depth and very narrow. Bars for 1/4 mile above gorge and then box canon to within a mile of camp.... Awful going, unable to ford river on our return as it has risen 6'. The boys in camp throw 3 trees across but they break and are swept down. No matches but light fire on a bar with a magnifying glass before sunset. Pass an unhappy night, but the river drops and we get across 3 am."

Swannell's journal entry for August 6 was titled "Dash for the Kitimaat". He was hoping that a quick trip down the valley would lead him to one of Monckton's stations or a landmark. That day Swannell found an old camp with a sign "A.L. Clore, Copper City, July 3, 1922." The next day "All hands climb mountain.... Harry & I cross alpine valley to rounded hogsback overlooking gorge. River out of sight in box canon in deep V valley for 8 miles. Set cairn, 1 read. As valley ahead appears impossible, our provisions nearly exhausted, our footgear in pieces (I have to climb in moccasins) decide to go back." On August 8, while three men began packing supplies back up the river, "Mike & I climb the mountain and read from a higher peak, but can spot nothing of Monckton's. Get 6 of my own back stations. Shoot a goat below on a huge rock slide which Mike retrieves after a hard scramble. Bad shape myself with a swollen foot. Harry's boots go to pieces. Everybody played out."

In his report to Umbach Swannell described their situation in this valley on the west side of the Coast Mountains. "For 7 miles the valley was acutely V-shaped, the river being out of sight in continuous box canyon.

The drop in the river from the head of the gorge to the foot of the box canyon is probably over 1,500 feet. We got no farther in this direction, our provisions being almost exhausted, our foot-gear cut to pieces, and what lay ahead unknown." Although his trip across the Coast Mountains had not been successful in establishing a connection with Monckton's triangulation network, Swannell was able to tie his most forward station into his survey of the headwaters of the Morice River. From this triangulation station Swannell read angles to several of the Coast Mountains in the vicinity, and he hoped that at least one would be able to provide a connection with Monckton's work.

By August 10 Swannell and his crew were back to their camp at the big meadows. He noted their "provisions remaining: 5 lbs flour, 10 lbs fruit, 2 lb barley and a little goat meat. No tea nor coffee." The next day "Mike, Harry & Ernle go over to huge glacier beyond meadows and set a cairn on peak behind. Report deep valleys running S & SW, but obscured by rain." On August 12 Swannell's crew returned to Atna Lake. "Ernle & I also climb ΔPat Peak and read into all forward stations." This gave Swannell another connection with the surveying that he had done on the west side of the Coast Mountains. Swannell further noted that, "Provisions finished – Hotcakes, fruit & the ptarmigan for breakfast – no tea coffee nor

sugar." Swannell's crew spent four days triangulating and traversing around Atna Lake. On the first day two men went back to Atna Bay to pick up some food from their cache. By the last day at Atna Lake "provisions nearly gone, a little milk & bread remaining."

Swannell's crew spent Sunday, August 17 moving camp back to Atna Bay on Morice Lake. "Backpack outfit in 7 loads 1 mile across Portage Trail. McLean & I shoot boat, light, through the 200 yd torrent outlet of Atna Lake. 12 foot drop, 70 ft. wide – straight but several bad jagged rocks which cannot be seen in time, the water being so muddy. The back wash at the foot would swamp a loaded boat. Portage boat at Falls and again across to Atna Bay." The next day, with the "weather continuing hopeless for mountain work and provisions running low we move to Main Arm" and on August 19 "take packers down to trail and help them pack across to Seymour [McBride] Lake. By wonderful good fortune the horses are still in the meadow where we left them a month ago. Packers saddled up and off to Houston 1 pm. McLean & I pack a case of gasoline back 5 miles to Morice Lake. Head wind & big sea but buck thru to camp."

During the next week high winds and heavy rain limited the surveying that Swannell and McLean were able to do. Swannell's journal for August 23 records,

■ Atna Peak from Atna Lake.
BC Archives I-59007

"Rain, gale in afternoon. Flour plays out. Heavy rain from early morning until 2 pm when a windstorm from the west sets in. Wind dies down at midnight and rain re-commences. Our diet is now fish, dehydro onions and cabbage and dried fruit. No work possible." Poor weather continued the next day. "Raining very heavily all day and night. New snow down to timber line. Eat last of our fish. Impossible to work. Steadiest downpour I remember." The weather was even worse on August 25. "Rained heavily during night. At dawn gale sets in from SW and increases in violence in afternoon. Impossible to launch boat. Hunt unsuccessfully up mountain behind camp. Food now down to desiccated onions & cabbage, fruit & 1 tin soup per diem." Two days later Swannell & McLean had their "first fine day in ten. Catch one 3 lb steelhead salmon and lose a big one. Return to camp and cook him for breakfast. Set signals along shore and hunt. Hook one 10 lb salmon on light tackle but lose it in landing, although had put a shot in him. Get 1 grouse. Cabbage, rhubarb & milk for supper. Harry is ill." The next day the packers returned. "One quart white alcohol and subsequent hilarity."

With all men back and adequate provisions Swannell's crew continued surveying and mapping Morice Lake. They set up and measured a base line where the Nanika River emptied into the lake, and completed the traverse survey between Morice and Seymour Lake. On September 4, "Three men leave with horses to set signal on mountain back of Poplar Lake." During the time Ekins, Money and Fenton were gone, Swannell and McLean continued surveying along the shore and established a base line at the head of the lake where they saw, "Big grizzly eating roots up river. We did not want him."

The men returned from setting the cairn on the mountain near Poplar Lake on September 12. The next day Swannell's crew moved their main camp to Seymour Lake. Ekins and Money began setting signals along the lake. Fenton went back to Houston to take and pick up mail and buy more food for the remainder of the season. Swannell must have sent letters to Monckton describing his trip across the Coast Mountains and his surveying in that area, for Monckton replied a week later. "I had your letters today, well we sure had quite a time up the good old Kitimat didn't we? But I do not think you saw the Kitimat at all, though what you did see is a mystery to me.... I wish we could meet here at Terrace in Oct, but I do not think I can be through unless there is a very radical change in the weather early enough and it would be impossible

A surveyor hauling a canoe over a Beaver dam, one of the many obstacles encountered while surveying.
BC Archives I-59037

for us to go to any of my stations that late. The station of yours that I shot on to gives a very small angle, less than half a degree, but I figure the error ought to be less than one per cent at that, and that will be enough to join the topographical features together well enough so that we can map out a scheme for next year to connect up."

Swannell and McLean went back to Morice Lake and on September 14 "reach Redslide Trail 9 am & summit of mountain by noon – very bad traveling. Visibility from cairn excellent, even Mt. Fulton being sharp. Get Nadina & new cairn on Poplar Mt. Get back to beach late and 'all in'. Cook supper and sleep on beach." The next day they travelled across the lake and climbed Mount Loring, a peak that Swannell had wanted to survey since early summer. "Very hard day on top of yesterday. Back of peak is a 1500' precipice onto a glacier. Huge maze of summit country to the east all above 5000 alt. lying between lake and North

Fork River. Barometer falls alarmingly." Swannell's journal for September 16 noted, "Pitched no camp yesterday, but wind & rain commencing 1:30 am – had to sling the tent up in the dark. Mountains again in clouds and usual coast weather. Spent day resting up & recalculating."

On September 21 Fenton returned from Houston, and he, Ekins and Money came to Morice Lake. By September 22 Swannell had finished surveying Morice Lake and the triangulation stations that he had set on all the major peaks in the area. "Rain most of night and snowing in mountains.... At 2 pm go 4 miles up lake and set a white signal 9 foot base for reading back into from Poplar Mt. For about an hour storm clouds lift around Nadina & get cairn on it."

The next day everyone went to Seymour Lake, and on September 24, Swannell began the triangulation of this body of water. Before returning to Houston Swannell

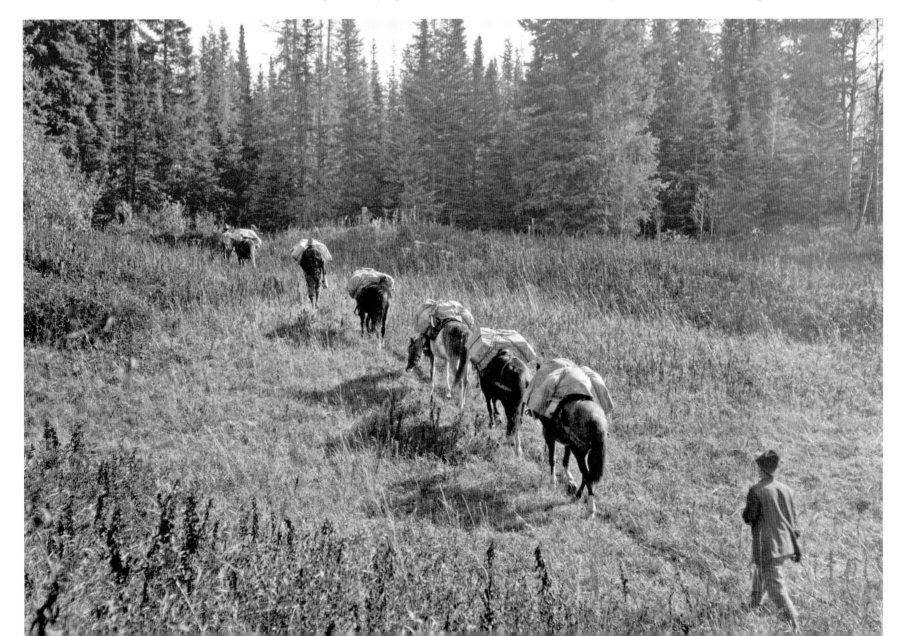

wanted to map more of the area and to reach the top of Poplar Mt so that he could survey from the cairn that the men had set there. "McLean & Fenton find two missing horses and leave at noon to get surplus stuff ahead and cruise better route & cut trail to ΔPoplar." By September 28 Swannell, Ekins and Money were at the head of Seymour Lake where Fenton and McLean rejoined them the following day. They measured a base at the head of the lake and then travelled to Poplar Lake, which they reached on October 2. Since Poplar Lake had already been surveyed Swannell did not need to map this lake. On October 4, with the "weather still making it impossible to read back to Morice Lake signals call today Sunday. Siwashes Jim Holland and Big Tommy visit us. First people I have seen since June 10th when we met the Moricetown Siwash David Denis." The next day Swannell and McLean climbed Poplar Mountain "Bitterly cold in violent gusts make reading very nasty."

On October 6 Swannell's crew started for Houston, moving "to about 3 miles above Rancherie on Nadina River." The next day they reached the LeCroixe Ranche, and on October 8 they were at Hayes Ranche on the Houston-Francois Lake Road. By October 9 the men were back at Houston where they sorted out their gear and packed up. McLean and Fenton took the pack train back to Knapper Ranch for wintering. Swannell left Houston on October 10, arriving in Vancouver three days later where he was met by his wife, his son Charles, who was attending UBC, and his youngest son Arthur. The next day "Charlie & George Vincent [Charles' close friend from UBC] to dinner with us at the Hudson Bay – one square meal for them at least. Afterwards take Arthur to see the big bears at Stanley Park." Swannell and his family took a night trip on the SS *Princess Alice*, arriving in Victoria at 7 am on October 15.

Swannell had not attained his main objective of connecting with Monckton's surveys. In his government report to Umbach he wrote that, "The intention was to push across the Coast Range to the headwaters of the Kitimat River. Up this valley P.M. Moncton, BCLS, was to carry a triangulation extended from a base at Terrace and connected with Kitimat Arm. Owing to the jumble of rugged glacier-bearing mountains, the bad weather encountered, and difficulties of transport we did not connect, although at one time were only 4 miles apart." Monckton did not reach the upper Kitimat until August 15 after Swannell had left. Rainy weather during most of his last two months of surveying limited Monckton's work in the headwaters of the Kitimat, although he was able to observe one of Swannell's

stations and survey to it. Swannell did extend his triangulation network. "In addition to mapping this part of the Coast Range, I surveyed two large lakes – all of this country being hitherto almost entirely unknown." He observed that, "Morice Lake is the farthest north of the remarkable group of large lakes which push far into the Coast Range between latitudes 53 and 54 N."

In later years Swannell described the 1924 field season as among the most difficult in his surveying career. His report to Umbach explains some of the problems encountered in surveying during 1924. "Our experience with the Morice River was rather unfortunate, as we struck extreme high water, it being early June. The river was bank-high everywhere, very muddy, and running like a millrace. Although we had an excellent river-boat and a heavy-duty Evinrude engine, recourse had often to be made to pole and paddle and occasionally to lining. At low water, however, the only time the Indians attempt to go up, there are many long bars up which they line their canoes." In describing Morice Lake he noted that, "Even in summer the lake is very rough, strong westerly winds almost continually blowing down it and the waves piling in very heavily on the beach at the outlet. Calm days were an exception."

Rain and wind kept Swannell's crew in camp several days during the summer. The portage into Atna Lake and the trip across the Coast Mountains had been rigorous. The men were short on food at times. In the field the men went over two months without seeing any other people. Only in 1914, when he had spent almost two months without encountering any other humans, had Swannell been so isolated during his field work.

Despite the difficulties, Swannell had travelled 705 miles by boat, 637 miles by pack train and 47 miles by backpacking. He had completed over 80 miles of traverse survey and occupied 158 triangulation stations.

In his report Umbach wrote that, "Mr. Swannell extended the control work from his previous season's work northerly to cover Morice Lake and the headwaters of the Copper River. It was hoped that this work could be connected to Mr. Monckton's triangulation of Kitimat Valley, but unfortunately the plans in this connection miscarried, and although certain rays were obtained by both parties on common points, the connection is not rigid." The stations that Monckton and Swannell had set in the Coast Range and the surveys that both men made from the peaks, provided the first tenuous connection of their networks and would become the basis for Swannell's surveying in 1925.

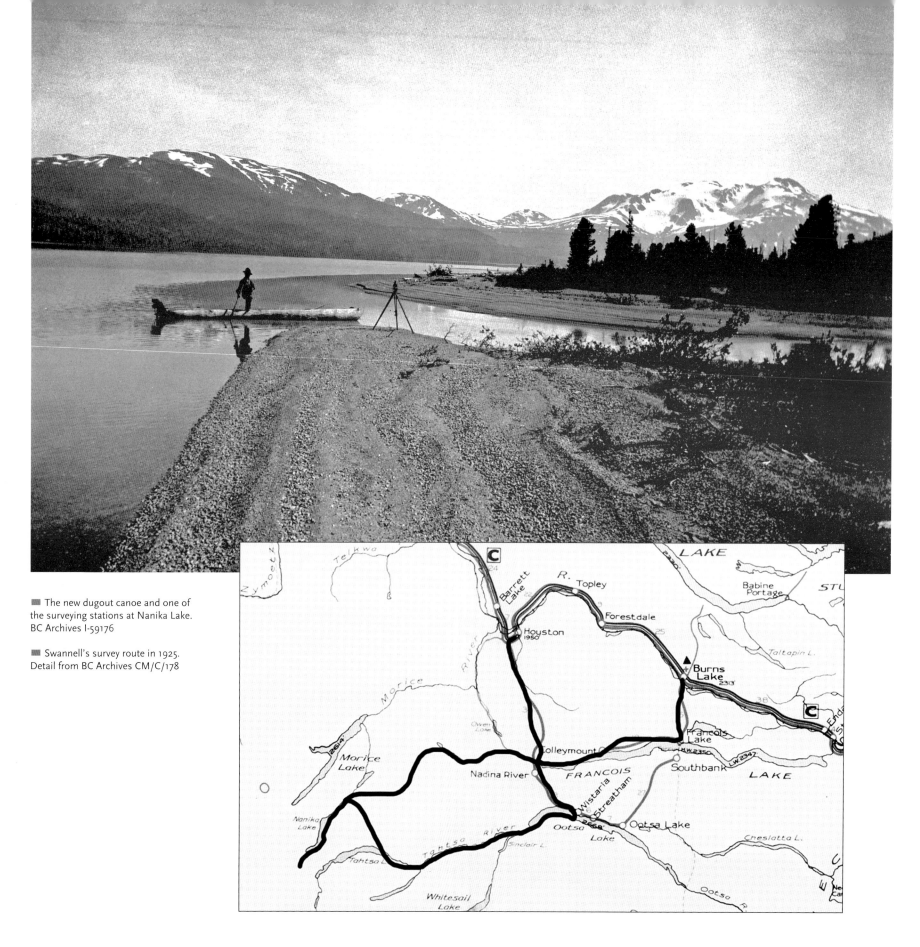

■ The new dugout canoe and one of the surveying stations at Nanika Lake. BC Archives I-59176

■ Swannell's survey route in 1925. Detail from BC Archives CM/C/178

1925

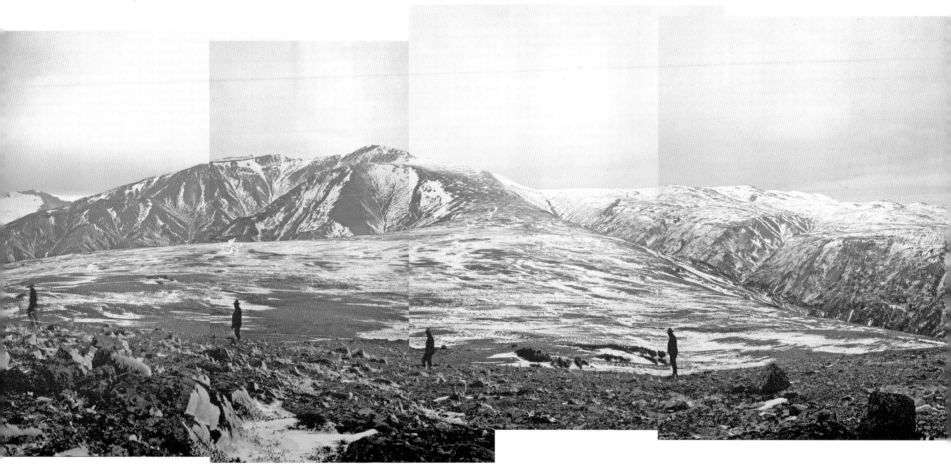

During the winter of 1924-25 Swannell worked on his calculations and map for the 1924 field season. In his entry for Saturday, January 17 Swannell wrote: "Discover 11'26" error in adjusting observation one on another for convergence – which throws out co-ordinates of entire survey & necessitates recalculating them." This was a significant error. Since the calculations for his first four seasons of surveying in central British Columbia were accurate Swannell knew that something was wrong with his 1924 survey. He spent three hours on Sunday "trying to get Morice bearings to check through to old work." It took Swannell and A.C. Pollard about 10 days of recalculating and plotting before they were able to accurately connect the Morice Lake survey with the 1920 to 1923 survey of the upper Nechako.

At the end of January, Swannell met Umbach to get Monckton's co-ordinates for his triangulation stations in the upper Kitimat. Umbach asked him if he was interested in surveying in the Dease Lake area in the northwestern part of the province. When Swannell visited the Surveyor-General again at the end of February, Umbach was "very glum regarding work this season." Near the end of March, Swannell had a "long talk with Umbach about season's work." The Surveyor-General must have given Swannell a promise to continue surveying in central BC, for P.M. Monckton sent him a letter on March 30 giving him the co-ordinates for his stations in the upper Kitimat, along with a description of his work in that area.

During March and April Swannell made contact with some people from his pre-World War I surveys. He received a letter from John Ronayne in Pemberton Meadows where Swannell surveyed in 1909. Ronayne wrote about Tom Greer, who worked for Swannell, and some of the settlers Swannell had met. Ronayne observed

Panorama of Sibola Plateau and Packtrain Peak. BC Archives I-59091–94

Vacation JOBS of U.B.C. Students

Many students at the University of B.C. spend their long summer vacation at strange jobs, earning wages which aid materially in defraying expenses of their college course. In the following article George G. Vincent tells of his experiences as "cook, assistant packer and general roustabout" with a party of the B.C. Exploratory Survey.

"As I stood by the track, late at night, waiting for the westbound train," he concludes, "a faint mist hung over the sleeping land, and a dim moon rose over the far ranges. In the distance a lone coyote sang a dreary saga and seemed to voice my regret at leaving that wonderful land and what had indeed been a most wonderful adventure."

By GEORGE G. VINCENT.

"COOK, assistant packer and general roustabout"—those were my official titles during the summer vacation. I succeeded in getting a job on a British Columbia Exploratory Survey party bound for the far northern portions of British Columbia and for months gloried in the chance to experience something of the hardships and thrills of the old pioneers and explorers who first fought their way through the Canadian wilderness. The job justified my titles to the last detail. There was no monotony and no complaint of time hanging heavy on my hands.

On March 25 we left Vancouver by steamer for Prince Rupert, and found ourselves at the dead of night at a little wayside station on the main line of the C.N.R. Stumbling through the darkness at length we gained the door of the "Hotel," a building of dovetailed logs, and retired thankfully to rest.

The following morning we were joined by two packers who were camped nearby, thus bringing the total

— Fording a glacier creek
— The writer makes a flap-jack
— In camp.

might be unfordable by night. There were innumerable sloughs and lakes in the valleys, their shores trampled and pitted with animal tracks.

As far as possible we lived off the country, but at times even rifle and fish hook would fail to supply the pot, and those were lean days in Israel! My cooking utensils were of the most primitive type, all cooking being over an open fire without even a fly as covering, and with a tin reflector as my only oven. Clothes and footgear showed very grave signs of wear. Luckily feed for the horses was fairly plentiful, and they remained in good condition.

FIRST WHITE MEN TO SEE LAKE NANIKA.

It was a great day when we at last sighted what the Indians called the Nanika Lake, or lakes. They had a superstition that these parts were haunted by a great serpent, and carefully avoided the whole region. We were probably the first of almost the first white men to set eyes upon the vast reaches of what we called Big Nanika, and which seemed to be a great glacier fed lake about thirty miles long; and to explore drear Little Nanika, which was connected with it by a beautiful river about eight miles in length.

On these lakes it was perilous and difficult to navigate a raft, so we searched around for a good canoe tree. There were very few large enough, but at length we located a big cottonwood on the shores of the smaller lake, and several members of the party, leaving the main camp and fighting their way through the dense bush, established a temporary camp and started to build a canoe. The feat was accomplished in the record time of twenty-four hours, with no other tools than axes and a small canoe adze.

The trip up the river to Big Nanika and the main camp was very swift, and there were frequent log jams over which the canoe had to be dragged. Several narrow escapes from drowning made all thankful when at last we hit the calm waters above, and triumphantly paddled the first canoe ever launched on those lakes. We had a great christening ceremony and celebration in which a keg of rum

When we reached the top of a mountain after many hours of scrambling, the instrument man would set up his ... size from a mile in length to fifty miles. It was a weird and awesome feeling to realize that most of this vast ... to the Sphinx ... a resting woman, and one of the smaller pinnacles bore a rude resemblance

■ George Vincent wrote this newspaper article, printed on October 25, 1925, about his experiences working on Swannell's survey crew. Vancouver *Province*

that, "the uncertainty of the fate of the PGE Ry [Pacific Great Eastern Railway] which is a mere political football naturally warns all strangers away from the valley" and he commented, "I envy you your explorations in terra incog." One of Swannell's entries recorded that "Charlie Hemeyer, after disappearing for 5 years, turns up." Hemeyer had worked for Swannell on his surveys in the Nechako River valley, and Swannell had visited him in Edmonton at the end of the 1914 field season. Swannell also spent time with George Copley, his surveying assistant from 1909 to 1914, who was back in the Victoria area.

Umbach's instructions to Swannell listed three objectives for his 1925 surveys. The first was "the extension of your topographic reconnaissance and triangulation to cover the area to the south and east of Morice Lake, to connect with your previous work of a similar nature along Tahtsa Lake and River." Umbach wanted Swannell to survey and map the area between his 1924 survey and the work that he did in the Nechako watershed. The second was "to extend your triangulation of last year northwest to make a more rigid connection

with Monckton's 1924 triangulation. It is important that the connection be rigidly established this year." Umbach gave the responsibility for connecting the two networks to Swannell so that Monckton could continue extending his network further north above the Skeena River. Finally, "In connection with the topography of Sibola Mountain it is understood that there are several mineral locations on this mountain, and you should, if possible, determine the position of these locations in order that they may be shown on your map."

Swannell left Victoria on May 23 and arrived in Houston on May 28. On the train from Prince Rupert he once again met fellow surveyor Dalby Morkill en route to his field work. At Houston Swannell's crew assembled and prepared for the field season. A.C. Pollard was back as Swannell's assistant for one more season. Mike Fenton, as packer, Harry McLean, as packer and boatman, and Ernle Money, as axeman, all returned from his 1924 crew.

The only new member was George Vincent, the good friend of Swannell's oldest son, Charles. F.W. Knewstubb, the well-known engineer for the provincial government's Water Rights Branch, had agreed to take Charles, who had finished his first year at UBC, on a water survey project at Quatsino. Swannell had "received sanction of S.G. [Surveyor-General] to take George Vincent at $75 clear." In the fall of 1925 Vincent wrote an article for the Vancouver *Province* describing his experiences on Swannell's survey crew. "Cook, assistant packer and general roustabout – those were my official titles during the summer vacation. I succeeded in getting a job on a British Columbia Exploratory Survey party bound for the far northern portions of British Columbia and for months gloried in the chance to experience some of the hardships and thrills of the old pioneers and explorers who first fought their way through the Canadian wilderness. The job justified my titles to the last detail. There was no monotony and no complaint of time hanging heavy on my hands."

On May 29 "Pollard, Money, Vincent & the packer Mike Fenton leave with 4 horses packed along Morice River Trail 10:30 am. Frank Madigan leaves with boat, engine & small outfit on a wagon for Hayes' Ranche on the Houston-Francois Road. McLean & I walk out by short cut past Bellacina's Ranche." Two days later Swannell and McLean reached Francois Lake at the mouth of the Nadina River. "Boat badly strained – fills. Give it until 11:30 to swell the seams." By early afternoon the two men arrived at the cabin of Swannell's friend Max Gebhardt. "Both have to bail continuously to keep boat afloat. Recaulk & drive nails home."

Swannell wanted to begin his survey by tying the triangulation station at Colleymount, above Francois Lake, to Nadina Mountain, one of his main stations near his surveys for 1925, and Poplar Mountain, which he had established at the end of the 1924 field season. On June 1 he set signals at the corners of four lots that had already been surveyed along Francois Lake and planned to tie the Colleymount station to those. However, "Nadina & Poplar Mts. in clouds all day so no use occupying Colleymount." The next morning Swannell and McLean "set brass bolt on cliff top Colleymount but could not read owing to rain. In afternoon climbed up again & got a round partly read before everything blotted out by rain squalls. Very wet and cold." On June 3 the two men travelled down Francois Lake and went to the top of Uncha Mountain on the south side of the lake where Pollard had set a triangulation station in 1922. "Although we find bluff where Pollard's signal must have stood all trace of signal & post destroyed by fire – Hunt all over mt. top vainly. No reading possible – very smoky & Nadina, Fulton & Poplar & Wells hardly visible." The next day Swannell went back up Colleymount, "but weather turns bad and have to abandon any attempt to read."

On June 5 "Ronald Prosser brings us, outfit & boat across to Ootsa Lake on a Ford truck." The next day was sunny, so Swannell went to the top of Stoney Mountain where he and McLean spent three hours "enlarging original cairn to a beehive 10' base & 9 foot high." Swannell spent part of Sunday, June 7 with the Eddings, one of the pioneer families on Ootsa Lake, before going down to Bennett's where he spent the night. There he met the school inspector, Fraser, and dragged "Harry McLean to church – first time since he was christened." The next day Swannell wanted to reset the signal that he set on Skins Hill in 1922. "In afternoon after a heavy thunderstorm go 5 miles down the lake & start up Skin's Hill – Halfway up very bad thunderstorm with hail followed by a drenching downpour. Very nasty on exposed crag, but set a bolt & put new canvas on the old signal and mighty glad to get down…. Get to Bennett's nearly perished with wet & cold." Following a day at Burns Lake on business Swannell went back at Colleymount. On June 10 he crossed "to Gebhardts & stay there. Mountains in clouds all day & useless to climb Colleymount." It rained the next two days, making it "impossible to read as clouds very low."

After two frustrating weeks around Francois and Ootsa Lake, Swannell and McLean left on June 13 for Poplar (Tagetochlain) Lake where they had finished the 1924 survey season. En route they met Schjelderup at the end of Francois Lake. Siwash Sam and his brother, Siwash Alex Michel, brought a pack train with four horses and transported Swannell's equipment to the lake. Swannell and McLean reached Poplar Lake on June 14, while the rest of the survey crew and their pack train arrived the next evening.

On June 16 the men began setting signals at several stations in the Poplar Lake area. The next day Swannell read four stations and made ties into the triangulation stations on Nadina and Poplar mountains. During the last two weeks in June, Swannell's crew surveyed several stations on the highest points nearby. McLean and Fenton brought in more food and established some caches at locations where they would work later in the summer. Pollard spent some time locating the Kid Price trail that they would follow into the Nanika Lake area after they completed their surveys around Poplar Lake. Then McLean and Money cleaned out the trail. Most days the weather was warm and sunny and the surveying proceeded smoothly. On July 2 Swannell plotted the surveying that had been done around Poplar Lake and took an observation on Polaris for direction.

Swannell's crew then started for Nanika Lake, located between Tahtsa and Morice lakes, following the Kid Price trail. In his report to the Surveyor-General, Swannell wrote that, "Kid Price, an old-time prospector had fifteen years ago cut a trail to the Sibolas and as we had been (erroneously) informed to Nanika Lake." A day's travel brought them to the Nadina River between Newcombe and Nadina Lake. Swannell spent about a week surveying these two lakes and setting triangulation stations on several high places around the area. From one of these he was able to connect his survey with the stations on Stoney, Nadina and Poplar mountains.

Some of the men cleared out the Kid Price trail ahead. One day "Harry & I spot trail ahead for 9 miles – Very hard to follow as apparently no one over it except Kid Price – & new burn 3 yrs ago over part." About 10 miles beyond the Nadina River Swannell's crew could find no further evidence of the Kid Price trail. Vincent wrote that, "One of the main objects of our party was to explore a lake or chain of lakes which was said to exist far back in the unknown country. We had a general idea where they were supposed to be, and gradually worked in that direction, exploring and mapping as we went. Frequently we went astray, and on one occasion landed up, completely bewildered, on a high plateau with abrupt mountains on each side and a great peak barring our way." In his report to Umbach, Swannell wrote that 26 miles from Poplar Lake the crew "reached a large alpine meadow. Here we found ourselves in a cul-de-sac.

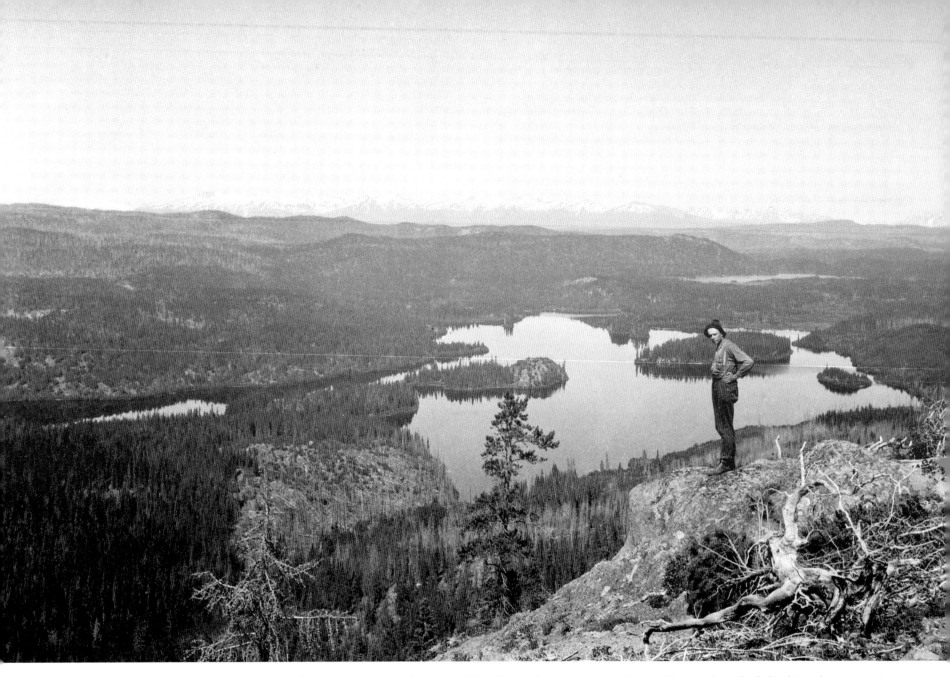

George Vincent standing on a slope above Tagetochlain Lake, with the Coast Mountains in the background. BC Archives I-59189

We back-tracked 3 miles and at a small lake found the sills of a burnt cabin and traces of a trail leading N.W. to Nanika Lake. The valley was largely meadow crossed by rocky ridges, nearly clean burnt. 30 miles from Tagetochlain Lake this trough valley ended and through a narrow gap we saw down into the swampy plain between Price and Nanika Lakes and cut our way down into it."

On July 18 "Pollard & I climb Price Mt. – over 7000' – reaching top at 1 pm – after a very exhausting climb up rockslides – Bitterly cold wind on top but stick to it 3 hrs – Get all main points Atna to Chikamin including peak 9020." From this peak Swannell was able to connect his 1925 surveying with all his main triangulation stations in the Coast Range between the peaks where he started in 1920 and his work northwest beyond Morice Lake in 1924.

George Vincent described climbing the mountains with Swannell or Pollard.

Most of our work was done by triangulation, and this necessitated the almost daily climbing of mountains, and not small mountains either! Two of us would leave camp at daybreak and commence our climb, packing a heavy transit and tripod on our backs. On our hips a small, very small lunch.

After many hours of strenuous scrambling and stumbling over boulders and deadfalls, we would hit the snow line, and then our worst troubles began. The snow was frequently so soft that one sank down at every step, or else so hard that one was in imminent danger of sliding down to perdition.

SURVEYING CENTRAL BRITISH COLUMBIA

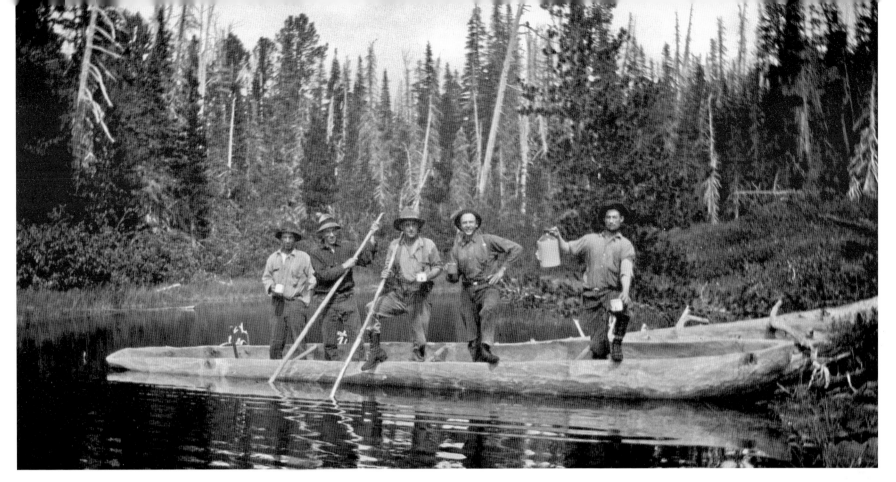

Glaciers on occasion barred our path, causing either wide detours or perilous crossings. Frequently, even at midsummer, we ran into blizzards on the mountain tops, and it was always bitterly cold and windy after a few thousand feet, making it necessary to add heavy mackinaws to our burdens.

When we reached the top of a mountain after many hours of scrambling, the instrument man would set up his transit and commence to take sights at the distant peaks for triangulation. This was if the weather was sufficiently clear. On the other hand, if it were cloudy, or the vision bad, as was only too frequently the case, all our labor had been in vain, and we simply had to climb all over again on the next fine day. It was a favorite trick of the weather to remain perfectly clear until we had reached the summit, and then for a sudden mist and squall of snow to come down. Thunderstorms frequently raged on the lower hills. Sometimes we would decide to wait for a while, on the off chance of the visibility improving, and would sit and shiver for an hour on an exposed peak, cursing all creation.

Even if it were fine, the reading of the various peaks usually took a number of hours, during which it was my job to accumulate enough rocks and build a cairn – not an easy task at that temperature and altitude. Then I would sit down and shiver, while the instrument man became numbed and short-tempered. The climb down was invariably the worst, and we were always dog tired by the time we reached camp.

Yet the views from the mountain tops were worth it. On a clear day endless miles of Coast Range were stretched out in snow-capped majesty as far as eye could see, while inland loomed leagues of hazy blue forests, dotted with countless lakes and silver tracery of streams, bounded in the distance by yet another chain of mighty peaks. From the top of one mountain on a fairly bright day I counted fifty-nine lakes, ranging in size from a mile in length to fifty miles. It was a weird and awesome feeling to realize that most of this panorama of tossed up peaks, rolling hills, and beautiful valleys, was practically unknown and untrodden by the foot of man, and that, as far as eye could see, there was no human habitation or human life. It gave one a curious sense of loneliness and humility.

On July 21 Swannell's crew finally arrived at Nanika Lake. Swannell's report to Umbach noted that "A much quicker route to Nanika Lake would be by boat from Ootsa to Tahtsa Lake. From a cabin eleven miles up Tahtsa Lake a trap-line blaze over a low pass leads in 7 miles down into Nanika Lake three miles from its head." The next day Swannell set up a base line and began surveying Nanika

■ Christening their new dugout canoe.
BC Archives I-59159

Lake. Since the men were unable to bring a boat or canoe to the lake they needed some type of transportation to travel around this 15-mile long lake. Initially they built a raft, but it was slow and not safe for working on a big lake. On July 23 "Mike, Harry & Ernle leave for mouth of Price River to make canoe – the nearest cottonwood being there." After the canoe was finished, Swannell went "down river with Harry & Ernle and get canoe up into lake. One log jam 300' long, 150' across at top – Drag canoe across in a side channel. River very swift."

Vincent described the construction of this canoe, and its dangerous trip back to the camp.

On these lakes it was perilous and difficult to navigate a raft, so we searched around for a good canoe tree. There were very few large enough, but at length we located a big cottonwood on the shores of the smaller lake, and several members of the party, leaving the main camp and fighting their way through the dense bush, established a temporary camp and started to build a canoe. The feat was accomplished in the record time of twenty-four hours, with no other tools than axes and a small canoe adze.

The trip up the river to Big Nanika and the main camp was swift, and there were frequent log jams over which the canoe had to be dragged. Several narrow escapes from drowning made all thankful when at last we hit the calm waters above, and triumphantly paddled the first canoe ever launched on those lakes. We had a great christening ceremony and celebration, in which a keg of rum was involved, and a weird song entitled "The Seattle Potlatch" sung by Harry the canoeman.

Swannell and McLean spent about 10 days surveying the lower part of Nanika Lake. The work proceeded smoothly although smoke from forest fires, high wind and rain occasionally limited their work. The other four men took the pack train back to Houston for more supplies. When they returned Swannell moved camp to three miles from the head of Nanika Lake and began surveying the upper part of this body of water. He found "Bolan's cabin at end Tahtsa Trap Trail. Good beach here for check-base which stake out." On August 8 Swannell climbed "Glacier Mt. (West Mt) 6700'. Set cairn & spent 5 hrs reading – Great view of both Tahtsa & Nanika Lakes – Connect

McLean and Fenton making a beam for a shelter in the survey camp at Nanika Lake. BC Archives I-59182

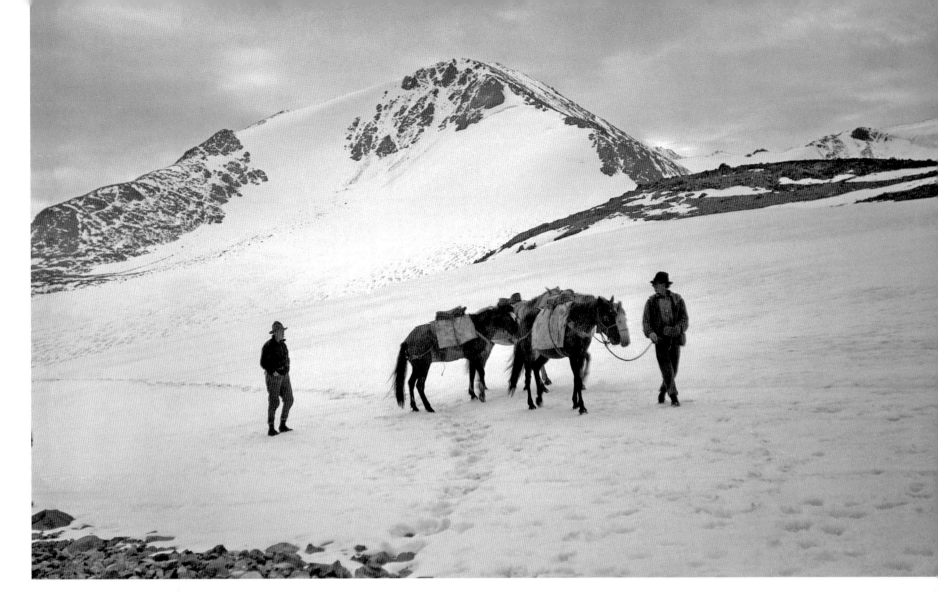

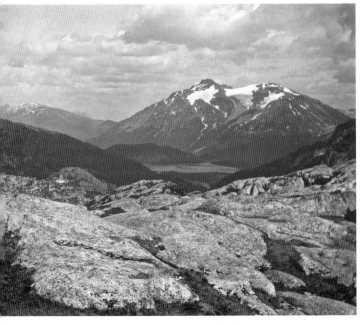

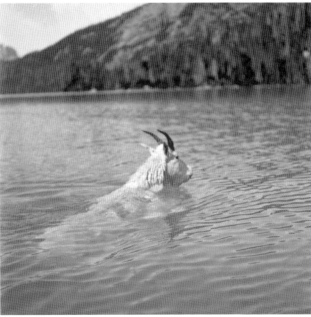

■ The pack train that arrived on September 1 with mail. BC Archives I-59113

■ *Far left*: Nanika Pass at the head of the Nanika drainage looking down into the Kemano valley. BC Archives I-59141

■ *Left*: Mountain Goat swimming in Nanika Lake. BC Archives I-68546

ΔRhine Crag & ΔCamp 5 to new work." Swannell now had a direct tie to his 1921 survey of the Tahtsa drainage.

On August 15 Swannell moved to the head of Nanika Lake. McLean built a raft to travel on upper Nanika Lake and the two men crossed the lake and went to Nanika Pass. This pass was less than 10 miles north of the Penteuch Pass area where Swannell looked down to Kemano from the Coast Mountains in 1921. Swannell recorded that Nanika Pass was "very rough and drops abruptly 2500' to fork of Kemano." Three days later, on their way back down Nanika Lake, Swannell and McLean saw a "big billy goat on rocky islet & chase him around for half an hour – takes to water & photograph him." Swannell spent a day at the cabin on the Tahtsa Trap Trail where he finished working on the base line he had established and surveyed the trail to Tahtsa Summit.

While Swannell completed surveying Nanika Lake some of the men began clearing a trail to the Sibola Mountains. George Vincent left the crew to return to university.

> It was none too willingly that I, with little grub and long days of hard traveling ahead of me, said "good-bye" to the other boys, and hit the trail for the railway, and Vancouver, and Varsity. The second to last day of my trek saw all my grub gone save dried apples, and on the last day I walked sixteen miles before breakfast. It was a strange feeling to meet

■ Right: Pollard shaving at camp.
BC Archives I-59186

■ Below: Swannell often spent the evening in camp doing calculations from the surveying he had done that day or working on field maps.
BC Archives I-59171

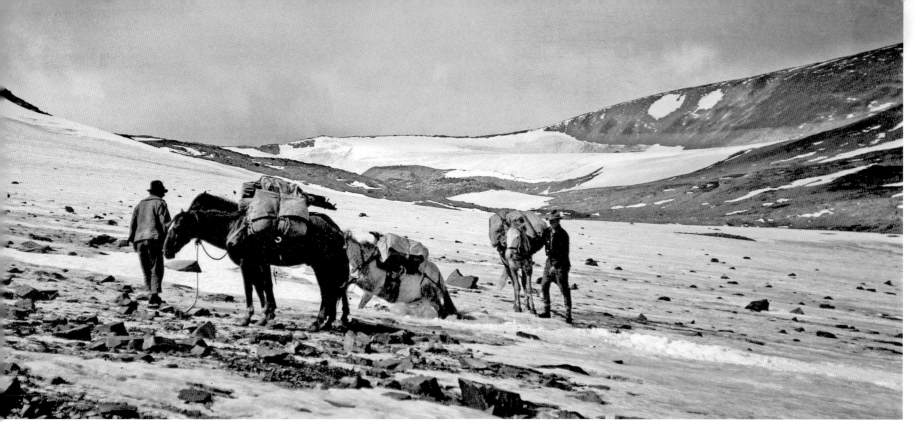

white men other than my five companions on the job, and still stranger to look down from a hilltop and see in the distance the red roof of a station and the gleaming rails. As I stood by the track, very late that night, waiting for the west bound train, a faint mist hung over the sleeping land, and a dim moon rose over the far ranges. In the distance a lone coyote sung dreary sagas, and seemed to voice my regret at leaving that wonderful country, and what had indeed been a most wonderful adventure.

On August 23 Swannell's crew made their first camp above Nanika Lake. Swannell's journal noted new snow in the mountains. The next day continuous rain until early evening kept the men in camp. Swanell wrote that there was "much new snow well into timber line." On August 26, "in spite of execrable weather move camp to timberline on the Sibola. Measure 1600' base in meadow and wait 3 hrs hoping clouds will lift." The next day "Fenton & McLean cruise ahead 7 mi & find feasible route across the range, but 2 feet new snow." On August 28 "McLean & Fenton ahead set 2 cairns & find better route towards Sweeney Mt. All above 5000 covered with new snow." Rain, sleet and snow continued for the last days of August.

The weather cleared on September 1. "Climb Cirque Mt. – Huge amphitheatre with small glacier under cliff – remainder loose rock & glacier detritus. Peak drops sheer 500' under station to glacier below – Last 500' up scramble up huge rock blocks but not very steep. Ernle

builds large cairn while I read – partly as a wind shield – Wind bitterly cold & vibration bad – Heavy clouds driving across the range, finally envelope up: blot everything out.... Took photo of pack train on glacier & a round from ΔCirque – Wonderful horizon of snowpeaks."

On September 3 the men travelled across the Sibola Plateau. "Take horses over 2 glaciers, two break through snow bridge into crevasse – Bad descent down snow above cornice hanging over Comb Ck. Gulch. Attempt

■ A horse falling through a glacier. Crossing glaciers was difficult for the men and their horses. BC Archives I-59114

■ *Below left*: Swannell's crew en route to the summit of Packtrain Peak. BC Archives I-59125

■ *Below*: Horses on Comb Creek cornice. BC Archives I-33825

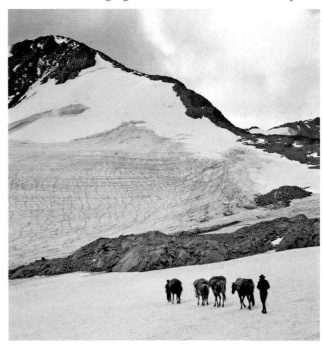

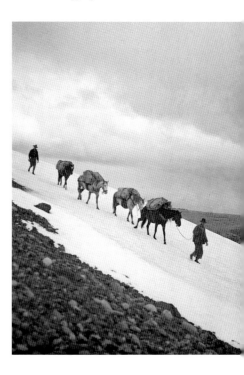

reading ΔSnowstorm but wind too violent." During the next two days Swannell and Money surveyed some of the mining claims in the area and set a cairn on the main ridge of Sweeney Mountain. The pack train travelled to Ootsa Lake to obtain more food and pick up mail, and Pollard went along to survey the newly cut Sweeney Trail.

On September 6 Swannell and Money returned "to Sibola Plateau & read ΔSnowstorm ΔWindstorm. Visibility excellent but wind bad in gusts. Tie 4 Monckton Peaks & Nadina, Wells, Chikamin & Core Mt." From

these two triangulation stations Swannell was finally able to make a rigid connection to Monckton's triangulation network. He was also able to tie Monckton's network with some of the main peaks of his 1920 to 1923 surveys, and the work that he was doing in 1925. Two days later the two men climbed to "ΔPacktrain Peak and spend nearly 6 hrs. reading. Get Monckton points, Nadina, Loring, Redslide, Mt. Wells, Chikamin, PH9020 – Tie into Anahim Butte.... Build very large cairn for reading into from Mt. Wells." The triangulation station on Packtrain Peak was even more successful. From this mountain Swannell was able to read survey angles to Monckton's triangulation network; Bishop's surveys in the Chilcotin; some of the main peaks of his own network; and two of the main triangulation stations from his 1924 survey around Morice Lake. The large cairn that the men built on Packtrain Peak was evidence of the importance of this station for Swannell's triangulation network.

During the next 10 days Swannell surveyed the Sibola Plateau and surrounding peaks along with the mineral claims staked in the area. One day Pollard and McLean surveyed on Sweeney Mountain. From there Pollard was able to make another connection with triangulation stations on Monckton's network. September 15 brought "The Big Storm – Raining in night and nearly all morning, turning into a gale of sleet & snow at 3pm. Have to build brush shelter around camp." The next morning four inches of snow covered the ground.

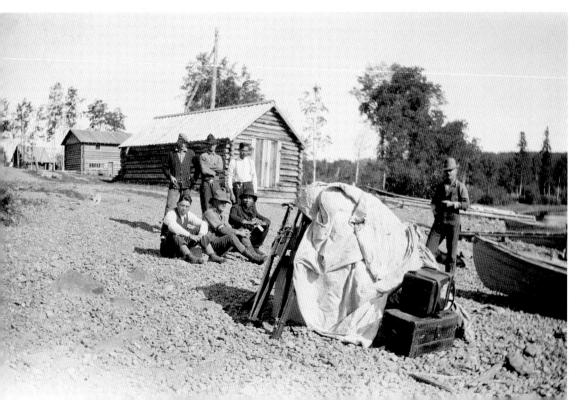

On September 20 Swannell's crew moved down to the Tahtsa where McLean had a boat waiting. Pollard and Fenton left with the pack train for Houston, while Swannell, McLean and Money went to Ootsa Lake. The next day the three men climbed "Mt. Wells, reaching cairn in 2 3/4 hrs. Read 5 hrs. – Visibility good & little wind. Very lucky." On September 23 Swannell, McLean and Fenton moved to Bennett's at Ootsa Lake. Two days later Swannell climbed Colleymount once more. In clear weather he finally succeeded in surveying from this triangulation station, completing his surveying for the 1925 season.

Swannell's crew travelled to Burns Lake and on to Houston where they packed up the supplies and equipment. From Houston Swannell took the train east to Red Pass Junction, where he stayed overnight. The next morning he left on the CN train, arriving in Vancouver on the morning of September 29. There, Swannell boarded the CPR steamship SS *Princess Patricia* for Victoria, where his wife, Ada, and his son, Lorne, came to meet him.

Swannell had a successful surveying season in 1925. He completed all of Umbach's objectives and considerably expanded the triangulation network on the east side of the Coast Range by linking his surveying with Bishop's work to the south, and Monckton's to the north. Swannell's summary for the season records that he and Pollard had surveyed 140 triangulation stations, more than one per day. Most of these stations were on mountains or high locations. Umbach's 1925 government report summarized the importance of Swannell's surveys in central British Columbia:

> A control and reconnaissance topographical survey was commenced in the immense lake area of the Upper Nechako River in 1920 and was practically completed in 1925. The triangulation forms another link in the chain along the east side of the Coast Range, and the topographical information, which completely alters existing maps, is expected to be of great importance in the development of these little-known areas, as well as forming a basis for the study of water storage and control problems on the Nechako River. Proposals have also been made from time to time to divert water from these lakes to the Coast for power purposes, and Mr. Swannell's maps will also give data which will be useful in approaching such a scheme.

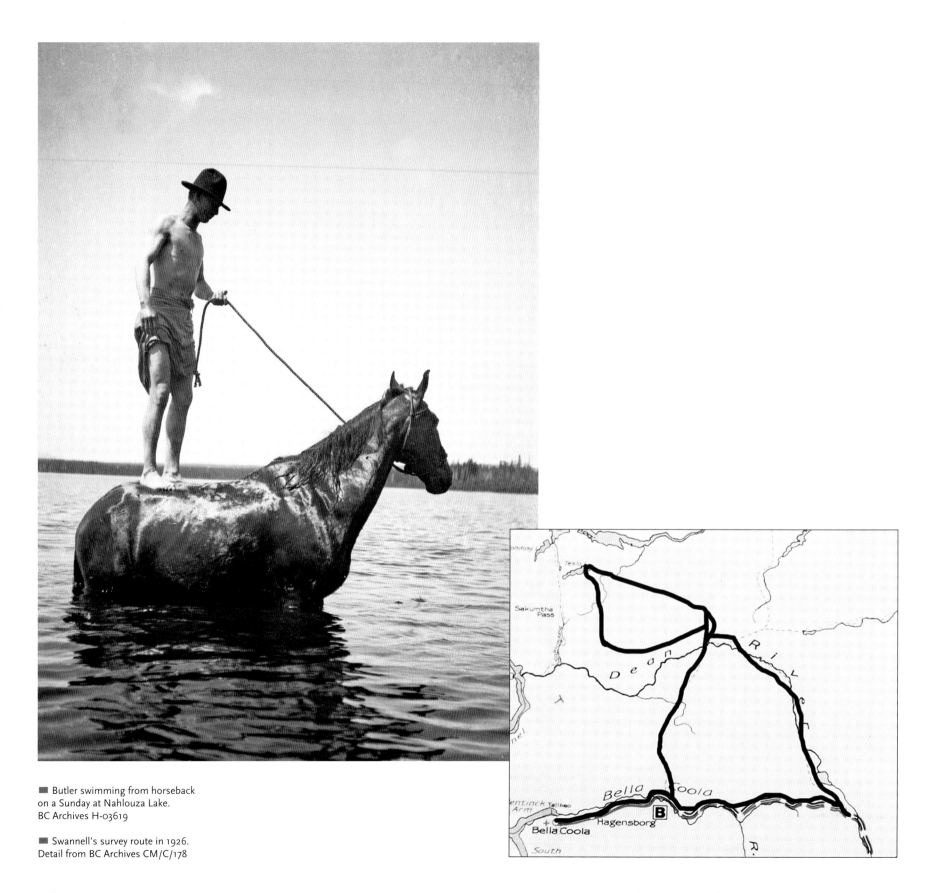

■ Butler swimming from horseback
on a Sunday at Nahlouza Lake.
BC Archives H-03619

■ Swannell's survey route in 1926.
Detail from BC Archives CM/C/178

1926

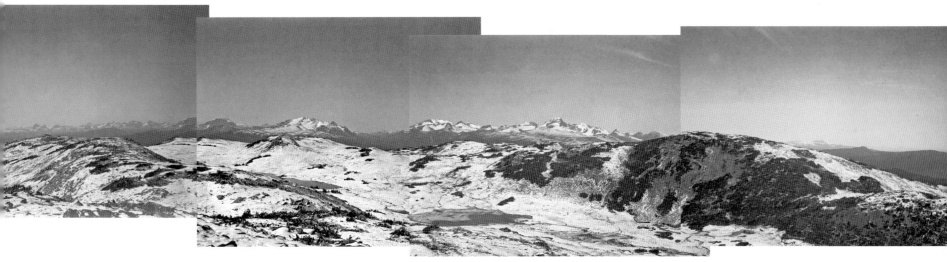

The Surveyor-General's report appeared to indicate that Swannell had finished his surveying in central British Columbia. However, as in 1924 and 1925, when Swannell extended his initial survey northward, the BC government now decided to expand his mapping and triangulation project southward. In his instructions for the 1926 field season Umbach wrote that he wanted Swannell to make a:

> topographic survey of area still unmapped by you, lying south of Eutsuk Lake including the valley of the Dean River and if time permits extending southward to the Bella Coola River and westward to Dean Channel. The standard of this work is to be similar to that done by you in previous years, and it is desired that you should pay particular attention to any feasible passes from the Coast to the Interior. You will, when on the ground, extend your triangulation southward as may be required, using Mr. Bishop's network of triangles where possible, and at the same time endeavour to improve the connection between these two nets of triangulation.

Bishop had surveyed from Eutsuk Lake to Bella Coola in 1923, making a connection between the coast and interior triangulation network. However, he did not have time to make an extensive topographic survey of the area. Despite Umbach's earlier complaints about Swannell including too much detail in his surveys and maps, the Surveyor-General must have developed an appreciation for the quality of his work. Much like the CPR, which 50 years previously had explored the passes through the Coast Mountains searching for the most favourable railroad line, the BC government wanted a detailed map of the possible routes between the coast and interior in central British Columbia. The government was beginning to consider potential hydro-electric projects in the area. It was also looking at transportation routes, for a network of roads was beginning to develop in the interior and along the coast, but there was no connecting route yet. The province also wanted more information about the economic potential of this remote area.

Swannell's 1926 surveying would connect with his work in 1920 when he had surveyed from Eutsuk Lake to Dean Channel further north. By tying into his own triangulation system and using Bishop's stations wherever possible, Swannell could connect the two networks more accurately, much as he had done with Monckton's network in 1925. Swannell had the option of beginning his work either from his own surveying at Eutsuk Lake or from Bella Coola. He wrote to Umbach that, "The latter place, however, I made my base of supplies for the first part of the season, in order to have an opportunity of examining the Summer Trail from the Bella Coola Valley to Ulkatcho – a route to the Interior Plateau as to which the Department had no information other than that given by Dr. Dawson in the Geological Survey Report of 1876, supplemented by a general

description in Mr. Bishop's 1923 report." Swannell also probably wanted to start at Bella Coola so he could explore a new area and follow Alexander Mackenzie's route through the Coast Mountains.

This year, Swannell had an entirely new crew. A.C. Pollard left government surveying, so M.H. Ramsey (BCLS #196) was hired as surveying assistant. Ramsey, who would be Swannell's assistant for the rest of his surveying in central British Columbia, had been a sailor in the British Navy and worked on government surveys in the Chilcotin with W.C. Merston (BCLS #75) for several years. Another crew member was Captain Jones, a former British officer who had resigned his commission to go to the Klondike around 1910. When World War I started Jones returned to the army from his place near Kluane Lake. Leonard Butler, an American who had fought in World War I, also worked on the crew. Butler received the nickname "Wahla" from the Chilcotin. Swannell's packer was George Powers. George's wife, Jessie, was the cook for the crew. This was the first time that Swannell employed a woman on his crew, and Jessie was probably one of the first women to work on a government surveying project.

Swannell, Ramsey and Jones left Victoria on June 3 for Vancouver where they boarded the Union Steamship boat *Venture* for the trip to Bella Coola. En route they stopped at several small communities along the coast,

two canneries in Smith Sound, and several canneries in Rivers Inlet. The ship passed Mackenzie's Rock and ran into "Green Bay 9 pm – many fishing boats out – Tahlco Cannery later – difficult steering to avoid nets. Arrive cannery wharf Bella Coola 11 pm."

Swannell spent a day "at Bella Coola outfitting, dividing custom between Brynildsen's & Christensen's stores. Arrange with Young, Road Superintendent, to meet at outlet Tesla Lake July 22 – he to bring canoe down from head of lake." On June 8 Swannell and his men left Bella Coola in two trucks each loaded with about 1800 pounds of goods. It took four hours to travel the 32 miles to Burnt Bridge Creek where they camped for the night. "Find Geo Powers, Jessie and Leonard Butler here with 14 horses – Very impressed with the packers from the Chilcotin." They also met J.W. Hober, one of the local people, who showed them the location of the survey corner that Swannell would use for the beginning of his survey. While the packers spent a day making up packs for the supplies, Swannell and Ramsey prepared for the surveying. Hober took them to the "site of Mackenzie's Friendly Village. Take photos of old fireplace & timbers – Old Indian, John Moody, camped at Burnt Bridge however say these remains are of old old trading post where three Americans lived, trading with Anahim Lake – says he is 66 & village inhabitants killed off by smallpox several years before his birth."

◼ *Below*: Brynildsen hotel after flood. BC Archives I-59293

◼ *Below right*: Leaving Christensen's store. Left to right: Captain Jones, Christensen and his sons, and Martin Ramsey. BC Archives I-59294

On June 10, while the packers moved their cache ahead, Swannell began a traverse survey of the Burnt Bridge Trail, a spur of the summer trail between Bella Coola and Ulkatcho. "Trail extremely steep & rocky & switchbacks very short – need turntable for the horses to make'm Wahla (Butler) says."

Two days later, on Saturday, Swannell decided to "Call today Sunday. With Jones make further cruise along Bella Coola River & find further evidence of Mackenzie's Friendly Village." Swannell observed that the current channel of Burnt Creek was about 300 feet further down the Bella Coola River and that, "The present mouth of Burnt Creek is not visible from the steep bluffs from which Mackenzie's guides showed him the village." He observed that the "old village site now mostly dense jungle of rose bushes – fine gooseberries – Further back to north still open. Here found several circular depressions & stones artificially sited – old fireplaces. Along the bank of the old channel – now partially overgrown & evidently dry many years found traces of old landings & trails for water." In his report to Umbach, Swannell provided more detail about his visit and subsequent information that he gathered. "This year, guided by Mr. J.W. Hober, who lives close by, we were able to locate the actual site of Mackenzie's village, abandoned when its inhabitants were almost wiped out by

smallpox in the early sixties of last century.... An old Indian told us that in his grandfather's day three 'Bostonmen' had had a trading post here. He neglected to add, what the Algatcho [Ulkatcho] Siwashes told us later, that the denizens of Friendly Village had belied their name, and some fifty years after Mackenzie's visit had murdered these American traders and looted and burnt the post. The timbers we found were charred by fire, so the yarn may perhaps be true."

The next day the crew moved camp to the West Fork of Burnt Bridge Creek. Swannell described the trail up this creek to the Surveyor-General. "So steep is the grade that in two and a half miles we had reached a broken plateau 3700 feet above the Bella Coola.... The view from here is wonderful and being the same prospect that so impressed Mackenzie nearly 130 years ago." Near this location Swannell and Ramsey established a "short base & triangulate in Mackenzie Peak – alt 8500 to our surprise (Mackenzie's Stupendous Mt.)". Swannell told Umbach that, "It is a landmark for many miles to the north on the Summer Trail and was plainly visible from Sigutlat Lake, fifty miles away."

The men spent four days surveying in the vicinity of this camp. One day, while moving supplies to their next camp the packers reported: "Fresh grizzly track –

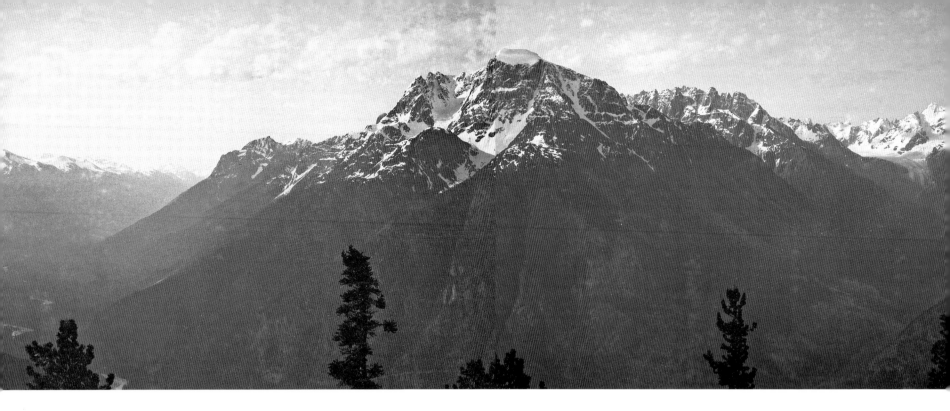

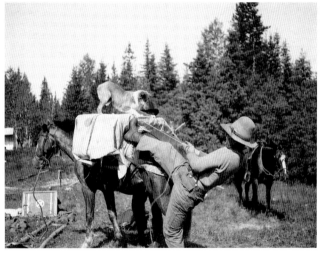

■ **Mackenzie Landmark*** – Stupendous Mountain. In Swannell's journal, he quotes Alexander Mackenzie: "Before us appeared a stupendous mountain whose snow-clad summit was lost in the clouds; between it and our immediate course flowed the river to which we were going."
BC Archives I-59317, I-59318

* Note: Throughout the 1926 and 1927 seasons Swannell located and photographed landmarks that Alexander Mackenzie described on his trip to the Pacific Ocean in 1793, and he usually included the explorer's description in his journal.

■ George Powers packing one of the horses with help from Jessie's dog, Entzoosul, who accompanied the survey crew. George came to the Chilcotin from Washington state in 1914. He fell in love with Jessie Bob, the daughter of a Chilcotin chief. Jessie's father forbade her to marry George, so the two eloped to the remote valley of Tatlayoko Lake. Jessie later reconciled with her father, and she and George eventually established a permanent home at Charlotte Lake. Tommy Walker, in his book, *Spatsizi*, describes his working relationship with George Powers when he operated his lodge in the Bella Coola River valley. In *Grass Beyond the Mountains*, Rich Hobson writes about a visit to George and Jessie's place at Charlotte Lake during his first winter in the Chilcotin.
BC Archives F-07948

■ Jessie Powers (left) and her sister.
Library and Archives Canada E-008222018

moccasins size 12 says George." On June 17 Swannell's crew made their third camp in a subalpine area one mile past Fish Lake. They were now on the main "Saghalie or Summer Trail". From Fish Lake Swannell traversed the main Saghalie Trail back towards Canoe Crossing almost to the divide leading down into the Bella Coola valley. He also spent a day traversing the Capoose Trail, which ran east to the Dean River north of Anahim Lake. During their time at this camp Ramsey got kicked in the head by a colt, and Ramsey and Powers spent a Sunday at Fish Lake where they caught 32 trout.

The crew spent the rest of June continuing their traverse along this trail. Swannell described the Saghalie Trail to the Surveyor-General. "For miles beyond Fish Lake the general direction of the Trail is remarkably straight, a very little east of True North. The country is semi-alpine, the timber stunted. To the east lie the terraced and scalloped western ridges of the Rainbow Mts.... Westward still the snow clad peaks of the main Coast Ranges were visible from every rise in the trail. From Mile 20 on the Trail starts swinging to the N.E. between broken ridges; the general slope of the country being N.W. down to the Dean River."

In an article for *The Beaver* magazine, Swannell wrote: "Three of us traversed trail and triangulated. As we were the first over the trail this summer – indeed the snow was still lying in draggled drifts – it was in wretched shape. The packers worked like Trojans, chopping through fallen timber, corduroying the worst mudholes; where the trail was hopelessly impassable, locating and cutting out a new one." Along the way Swannell established a triangulation

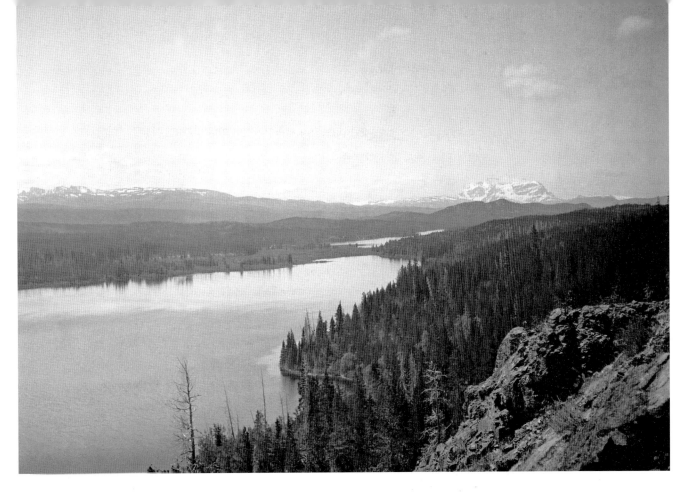

■ **Mackenzie Landmark*** – Tanya Lake. Swannell noted in his diary: "Tanyabunkut or Long Lake. Mackenzie came along here 1793." BC Archives I-59405

* See "Note" on facing page.

■ *Below*: Fording the Tesla River. BC Archives I-59440

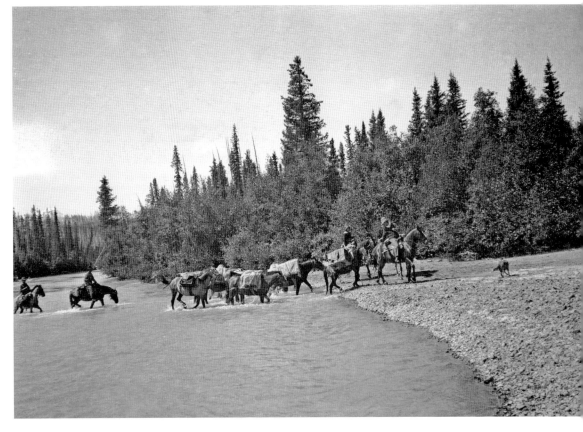

station where he was able to connect his survey with two of Bishop's triangulation stations, Peak 9020 that he had used during his survey of the Nechako headwaters, and several of the mountains to the north where he would be surveying later that summer. While traversing the trail, Swannell's crew met a group of Ulkatcho with 60 horses travelling to the Bella Coola valley. Swannell noted that Cahoose, Squinas and Captain Harry were among the First Nations people. "They were highly delighted that we had a passable trail cut out ahead for them; but warned us of bad trail in front of us. 'Jes' you come dat place you cly' – with rage presumably! From Mile 15 to Mile 26 the trail was indeed execrable."

As they passed Tanya Lake, Swannell noted: "Lower end Long Lake (Tanya) an Indian fishing station – probably old village site." On July 2 they forded the Dean River, 55 miles on their survey traverse. After crossing this river, Swannell did not continue the remaining 12 miles to the First Nations village at Ulkatcho, but instead headed northwest to Qualcho Lake, arriving at the lake's outlet two days later. Monday, July 5 was "Holiday all hands. Gather pitch & spend several hours patching up old canoe. Camp on old village site – keekillie houses & old caches dug into ridge obsidian chips – beautiful view up lake. Obsidian found on Anahim Peak & also Cheslatta Lake – traded over whole Interior." Swannell

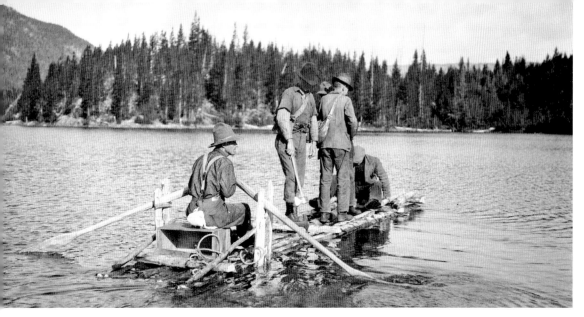

Rafting on Tesla Lake, with Olaf Johansen at the oars. Leonard Butler stands in the centre of the raft. Beside him, with the bag over his shoulder, is Douglas Lay, a Department of Mines engineer, who later became a senior mineralogist in the provincial government. Captain Jones sits at the bow. BC Archives I-59437

Below: Rafting on Tesla Lake. BC Archives I-59408

spent three days doing a traverse and triangulation survey around the lake, and one evening took an observation on Polaris for direction.

Then the crew went to Nahlouza Lake and did similar surveys. Sunday, July 11 was "Holiday all hands. Leonard out swimming from horseback." Next was Tahuntesko Lake. Swannell's crew reached the outlet of the lake on July 16 and were now less than 10 miles south of Eutsuk Lake. From the lake Swannell started a "traverse toward Tesla Crossing, but find station stakes of Bishop & discontinue." Once again he had made a connection with

Bishop's survey through the area. Swannell and Ramsey set up and measured a base in a meadow near the lake.

On July 22 Swannell's crew arrived at Tesla Lake as he had planned. "Raining most of day & heavy rain at night." On the following day Young arrived – without a canoe. "Young, Gadsden, Bert Clayton & Dist. Mining Engineer Douglas Lay arrive on raft thoroughly soaked and without blankets or food. Our cook made slapjacks for an hour to fill them." At Tesla Lake Swannell climbed "high craggy hill to find best route for trail to Eutsuk – Erect signal." Young and Lay and their helpers assisted Swannell by setting signals along the lake on their way to Tesla Mountain. Lay and two men also erected a cairn on Wahla Mountain, the name the Chilcotins gave to Butler.

During the last days of July some of Swannell's crew cut 4 1/2 miles of pack trail from the Tesla River to Eutsuk Lake. Before leaving their camp at Burnt Bridge Creek, Swannell had written G.S. Eddings at Ootsa Lake requesting that he bring a boat load of supplies to Eutsuk Lake on August 1. Eddings wrote back to Swannell: "Received your letter of June 14 June the 30 and I will be on hand Aug. 1st with a boat and the grub you sent for. I will probably bring Vantine along to help me.... I will fix up the boat a little and start in time enough to spend 2 or

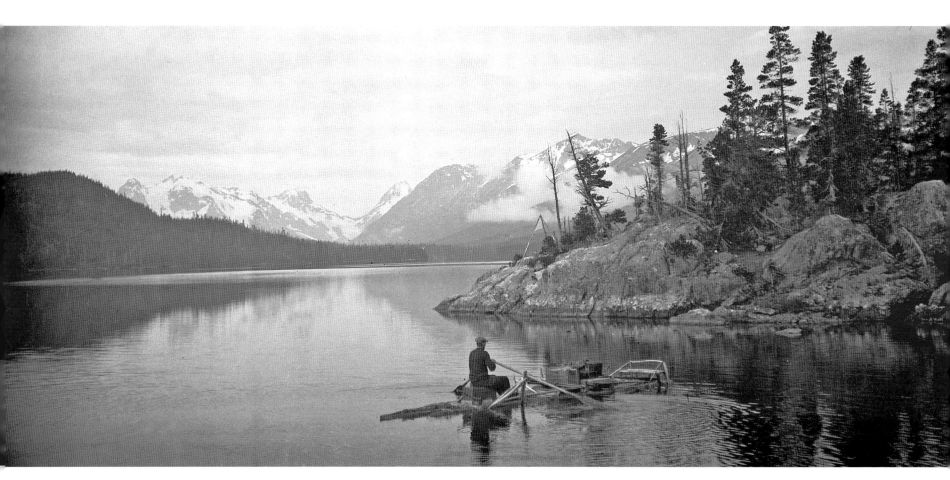

3 days on the portage and put in some skids in places as it is not in much shape.... The spring has been cool and frosty with high cold winds and the gardens are very backward. It has only warmed up within the last week so that stuff has begun to grow. No excitement on the Lake as usual, no one has died or been murdered.... And if you are on the south side of Eutsuk Aug 1st I'll find you. Make a big smoke and I'll make one in answer from the north side and come across." On August 1 "Ramsey & packers at Eutsuk Lake with pack trains to meet boat with supplies. Left camp at 9 am, returned 10 pm."

Swannell spent the first three weeks of August surveying Tesla Lake and the surrounding area. The lack of a canoe meant that the surveyors had to use a raft, making their work more difficult. "Get deck & rack for stuff on raft," Swannell wrote on July 28. "Caught by wind & load nearly washed off raft," Swannell wrote two days later. The following day "wind rises 10:00 am – to lighten raft put Jones ashore." On August 1 Swannell recorded in his journal that, "In view of our raft turning submarine yesterday add an extra log & high deck for dunnage." On a few days, waves from high winds soaked the men and their supplies on the raft. One day the surveyors were "Held up on Gull Rock 2 hrs. by violent wind & heavy sea – no shelter or wood – have to take turns holding raft in lee of islet – Get off during lull but caught on a lee shore – raft does not rise to the seas – After hour hard pull get into cove & find Dawson & Olaf refuging there. Wait until wind dies down at sunset." Travel on the raft was slow compared to a canoe. On August 6 Swannell observed: "Self & Jones up lake triangulating – terribly slow work with a raft. 1.84 miles per hour our best record for rowing & paddling."

One day when it was too windy to work on the lake, Swannell climbed Horseshoe Mountain and erected a cairn on the first summit. From this station Swannell located "several more hitherto unknown lakes" and tied into some of his triangulation stations around Eutsuk Lake and two of Bishop's. Swannell went back up this mountain again while he was at Tesla Lake, and used this station for his topography of the Tesla Lakes.

Swannell also climbed the low pass between Tesla Lake and Pondosy Bay on Eutsuk Lake. "Judging from very old chopping seen here and there in this pass and down the Sacumtha Divide there must have been an old grease-trail, last used some 60 years ago, from Eutsuk Lake to Kimsquit Bay," he wrote Umbach. While triangulating upper Tesla Lake Swannell found "Duffy's cabin at head & very old Siwash foot-trail reblazed by him." Swannell followed this trail through Sacumtha Pass over the Coast Mountains for about four miles. "Traces

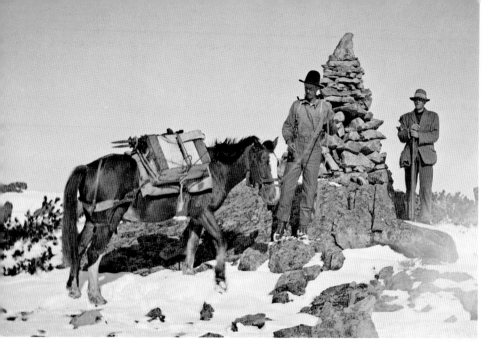

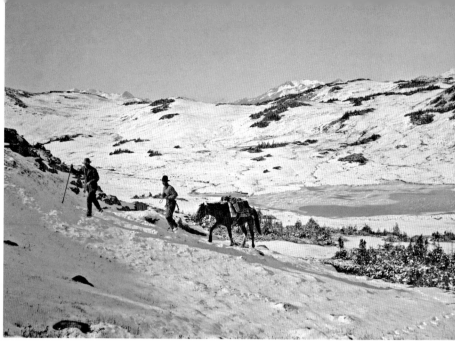

occasionally of very old Siwash trail. Oldest blaze 61 yrs. – One pine skinned for inner bark exactly 100 yrs ago. White man blazed 31 yrs ago as Pondosy Trail – reblazed probably by Duffy." In his report to the Surveyor-General Swannell wrote: "Last year about 12 miles of trail was opened up and built from Kimsquit, at the mouth of the Dean, to a bridge a couple of miles up the Sacumtha, its ultimate destination being Tesla Mt. where the trail-builders have a group of mineral claims." He commented that: "It would seem advisable, however, to extend the trail directly to Upper Tesla and across to Pondosy Bay, Eutsuk Lake, whence there is direct communication by water to the Ootsa Lake settlements. Swannell observed that: "From Kimsquit Bay to Upper Tesla Lake is undoubtedly the shortest, and in many respects, the best route from saltwater to the Nechako-Fraser watershed. The summit is 1500 feet lower than that of the Bella Coola – Algatcho Summer Trail, the distance only 35 miles."

While Swannell was working around Tesla Lake Ramsey cut and surveyed an eight-mile trail around the slope of Mount Nadedikus to Oppy Lake. The crew moved camp on August 21 and Swannell spent the rest of the month surveying around this lake. Ramsey worked in the alpine area southwest of Oppy Lake and found what "probably is the old Kimsquit Trail". Ramsey had made arrangements to pick up another load of supplies at Eutsuk Lake on September 1. This time Swannell and George and Jessie Powers made the trip. They arrived at Eutsuk Lake on the afternoon of August 31 where Swannell found his friends Bill Henson and Shorty Grell already there with 1000 pounds of goods.

George, Jessie and Shorty Grell took the supplies back to Oppy Lake while Swannell and Henson went to Bennett's at Ootsa Lake where they spent a couple

of days. On the return trip Swannell and Henson went into Pondosy Lake, then up to Forbus Lake trying to reach the pass towards Smaby Peak, only a few miles from where Swannell had crossed the Coast Mountains in 1920. However, they didn't reach the pass because of dense brush. Swannell spent two days doing a rapid triangulation of Pondosy Lake to add to his topography of the region. By September 10 Swannell was back at Eutsuk Lake where George, Jessie and Shorty Grell met him.

While Swannell was away Ramsey continued the surveying. Like Swannell he kept a diary. Initially he continued south of Oppy Lake finding more evidence of old trails used by the First Nations people to travel through the passes of the Coast Mountains. On September 1 "All hands up Ramsey Mt. Built 2 cairns (narrow loose top – first cairn fell down taking foundation & pitched down glacier nearly taking Butler along." The next day the crew headed for Watut Mountain. "At noon, following up a draw killed bull caribou – Now too late for reaching cairn." However, they did reach Watut the next day. On Sunday, September 6 Ramsey recorded that "Divine Service was not held – there was no collection."

Ramsey, Jones and Butler left on September 8 for a week trip surveying through another pass in the Coast Mountains. On September 10 they "moved camp down to meadow on Bernhardt Creek – En route discovered old Kimsquit Trail". The next day Ramsey and his crew "left camp 7 am to explore old Kimsquit Trail. Struck up Bernhardt Creek and found trail crossing high up – followed to highest pt 4500 where we could see into Dean & Sacumtha Valleys. To camp 4 pm – later explored down Bernhardt Creek southerly – bad, very rough broken hillside & windfall in narrow main valley below lake. Returned 7:30 pm. Ramsey takes swim in

lake (impromptu – fell off sidehill)." By September 14 Ramsey was back at Oppy Lake. "Swannell & Powers cum Jessie rejoined the community and were received with the customary celebrations and firing of salutes. In the evening what Mackenzie would call a regale."

That night the first snowstorm of the season occurred, and the following day everyone remained in camp while the gale and snow continued. It was now mid-September and time to begin returning closer to the main trails. Swannell and the crew moved to Watut Lake and on September 18 "self, Butler & Jones climb Watut taking transit etc. right to top on pack horse – Glorious day if a little sharp. Get very excellent readings." The next day, while still at Watut Lake, it began snowing at dusk. In his journal entry for September 21 Swannell wrote: "Snow continues all night without intermission until dark – 24 hrs altogether. Regular blizzard and very miserable in camp as impossible to keep warm with open fires." The morning of September 22 was "clear – 10 inches snow & trees frozen & crusted over." Swannell went back to timberline on Watut to take photographs. He noted in his journal that three people had suffered some frostbite to their feet.

Since the trail to Sigutlat Lake was filled with windfall Swannell's crew cut their own trail to Nahlouza Creek, "miserable work a/c heavy snow on branches & windfall". Their camp at Nahlouza Creek was near the 53rd parallel that Bishop had surveyed in 1913. "Bring trail traverse to camp 1.75 miles – Tie to old Post Ctr L.2142 – Trace line to 53rd to 92m [mile post] – follow latter east to Nahlouza Creek." Swannell had now connected his 1926 work with a survey lot and a major place on Bishop's survey in the area. It was only one mile further west that Bishop ran his survey from the 53rd parallel to Eutsuk Lake, Swannell's starting point for his survey of central British Columbia. While at this camp Swannell took an inventory of their supplies. "Will be short sugar, bacon, baking powder. 900 lbs on hand, including Nahlouza cache & excluding fresh vegetables. Exit eggs from hot cake batter. OB Joyful one bottle only (HBCo Rum). Finish caribou meat."

On September 28 Swannell's crew reached Sigutlat Lake, their 50th camp. "Cruise down Sigutlat River & find old CPR line trail – latter hardly traceable." In his government report Swannell wrote that: "It was up its [Sigutlat] outlet, the Iltayusko, that the C.P.R. location line of 1876 was run from the Dean. The country here is very rough, the dense stand of hemlock foul with brush and windfall so that hardly a trace remains of the pack-trail of fifty years ago."

Swannell also described to Umbach the evidence of the "Stick" Trail that he found along Sigutlat Lake and in the area.

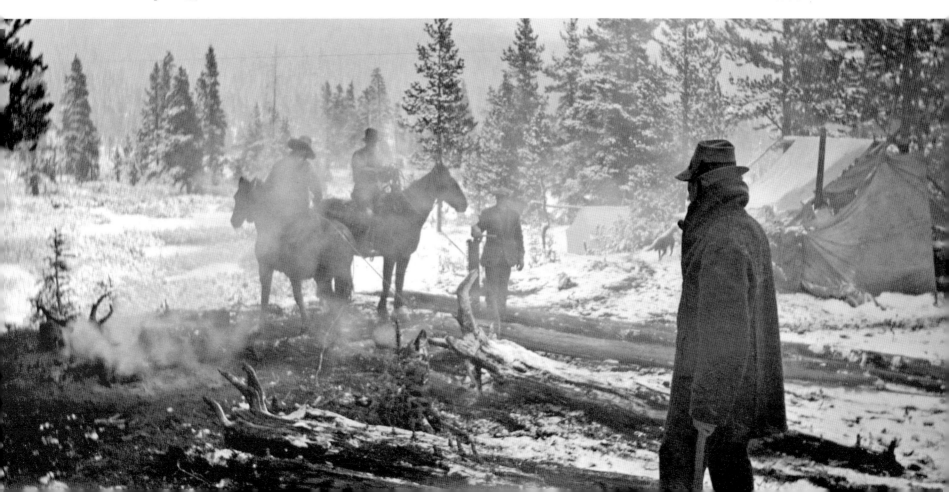

Hauling firewood to camp.
BC Archives I-59409

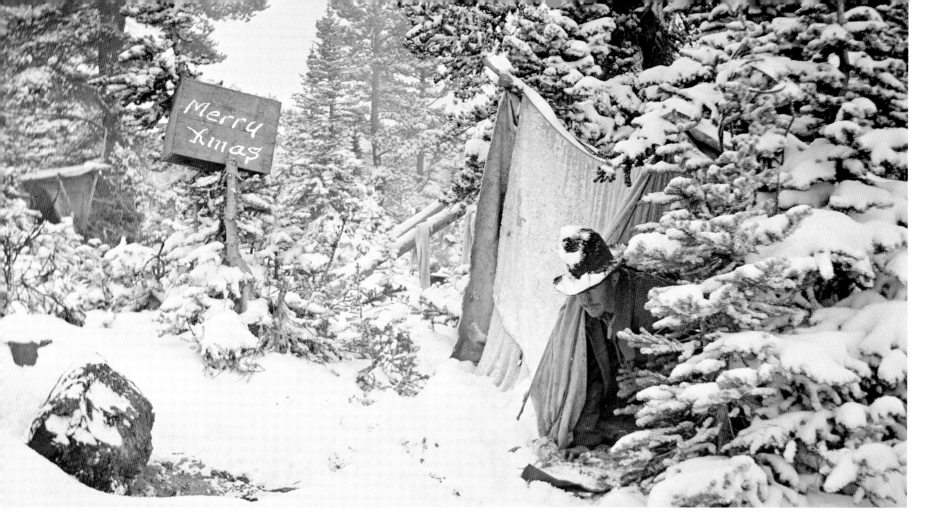

Swannell's crew made the "Merry Xmas" sign after the big snowstorm. BC Archives H-03649

The old "Stick" Trail – so called because travelled by the "Stick" or Forest Indians of the Interior – followed the north shore of Sigutlat Lake, struck across to a smaller lake beyond and worked up into the high alpine country where we had before stumbled across it. It has been disused for a generation except by an occasional Siwash or white trapper, and is, near Sigutlat Lake, badly grown over and blocked by fallen timber. Formerly it must have been as much used as is the present Bella Coola trail. It was chopped out wide and old camps are everywhere. The very old chopping had been done with axes made after the stone-axe pattern – a hoop-iron blade lashed at right angles to the haft like a hoe. Less old blazes I chopped out showed 71 and 83 rings of annual growth respectively.

Swannell spent about two weeks at Sigutlat, triangulating the lake along with establishing and measuring a base line to complete the surveying for the season. From one of the stations on the base he took an observation on Polaris and was able to sight Peak 9020. Swannell set a large triangulation station on Sigutlat Bluff where he was able to sight both Stupendous Mountain

in the Bella Coola valley and one of his triangulation stations around Eutsuk Lake.

From Sigutlat Lake Swannell's crew went back to Qualcho Lake. "Fix with Captain Harry for use of his canoe by leaving 3 lbs tea, 20 apples & pail lard with canoe & giving him 7 lbs at his cabin." Swannell and Ramsey spent an "afternoon cruising out the old CPR line & trail – in places both very distinct." Swannell described to Umbach what he found at Qualcho Lake. "From Algatcho [Ulkatcho] to Sigutlat Lake, 35 miles, there is a good trail, the section from Kwalcho Lake on being the route of 'Y' Division of the C.P.R. survey in 1876. The work of their axemen is still evident along this wide cut trail and the actual location line in many places may be easily traced. Indeed, while surveying Kwalcho Lake, we found an old camp, with the stakes on which the draughtsman had supported his table still standing. On a large spruce was the inscription in red:

C.P.R.S.
'Y'
Camp No. 7
July 24th, 1876
Moved camp July 27th

"On page 38 of Dr. Dawson's Report for 1876 he mentioned visiting Mr. Jos. Hunter, in charge of 'Y' Division at this identical camp." Swannell "spent two hours chopping & wedging out the slab", which he gave to the BC Archives.

From Qualcho Lake the crew travelled to Ulkatcho, where Swannell bought food and moccasins at Stellus' store before continuing down the trail. At the Salmon River crossing they had "lunch (including rum in a dirty wine glass) with Capoose – resplendent in a buckskin coat." At camp on October 21 Swannell wrote that: "Tonight being Trafalgar Day finished the rum." In a note added later Swannell commented that: "The bright idea was Ramsey's as he had served in the British Navy."

The next day Swannell's crew reached Towdystan.

At Towdystan, Swannell and his crew followed the Atnarko trail to the Bella Coola valley. They found some of the First Nations people staying at Precipice Camp, including old Guichon, Celestine and Domus Squiness. On October 27 the surveying crew "reached cabin at Stuie 4 pm, passing HBCo man Ware going in to start a trading post at Anahim Lake." The following day they arrived at Wilkersons 1 1/2 miles above Canoe Crossing Bridge having travelled 164 miles from Sigutlat Lake in 12 days. During the 1926 season Swannell's crew had travelled over 1000 miles by horse, boat, raft and canoe; had run over 140 miles of traverse; and had occupied 133 triangulation stations.

■ Camp at Sigutlat Lake. Left to right: Swannell, Powers, Jones and Ramsey. BC Archives I-33881

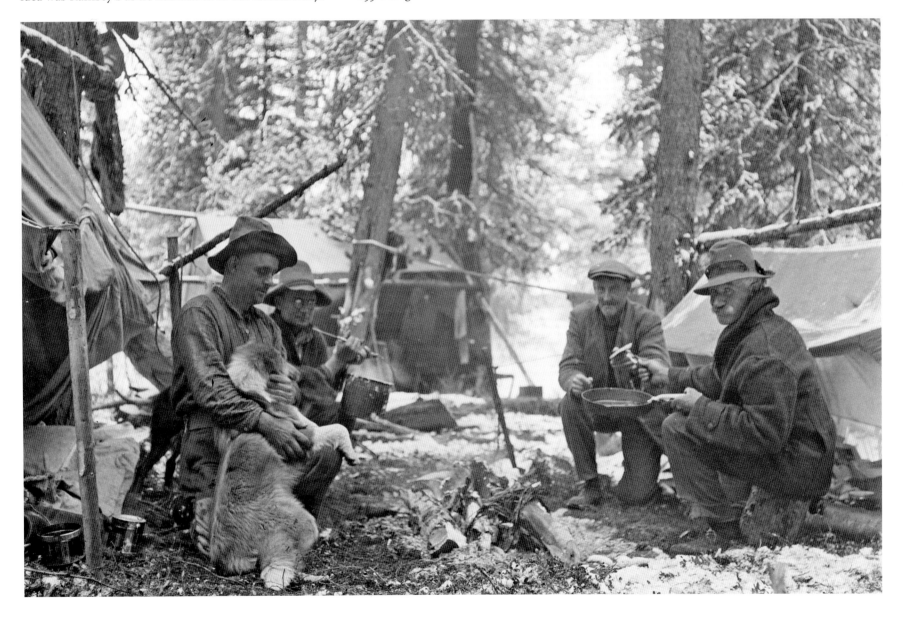

■ *Below*: Section of the tree that Swannell
found at Qualcho Lake. Although the
inscription is over 130 years old and
partially covered with pitch, some of the
writing is still legible. RBCM 964.2580

The next day, before leaving for Bella Coola, Swannell was "shown old 4 foot cottonwood about 1/2 mile down road from Canoe Xing Bridge on Hog's place. 'Palmer Camp 8'. J. Black cut into far side of tree – F. H. Powell on small cedar. Palmer inscription had been cut down 30 years ago. Chop into scar on cedar 64 years by rings... Camp 8 Palmer about July 20, 1862. Lieut. Palmer here with two sappers, Breakenridge & Edwards." Lieutenant Henry Palmer was a member of the Royal Engineers who made a survey regarding the feasibility for a road from Bella Coola to the Cariboo gold fields.

By November 1 Swannell was back in Victoria. The 1926 season had been very productive. He had mapped the area from Eutsuk Lake south to the Bella Coola valley. Although Swannell's surveying had not reached Dean Channel, he had mapped several passes through the Coast Mountains in this area and found trails that led to the ocean. Swannell also made a firm connection with the surveys that Bishop had made in the Chilcotin. In his report the Surveyor-General wrote that from Monckton's surveys, which had reached Meziadin Lake near Stewart, there was a "chain of triangulation control surveys which now extends along the east side of the Coast Range as an unbroken net to the 49th parallel."

In his government report Swannell commented on the economic potential of the area that he surveyed. "On account of the high altitude and rugged nature of the mountain area mapped, there is of course, no agricultural land." He observed that most of the forest was pine that was less than a foot in diameter, and he wrote that: "The mountain area has only been prospected in very desultory fashion." Swannell believed that: "This plateau itself, at an average elevation of 3000 feet, must, for many years, remain what it is now, viz: Indian trapping country."

Swannell had also found considerable evidence of the history of the area. He had followed part of Mackenzie's route through the Chilcotins and took photographs of landmarks described by this explorer. He found remnants of the CPR and Palmer surveys. Throughout his surveying in 1926 Swannell located evidence of the extensive network of trails once used by the First Nations people in the region. Most of the trails were seldom used anymore and were becoming overgrown. "In every defile in the welter of mountains to the north we were struck with the amount of old Indian hacking, hardly any of it newer than 60 years. In Mackenzie's day the 'Stick' Indians were likely ten times as numerous as now, smallpox about 1865 probably accounting for their disappearance." Swannell also believed that: "The old 'moccasin trails' of Mackenzie's day were in much better condition than the horse trails that have superseded them."

Although the network of trails had diminished by 1926, the First Nations people in the Chilcotin still followed ancient routes to the coast. In the magazine article "On Mackenzie's Trail", Swannell wrote that both Alexander Mackenzie in 1793 and George Dawson from the Geological Survey in 1876 described meeting a group of First Nations people travelling to Bella Coola. He commented: "We ourselves, 133 years after Mackenzie, met a similar although smaller band bound for Bella Coola.... One wonders for how many years, perhaps hundreds, this annual trek has been made."

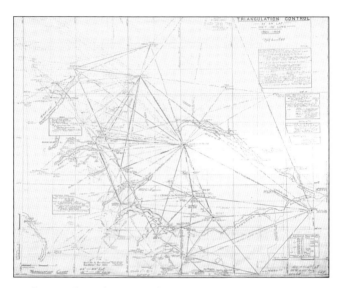

■ This map shows the main peaks that Swannell used for his triangulation network. He based his triangulation surveys and mapping on the framework provided by these main triangulation stations. BC Archives CM/A/14208

■ The Bella Coola wagon road. BC Archives G-00874

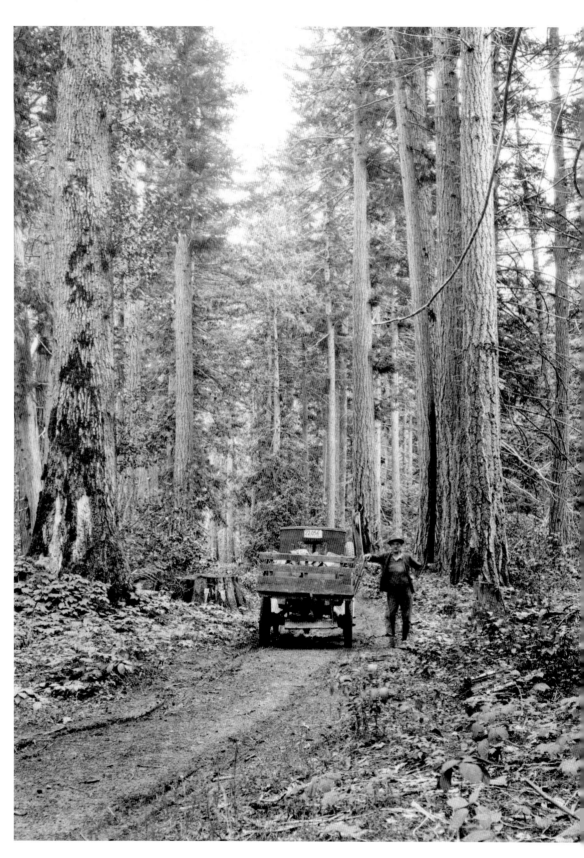

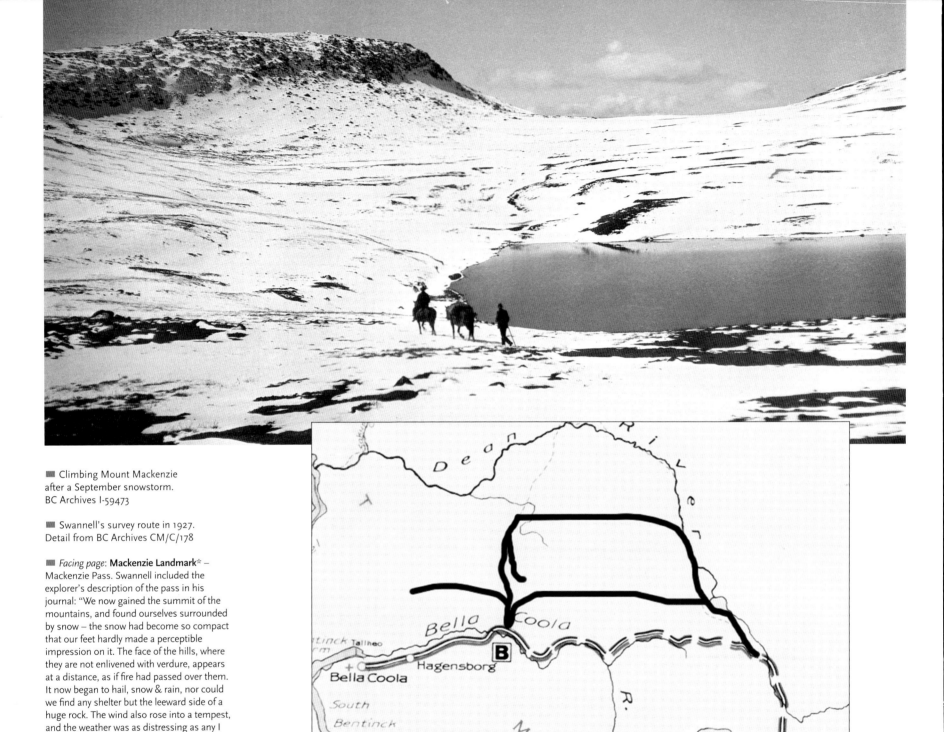

■ Climbing Mount Mackenzie
after a September snowstorm.
BC Archives I-59473

■ Swannell's survey route in 1927.
Detail from BC Archives CM/C/178

■ *Facing page:* **Mackenzie Landmark**＊ –
Mackenzie Pass. Swannell included the
explorer's description of the pass in his
journal: "We now gained the summit of the
mountains, and found ourselves surrounded
by snow – the snow had become so compact
that our feet hardly made a perceptible
impression on it. The face of the hills, where
they are not enlivened with verdure, appears
at a distance, as if fire had passed over them.
It now began to hail, snow & rain, nor could
we find any shelter but the leeward side of a
huge rock. The wind also rose into a tempest,
and the weather was as distressing as any I
had ever experienced. After an absence of an
hour and a half, our hunters brought a small
doe of the rein-deer species, which was all
they had killed, though they fired twelve shots
at a large herd of them. Their ill-success
they attributed to the weather."
BC Archives I-59470–72

＊ Note: Throughout the 1926 and
1927 seasons Swannell located and
photographed landmarks that Alexander
Mackenzie described on his trip to the
Pacific Ocean in 1793, and he usually
included the explorer's description in
his journal.

1927

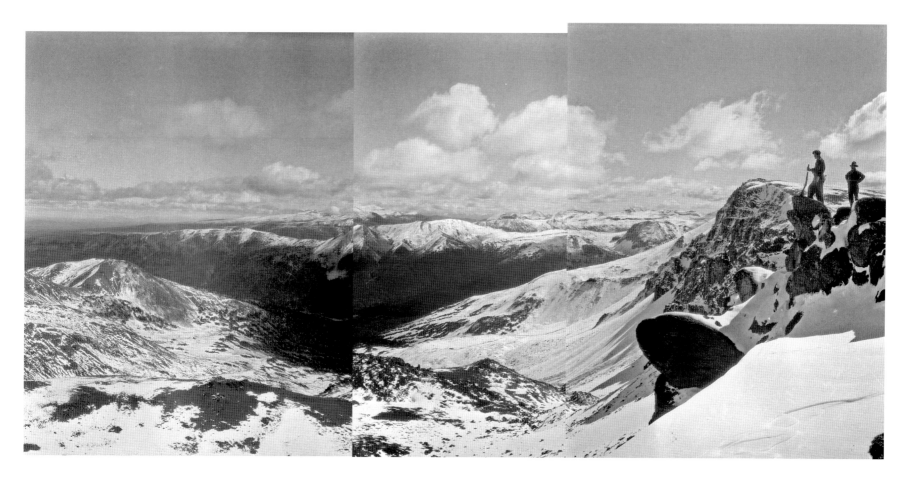

During the Christmas holidays Swannell usually sent Christmas cards and presents to his crew members and settlers he knew in central British Columbia. Shorty Grell, in a letter of reply written on January 1 from Henson's store on Ootsa Lake, described Christmas celebrations in that remote region.

A Happy New Year! I was very pleased to hear from you. The foods you sent reached me OK & I wish to thank you pronto for your trouble.

I had a rare Xmas – Had Leon & his family for dinner, also Mr. Chas McHenry (colored). Leon, his wife, McHenry & myself sat at a table. The rest ate off the floor. After dinner we repaired to McHenry's residence for swigging spree. Say it was GRAND! But I had to boil my woollen ware next day. When I got here to Henson I rec'd a Xmas box from a couple of ladies (Vancouver). Plum pudding Christmas Cake with greetings written on it in pink sugar coating & beautifully decorated. Half a dozen mince pies – a peck of apples <u>AND TWO PLUGS OF CHEWING TOBACCO!!!</u> The same mail that brought the above Santa Claus also delivered four parcel. HOT DOG! And now I have a stomach ache. Everybody here is

■ Chilanko Forks, one of the small ranching communities in the Chilcotin.
BC Archives I-33362

■ *Below*: George Copley (right) at a ranch near Williams Lake. Copley, Swannell's life-long friend and surveying assistant from 1909 to 1914, worked for the BC Forest Service at Williams Lake. Swannell visited him en route to his 1927 field season.
BC Archives I-57172

■ *Below right*: Children at Tatla Lake.
Library and Archives Canada E-008222021

making noises like they wants to go to sleep – we saw the new year in last night – so I guess I'll close – with best wishes. Good night.

Yours, J.W. Grell

The Surveyor-General wanted Swannell to extend his topographic survey southward in 1927, with a particular focus on the area between the Dean and Bella Coola rivers, including the valley of the Dean River. The previous year Swannell had concentrated his mapping and triangulation surveying in the area between the Dean River and Eutsuk Lake. He had traversed the Saghalie

Trail and established a few triangulation stations between the Dean and Bella Coola rivers, but he did not survey the area in detail. Although Swannell had mapped the passes through the Coast Mountains and located routes into the Dean and Sacumtha valleys he did not have time to actually make a survey down to the ocean.

In Swannell's government report for 1927 he wrote: "It being impracticable, almost impossible to cross the Lower Dean Gorge, it was decided to detach my assistant Mr. M.H. Ramsey, give him a small party and let him work in from Kimsquit, joining me early in the Fall at a pre-arranged locality." Ramsey had done most of the surveying in the Coast Mountain passes the previous year and had spent a week locating the Stick

Trail, which led down into the Sacumtha and Dean valleys. Swannell would concentrate on providing more detail to the southern part of the area where he surveyed last year, Umbach's main objective.

Williams Lake was Swannell's point of organization for 1927. In late May Swannell and Captain Jones left Victoria. Swannell's wife, Ada, joined him for the trip to Williams Lake so that they could visit their friends, George and Mabel Copley, who had moved there. It was the first time that Ada had travelled with Swannell to the interior since 1913. From Victoria the three of them travelled to Vancouver where they took a boat up Howe Sound to Squamish. There they took the P.G.E. train to Williams Lake. After spending a few days at Williams

■ The surveying crew could travel by truck only as far as Tatla Lake. From there they needed a wagon to take them and their supplies to Towdystan, where the surveying began in 1927. BC Archives I-59599

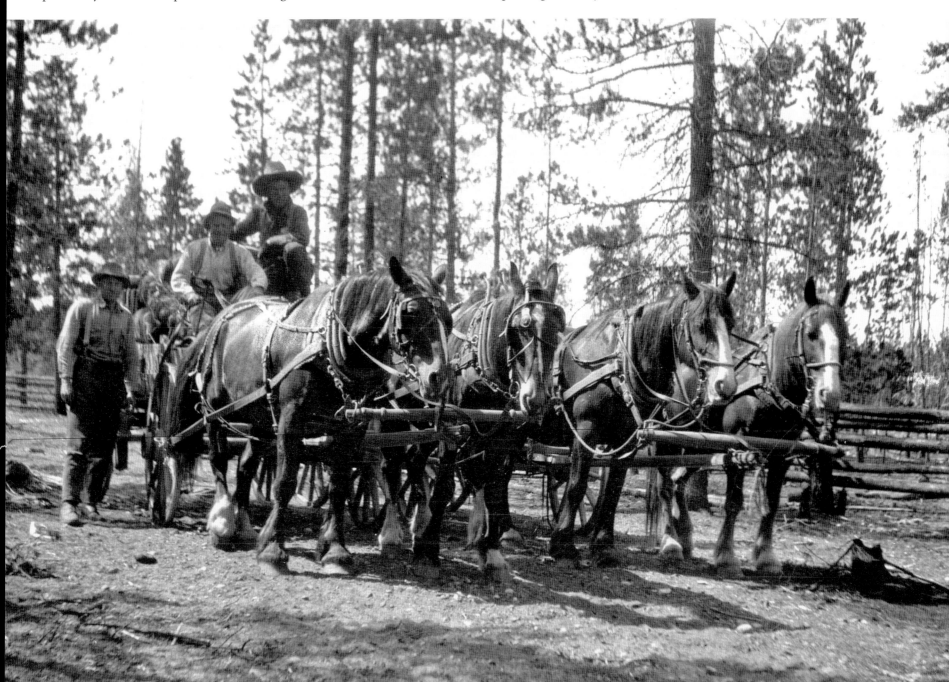

Lake, Swannell and Butler left by truck on the evening of June 3, travelling 30 miles to Bechers. The next day they reached "Tatla Lake 10 pm 130 miles by truck, with 1700 lbs. Hrs. traveling 12 1/2."

At Tatla Lake Swannell picked up Leonard Butler again, along with Tom Stepp, who would be both cook and packer's helper this year. "Tom was US Veteran of the 1914 war. Big Southerner, as he said 'brought up on sow bosom and corn-pone'. Iron hook for left hand. Cook – excellent good-humoured chap." Stepp and Butler had met and become friends after World War I. Around 1920 they brought a herd of horses from the United States to the Chilcotin where both men purchased land and established a ranch. Butler and Stepp also worked for George Powers when he needed additional help.

From Tatla Lake, Swannell and his crew travelled by wagon to Towdystan. "Powers meets us 8 1/2 miles from Towdystan with a snap team." Swannell and the men spent a few days at Towdystan preparing for the field season. On June 10 Swannell's crew was ready to depart. "Packer hunting horses 4 am – have got out of pasture – Get in all but 4 by 2 pm – Cook out all day hunting horses, returns 7 pm – no luck. 7 Nemaiah valley horses hit back across country." Meanwhile, "self & Jones hunting survey cors [corners], take solar obser[vation] & in aft. run trav[erse] along Kapan Road."

■ *Right*: Squinas and his horse at Towdystan. Squinas was a well known First Nations resident of the Anahim Lake area. BC Archives H-03639

■ *Below*: Captain Jones (left) and George Powers during surveys around Klootch Lake at the beginning of the 1927 season. The men have just established a survey post. Swannell's theodolite sits on the tripod and his surveying chain hangs from a pole. BC Archives I-59611

■ *Below right*: Petroglyph near the road from Towdystan to Charlotte Lake. BC Archives I-33907

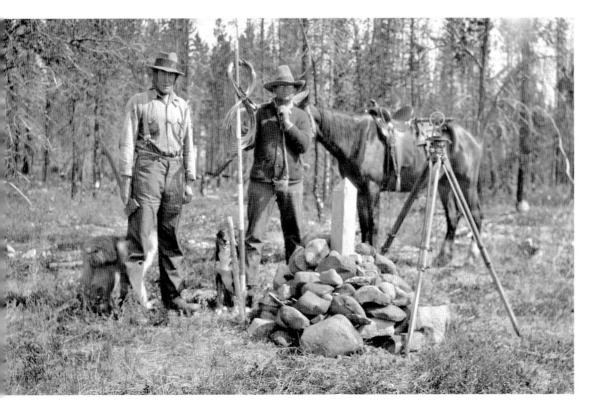

In his instructions to Swannell, Umbach had also requested him to "survey into lots of 80 – 160 acres any areas of Crown land suitable for settlers which you may encounter, particularly around Dusty Lake." Swannell wrote to the Surveyor-General: "The season being very late, the mountains full of snow, and no horse feed, we occupied the enforced delay by surveying into lots a string of meadow halfway between Towdystan and Kapan (Charlotte) Lake." On June 22 Swannell and his crew visited a site that was part of the 1864 Chilcotin War. "MacDonalds Pack Train 1864 – Massacre. Move to Fish Trap betw.[een] 10 – 12 miles. Here on left bank of the Dean River just above the old fish trap ford is an open knoll where the 4 or 5 white packers of 1864 dug a trench – according to Indian report lay here 3 days, then thinking the Chilcotins gone started for Bella Coola & were ambushed and all killed three miles down the trail (authority old Indian Guichon)."

After spending June 23 outfitting at the Hudson's Bay Company store in Anahim Lake Swannell and his crew travelled to the beginning of the Capoose Trail on the Dean River just below Abuntlet Lake. At their first campsite along the trail "Capoose & pack-train arrive from Bella Coola."

While at Fish Lake in 1926 Swannell had traversed a few miles of the western end of this trail. It took the surveyors about three weeks to traverse and triangulate

■ *Above*: Site of the Fish Trap massacre. Swannell took several photographs of his crew reenacting events at this site from the Chilcotin War in 1864. The site was still mainly bare in 1927 and the trench could be easily located. (See page 173 for a comparison with the site today.) BC Archives I-59567

■ *Left*: Celebrating Dominion Day. George Powers and Tom Stepp stand and exchange toasts; Leonard Butler and Captain Jones sit in front. BC Archives I-59561

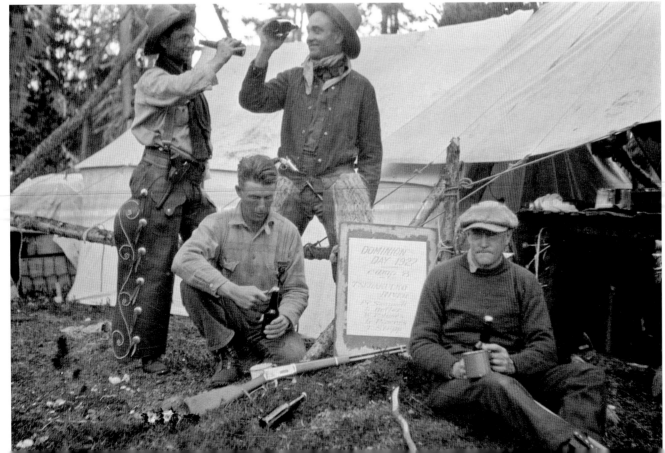

the 43-mile-long Capoose Trail. The second half of the trail was mainly through subalpine country, and since the trail was not used much anymore, it was hard to find in places. There were several days of cold rainy weather in this open country. Swannell's July 2 journal recorded that, "Self, Jones set signal 'Scarp' & carry on to high summit of Rainbows, building cairn on jutting prong ΔKasulko. Weather execrable – rain & caught in violent storm of rain, sleet & hail on open summits – Reach home absolutely drenched. The next day the men celebrated "the deferred Dominion Day ... Creek rises about 2 foot owing to heavy rains." The triangulation station Swannell set on July 4 was named Dominion.

Beginning July 6 there was rain every day for a week. "Self & Jones spend an unhappy day on Misty Mt on the rim of the Great Bella Coola Valley – nothing but mist, rain & clouds – with occasional glimpses of the peaks. Hrs (trying to) work 7," wrote Swannell on July 12. The next day he and Jones had a "Long wait on top until 2 pm until fog quits rolling up out of Bella Coola Valley – Reach new camp 7pm – near lake, probably the 'large pond with a tomb on its banks' of Mackenzie's narrative July 17, 1793 (Sit-ka-ta-pa Lake)."

From Sitkatapa Lake, Swannell and Butler tried to follow Mackenzie's exact route down into the Bella Coola valley. Swannell described this experience to the Surveyor-General.

■ The horses gathered around the smudge. The smoke kept away many of the insects that would pester and bite them during the summer. BC Archives F-07967

A mile farther south [is] the rim of the Bella Coola Gorge which Mackenzie aptly calls the 'brink of a precipice'. From here my packer Butler and I attempted to further trace Mackenzie's track. After considerable search we found a projecting bluff the unique point on the plateau rim from which the mouth of Burnt Bridge Creek is visible. It must have been here that 134 years before Mackenzie's guides 'discovered the river to us and a village on its banks'. There is no trail nor was there one in Mackenzie's day, the traveled route being from Sit-ka-ta-pa Lake southwestward down to the Bella Coola River at Canoe Crossing. The way down is obvious, a plunge of 2000 feet into a narrow ravine. Once in this there was no getting out – the steep sides were such an impenetrable jungle of alder, willow, devil's club and scrub hemlock and windfall lying under rock-slide and cliff, we took the torrent bed by preference.

■ *Above*: **Mackenzie Landmark**＊ – The survey crew passing Sitkatapa Lake. This was Alexander Mackenzie's "large pond with a tomb on its banks", noted Swannell. BC Archives I-33896

■ **Mackenzie Landmark**＊ – Swannell took Mackenzie's route along the rim of the Bella Coola Gorge and quoted the explorer's description of the locale: "We continued to descend till we came to the brink of a precipice from whence our guides discovered the river to us and a village [Friendly Village] on its banks." The route down Burnt Bridge Creek was a secondary route to the Bella Coola River valley, used by First Peoples. BC Archives I-59504

＊ See "Note" on page 132.

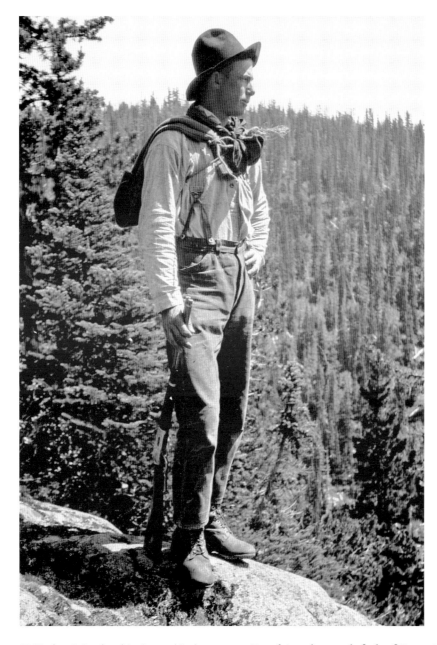

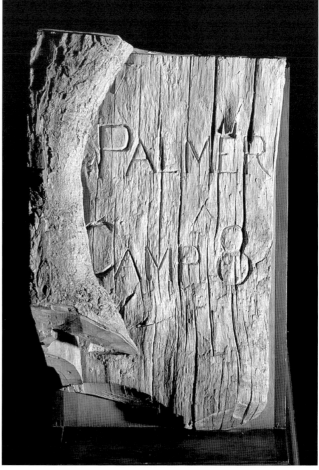

 Mackenzie Landmark* – Leonard Butler at the location where Swannell thought Mackenzie looked down Burnt Bridge Creek to the Bella Coola River valley before beginning his descent. BC Archives I-59517

* See "Note" on page 132.

 Above right: Swannell first visited the Palmer campsite in the fall of 1926. He cut out this inscription and sent it to the provincial museum in Victoria (now the Royal BC Museum). BC Archives I-59583

 Below right: The Palmer inscription today. RBCM 965.2141.1

Reaching the north fork of Burnt Bridge Creek at the bottom of these precipices we made a precarious crossing by wading and jumping from boulder to boulder. Shortly after we crossed the east fork, which falls over the plateau rim as a waterfall with a plunge of several hundred feet. We were here 1100 feet above sea level. From here down Burnt Bridge Creek the grade is easy but traveling bad on account of the fallen timber and underbrush. The air line distance from the plateau rim to the Bella Coola River is little over 6 miles, the descent about 4000 feet mostly in the first two miles. It took us 7 very strenuous hours and we found the going very rough, difficult, and dangerous although we had light packs, heavily nailed boots and were in excellent physical trim.

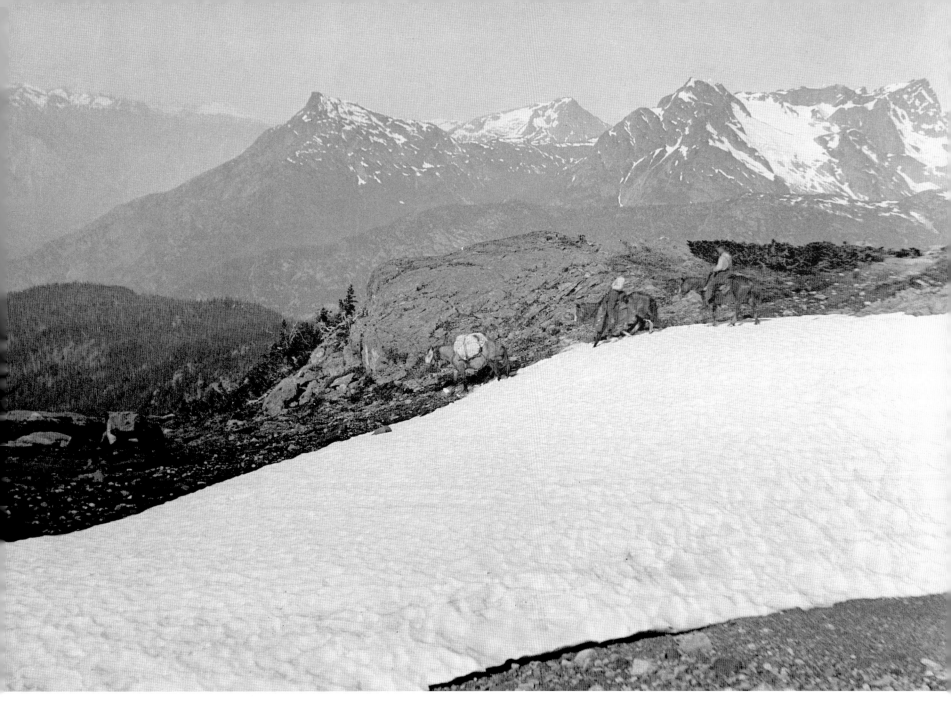

They had supper with J.W. Hober, who had shown Swannell the remains of Friendly Village and the Palmer inscription tree in 1926. Hober then drove them to Canoe Crossing, where Swannell and Butler spent the following day recuperating and revisiting Palmer's Camp. Then the two men hiked up the Canoe Crossing trail until they reached the camp Powers had established. "Powers reached here at 8 pm last night, having to lead horses separately over glare rock & snow of the summit." The next day Swannell and his crew travelled over the summit, passing the junction of the Burnt Bridge Creek trail and the camp that they had near Fish Lake last year.

The men continued north on the Saghalie Trail until they were on the north side of Mount Tzeetsaytsul, the highest peak in the Coast Mountains between the Bella Coola and Dean rivers. "Below the sheer cliffs of its northern buttress lies a high alpine valley through which we managed to push with our pack-train into the heart of the Coast Range along an old Siwash hunting trail," Swannell wrote in his report to Umbach. He noted that the trail had been "re-cut by white trappers." Once again Swannell found evidence of the First Nations people travelling through the passes of the Coast Mountains.

■ On the summit of Canoe Crossing trail, the main route that First Peoples used to cross the Coast Mountains between the Chilcotin and the Bella Coola River valley. BC Archives I-59589

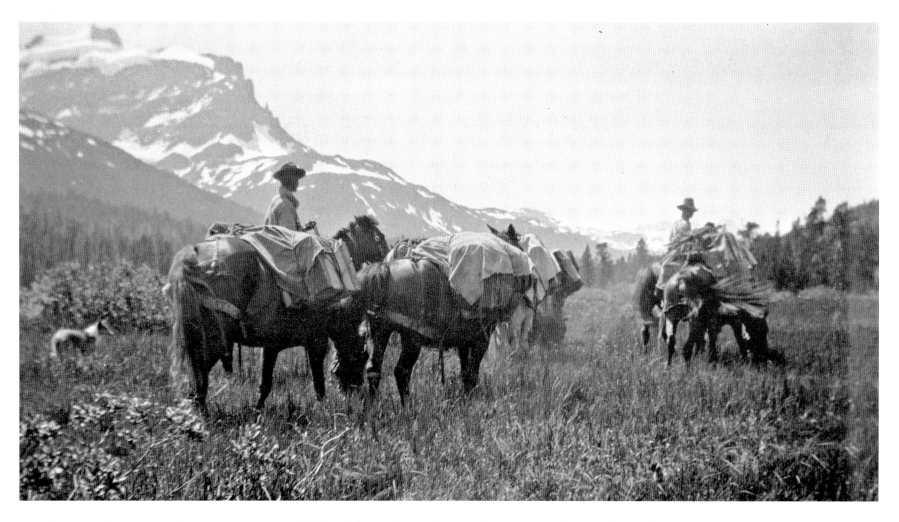

Pack train in meadows near triangulation station Compass, in the Coast Mountains. BC Archives I-59552

Swannell followed this trail west for 20 miles. From a triangulation station on Compass Mountain he was able to connect his survey with Swannell, Wells and Nadina, three of the major stations from his surveys on the Nechako headwaters. Fortunately the survey crew had good weather while they were in this rugged country and they were able to establish triangulation stations on the mountains almost every day. By July 29 the men moved "camp to end Tal-che-a-zoone Lake at 'place where the devil lives' (old rock-slide running into lake). 4 horses swim out into lake & Leonard's horse nearly drowns when he tried to head them off – Luckily mostly dunnage that gets wet.... Camp at very old meat cache, with much heavy chopping, all old ... Cruise for reported Grease Trail down Salloomt, but no Indian trace at all." In his report to Umbach, Swannell wrote: "According to Indian legend a devil dwells here and my packers now give this credence for here the pack-train emulated the Gadarene swine and rushed into the lake. A more prosaic explanation would be the plague of bull-dog flies which drove the horses frantic and indeed nearly stung one to death."

Swannell spent about 10 days surveying in the vicinity. On July 30 Swannell and an assistant climbed "Sockeye Mt. starting with 2 horses, but soon too steep – all rock-slide, so back-pack to top – Find Bishop cairn above Kalone Glacier – likely cruising a route to climb 'West'. Huge white smoke cloud vicinity Kwalcho & all Dean Valley filled with smoke, but get cairns to SE O.K. Leave transit on top for another attempt. Bulldog flies very bad. Mosquitos as per usual." Swannell searched unsuccessfully for passable routes beyond the Talcheazoone Lakes. On August 1 the men went "down into supposed valley of Kalone Creek – 2 miles O.K. then an awful jungle of alder, willow & devils club in the heavy timber and half a mile of rock-slide. Trappers cabin at Forks. Decide it will take a week to cut trail down. Mosquitos in clouds in long grass." While Swannell and Butler tried unsuccessfully to reach Bishop's ∆West from

their camp, Powers and Jones cut "trail down the Necleetsconnay – George smashes his glasses & cuts his face badly on a slide." After two more days of work the men had only cut out five miles of trail. Then Swannell went "nearly 4 miles down the gorge to a clump of large cottonwood – all bad going – rockslide & green slide – no cross valley leading north & heavy timber 2 miles further. Decide it is impracticable to proceed further – Smash my knee badly on a rock & hard getting home." Swannell again noted the vicious bulldogs. "In 30 yrs have never seen them half as bad. One horse nearly killed by them – gives up entirely. Mosquitos & small flies also hell."

Smoke was limiting visibility and making triangulation difficult, so on August 9 "Jones & Butler climb Sockeye Mt. & bring big transit down. Packer busy building smudges & doctoring sick horse, whom we swathe in sacking & smear with a mixture of tar, Minard's ointment & zinc ointment." Swannell's crew spent a week travelling back to the Saghalie Trail. They established a base line and surveyed from the top of several mountains. On August 12 Swannell's crew went

■ Butler (left) and Jones at triangulation station Tanya, near the lake. BC Archives I-59576

■ *Below*: Sundayman and wife at Tanya Lake. BC Archives H-03537

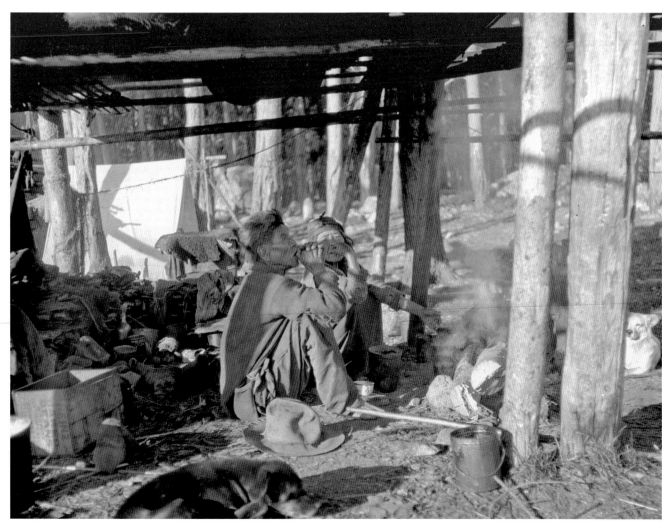

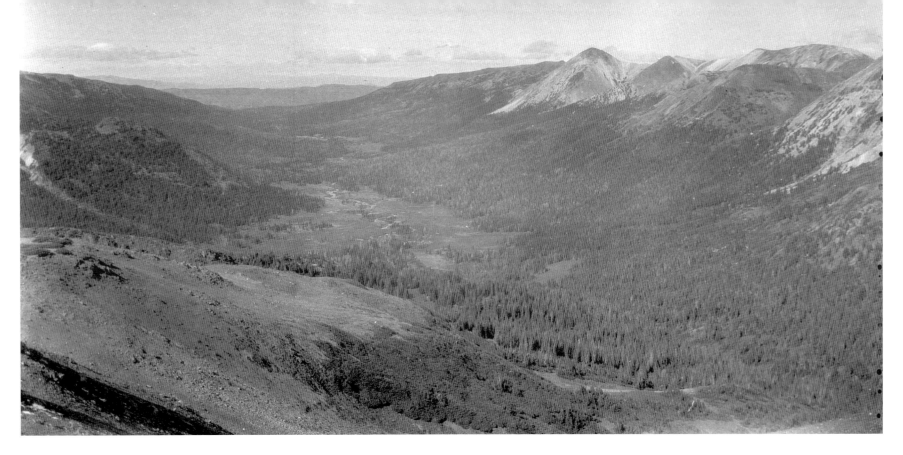

■ **Mackenzie Landmark*** – Alexander Mackenzie's description accompanied this photograph: "Before the sun rose our guides summoned us to proceed into a beautiful valley watered by a small river." BC Archives I-59507

* See "Note" on page 132.

back up Stepp Mountain to the triangulation station that he had established while travelling to the Talcheazoone Lakes, so that he could add the peaks to the west. "All hands pack gear up Stepp Mt. – Finish lower sta. – 4 hrs on upper Δ. Glorious day – no flies until we return into valley. Butler gets a nanny & kid – we get 110 lbs meat down. Cannot read without cairn as windshield." By the time Swannell climbed Compass Mountain again on August 16, smoke from forest fires was once more reducing visibility. The next day the crew reached the Saghalie Trail. "Find cache OK.... Weather fine, but smoke very dense & surrounding mts. completely hidden." In a note added later to his journal Swannell wrote: "We had left a couple of dozen home brew beer here and eagerly looked forward to trying this on our return – But the head was so terrific we hardly saved any."

Swannell tried to survey more of the Coast Mountains before heading to Tanya Lake but smoke from the forest fires persisted. On August 18 he wrote: "Smoke worse than ever & strong smell of fire. Absolutely hopeless to do any work." The following day he observed: "Smoke very dense & everything blotted out." On August 20 he "set signal top of sheer cliffs, the Tahyezko Gorge here being at least 1000 feet deep, cut into solid rock. Must be wonderful view from here, but everything blotted out in dense smoke. Strike back going home & nearly get lost as all landmarks invisible." Meanwhile Leonard and Tom left for Tanya Lake with some supplies. They were also to reset the signal on ΔGranite Boss, a 1926 triangulation

station, and establish a very large one on the mountain above Tanya Lake so that Ramsey could use them to connect his survey with the main network Swannell had established. After it rained on August 26 Swannell climbed "ΔGranite Boss with one man & 2 horses and air being now clear of smoke get station well read although too windy for good results. Get cairn of Ramsey's on rounded mountain next Sacumtha."

On August 28 Swannell's crew arrived at Tanya Lake. "Stellus & Betty, old Sundayman & squaw & two little girls here – making salmon & soopallalie cake. Sundayman remembers Dawson & Hunter 1876 & Seymour – Hunter big man, sideboard whiskers. Dawson 'yakha hyiu tikkegh iskem chikamin stone (he was very fond of collecting ore)." At Tanya Lake, Powers found the old hunting route that Mackenzie probably followed through the mountains. The men also searched for the old trail to the salmon fishing area on the Dean River. September 1 was "Labour Day – Holiday – Men down the river to see the salmon – now commencing to die off rapidly – big spring salmon struggling over riffles in 3 inches of water. Go three miles down myself & find where old Yeltesse trail leaves the present trail to the fishing places down stream." The next day Swannell and Powers followed this trail to a viewpoint of the Dean Valley.

Swannell and his crew then retraced Mackenzie's trail through the mountains. "Move camp along very old trail (Mackenzie's route) to his 'beautiful little valley'.

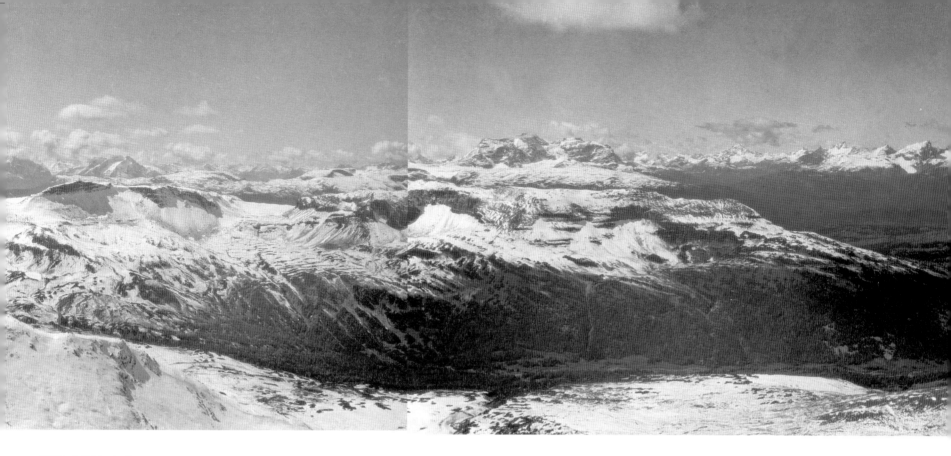

Trail overgrown but astonishingly good – deeply indented into ground in places." On September 6 Swannell's crew climbed "Mackenzie & by a circuitous route get horses to top in 4 hrs. New snow 1 1/4 feet deep in drifts and 4" above 5000'. Weather clear and sunny but wind cold. Can find no station mark under Bishop's cairn."

The next day Swannell climbed "Mackenzie again & complete reading except could have spent several hours more sketching – Panorama from here absolutely marvellous especially the tremendous mountains south of the Bella Coola. Read into ΔKapan, Swannell & very dist[ant] peak possibly Sinkut Mt. Perkins visible & Chef & Michel." Not only was Swannell able to enjoy the view and the historic significance of being on this mountain, he was also able to make another connection from Bishop's network to both his 1926 and 1927 surveys in the Chilcotin, and his Nechako surveys.

While surveying the next day, Swannell's crew met "Kluskus Siwashes – old Tsil, Jerry Boy, Louis Squiness, Malford, Aggie (Tsil's wife) & Emmy, Louis' wife. Louis fined $25 for leaving campfire – when served with blue paper 'Me I scare like hell, I don't know what kind'." Swannell named his two triangulation stations that day Louis and Squiness. Swannell established three triangulation stations around Mackenzie Pass to map the area. "Walk around rim of plateau and locate the identical defile passed by Mackenzie."

■ R.P. Bishop had established a surveying station on the top of Mount Mackenzie in 1923. Swannell not only enjoyed the view and sense of history from this location, but he was able to survey to several of his stations in both the Chilcotin and Nechako, and to some of Bishop's stations around the area. BC Archives I-59466, I-59467

■ *Left*: This photograph, taken at Kimsquit, shows the grave of a member of the Canadian Pacific Railway survey expedition who died in 1876. The photograph was loose in Swannell's files and was probably made by one of the men in Ramsey's party in 1927. Library and Archives Canada E-008222017

■ The remains of a cantilevered bridge on the CPR pack trail. This was the same "Y" party of the CPR whose camp Swannell found at Qualcho Lake in 1926. BC Archives F-07968

■ *Right*: First Nations fish ladder at Salmon House. BC Archives F-07976

Swannell described following Mackenzie's route from Tanya Lake to Mackenzie Pass to the Surveyor-General.

Mackenzie in his journal states that on the 15th July 1793 he camped 'on a very pleasant green spot' which would appear to be at the head of Lower Tanya Lake. Next day he parted with his Indian friends, who were bound for Yeltesse, and headed for the mountain pass which had been pointed out to him as his shortest route. We, this year, while hunting horses, found the old trail leading inconspicuously out of the large meadow on Lot 697. This trail is deeply indented in the ground and, although overgrown, is in fair shape, which is remarkable as it is only occasionally used by the present-day Indians as a hunting trail. About 9 miles from Tanya Lake, after climbing over a timbered mountain-spur, we, to quote Mackenzie's own words, 'descended into a beautiful valley watered by a small river'. This is the stream which joins the Takia River some 2 1/2 miles up from the Dean. For three miles the valley floor is almost level, nearly a mile wide, the beautifully limpid stream winding through large meadows. The head of the valley is a large cliff-capped amphitheatre, the main branch of the stream rising in a basin a mile or so south of the cairn on Mackenzie Mt. (7064'). It was up this fork that Mackenzie's guides took him and then, as now, ground hogs were numerous in the rock slides. The trail up this fork is very faint, vanishing for half a mile at a time. The actual place where he crossed the divide is very definite, it being a defile which until late in the summer is snow-filled. Near here we picked up the old moccasin trail for several hundred yards. We had carefully cruised the rim of the amphitheatre for four miles and nowhere else is there easy access out of the valley, in most places the cliffs are unscalable. The height of Mackenzie Pass by aneroid is 6000', its distance from Tanya Lake 16 miles.

The view from the pass is splendid. Below lies the beautiful alpine valley walled on either side by the steep slopes of the Tsi-Tsutl Mts., their summits rainbow-hued in vivid red, purple and ochre-yellow tones (the Indians tell me 'Tsi-Tsutl' means painted rocks – the very earth under foot at the defile is a deep red). Ahead on the south-slope extend miles of open plateaux descending in steps to the brink of the Bella Coola Gorge, across which looms up Mackenzie's 'stupendous mountain'. This pass is the highest point on the whole route of Mackenzie from sea to sea and should be marked by a monument to his memory and to that of his voyageurs.

Swannell's crew moved back to Tanya Lake on September 12. As they were setting up camp Ramsey's party arrived after a three-month survey that began on June 13 on the coast. Ramsey's packer and guide was young Lester Dorsey, who would become one of the best-known outfitters in the Chilcotin. Ramsey wrote a report describing the survey and his observations of the land. "The large Indian Reserve at Kimsquit is now deserted, not a solitary member of the tribe remaining in occupation. There are about a dozen of more or less modern houses and the ruins of very old shacks nearer to the river. Wild rose bushes and weeds shoulder high are growing right up to the windows of the houses." Ramsey reported that, "Kimsquit is situated about six miles from the head of Dean Channel and consists of two canneries (now operated as fishing stations) on opposite sides of the channel. Kimsquit Cannery, on the easterly side is situated on lot 13 and in former years was the supply point for the interior Indians who traveled the Stick Trail. With the development of Bella Coola and the closing

■ Salmon leaping the falls at Salmon House. BC Archives F-07975

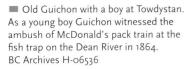

■ Old Guichon with a boy at Towdystan. As a young boy Guichon witnessed the ambush of McDonald's pack train at the fish trap on the Dean River in 1864. BC Archives H-06536

■ *Right*: Bob Stranaghan and his bride. BC Archives I-59591

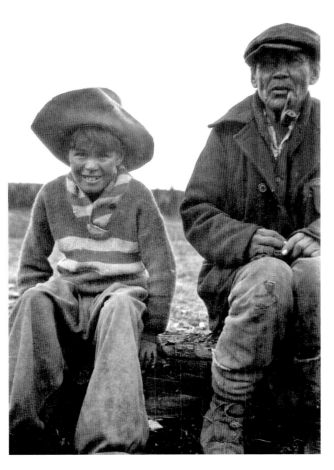

down of the canneries this route to the interior fell into disuse and has not been traveled for many years." While travelling along the Dean River, Ramsey found evidence of the CPR survey. "In the early days of the preliminary surveys of the CPR Kimsquit was the base of operations for the parties engaged on the Dean River route and the graves of members of these parties who lost their lives during the work are still in a fair state of preservation."

In 1926 the provincial government spent money to improve the Stick Trail up the Dean Valley, with the objective of providing a transportation route to the new mining claims near Tesla Lake. The provincial government had improved the trail as far as the crossing of the Sacumtha River where a bridge had been built. From this point Ramsey and his crew constructed three miles of trail over to the Stick Trail and followed it up to the pass he had surveyed during his trip the previous September. Ramsey spent several days in this area establishing triangulation stations and mapping the area before heading to Tanya Lake to rejoin Swannell and his crew. In his government report Swannell wrote about Ramsey's survey. "Picking up stations of the Coast Triangulation on Dean Channel he carried a system up the Dean Valley finally closing very satisfactorily on our Interior Triangulation." Not only did Ramsey map the Dean Valley, he also made another connection between the coast and interior triangulation nets. During his three months of surveying Ramsey had travelled 319 miles by pack train and 92 miles by boat, and he had occupied 39 triangulation stations.

The next day was "Holiday all hands". Swannell spent the rest of September surveying in the vicinity of Tanya Lake. He set up a base line, mapped the lake, and he and Ramsey surveyed some triangulation stations. The men spent a couple of days clearing the trail to Salmon House that Swannell and Powers had found at the beginning of September, and on September 22 they reached this historic location on the Dean River.

Swannell wrote a detailed account of his trip to Salmon House.

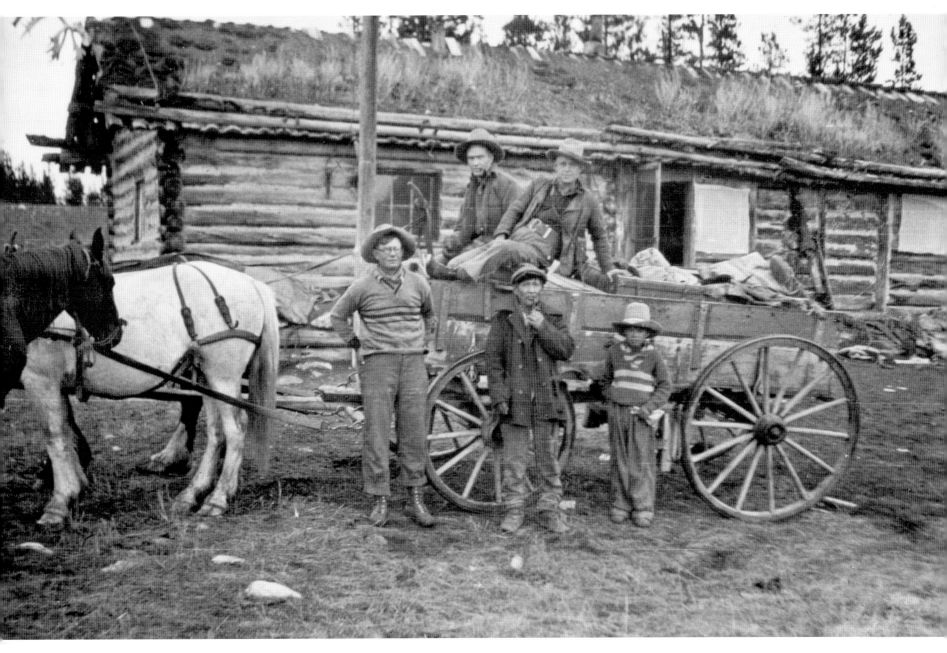

The interior Indians had resorted to this spot from time immemorial for their great annual fishery but for a generation it has been deserted; the Indians nowadays catching and curing their salmon in the three miles of Takia River below Tanya Lake. After following this stream down for three miles, the old trail cut across country to the southwest passing through stony jack pine country and swamp to a beaver pond and large swamp meadow 6 miles out. Shortly beyond here the trail drops rapidly into the Dean Valley. 11 1/2 miles from Tanya we camped at the last place where horse-feed was available, around a beaver pond called The-tsud-tee by the Indians. The elevation here is 2400'. Three miles farther we reached a promontory formed at the junction of the Dean and Tahyezko Valleys. The trail zig-zags steeply down the spur to a triangular-shaped stony flat 200 feet above the river. From this bench the ancient foot-trail works down the steep rocky walls of the gorge to the river. Around bad corners pole guard-rails had been lashed with bark rope and notched logs serve as ladders. The trail is deeply indented and has been much used long ago.

Powers' cabin at Towdystan. George Powers, Guichon and a young boy stand in front of the wagon, and Tom Stepp and Frank Swannell sit on it. Swannell and Stepp travelled with Guichon in his wagon to Kleena Kleene.
Library and Archives Canada E-008222020

The fishing place is at the head of a 15 foot falls above a deep pool. The width across the brink of the falls is 30 feet broken midway by a jutting rock. Across here the old time Indians built a rickety pole and bark rope bridge from which they suspended baskets into which the salmon fell in attempting to leap the falls. No trace, except the old clearings, exists of the smoke-houses which formerly stood on the benches above the falls on both sides of the river. The Dean River is in a narrow rock-walled gorge below this point. About 1/2 mile down at right angles the Tahyezko enters, its water milky-white in contrast with the clear waters of the Dean. Just above here are the ruins of the old CPR survey cantilever bridge of 1876 and several hundred yards of the old mule trail.

Swannell made a triangulation survey from Tanya Lake to the Dean River. After returning from Salmon House, Swannell's crew spent a few more days surveying around Tanya Lake before moving to Squiness Lake. Swanell spent September 29 to October 1 mapping the lake, reading one more triangulation station, and taking a final observation on Polaris. One day, while the men were at Squiness Lake, "Tommy, Pretty Charlie, klootches & about a doz. pack-horses go past. Stellus to supper."

From Squiness Lake, five days of travel brought Swannell and the crew back to Towdystan. October 8 was spent "Sundaying at Towdystan, inventorying & packing up. Bob Stranaghan & bride arrive 7 pm like Joseph and Mary in Egypt – He leading a pack-horse, she riding wearing his chaps & mackinaw shirt." The next day

"Stepp & I leave with part of baggage in Guichon's wagon for Kleena Kleene." Ramsey took the rest of the crew to complete a few small surveys in the area before he rejoined Swannell. On October 14 Swannell, Ramsey, Jones and Powers left Kleena Kleene by automobile. It took the men four days to reach Vancouver, the first time that Swannell had travelled almost entirely by car during any of his trips to or from his field surveying. This was also the first year that the majority of the miles that he travelled were by car.

In his report to Umbach, Swannell noted that, "The interior of the Coast Range in which we worked most of the summer is unprospected." He thought that the Tsi-Tsult Mountains "offer to my mind, ideal summer range for sheep", while "outside the mountains there is little good soil except in the meadows and nearly all of these are covered by surveyed lots." Swannell observed that, "There was little game in the interior of the Range. Grizzly were very scarce, goat fairly numerous. Moose seem to be pushing westward.... There are caribou in the Tsi-Tsutl Mts. Still, formerly they were numerous.... It is worthy of note that there were goat still in the deep valley of Burnt Bridge Creek as recorded by Mackenzie.

Swannell had a second successful season surveying in the Chilcotins. With the assistance of Ramsey he had completed both of the Surveyor-General's objectives for the year, and in the process he had discovered important evidence of the history of the area. In his government report the Surveyor-General wrote: "Mr. Swannell was employed on a triangulation and topographical reconnaissance survey on an area lying directly east of the summit of the Coast Range, between the Dean and Bella Coola Rivers. His assistant, M.H. Ramsey, B.C.L.S., in the earlier portion of the season mapped the lower portion of the Dean River and including Sakumtha Pass, which is an important pass from the head of Dean Channel to the lake area at the head of the Nechako River, and through which a trail is being constructed with a view to assisting mining development in this area." Umbach commented: "This work was an extension of previous surveys in the district and the resulting maps and reports will form an important addition to the available information about this interesting section of the Province."

■ Swannell made this map after his 1926 and 1927 surveys in the Chilcotin. He included Mackenzie's route through the area as part of his interest in the history of the region. Swannell also made a large-scale map, plotting Mackenzie's voyage from the Rocky Mountains to the Pacific Ocean and his return route.
BC Archives CM/A/14198

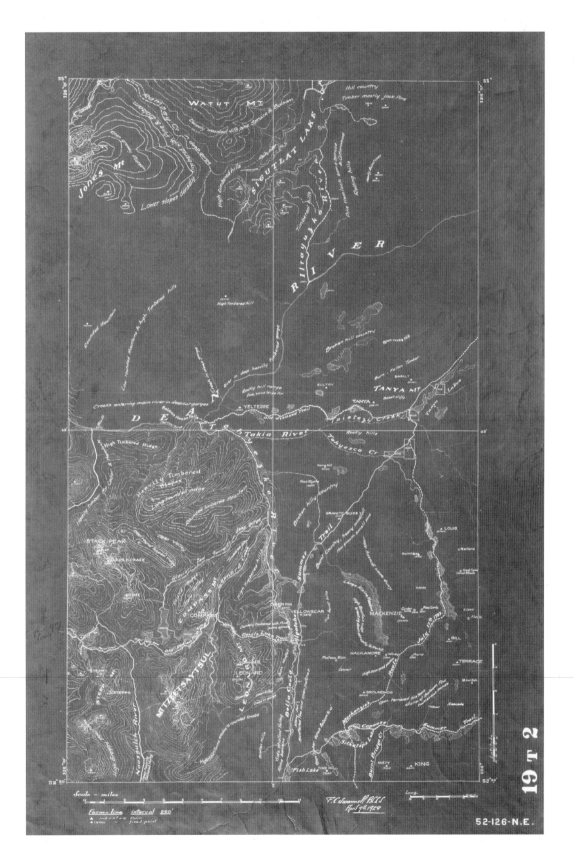

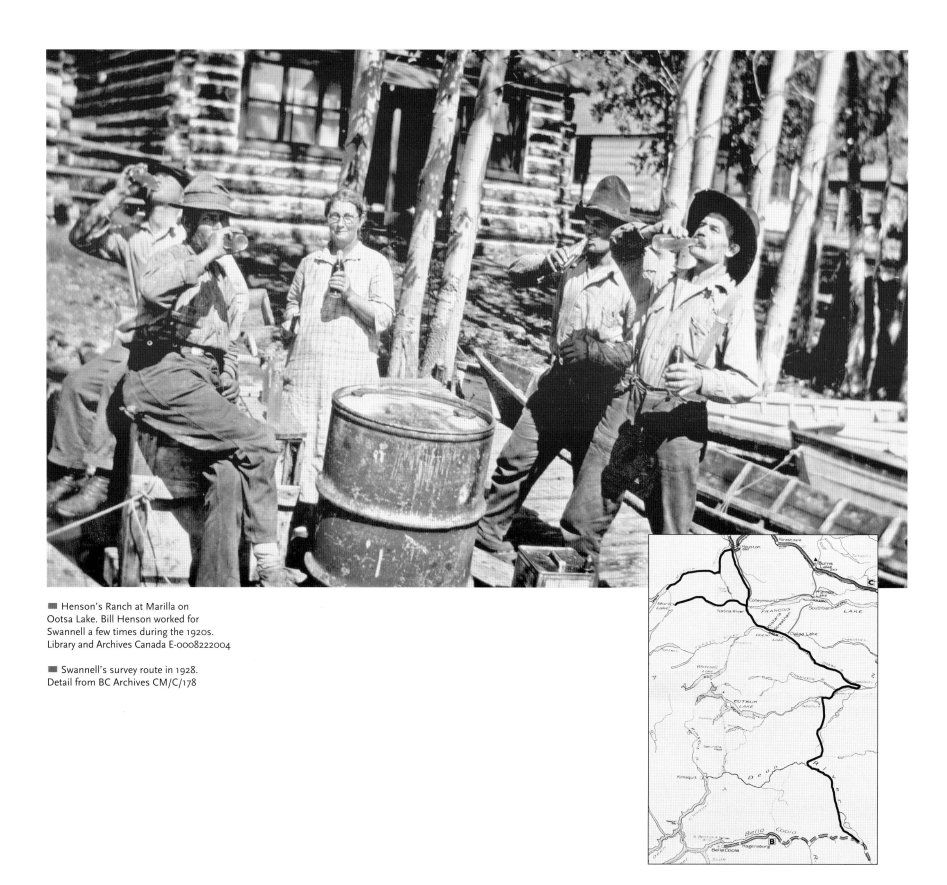

■ Henson's Ranch at Marilla on
Ootsa Lake. Bill Henson worked for
Swannell a few times during the 1920s.
Library and Archives Canada E-0008222004

■ Swannell's survey route in 1928.
Detail from BC Archives CM/C/178

1928

After four years of extending his surveys north and south of the Nechako watershed Swannell probably thought that he had finished surveying in central British Columbia. However, Umbach still had some work in the area that he wanted the surveyor to complete. There were two distinct parts to Swannell's 1928 surveys: a traverse of the Bella Coola trail from Ulkatcho to Tetachuck Lake; and a topographical reconnaissance of the Nadina and Morice river basins.

During the winter of 1927-28 Swannell produced a map based on his two seasons of surveying in the

Chilcotin. The map included Mackenzie's route through the area that Swannell surveyed. In January he presented a paper and slide program about Mackenzie's expedition to the Pacific Ocean at the Corporation of British Columbia Land Surveyors' annual general meeting in Vancouver. At this meeting Swannell was elected to be a member of the Board of the BCLS. While he was in Vancouver, Swannell took his first airplane ride, a 15-minute flight on a sea plane from Jericho Beach.

On May 16 Swannell left Victoria for his ninth season of surveying in central British Columbia. His route to the

■ F.W. Knewstubb (left) and Stanley Frame (far right) were well-known engineers for the BC government's Water Rights Branch. They spent a few summers in the west Chilcotin and Coast Mountains investigating the potential for hydro-electric projects. In 1928 they went to Tatlayoko Lake. Knewstubb Reservoir on the upper Nechako River, part of the Alcan project, is named for F.W. Knewstubb. Jeff Reid (standing beside Knewstubb) was Swannell's cook during the 1928 season. The fourth man, with the wheel, is probably the driver.
BC Archives I-57194

Chilcotin was the same as last spring. At Squamish he joined the provincial government's Water Branch crew, headed by F.W. Knewstubb. Knewstubb, a well-known hydraulic engineer for whom Knewstubb Reservoir would be named, was going to the Chilcotin to examine potential hydro-electric projects in the headwaters of the Coast Mountains. On May 19 Swannell reached Kleena Kleene where he found George Powers waiting for him.

At Kleena Kleene Tom Stepp joined Swannell for a second season. Swannell had hoped that Leonard Butler would be part of the crew, but he was getting married soon. M.H. Ramsey, Swannell's assistant for the third year, began the season working independently, as in 1927. While Swannell was surveying in the Chilcotin, Ramsey was surveying the islands in Ootsa Lake and doing some other work to add to Swannell's topography of that area. The two members of Ramsey's crew were Jack Bennett and Al Phipps. Phipps articled to be a surveyor under Swannell and worked for him for many years.

Before going to Ulkatcho to survey the Bella Coola trail, Swannell spent a week surveying four lots for the government around One Eye Lake. Then he travelled to Towdystan where May 30 was spent "outfitting and shoeing horses". Swannell, Powers and Stepp travelled to Anahim Lake and on to Ulkatcho where they arrived on June 6. Along the route they stopped one night at the Capoose Ranch where "after prolonged negotiation purchase and slaughter one of Capoose's sheep." Near Ulkatcho "Cahoose & other Siwashes pass on way to 'Priest Time' Algatcho." When Swannell's crew arrived at the First Nations village they found "Siwashes congregated at Algatcho awaiting Father Thomas. Stop a few minutes at Old Tom's store."

Swannell spent a few days at Ulkatcho. While he was there he "went down to outlet of Algatcho [Gatcho] Lake and photographed old weir & trap, probably identical place Mackenzie describes July 15, 1793 – 'or weir formed by the natives for the purpose of placing their fishing machines, many of which of different sizes, were lying on the ends of the river'." He also found a cottonwood tree with a CPR inscription written in red keel that was partially legible and the "trace of 3 or 4 old cabins, long burnt, of squared timber." Swannell located some of the original survey posts for the reserve and began his work by resurveying part of its boundary.

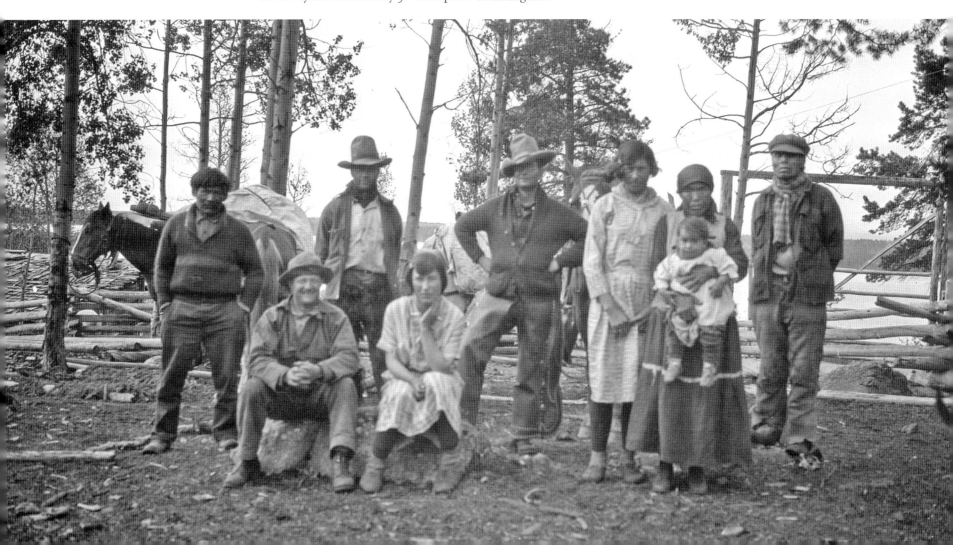

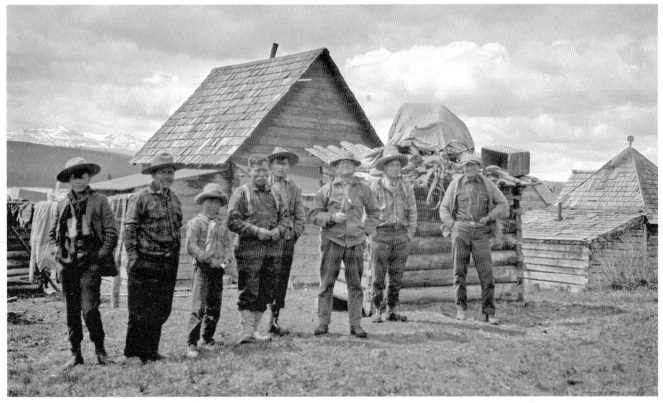

■ Above: Ulkatcho village.
BC Archives G-00872

■ People of Ulkatcho, including Pretty Charlie, Captain Harry, and Stellus.
BC Archives H-06534

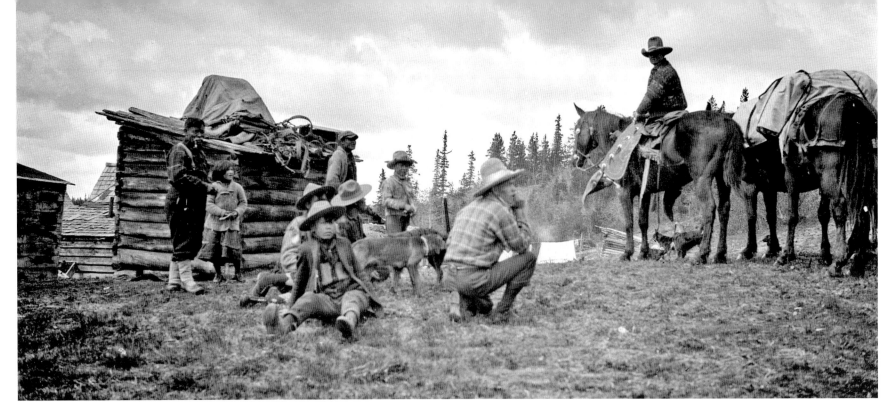

■ Arrival of Swannell's pack train at Ulkatcho village. BC Archives H-06533

■ *Below*: Tom Krestniuk's daughter. Krestniuk operated the store at Ulkatcho. BC Archives I-57182

In 1927 Paul Krestenuk, who operated a store at Ulkatcho, built a wagon road from Tetachuck to Ulkatcho to make it easier to bring in supplies. The road generally followed the Bella Coola trail. The provincial government wanted Swannell to make a traverse of this road so they could put it on their map of the area. This survey would also be connected with Swannell's work in both the Chilcotin and Nechako.

On June 9 Swannell's crew moved camp north of Ulkatcho. From Kleena Kleene Swannell had written Bill Henson at Ootsa Lake, and he joined the crew at this location. While they were traversing Swannell marked in his field book the places where the original Bella Coola trail diverged and rejoined the wagon road. On June 14 Swannell's crew reached Cold Creek where they camped for five days. One evening "several dozen Siwashes encamp with us – White Eye Jack's crowd & Algatcho Charlie – Zulin goes thru to Tetachuck." One day they ran a spur traverse to Entiako Lake and found the old CPR trail. By June 19 Swannell's crew reached the Tetachuck River, where they completed the 33-mile traverse by connecting it to one of the lot surveys at the location. They swam the "horses across the Tetachuck with no trouble although the river is very high" and camped on the far bank with Harry McLean, who had previously worked for Swannell.

The next day the men took a "deferred Sunday. Henson & I help Collins & Harry portage thru heavy canoe abt 4 miles on our shoulders – only pole her halfway up Upper Rapid. Powers & Stepp take their outfit across on 2 horses. I leave with Henson at 3:30 by water with most of the horse loads taking the Negro McHenry

to the Entiako. Delayed 2 hrs by engine trouble. Camp at 10 on Natalkuz." On June 21 Swannell arrived "at Henson's store at noon and push on reaching Bennetts 7pm. Stiff poling in river. Pack train reaches head of Chelaslie Lake – delayed at the Chelaslie Crossing owing to White Jack's crowd having hidden canoe and rafts on the far side." From Bennett's, Swannell went "up lake to Ramsey's Camp, but cannot locate him, passing his boat in a cove. Return to Bennett's & Ramsey comes down after work…. Return to Hensons arriving 11 pm. Pack train arrives at Hensons 1 pm & get horses swim across." Swannell's crew and the horses had now reached the east end of Ootsa Lake, and Swannell had made contact with Ramsey whose men were working further up the lake.

It took Swannell and his men the rest of June to get the horses and supplies moved to Tagetochlain (Poplar) Lake. During that time Swannell got one of the Ootsa Lake residents to make a part that he needed to repair his transit. He also went into Burns Lake one day for business, and visited his friend, Max Gebhardt, at Francois Lake. At Poplar Lake they patched up "old Siwash canoes" and moved to the head of the lake.

Swannell had been at this location at the end of the 1924 and the beginning of the 1925 season. In his surveys during these two years he had not covered the area between Poplar Lake and the Morice River, and he had not mapped the Lamprey Creek drainage. Swannell described the method of surveying that he used in 1928 to Umbach. "I myself made the triangulation control leaving Mr. Ramsey to make transit traverses of the existing trails and such new trails as we cruised and

cut ourselves. These traverses, being carefully done and posted at mile intervals, will be of great value, in conjunction with the monumented hill stations, in giving a rigid framework upon which subsequent more detailed forest surveys may be based. As a further control Morice River was traversed by stadia for some 40 miles from the land surveys at Owen Creek to Morice Lake. The triangulation is closed on the Dominion Geodetic Station on Morice Mountain."

Swannell began his survey by resetting signals on some of the triangulation stations that he had previously set in the vicinity of Poplar Lake, and by setting two new stations. "George & I set lobstick signal on Bittern Hill slashing flat top of hill for a couple of acres clear of alder brush." (A lobstick is a tree whose lower branches have been cut off so that it can be used to identify a location. Lobsticks were sometimes used as signals, particularly when there was only one large tree in a location.) Meanwhile, Ramsey began a trail traverse to the northwest towards Bittern and Bill Nye lakes. On Sunday, July 8, while they were still camped at Poplar Lake, "Bennett goes hunting & resets Moose Hill signal. Phipps down the lake fishing – George & Bill out hunting on horseback – No luck anybody."

Their next camp was at Lamprey Creek at the end of the trail that came from the Morice River up this valley.

■ Fish trap at Ulkatcho near Mackenzie Rock, a typical First Nations trap at a traditional location. BC Archives H-06531

■ CPR inscription at Graveyard Creek. Frank Swannell (left) and Tom Stepp standing beside another piece of evidence of the CPR exploration surveys through this area in the 1870s. BC Archives F-07908

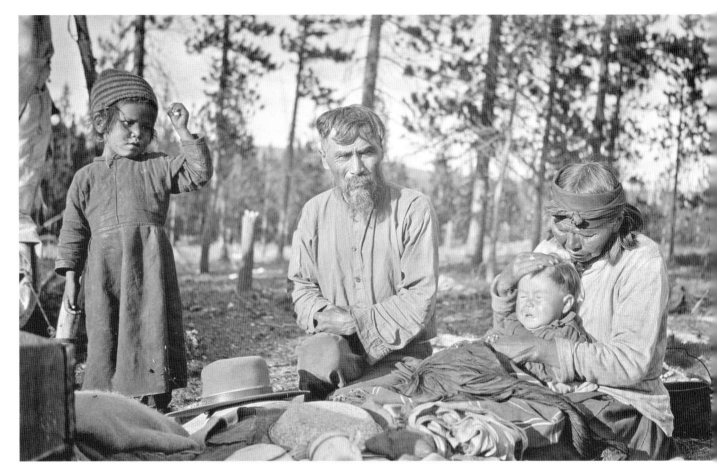

■ White Eye Jack, his wife, Lena, and their children, from the Cheslatta First Nation. Swannell met White Eye Jack a few times while surveying central BC.
BC Archives I-33122

■ *Below*: Cold Creek camp, the main campsite between Algatcho and Tetachuck on the historic Bella Coola Trail.
BC Archives I-33846

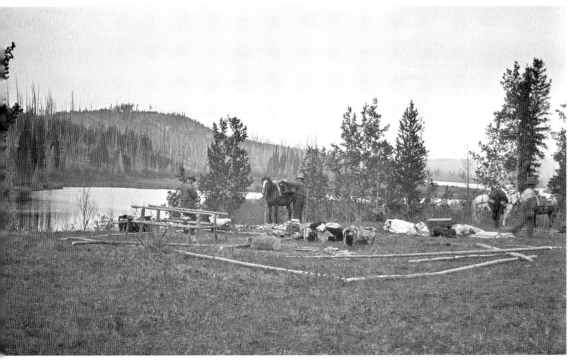

While the men were there Harry McLean arrived to join Swannell's crew by helping George with the packing. This was the fourth season that McLean worked for Swannell. On July 14 "self & George head across for Morice River – bad going through balsam, windfall & brush – headed off by large lake – apparently Collins Lake." Although Swannell would have seen this lake from his triangulation stations he had not mapped it yet and did not know its exact location. During the next two weeks Swannell and Ramsey's crew surveyed the area around Lamprey Creek. One day "Tom cruises off-trail from Bill Nye Lake to River Trail & endeavours unsuccessfully to find a reported trail into Collins Lake." Meanwhile Powers and McLean went into Houston to take in and pick up mail, and to buy some supplies. On July 26 Swannell "reread ΔBittern Hill to close triangulations set to date. Ramsey & Al on previously cut traverse. Packers arrive from Houston 2 pm bringing news of Conservative sweep in the election."

The next day the men moved camp to Lamprey Lake at the head of this valley. Swannell's crew had cut six miles of new trail to reach this lake. Phipps and Bennett

made a big raft for the crew to use while surveying the lake. While they were at Lamprey Lake Swannell took a solar and Polaris observation. Swannell's crew also constructed a trail over to Anzac Lake in the Nanika/Kidprice drainage. Swannell and Ramsey spent a week surveying Anzac and Stepp Lakes. Swannell noted that they were "at end of string of lakes running 40 miles westward." When he had surveyed this drainage in 1925 Swannell had only triangulated Kidprice and Nanika Lakes, and did not have time to map the two smaller lakes in detail. On August 10 "Ramsey surveys Phipps Lake, building 2 rafts. Self reading ΔPhipps – taking transit up with horses. Lake traverse 2 miles. Tri station read 1. Weather fine but strong west wind." Swannell's crew then travelled to Newcombe Lake, crossing the Skeena/Fraser divide.

At Newcombe Lake "Harry & I get trail to foot of lake & cut out a mile of Siwash trap-trail. Bring Siwash raft up to camp." Swannell left Ramsey, Phipps & Bennett to survey Newcombe Lake, while he, the rest of the crew,

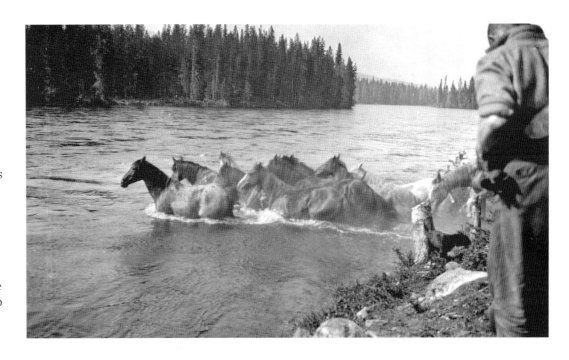

■ Swimming a packtrain at Tetachuck Lake, where the Bella Coola trail crossed the southern part of the Great Circle route. BC Archives F-07907

■ Women with babies at Cold Creek camp on the Bella Coola Trail. One of the women is Chief Louis's daughter. BC Archives I-57270

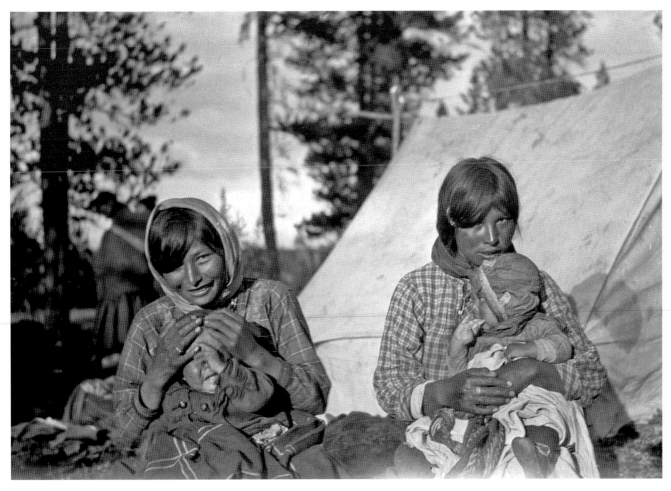

and the pack train departed for Francois Lake. En route, Swannell surveyed from two triangulation stations that he had set in previous years into his 1928 stations. At Francois Lake Swannell spent two days at Max Gebhardt's cabin doing calculations for his surveys, while McLean went "down the lake to North Bank getting provisions which have to be brought in from Burns [Lake]." When Harry returned he went "up lake bringing back George and our outfit." Stepp and Henson then took the pack train back to Ramsey's crew while Swannell, McLean and Powers "put boat & outfit on truck and go through to Houston." It took a couple of days for the men to transport their equipment and travel up the Morice River to Owen Creek. "Much hauling boat & poling.... River almost one continuous riffle – 5 miles, nearer 6 p. hour average rate – in riffles over 8 miles. Tracking bad as bead-rounded boulders." On the way up the Morice, Swannell and his men spent one night at the cabin of Old Douglas.

Swannell began his survey of the Morice River at Owen Creek on August 28. "Start traverse after long hunt for last survey corner up in side channel, blocked with log jam & dense willow – have to cut traverse inland – nearly lose dog (Sharkey) under the same jam where Harry & I nearly smashed up four years ago." Swannell described the Morice River to Umbach. "From Owen Creek to the triple forks, where the outlet of Morice River, the Talbitsa and the North Fork all join to form the main river, the Morice is exceedingly tortuous, seldom confined to one channel

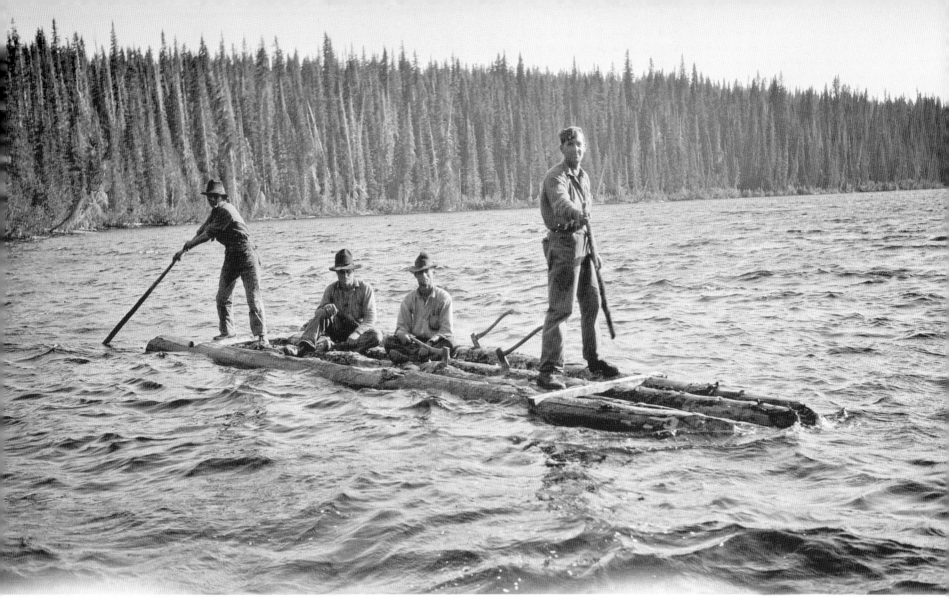

and everywhere very swift averaging at least 5 miles per hour. In many places the channel is shifting, the navigable channel of one season blocking with drift timber and in a few years becoming a back-slough."

When the men reached Lamprey Creek "McLean goes up trail with mail and finds Ramsey at Lamprey Lake." After surveying Newcombe Lake Ramsey went back to Anzac and Lamprey lakes to add more detail to the survey of this area and make additional ties to Swannell's 1925 survey of Kidprice and Nanika Lakes.

After McLean returned, Swannell, Powers and McLean continued their traverse up the Morice River. By September 9 the men were camped near the confluence of the Morice, North Fork and Talbitsa. As they worked up the Morice River Swannell also continued his triangulation of the area. "Triangulation to the south [was] extended by occupying several bare hill spurs readily accessible from the river," he wrote to Umbach. Near the junction Swannell set a triangulation "station

1/2 mile up Talbitsa. East wind driving a solid wall of smoke up the river – Nadina completely blotted out – to west raining – a curious effect. By a miracle, thru a rift in the clouds get Seymour Cairn [a triangulation station from his 1924 surveys]."

Above the confluence the Morice became "swifter – 7-8 miles per hour. Cannot make two riffles with pole & engine & have to line." On September 14 Swannell wrote in his journal: "Weather raw & cold – one heavy shower. New snow on mountains. River more rapid & line twice, once very bad, line fouling under big boulder." The next day they arrived at Morice Lake in the late afternoon. "Catch 1 – 3 lb. trout. Weather cold and raw, rain at night. River full of humpback salmon. Remains very old fish trap across head of river."

After a Sunday of rest Swannell and his crew returned down the Morice River, surveying some triangulation stations along the way. At Lamprey Creek, Powers left to find Ramsey's crew who were surveying

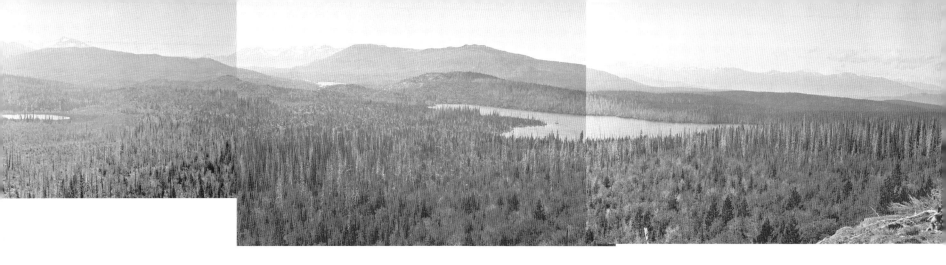

Panorama from Phipps Bluff, a triangulation station above Phipps Lake. While Swannell was tying this station into his triangulation survey of the area, Ramsey was surveying the shore of Phipps Lake. Swannell made a connection from his triangulation station to some of Ramsey's stations along the lake. The panorama from Phipps Bluff would be used back in Victoria to help Swannell provide more detail in his map of the area. BC Archives I-33845, I-59261, I-59260

Below left: Swannell's triangulation at Phipps Bluff overlooking Phipps Lake. The triangulation is tied in to Bennett and Newcomb, stations near two lakes in the area.

Below right: Ramsey's survey of Phipps Lake.

down the creek from Lamprey Lake. He picked up three horses and headed to Houston where Swannell and McLean had gone. At Houston "McLean's time stops and pay him off." Swannell also made arrangements with McLean for him to drive their crew back to Vancouver at the end of the field season for $350.

Swannell and Powers returned "up the river trail with saddle horse and two pack horses, making through to Douglas cabin." On September 24, "accompanied by Douglas move camp to Morice Mt. – camping about a mile from Geodetic station. Threatening rain and one

sharp shower. Make camp in stunted balsam 2 pm, climb to station but only succeed in reading into Nadina, Pimpernel & Poplar when clouds lift." The next day Swannell went back to the "Geodetic Station on a forlorn hope – above clouds until nearly noon & when they finally break up find the east wind has filled the country with smoke. Leave summit 2 pm & reach river 6 pm." Then Swannell and Powers went to Owen Creek where he tried "to connect surveys to Geodetic Station but too smoky." On September 27, after a "long wait in morning until fog lifts", the weather was finally clear. Swannell was able to

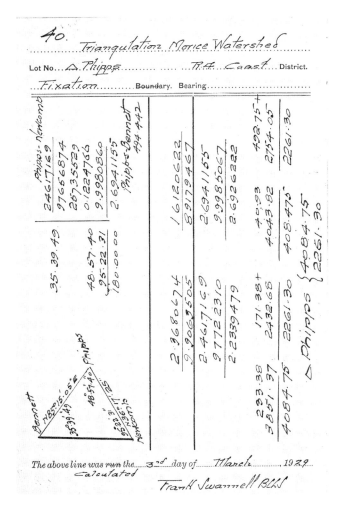

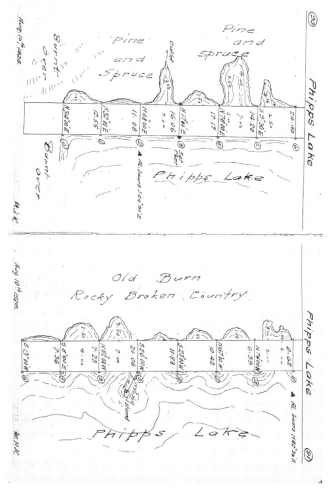

tie one of the mile posts that Ramsey set with a survey post at Owen Creek, two of the triangulation stations that he set in 1928, and the Geodetic Station on Morice Mountain. He also took a solar observation. Now he had a firm connection between his 1924 and 1928 surveys.

Swannell joined Ramsey, and the men spent the last days of September and the first week of October completing the survey of the area. The fall's first snowstorm occurred on the second day of October. Four days later Swannell and Powers walked "thru to Owens Creek with 3 horses heavily packed – 13 miles", and the next day they continued 12 miles to Douglas' cabin. On that same day, October 7, Ramsey reached the mouth of Lamprey Creek where he connected his traverse with

Swannell's survey of the Morice River. He also took an observation on Polaris to finish his work.

Swannell had completed the surveys requested by Umbach. In the process he had extended his triangulation network north to the Morice River, and added more detail to the east side of his work in the Chilcotin. In summarizing Swannell's work, the Surveyor-General wrote: "Mr. Swannell's work consisted mainly of a topographical reconnaissance of the basins of the Morice and Nadina Rivers. Owing to the fact that the area is fairly heavily timbered and does not present much relief, much of the work consisted of traversing instead of triangulation.... The work of this party will be of assistance in connection with the forest surveys contemplated for the near future, and also in connection with mining developments in the area covered."

1928 was the easiest of Swannell's nine years of surveying in central British Columbia. The weather had been warm and fairly dry. Mosquitoes and flies were only mentioned in his journal a few times. Most of the surveying was traverse work through forested areas. Swannell only surveyed at 44 triangulation stations, some previously established when he was in the area in 1924 and 1925. Most of the stations were on open hillsides, and Swannell was only on a few mountain summits during the season.

There was one thing Swannell wanted to do before finishing his surveying for 1928. On October 9 "George & I take three horses up Morice Mt. striking into new snow at alt. 2500 – getting deeper until at old camp of Sept 25 there is nearly a foot. Clouds never lift, but push up to station at 2 pm in a blinding snowstorm."

Although Swannell could not see the mountains he knew that the work of his last nine years circled him in a panorama. Just south of him was tall, blocky Nadina Mountain. Swannell had used the triangulation station on this peak many times, but he had never been able to survey from it. Further south, behind Nadina, were Chikamin, Musclow and the high mountains around Whitesail and Eutsuk Lakes where he surveyed in 1920 and worked his way through the Coast Mountains down to Kimsquit. West of these mountains was the Tahtsa drainage and some of the peaks that he had surveyed when he was there in 1921. To the southeast was Mount Wells (Stoney Mountain). Swannell had followed a First Nations hunting trail to the top of this mountain in 1921. He established a triangulation station there and had surveyed from the top of this mountain several times. Further southeast was the mountain that had been named for him. Swannell had been on the top of that peak in 1922 and had surveyed to it from many triangulation stations during the last nine years. In the same direction

Old Douglas playing the banjo outside his cabin. BC Archives I-57178

were the valleys containing the lakes of the Nechako headwaters that he had triangulated in 1922 and 1923.

To the north and northeast were the mountains around Babine and Takla Lakes where he had also surveyed in 1923, during his lone trip back to northern BC. Westward was the valley where Morice Lake was located. Swannell had surveyed this lake in 1924. Beyond it were the rugged peaks where Swannell had tried to find a route through the Coast Mountains to connect with Monckton's network. Swannell had also first surveyed from Morice Mountain in 1924. That had been his most difficult year in central British Columbia. Among the year's challenges were miserable weather, isolation, diminished provisions, and a close call with a grizzly bear.

To the southwest, between the Morice and Tahtsa drainages, was the valley where Nanika and Kidprice lakes were located. Swannell had surveyed there in 1925, along with the adjacent mountains of the Sibola Range. He had also returned briefly to this drainage in 1928 while surveying at Anzac and Stepp Lakes. On the distant southern horizon were mountains that Swannell had surveyed in the Chilcotin in 1926 and 1927. Below him, to the west, was the Morice River that he had most recently surveyed, and in the forested area to the southwest were valleys containing the lakes that he had added to his triangulation network this year.

Swannell could not have known that the information from his surveys and maps would be vital in establishing

■■ *Right*: The Geodetic Survey station at Morice Mountain. Swannell initially surveyed from Morice Mountain in 1924. When he returned in 1928 he found that the Geodetic Survey had established their station about 10 feet (three metres) from his, so Swannell used both stations in his 1928 survey. BC Archives I-33636

■■ *Below*: The survey crew had a difficult time working their way up the Morice River. BC Archives I-59203

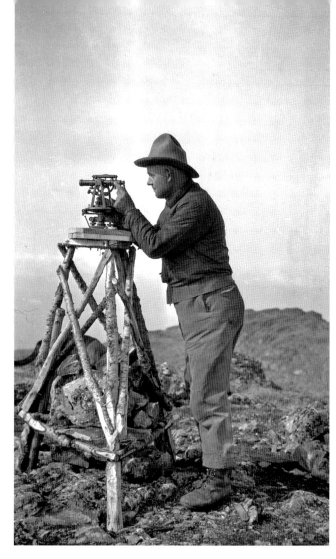

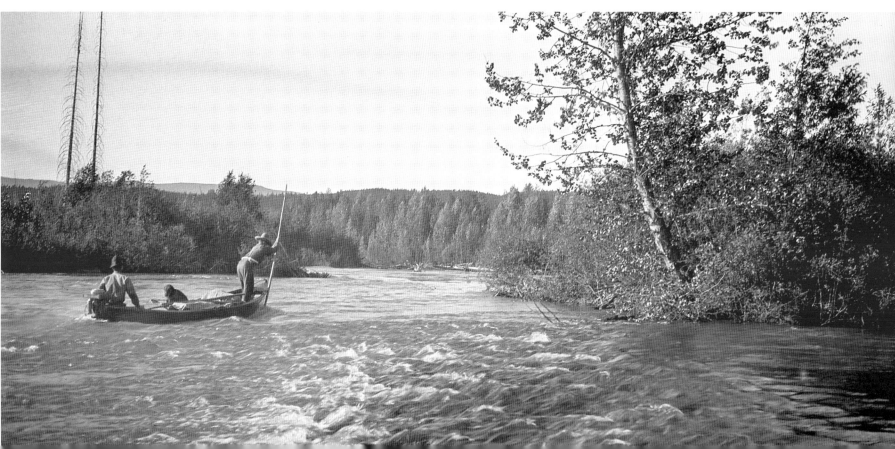

one of British Columbia's largest provincial parks, Tweedsmuir, which would preserve a sizeable portion of this region as wilderness. He also did not realize that his work would be instrumental in the creation of the province's first mega-project after World War II and that almost a quarter century later, as an old man, he would come back to this area and witness a landscape that was vastly altered by the Kenney Dam.

Swannell and Powers stayed on top of Morice Mountain, "freezing" for 20 minutes and then "with difficulty track our way down & make camp. Blizzard continues until 10 pm." Swannell had hoped that the weather would clear and that he could survey from the top of Morice Mountain, but the next day there was "sixteen inches snow at camp & probably nearly two foot at station. Clouds only lift for a moment or two and crags above never clear." In the early afternoon Swannell reluctantly went up and brought down the "big transit" that he had left on the summit. Then he and Powers went down the mountain, camping that night along the Morice River.

The two men returned to Houston the next day and found that Ramsey and the rest of the men had come in the previous evening. To mark the end of the season there was a "celebration at night & the bartender (Harry McLean) with helper Bill Henson becoming bewildered in the rush of orders a compromise is made by calling the consumption $5 per head, beer being 3 bottles one dollar." The next day "leave Houston 1 pm, arriving Burns Lake 4:30 pm ... driven by McLean. Road very greasy & McLean shows himself hopeless as a driver. Drag him out of a black-jack game in a shed at Burns Lake & call the proposed motor trip to Vancouver off. Give him $50." Instead the men boarded a train that took them to Red Pass Junction. They stayed overnight, then took another train to Vancouver, and a boat to Victoria.

Frank Swannell had completed his famous surveying and mapping project of central British Columbia. Next season it would be time to return to northern British Columbia.

■ George Powers takes the horses through the snow on Morice Mountain. BC Archives I-57207

■ Sunset from the summit of Mount
Swannell. All photographs in this chapter
by Jay Sherwood.

SUMMER 2005 AND 2006

When summer vacation arrived in June 2005, it wasn't just students who were leaving for new adventures. Departing Vancouver two days after the completion of the school year, I took a break from my job as a teacher, and spent most of the summer of 2005 visiting places where Swannell surveyed from 1920 to 1928.

On the way north I visited Frank Swannell's grandson, Geoff, who lives near Kamloops, and through him made contact with another grandson, Brian Pollard, the son of Swannell's surveying assistant for four years. In Prince George I worked with Archives staff at the University of Northern BC for two days examining the collection of Al Phipps material that they had recently acquired. It provided me with a better perspective of the man who first joined Swannell's crew in 1928 and became an important part of Swannell's surveying for over a decade.

My first hike was to the top of Uncha Mountain on the south side of Francois Lake. Eventually I located the unmarked ATV/snowmobile trail that leads to the microwave tower at the top of the mountain. When Swannell surveyed from this location in the 1920s a forest fire had burned down the trees and he had a clear view of the area. Today the vista to the north is covered. However, I was able to see Mount Swannell, Mount Wells (Stoney Mountain), and Nadina Mountain. These three peaks, which were an integral part of Swannell's triangulation network, would become landmarks that I would see often during the summer.

The next day I went to Phipps Lake. Several years ago the area was logged to within 300 meters of the lake, but Phipps Lake still looks much like Swannell and his crew found it during early August in 1928.

Two days later I hiked up Nadina Mountain. It's a long way from timberline to the summit of the peak. As I walked up the steep slope and scrambled over rocks, a vista of the area appeared. I was able to see Mount Swannell, Mount Wells and Uncha Mountain, the Coast Mountains to the west around Morice Lake, and some nearby peaks and lakes.

Just before reaching the top, storm clouds began moving in from the west. Looking at the place where I began climbing up the mountain far below me, I realized I did not want to be caught in the rain without shelter or lose my direction in the clouds, so I reluctantly turned back.

From there I travelled to Terrace where I joined Aaron Hill. I had met Aaron while doing research at the BC Archives. He was working on a fisheries study in the Kitlope where Swannell surveyed in 1921, and he had offered to take me in with his crew for a week at the end of June. I wanted to visit the Kitlope close to the time of the year when Swannell was there. Unfortunately, it rained every day and the mountains were never visible, much like the conditions Swannell encountered in 1921.

From central BC, the trail of Swannell research took me to Library and Archives Canada in Ottawa, where Swannell's 1923, 1924 and 1928 journals are kept. The week in Ottawa was extremely hot and humid, and it was a strange sensation to sit in an air conditioned building reading of events so far away and in such a cool climate.

In early August I returned to central BC, where I met Les Burgener, an old friend and fellow teacher, in Vanderhoof. We camped at Nechako Lodge and hiked down into the old Grand Canyon of the Nechako River. The river bed below Kenney Dam is virtually dry, for the water from the upper Nechako watershed now comes out through the Cheslatta River. After a morning rainstorm, Joe Doerig of Nechako Aviation flew us around Mount Swannell and out to the west where we had a full view of the cloud-topped Coast Mountains. Then we rented a riverboat and Les drove us up the reservoir to the old cabin at the foot of Mount Swannell. From here, we started our backpack trip to the top of the mountain. In the early evening, after four hours of cross-country travel, we reached the summit of the peak.

In his journals Swannell often mentions the cold and wind he encountered while surveying from his mountaintop triangulation stations. Les and I found similar conditions on the summit of Mount Swannell. After wearing only shirts and sweating on the way up,

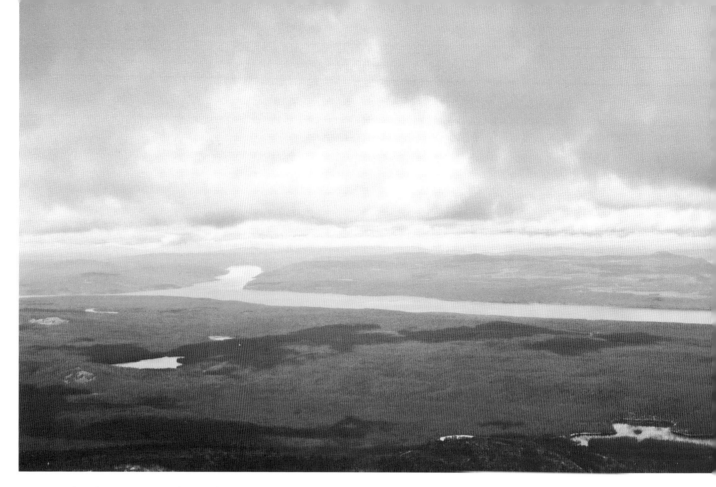

Chelaslie Lake from Swannell Mountain – the same view as shown on page 69. The Kenney Dam has altered the lake and flooded Chelaslie Arm. The water in the reservoir has backed up into the Entiako River on the right.

Below: Natalkuz Lake from Swannell Mountain – the same view as shown on page 70. The landscape has changed considerably since 1922. Much of Jim Smith Point, which separated the lakes, has disappeared.

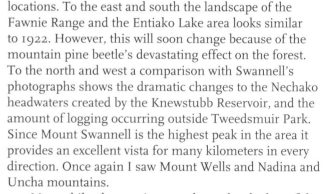

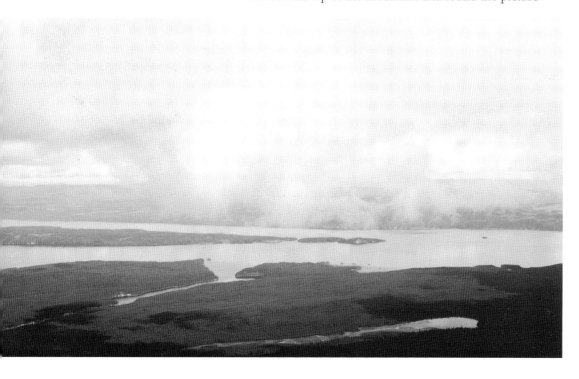

we immediately put on every layer of warm clothing we could find. Les started supper and searched in vain for a level place out of the wind to put up a tent, while I took out copies of the seven photographs that Swannell took at the top of the mountain and found the picture

locations. To the east and south the landscape of the Fawnie Range and the Entiako Lake area looks similar to 1922. However, this will soon change because of the mountain pine beetle's devastating effect on the forest. To the north and west a comparison with Swannell's photographs shows the dramatic changes to the Nechako headwaters created by the Knewstubb Reservoir, and the amount of logging occurring outside Tweedsmuir Park. Since Mount Swannell is the highest peak in the area it provides an excellent vista for many kilometers in every direction. Once again I saw Mount Wells and Nadina and Uncha mountains.

Meanwhile, the evening sun threw the shadow of the triangular-shaped summit of Mount Swannell onto the shoulder of the Fawnie Range. A few minutes later a faint rainbow arched over this shadow. Then the sun went down directly behind Chelaslie Lake where Swannell's crew surveyed in 1923. Following that, the clouds in the western sky lit up in brilliant colors.

We spent the night sleeping on a narrow platform under the Forest Service lookout on the peak while the wind continued to roar outside. At times I woke up during the night to see stars above and a clear view of the valley below, while at other times fog rolled up and obscured the sky.

Following this trip I travelled to Houston. Staff at the Information Centre provided directions for the route up

Mount Morice since there is no trail. Like Mount Swannell, Mount Morice is not a particularly high mountain, but its location provides an outstanding vista in every direction. From this peak I could see all the familiar mountains that I had been following all summer, and almost all the locations where Swannell surveyed between 1920 and 1928. It was easy to see why he wanted to complete his survey of central BC on this mountain in October 1928.

From Houston I travelled to the First Nations village at Fort Babine. There I met Fred Williams, who was working on historical research for the Fort Babine band. He was very interested in Swannell's photographs, particularly the ones that showed their salmon fishery in 1923. Fred invited me to join him for lunch with an exchange group that they were hosting from the Navajo Reservation in Arizona. The salmon were beginning to come up the river and we had some of last year's smoked salmon, and some of this year's fresh salmon.

In the afternoon Fred brought one of the village elders to look at the photographs. When he saw the picture with the two men, the elder immediately pointed to one. "That's Old Fort Chief Michel," he said without hesitation. "I remember him from when I was a little boy." The elder smiled. The photograph must have brought back some happy memories. In the afternoon I walked around the village. Swannell took several pictures of Fort Babine in 1923, and it was interesting to stand at the same sites. I found the location of the 1913 and 1923 Hudson's Bay Company posts. A flagpole still stands on its original location. The church is the only remaining building from 1923, and it has been renovated. Swannell's photographs show that Fort Babine was more extensive and more densely populated than today.

Then it was back to Terrace and another week in the Kitlope. This time there was good weather and the mountains were visible almost every day. It was nice

■ Looking south over Phipps Lake.

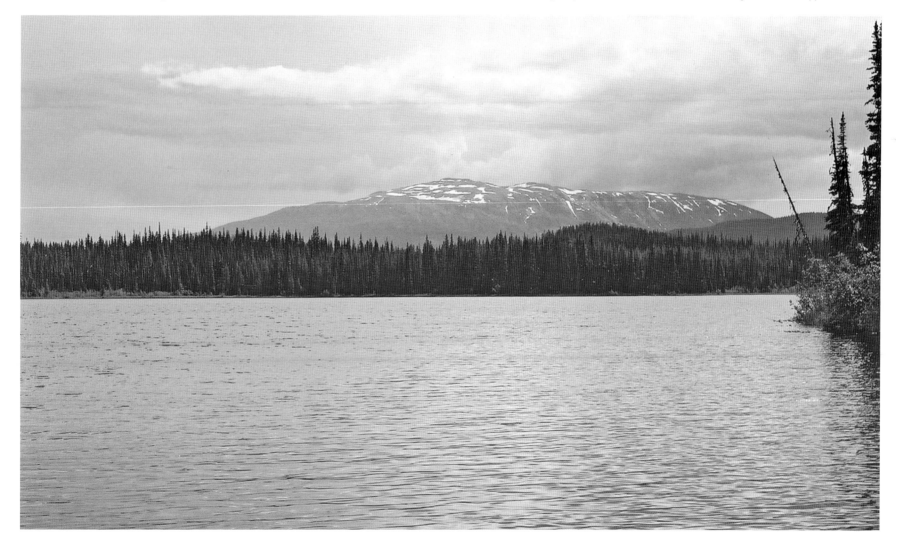

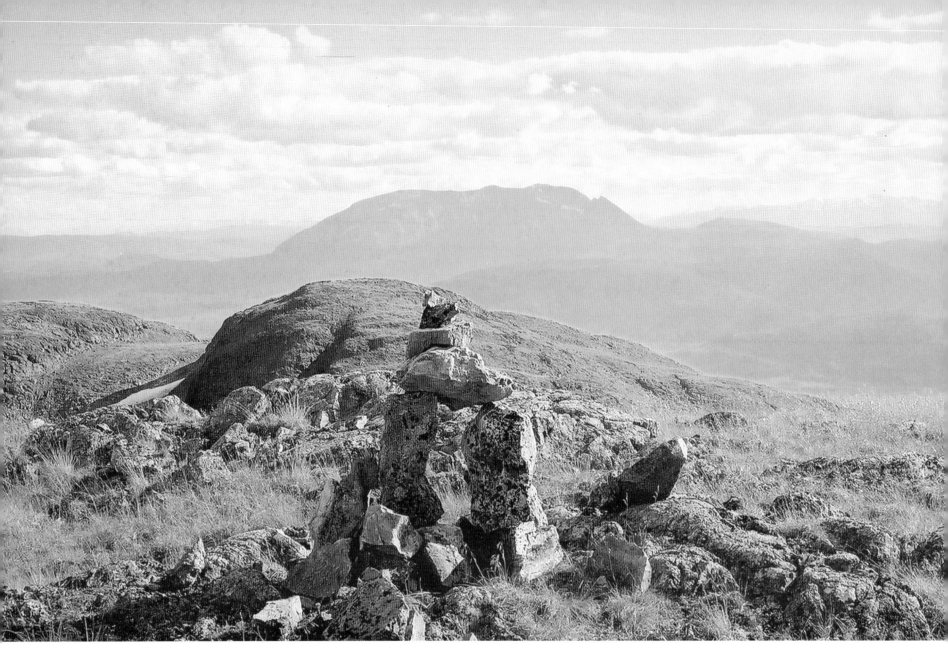

to once again have my tent underneath the big old Sitka spruce along the Kitlope River. One morning I canoed down the river to Gardner Canal where I located Swannell's camp at the foot of the canal. The old Sitka spruce that appears in one of his photographs near his first camp is still there. I visited the deserted village of Misk'usa and saw the replica totem pole that has been placed on the bank facing the river. Using Swannell's photograph I stood at the original site of the G'psgolox totem pole. When I turned in the direction the totem pole faced and looked up, I was gazing directly down the river to Gardner Canal. It was a powerful feeling to see the view that the G'psgolox totem pole had. I realized that this totem pole had not only cultural significance, but that it was also a geographic marker. When a person

reached the head of Gardner Canal and turned to go up the Kitlope River they would have been looking directly at the pole marking the village of Misk'usa.

One afternoon I canoed around Kitlope Lake. Swannell took most of his photographs at survey stations, and I located five of the six sites. At each site, while I was exploring and taking pictures, animals, including birds, fish and seals, came to visit me. Although it was August, more than two months later than Swannell was at Kitlope Lake, a comparison with Swannell's photographs show that the glaciers around the lake (which were already receding in 1921) have now retreated to the tops of the mountains. It was interesting to see the changes in the lake outlet and along the river that have occurred since Swannell surveyed there. The Kitlope is a very dynamic valley.

In late August my son and I hiked part of the Burnt Bridge Creek trail that Swannell followed at the beginning of his 1926 surveys. The summer of 2005 ended with the two of us taking a day hike into the Rainbow Range in Tweedsmuir Park. Looking west from the ridge top we reached I could see the Coast Mountains, some of the rainbow-coloured mountains near Mackenzie Pass, and many of the places where Swannell travelled in 1926 and 1927.

In the spring of 2006 the Haisla repatriated the G'psgolox totem pole from Sweden to Kitimat. When it first came to Canada the totem pole was on display at the UBC Museum of Anthropology. Twice I went out to see it. I took the copy of Swannell's photograph of the totem pole that I had taken to Misk'usa with me and placed it beside the pole to give it a connection with its former home. It was inspirational to personally view the G'psgolox totem pole, especially after I had been to Misk'usa. It was also interesting to compare its condition in 2006 with the photograph that was taken 85 years

earlier. Some sections looked much like Swannell's photograph, while other parts have deteriorated through the years.

In the summer of 2006 I took a four-day backpack trip in the southern part of Tweedsmuir Park. Following the Capoose trail that Swannell travelled in 1927, I turned north on the Tweedsmuir trail and arrived at the Rainbow cabin a few kilometers below Mackenzie Pass. The big old lodgepole pines with the deep blazes that were present when Swannell travelled through this area are dying now. The day that I planned to climb Mount Mackenzie was cold and foggy. However, I had hiked to Mackenzie Pass in 1994 with my sons and saw the view that Mackenzie and Swannell witnessed and described.

While I was in the Chilcotin I visited the 1864 Fish Trap massacre site. Swannell took a set of photographs showing this location in 1927. Almost 80 years later this site, which was open when Swannell visited, is now covered with many young aspen. However, there are only a few conifer trees that have started to grow at this

Fort Babine, the photograph taken from a location close to Swannell's photograph on page 86. The church is the only building from 1923 still standing.

location, and it was still possible to find most of the places where Swannell took his photographs.

During the past two summers I have contacted or personally met several descendants of the men who worked with Swannell in the 1920s. I enjoyed hearing their stories and the information they provided, and have tried to incorporate this material into the book. Visiting some of the places where Swannell worked and meeting people who had a connection with him added to my understanding and appreciation of the work that he and his crew did and the land through which they travelled while surveying central British Columbia.

Jay Sherwood
November 2006

■ The newly carved G'psgolox mortuary pole in the village of Misk'usa (see page 40).

■ Looking north over Kitlope Lake – a view similar to the one on page 44. The gravel bar is not as large, and only a vestige of the glacier remains at the top of the mountain.

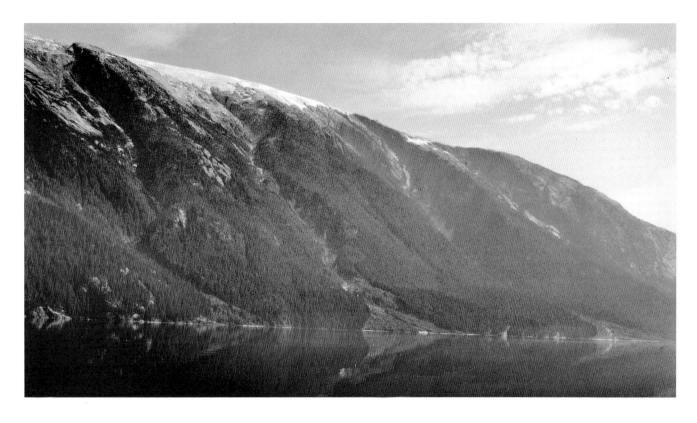

■ Looking southeast over Kitlope Lake – a view similar to the one on page 45. Both of these recent photographs show that the glaciers around Kitlope Lake are receding.

■ *Below*: The Fish Trap Massacre site in 2006 (see page 137).

Appendix
The People of Swannell's Surveys

Many men worked on Swannell's crews during his survey of central British Columbia. Most of these people were from the area where Swannell surveyed, and only a few worked more than two seasons. A.C. Pollard and Harry McLean were members of his crew for four years, while M.H. Ramsey, George Powers and Mike Fenton worked for three. Swannell remained in contact with many of these people throughout his life.

1920
Fort, E.D., Surveying Assistant
Butterfield, A.J. (Alf)
Haven, C.D (Shorty)
Kastberg, Viktor
Lee, Ed
Musclow, Charles

1921
Pollard, A.C., Surveying Assistant
Gebhardt, Max
Kastberg, Victor
Lowe, Douglas
Musclow, Charles
Musclow, Harry

1922
Pollard, A.C., Surveying Assistant
Gebhardt, Max
Morgan, James
Musclow, Charles
Stranack, Bob

1923
Pollard, A.C., Surveying Assistant
Fenton, Mike
Goodrich, C.A.
Henson, Bill
McLean, Harry
Michel, Jack
Morgan, James

1924
Ekins, W.E.
Fenton, Mike
McLean, Harry
Money, Ernle

1925
Pollard, A.C., Surveying Assistant
Fenton, Mike
McLean, Harry
Money, Ernle
Vincent, George

1926
Ramsey, M.H., Surveying Assistant
Butler, Leonard (Wahla)
Jones, Captain
Powers, George
Powers, Mrs. Jessie

1927
Butler, Leonard (Wahla)
Jones, Captain
Powers, George
Stepp, Tom

Ramsey's Crew
Ramsey, M.H., Surveying Assistant
Bryant, C.
Dorsey, Lester
Gadsden, Percy
Holmes, Frank
Stranaghan, R.

1928
Ramsey, M.H., Surveying Assistant
Bennett, Jack
Henson, Bill
McLean, Harry
Phipps, Al
Powers, George
Reid, Jeff
Stepp, Tom

Many of the men who worked for Frank Swannell in central BC have geographic features named for them.

The area around the southwest end of Eutsuk Lake has several features named for the men of Swannell's surveys. Viktor Kastberg, Swannell's cook and assistant during the 1920 season, has Mount Kastberg, south of Eutsuk Lake, named for him. Kastberg, Swannell and Fort climbed this mountain on August 14, 1920, and established a triangulation station there. Kastberg was also a Forest Branch member of Swannell's crew in 1913 and has a creek in the Ominecas named for him.

Mount Haven, in the same area, along with Haven Lake, are named for Shorty Haven. Charles Musclow had Mount Musclow and Musclow Lake named for him. Mount Stranack recognizes Bob Stranack, a member of Swannell's crew in 1922.

Pollard Peak and Pollard Creek are named for A.C. Pollard, Swannell's surveying assistant for four years. These two geographical features in the Kimsquit drainage were visible from the 1922 survey in the Lindquist Pass area.

Some of the geographical features inside the lakes of the Great Circle are named for the men who surveyed this area in 1923. Morgan Lake recognizes Jimmy Morgan, nearby Goodrich Lake is named for C.A. Goodrich, and Jack Michel is remembered with Michel Lake, Michel Peak and Michel Creek. Mike Fenton has a lake in this area named for him.

Fenton, who worked for Swannell from 1923 to 1925, has a creek that drains into the Morice River named for him. There is also another creek that drains into Nanika Lake that is named for Fenton. Originally, Swannell wanted to name this creek for Harry McLean, but since McLean is used for several geographical features in British Columbia, Fenton Creek was selected.

There are other features in and around the Nanika-Kidprice drainage named for Swannell's crew members who worked there in 1928. Anzac Lake recognizes Jack Bennett. According to a note written by G.G. Aitken, Chief Geographer for British Columbia's Department of Lands, "Mr. Swannell named this after Jack Bennett, an axeman on his party, an Australian who served in 16th Can. Scot. in Great War." (Anzac is the name for the Australian/New Zealand army corps in World War I.) Originally Swannell had named it Bennett Lake. Stepp Lake is named for Tom Stepp, another member of his 1928 crew. Originally Swannell named this lake for Harry McLean, but it was rejected for the same reason that McLean Creek was not accepted. The creek that flows from Stepp Lake into Kidprice Lake is also named for Stepp. Nearby Phipps Lake recognizes Al Phipps, who first worked for Frank Swannell in 1928.

Some members of Swannell's 1926 and 1927 crews are part of the geographic landscape of the Chilcotin. M.H. Ramsey, Swannell's surveying assistant, has Ramsey Peak and Ramsey Creek named for him. Butler Peak and Mount Leonard are both named for Leonard Butler. His nickname, Wahla, is also remembered in Wahla Peak and Wahla Lake. Mount Jones is named for Captain Jones and Mount Stepp for Tom Stepp.

The O.B. Joyful rum that the men drank for special occasions is toasted in Ob Peak between Morice and Kidprice Lake. When the name was originally proposed by Swannell as O.B. Peak there was a note from the Geographic Board asking him to "please supply reference meaning." Whether Swannell provided an explanation is unknown, but his name for the peak was accepted, although a geographer (who probably did not realize the significance of the name) changed it to Ob Peak. It's an appropriate reminder of surveying in central British Columbia in the 1920s.

Acknowledgements

I would like to express my thanks to the many people who provided assistance during the research and writing of *Surveying Central British Columbia*. It was nice to have your support and to know that there is so much interest in BC's history.

Thank you once again to my wife, Linda, for all your assistance with this project, and to my entire family for their support and encouragement.

The Association of BC Land Surveyors provided financial assistance towards the research trip to Ottawa in 2005. I am grateful to the association for their continued support. Thank you to the staff of the British Columbia Archives for their assistance, particularly the people who continue to cheerfully retrieve material and tolerate my foibles. I would especially like to acknowledge Kelly-Ann Turkington for her help in finding the unpublished photographs and maps used in this book. Thanks also to the staff at Library and Archives Canada in Ottawa – they lived up to their reputation for excellent service.

Jeff Beddoes once again arranged for me to access Swannell's field surveying books and to publish some of the pages. These books provided a wealth of information and insight into Swannell's surveying in central BC. Janet Mason of the Base Mapping & Geomatic Services Branch continued to provide access to the geographical record cards and Swannell's correspondence regarding the naming of geographical features.

During my research I made contact with descendants of several men who worked on Swannell's surveying crews. The information provided by these family members helped me better understand the lives of these men. I appreciate your assistance. I would also like to recognize the people in the archives on Saltspring Island, who allowed me to read Ed Lee's 1920 diary, an interesting account of working on a surveying crew.

Lillian Fletcher, George Copley's granddaughter, and Kris Andrews, Gerry Smedley Andrew's daughter, provided contacts for people involved with Swannell's surveying in the Chilcotin. It was nice to have the descendants of two people who were an integral part of the first book involved in the second book. Frank Swannell's grandson, Geoff Swannell, also provided information and allowed me to photograph some of his grandfather's World War I items. My thanks also goes to Lil McIntosh for sharing her knowledge of the history of the Nechako River valley and for her hospitality.

During the summer of 2005 I visited some of the places where Swannell surveyed during the 1920s. Aaron Hill took me to the Kitlope twice. It was a special privilege to see this remote wilderness area virtually unchanged since Swannell was there in 1921. It was a pleasure to work with Aaron and combine Swannell's historical material with his salmon studies. Les Burgener, a friend and fellow teacher from Vanderhoof, organized and led our two-day trip up Mt Swannell. It was fun to be outdoors with Les again, and the trip up Mt Swannell was a special experience. My appreciation also goes to Joe and Elisabeth Doering of Nechako Lodge for the plane trip around Mt Swannell and the boat rental.

I would like to thank Fred Williams of the Fort Babine Band for the information and hospitality he provided during my day there. Nanakila Institute and the Haisla First Nations shared their history of the G'psgolox totem pole and the Kitlope area, and their assistance is appreciated.

Finally I would like to thank Gerry Truscott and the Royal BC Museum for publishing the second book on Frank Swannell's career. I hope that it's the beginning of a continuing partnership for producing material on BC's history.

Jay Sherwood
August 2007

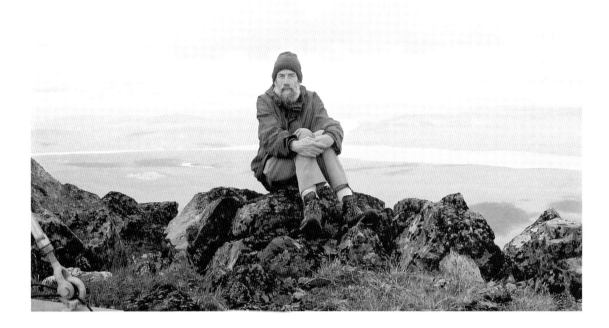

Jay Sherwood at the summit of Mount Swannell. Les Burgener photograph

About the Author: Jay Sherwood

A historian and former surveyor, Jay Sherwood is the author of *Surveying Northern British Columbia*, a 2005 BC Book Prize finalist. From 1979 to 1986, he lived in Vanderhoof where he first learned about Frank Swannell through his involvement with the local history society. As part of the research for *Surveying Central British Columbia*, Sherwood spent part of the last three summers visiting places in central BC where Swannell surveyed. He now lives in Vancouver where he works as a teacher-librarian. He is involved in several research projects on the history of British Columbia.

Surveying Central British Columbia: A Photojournal of Frank Swannell, 1920–28
Edited by Andrea Scott.
Designed by Chris Tyrrell and Michael Carter, RBCM.
Digital photographic production by Kelly-Ann Turkington, Kim Martin and Carlo Mocellin, RBCM.
Layout and typesetting by Michael Carter (RBCM) and Reber Creative.
Typeset in Scala 10/12 (body) and Scala Sans 8/9.5 (captions).
Printed in Canada by Kromar Printing, Winnipeg.
All photographs and other illustrations reprinted with permission from their sources.

Sources Consulted

Books

Anderson, Frank W. *Old Bill Miner*. Surrey: Heritage House Publishing, 2001.

Bonner, Veera, Irene Bliss and Hazel Litterick. *Chilcotin: Preserving Pioneer Memories*. Surrey: Heritage House Publishing, 1995.

Burns Lake & District. Burns Lake: Burns Lake Historical Society, 1973.

Fleming, Sandford. *Report on Surveys and Preliminary Operations on the Canada Pacific Railway up to January 1877*. Ottawa: MacLean, Rogers & Co., 1877.

Grauer, Peter. *Interred with their Bones: Bill Miner in Canada*. Kamloops: Partners in Publishing, 2006.

Henderson, Bob. *In the Land of the Red Goat*. Smithers: Creekstone Press, 2006.

Hoagland, Edward. *Notes from the Century Before*. Vancouver: Douglas & McIntyre, 1969.

Hobson, Richmond P. *Grass Beyond the Mountains*. Toronto: McClelland and Stewart, 1951.

Rajala, Richard. *Up-Coast: Forests and Industry on British Columbia's North Coast, 1870-2005*. Victoria: Royal BC Museum, 2006.

Walker, A. (Tommy). *Spatsizi*. Surrey: Antonson Publishing, 1976.

Articles, Pamphlets, Diaries, Videos

Andrews, Gerry Smedley. "Frank Cyril Swannell, 1880–1969: Pioneer British Columbia Land Surveyor." Transcript of speech for the BC Provincial Museum, June 20, 1979.

— "Surveys & Mapping in British Columbia Resources Development." Transcript of speech for the 7th British Columbia Natural Resources Conference, Victoria, February, 1954.

British Columbia Archives. "Frank Swannell: British Columbia Land Surveyor." Pamphlet produced for photo exhibit, 1979.

British Columbia Land Surveyors. "R.P. Bishop." In *1955 Annual General Report: Report of the Proceedings of the Fiftieth Annual General Meeting of Land Surveyors of the Province of British Columbia*, pp. 47–48.

Cardinal, Gil. *Totem: The Return of G'psgolox Pole*. National Film Board, 2003.

"Frank Cyril Swannell, B.C.L.S., D.L.S. 1880–1969" *B.C.L.S. Proceedings-1970*, pp.117–19. Victoria: Corporation of Land Surveyors of the Province of British Columbia. Report of proceedings of the 65th annual general meeting.

"Frank Cyril Swannell." *The Canadian Surveyor* 24:1 (March 1970) pp.164–65.

Gauer, Frank. "To See the World Through Others' Eyes." *The Vancouver Sun*, February 28, 2006, pp. E6–E7.

Hansen, Darah. "An Emotional Homecoming." *The Vancouver Sun*, April 27, 2006, pp. B2–B3.

Karen, Mattia. "Sweden Returns Totem Pole Taken from B.C. Native Band." *The Vancouver Sun*, March 15, 2006, p. A3.

Lee, Jeff. "A Totem Pole Comes Home." *The Vancouver Sun*, March 1, 2006, p. A3.

Lee, T.E. "Diary – 1920." Copy at Salt Spring Island Archives, Ganges, BC.

Lutz, John. "The War that Nobody Won." *British Columbia Magazine*, Winter 2005, pp. 42–49.

Mackie, John. "Tracking the Notorious Miner." The *Vancouver Sun*, June 24, 2006, pp. C1, C11.

Neering, Rosemary. "Swannell's Album." *British Columbia Magazine*, Spring 2005, pp. 44–49.

Professional Land Surveyors of British Columbia. *Cumulative Nominal Roll*, 4th edition. Victoria: Professional Land Surveyors of British Columbia, 1978.

Roll of Honour: British Columbia Land Surveyors, the Great War, 1914–1918. Victoria: Corporation of British Columbia Land Surveyors, n.d.

Swannell, F.C. "Alexander Mackenzie as Surveyor." *The Beaver*, Winter 1959, pp. 20–25.

— "Lieutenant Palmer Makes a Survey." *The Beaver*, Autumn 1961, pp. 33–38.

— "On Mackenzie's Trail." *The Beaver*, Summer 1958, pp. 9–14.

Vincent, George G. "Vacation Jobs for U.B.C. Students." Vancouver *Province*, October 25, 1925, magazine section, p. 2.

Government of British Columbia

Base Mapping and Geomatic Services Branch. BC Geographical Names Information System.

Bishop, R.P. "55th Parallel of Latitude." Pp. G30–39 in *Sessional Papers, First Session, Fifteenth Parliament of the Province of British Columbia. Session 1921*. Victoria: King's Printer, 1921.

— "Triangulation Control, Babine Lake." Pp. H87–97 in *Sessional Papers, Second Session, Fifteenth Parliament of the Province of British Columbia. Session 1921*. Victoria: King's Printer, 1921.

— "Control Survey, Chilko Lake, Range 1, Coast, and Lillooet Districts." Pp. K95–105 in *Sessional Papers, Third Session, Fifteenth Parliament of the Province of British Columbia. Session 1922*. Victoria: King's Printer, 1922.

— "Control Surveys, Range 3, Coast District." Pp. F94–101 in *Sessional Papers, Fourth Session, Fifteenth Parliament of the Province of British Columbia. Session 1923*. Victoria: King's Printer, 1923.

Dawson, G.H. "Report of the Surveyor-General." Pp. D49–61 in *Sessional Papers, Third Session, Thirteenth Parliament of the Province of British Columbia. Session 1915*. Victoria: King's Printer, 1915.

— "Report of the Surveyor-General." Pp. B53–57 in *Sessional Papers, Fourth Session, Thirteenth Parliament of the Province of British Columbia. Session 1916.* Victoria: King's Printer, 1916.

Monckton, P.M. "Triangulation Surveys, Lakelse and Kitimat Valleys, Range 5, Coast District." Pp. D116–18 in *Sessional Papers, First Session, Sixteenth Parliament of the Province of British Columbia. Session 1924.* Victoria: King's Printer, 1924.

Surveyor-General's Department. Field book registers, 1920–1928.

Swannell, F.C. "Connection and Reconnaissance Survey, Ootsa Lake to Dean Channel." Pp. G118–21 in *Sessional Papers, First Session, Fifteenth Parliament of the Province of British Columbia. Session 1921.* Victoria: King's Printer, 1921.

— "Triangulation and Reconnaissance Survey, Kitlope Valley and Tahtsa Lake, Range 4, Coast District." Pp. H82–86 in *Sessional Papers, Second Session, Fifteenth Parliament of the Province of British Columbia. Session 1921.* Victoria: King's Printer, 1921.

— "Control Survey, Range 4, Coast District." Pp. K91–95 in *Sessional Pupers, Third Session, Fifteenth Parliament of the Province of British Columbia. Session 1922.* Victoria: King's Printer, 1922.

— "Control Surveys, Ranges 4 and 5 Coast District." Pp. F90–94 in *Sessional Papers, Fourth Session, Fifteenth Parliament of the Province of British Columbia. Session 1923.* Victoria: King's Printer, 1923.

— "Triangulation Survey, Morice Lake, Ranges 4 and 5 Coast District." Pp. D38–42 in *Sessional Papers, First Session, Sixteenth Parliament of the Province of British Columbia. Session 1924.* Victoria: King's Printer, 1924.

Umbach, J.E. "Report of the Surveyor-General." Pp. L21–26 in *Sessional Papers, First Session, Fourteenth Parliament of the Province of British Columbia. Session 1917.* Victoria: King's Printer, 1917.

— "Report of the Surveyor-General." Pp. H13–16 in *Sessional Papers, Second Session, Fourteenth Parliament of the Province of British Columbia. Session 1918.* Victoria: King's Printer, 1918.

— "Report of the Surveyor-General." Pp. N25–28 in *Sessional Papers, Third Session, Fourteenth Parliament of the Province of British Columbia. Session 1919.* Victoria: King's Printer, 1919.

— "Report of the Surveyor-General." Pp. G19–23 in *Sessional Papers, Fourth Session, Fourteenth Parliament of the Province of British Columbia. Session 1920.* Victoria: King's Printer, 1920.

— "Report of the Surveyor-General." Pp. G15–20 in *Sessional Papers, First Session, Fifteenth Parliament of the Province of British Columbia. Session 1921.* Victoria: King's Printer, 1921.

— "Report of the Surveyor-General." Pp. H15–19 in *Sessional Papers, Second Session, Fifteenth Parliament of the Province of British Columbia. Session 1921.* Victoria: King's Printer, 1921.

— "Report of the Surveyor-General." Pp. K17–21 in *Sessional Papers, Third Session, Fifteenth Parliament of the Province of British Columbia. Session 1922.* Victoria: King's Printer, 1922.

— "Report of the Surveyor-General." pp. F15–18 in *Sessional Papers, Fourth Session, Fifteenth Parliament of the Province of British Columbia. Session 1923.* Victoria: King's Printer, 1923.

— "Report of the Surveyor-General." Pp. D17–21 in *Sessional Papers, First Session, Sixteenth Parliament of the Province of British Columbia. Session 1924.* Victoria: King's Printer, 1924.

— "Report of the Surveyor-General." Pp. T17-25 in *Sessional Papers, Second Session, Sixteenth Parliament of the Province of British Columbia. Session 1925.* Victoria: King's Printer, 1925.

— "Report of the Surveyor-General." Pp. W15–23 in *Sessional Papers, Third Session, Sixteenth Parliament of the Province of British Columbia. Session 1926.* Victoria: King's Printer, 1927.

— "Report of the Surveyor-General." Pp. F15–25 in *Sessional Papers, Fourth Session, Sixteenth Parliament of the Province of British Columbia. Session 1928.* Victoria: King's Printer, 1928.

— "Report of the Surveyor-General." Pp. E15–25 in *Sessional Papers, First Session, Seventeenth Parliament of the Province of British Columbia. Session 1929.* Victoria: King's Printer, 1929.

Underhill, J.T. "Dean and Labouchere Channels, Coast District." Pp. G87–92 in *Sessional Papers, Fourth Session, Fourteenth Parliament of the Province of British Columbia. Session 1920.* Victoria: King's Printer, 1920.

— "Triangulation Survey, Gardner Canal and Vicinity, Ranges 3 and 4, Coast District." Pp. G110–14 in *Sessional Papers, First Session, Fifteenth Parliament of the Province of British Columbia. Session 1921.* Victoria: King's Printer, 1921.

Archives

R2076-0-1-E (original access numbers 1955-042 and 1965-004). Field journals for 1923, 1924, and 1928. Library and Archives Canada

Swannell, Frank. MS392 (journals and correspondence). BC Archives.

— 98002-17 (photos and negatives). BC Archives.

Interviews

Sherwood, Jay. Interviews with Gerry Smedley Andrews and Art Swannell. December, 1986.

— Interview with Lorne Musclow. July, 2005.

Websites

BC Archives – www.bcarchives.gov.bc.ca.

BC Geographical Names – http://ilmbwww.gov.bc.ca/bcnames/.

Index